BEAUTY

THE TWENTIETH CENTURY

Nathalie Chahine currently works as a writer at Bayard Presse. She co-wrote and managed the production of *100 ans de beauté* (Editions Atlas, 1996).

Catherine Jazdzewski is an editor at *Vogue* and also works for Le Monde. She is the author of Helena Rubinstein (Editions Assouline, 1999), and *On se fait une beauté?* (Flammarion, 2000).

Marie-Pierre Lannelongue is a writer at *Elle*, where she has worked for four years.

Françoise Mohrt was the senior beauty editor at *Vogue* France from 1960 to 1978 and has written numerous articles in *Arichitectural Design, La Mode en peinture, Vogue Dècoration, LílgoVste, Beaux-Arts,* and *Le Figaro.* She is also the author of *Trente ans d'èlègance et de crèations* (Jacques Damase, 1983), a book dedicated to Marcel Rochas, and *Style Givenchy* (Editions Assouline, 1998).

Fabienne Rousso has worked at *Elle* since 1983 and is the author of several books, including *Rendez-vous díamour à Paris* (La Martinière, 2000). A filmmaker, she won the documentary film prize at the International Film Festival in Chicago in 1996 for her film *Zakhor.*

Dorothy Schefer Faux worked for Mirabella and *Vogue.* She is the founder and editor in chief of gloss.com, a new Internet communications and information site. She continues to work for major womenís fashion and beauty magazines in the United States and published *What Is Beauty?* in 1997 (Editions Assouline).

Francine Vormese has been an international fashion reporter at *Elle* magazine since 1977; in 1988 she took over as editor of the Voyages column. She also writes for *Elle Dècoration.* She is coauthor of *Années Elle 1945–2000* and editorial writer at *Elle Dècoration* for the *Best of des voyages publication* (Editions Filipacchi).

First published in the United States of America in 2000
By UNIVERSE PUBLISHING
A Division of Rizzoli international Publications, Inc.
300 Park Avenue South
New York, NY 10010
© 2000 Editions Assouline, Paris

Illustrations: Lola Blanchat and Delphine Pietri
·English Text and captions translated by Cindy Calder
and Elizabeth Heard

ISBN 0-7893-0512-7
00 01 02 03 04 05 / 10 9 8 7 6 5 4 3 2 1

Printed and bound in Italy

BEAUTY

THE TWENTIETH CENTURY

INTRODUCTION BY DOROTHY SCHEFER FAUX

NATHALIE CHAHINE
CATHERINE JAZDZEWSKI
MARIE-PIERRE LANNELONGUE
FRANÇOISE MOHRT
FABIENNE ROUSSO
FRANCINE VORMESE

UNIVERSE

"People say sometimes that Beauty is only superficial. That may be so.
But at least it is not so superifical as Thought is.
To me, Beauty is the wonder of wonders.
It is only shallow people who do not judge by appearances.
The true mystery of the world is the visible, not the invisible...."

Oscar Wilde, The Picture of Dorian Gray

CONTENTS

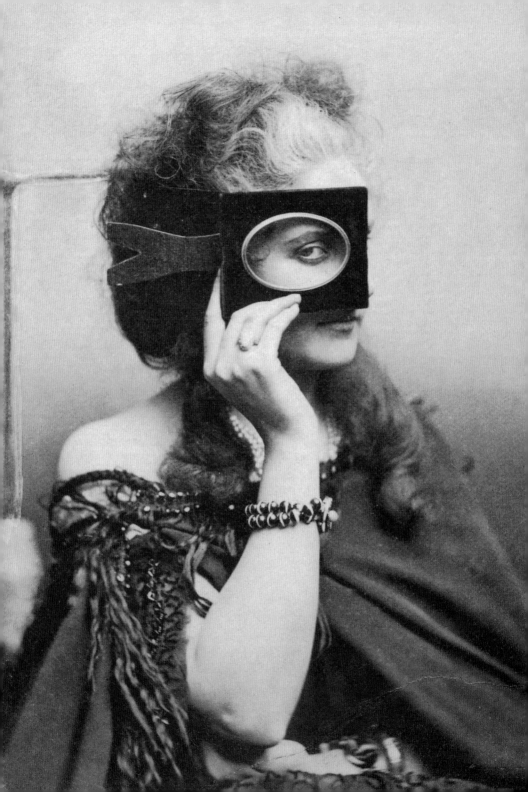

Beauty | Introduction

Introduction

The Future of Beauty : Empowering the Ideal

On a rainy December night at New York's Metropolitan Museum of Art, with only a few weeks of the twentieth century remaining, history was made. The Rolling Stones blared through the galleries of time's most beautiful objects, among today's most beautiful people, as the Met's Costume Institute honored the artists of rock for their contributions to style (not to mention the stylish people who have benefited from it) at the annual gala benefit, the "Party of the Year." "It would be difficult to overestimate the influence of rock on late-twentieth-century style," proclaimed Richard Martin, curator of the Costume Institute until his death in November 1999. "More than movies and/or the fashion industry, rock has been a dynamic force in visual style." And the world of fashion and beauty has appropriated rock: fashion shows of the late 1990s resembled rock concerts; designers such as Calvin Klein have replaced fashion models with rock stars in their ads; makeup lines like Tommy Hilfiger and MAC name their colors after rock 'n roll references; and makeup artists themselves turn to rock 'n roll for inspiration: "Music can make me think about colors and give me ideas for different looks," claims makeup artist Dick Page, known for being the trailblazer of minimalist makeup.

But what is it about rock 'n roll that has made it such a powerful influence in style and beauty at the turn of this century? The glamour, diversity, provocation, and the issues addressed by performers make it relevant to our time. A pretty face can be appealing, but "beauty" is all the more potent when it is more than just a facade, when it is a symbol for something greater, something that stirs the soul. Music carries with it the emotion, the thought, the passion of the artist that a face alone can't provide.

Cindy Sherman,
Untitled Film Still.
1977.

Previous page:
The Countess of
Castiglione. Often
referred to as the
beauty of the
century by her
contemporaries, she
used photography to
place herself center
stage throughout
her life. (P. L. Pierson,
Scherzo di Follia,
1861–67.)

And so the accoutrements of music—the style and the fashion—were indeed a major event that night at the Met because of their role as a symbol for the expression of our time. And the icons that gathered together represented a monumental example of our expanding ideals of modern beauty: music stars such as Liz Phair, Jennifer Lopez, Whitney Houston, and rapper Lil' Kim; models Kate Moss, Naomi Campbell, Iman; social figures Diane Von Furstenberg, Princess Marie Chantal of Greece, Aerin Lauder; actresses Gwyneth Paltrow, Heather Graham, and actress and Estee Lauder model Elizabeth Hurley. Vogue editor at large Andre Leon Talley remarked to the *New York Times*, "Did you ever think you'd see a scene like this? Annette de la Renta in her billowy couture silks and Lil' Kim in her Versace bikini. They are the sum of the evening." And, what would seem, the sum of the century.

As the 1990s drew the millennium to a close, after spending over fifty years contemplating and addressing social issues, from racism and bigotry to women's rights, poverty and gender roles, the look of beauty has served as our mirror. Appearance has reflected the process of transformation through various incarnations and extreme images, as we've sought in this postmodern climate to change and then regain our equilibrium: deconstructivism, anti-beauty, heroin chic, global/multicultural influences, androgyny, to name a few. The result is a beauty ideal of today that could be any of these, or something else entirely. Most of all, beauty is plural and defined by the individual more than ever. We are beginning to see the effect of soul-searching and the milestones we've achieved over the course of the century. The beauty revolution? Perhaps. . . .

Individual beauty as we think of it did not exist on a broad scale until the 1960s. Today, we can become overwhelmed by the different types of beauty, looks, and styles available to us, by the vast array of choices we're faced with in our effort to appear individual. However, for the first half of the century, there was generally one ideal of beauty at any one moment that most women strove to emulate. For example, during the 1910s, with the last vestiges of the Belle Epoque lingering, women looked to pictures of aristocratic women who were photographed in the latest hairstyle and

Mariko Mori,
Mirage. 1997

fashion. The requirement was a tiny waist and an S-shape posture attainable only through debilitating bone corsets, huge, heavy hats worn on top of piles of false hair balanced precariously on extended necks, and faces painted to look natural. Inconceivable to our fast-paced lifestyle, these styles could be worn only by women who didn't have to walk far or perform domestic functions, for they required an immobile and torturous, though decorative shape.

When the cinema began in its popular form in the postwar 1920s, it became by far the favorite type of entertainment. With it, a new modern style spread like wildfire reaching women of all ages and classes. The trend-setting influence of the beautiful and beloved movie star of the silverscreen surpassed that of the society woman. And as fast as the medium, so was the singular new style: short dresses, short hair, dark makeup, sportswear. The exotic beauty—bobbed hair, kohl-rimmed eyes, dark lipstick, thin, corsetless bodies—of actresses like Louise Brooks and Gloria Swanson was to influence an entire generation of women. A woman of the 1920s couldn't possibly be considered modern without chopping off her hair. Although the dictates of fashion may have been uniformly severe, the 1920s marked

the beginning of what we now consider modern beauty. And the iconic style of these film stars was so pervasive that it was to resurface throughout the century.

Hollywood would continue to be the most influential force in determining style and beauty for another thirty years. In the 1930s, after the Great Depression hit, Hollywood offered much-needed fantasy and escapism. Its impact on style and glamour was unprecedented. The sultry looks of stars such as Marlene Dietrich and Greta Garbo achieved international notoriety. Their piercing eyes, dark, defined lips, narrow, arched brows, and soft, refined hair was the defining look of the decade. Jean Harlow was the first star to dye her hair platinum blonde, and started a trend that would be forever associated with Hollywood glamour and is copied to this day. Marlene Dietrich, Carole Lombard, Veronica Lake, Lauren Bacall, Marilyn Monroe, Grace Kelly, Anita Ekberg, Brigitte Bardot, Farrah Fawcett, Catherine Deneuve, and Gwyneth Paltrow were all offspring of Harlow's blonde sensation.

During World War II, Hollywood again supplied its share of glamour queens to inspire duty and dedication in women on the home front, and to increase troop morale. The ultra-femininity of Veronica Lake, Rita Hayworth, and Lauren Bacall made ideal pin-ups with their long, full, slightly curly hair, heavy makeup, big, doe eyes, and full lips. The voluptuous poses and risqué clothing like short shorts, tight shirts, and flowing hair created a new beauty icon: the bombshell. From then on, bombshells such as Marilyn Monroe, Brigitte Bardot, and Cindy Crawford continued to inspire the adoration of men and the emulation of women.

Fashion has always been one of beauty's greatest influences, and likewise, beauty for fashion. Today's high fashion maga-

Helmut Newton
for *Votre Beauté* in 1970.

Cover of Esquire
(1968) by Georges Lois, famous image maker of the 1960s.

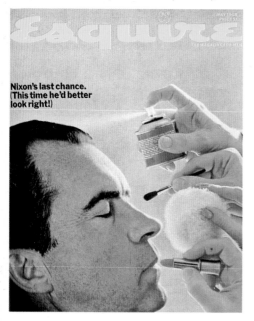

Nixon's last chance.
(This time he'd better look right!)

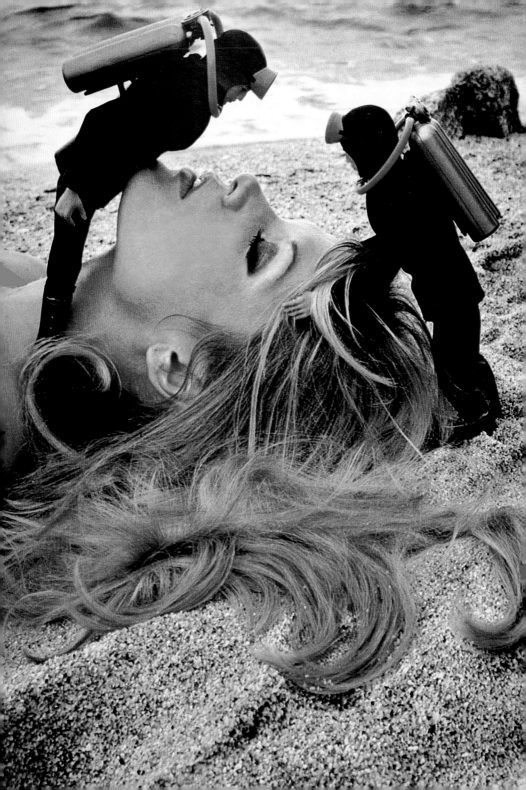

zines uphold a version of beauty that is unabashedly rich, thin, and unattainable for most women. Yet women still love the dignity and aspirational qualities they convey. This vision of women began in the late 1940s and early 1950s when Richard Avedon and Irving Penn provided the stunning, stylized photographs of Dior's New Look. In the wake of World War II, when Europe was left to rebuild with few resources and broken spirits, it took someone as inspired as Christian Dior to reinstill hope. He wanted women to bring France back from the dead through their beauty, and created a style that, like the Belle Epoque, turned women into living flowers to blossom out of the rubble. The New Look, as Dior called it, was an entire look, from the the pulled-back hairstyle, painted face, and requisite exaggerated posture to the quintessential strapless dress with full skirt and corseted wasp waist. Dior's immediate solution to impose dignity on women was restrictive and severe, resuscitating many turn-of-the-century ideas of beauty. Dior imposed shapes on women: A, H, Y, oval, scissor, and required a new posture which was, in effect, the S-shape in reverse. Women were once again donning boned corsets and restrictive skirts, then also accepting the Belle Epoque notion of the immobile flower. Coco Chanel was outraged. She proclaimed he wanted women "to look like armchairs. He put covers on them." And she came out of retirement.

Chanel interpreted beauty and dignity differently. She believed dignity was inherent in a woman who had the freedom to express it. The new version of the elegant sportswear Chanel first developed in the 1920s, not only returned to 1950s women their shape and freedom of movement, but inspired a direction in fashion and beauty that has persisted to the present: natural shapes, basic, movable clothes, simple accessories, natural beauty. The more relaxed and natural structure of her clothes affected the beauty of the day as well. Makeup and hair were toned down and more simple, as opposed to Dior's severe, painted faces with highly arched eyebrows and dark lips. Chanel's philosophy went on to inspire and influence some of the most significant imagemakers of the century. Diane Von Furstenburg whom *Newsweek* deemed "the most marketable female in fashion since Coco Chanel," changed the way women—particularly the new group of

Matthew Barney,
CR4: Faerie Field,
1994.

career women—dressed in the 1970s with a single design: the wrap dress. Easy and feminine, her wrap dress could go from day to night, allowing women freedom of movement while still looking chic and sexy. Diane Von Furstenburg wanted women to bring their own beauty and style to the dress and not the other way around. In the 1980s and 1990s, Donna Karan took women's style one step further, revolutionizing design with her chic basics that created not only a new convenience for women, but a more natural and sexy look, discarding the masculine power suit, big hair, and heavy makeup. Like Chanel, she was a modern, working woman in touch with the women of her time and what they needed.

The forces that determine what is beautiful began to shift in the 50s. While mothers sought to emulate a combination of the perfect homemaker in June Cleaver, the sex appeal of Marilyn Monroe, and the stylized vogue look of both Lisa Fonsgrives and Suzy Parker, their daughters' choices were largely determined by the type of music they preferred or which television stars they wanted to emulate. Their icons varied greatly:

Elvis, jeans, and ponytails; Audrey Hepburn, eyeliner, and capris; Brigitte Bardot, bottle blonde, tight sweaters. Although the style of the "'50s mother" has never returned, the icons of youth are just as prevalent today. Makeup artist Sandy Linter who creates faces for many of today's celebrities agrees. "When I make up celebrities," she says, "they all ask to look like Madonna or Audrey Hepburn."

As 1950s girls grew older, they maintained a strong identification with their generation, and began to feel a chasm between their values and those of their parents. When Yves Saint Laurent took over Dior in 1957, and his "Beat Look" infused their mother's couture with street style, the scales in high fashion and beauty began tipping toward the energy and change of a younger generation. Both in Europe and the U.S., the 1960s were a time of great social transformation and political unrest. When the Kennedys entered the White House in 1960, it was the Kennedy youth, idealism, and desire for change that people adored. And Jackie, with her sophisticated yet modern style, was looked up to for the rest of her life for her sense of style and grace. Music as a social force had reached a zenith with the mass hysteria over the Beatles and Rolling Stones. Soon it seemed the entire Western world under the age of thirty was adopting the Swinging English

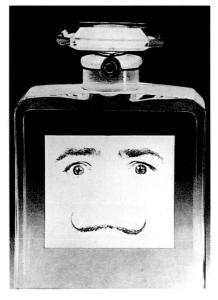

La Moustache de Dali photographed by Philippe Halsmann.

look of Twiggy, Biba and King's Road, Mary Quant miniskirts, wide eyes and fake eyelashes, bouffants, beehives, urchin cuts, and pale lipstick. Pop Art and Op Art by Andy Warhol, Bridget Riley, David Hockney, and Frank Stella inspired geometric looks in clothes, hair, and makeup. The Vidal Sassoon geometric bob, thick, low bangs, the chignon, triangular black liquid eyeliner on the eyes, and the defined but pale lip was all part of the look. But after John F. Kennedy was assassinated and the Vietnam War escalated, beauty and fashion were suddenly considered frivolous. The differences between the two generations were sealed, and the youth laid claim on the

Andy Warhol,
Before and After,
1960.

future. Anti-war protests, feminism, civil rights, rock, the Pill, and sexual liberation caused 1960s women to see themselves and their world transformed. Idealism and antimaterialism were expressed in vintage and thrift-store clothing, long, middle-parted, uncoiffed hair, and the natural make-up of Grace Slick, or the psychedelic-painted face of Penelope Tree.

The 1970s saw the war draw to a close, the rise of the Watergate scandal, and a deepening oil crisis. Domestic U.S. politics, such as feminism and civil rights, added a difficult but needed upheaval. It was a time of disillusionment, uncertainty, and distrust of authority, reflected in everything, including the look of the time. The focus was on figuring things out whether through mystical religions, psychotherapy, or radicalism. Art had abandoned the concept of idealizing beauty and the human form. Abstract artists who relinquished the visual representation of the human form continued, joined by the new photorealists like Chuck Close who tried to strip away all idealism and forced notions of the observer. The silhouette of the 1970s was very tall and thin, nails were long and often fake. Hair was permed, layered, frosted, or colored in garish hues, and makeup was colorful with frosty shadows, thin eyebrows, dark or coral lips, and contour

shading to the cheek.

Style and beauty during the 1970s was as uncertain as its context, looking back with nostalgia to easier, less complicated times, or searching for escape into fantasy. The gypsy-inspired, romantic look with straight, permed, or feathered hair and natural but feminine makeup represented the former; the latter the result of provocative glam rock, disco, and beginnings of punk: Bianca Jagger, Diana Ross, and Debbie Harry, and the tan, Jet-Set look of Cheryl Tiegs, Lauren Hutton, and Farrah Fawcett. But even the avant garde was caught in the grips of nostalgia. "It's not true . . . that people were more beautiful or the times more glamorous in the '70s," Bob Colacello, editor of *Interview* magazine and an established feature at Warhol's Factory, remarked looking back. "At the time, we longed for the style and stars of the '30s and '40s—Garbo, Dietrich, Gary Cooper, Errol Flynn." As some looks inspired the past, model Beverly Johnson looked ahead. She became the first African-American top model and by doing so, broke the color barrier in the image industry.

The excesses of the 1980s brought about an excess of change. The surge in new wealth inspired unabashed, unreflective materialism: logos, labels, conspicuous displays of wealth, and a high-maintenance lifestyle. The bigger the better for hair, shoulder pads, height, breasts. Inspired by pop stars such as Cyndi Lauper and Madonna, younger women were also pushing boundaries with heavy makeup, intentionally messed-up and off-colored hair, torn clothes, and lingerie worn as outerwear. The workout and health craze had also begun, so women were flaunting their athletic bodies in tight clothes. Women on a wide scale began to attain powerful positions in the workforce. They pulled out all the stops with power dressing and strong makeup emphasizing all features; they also tried to place equal emphasis on all aspects of their life—family, career, home, lifestyle—leading to the term superwoman. And then the supermodel. Cindy Crawford, Claudia Schiffer, Naomi Campbell, Linda Evangelista, and Christy Turlington were larger-than-life models who commanded the attention of the world and controlled their salaries and their careers. They starred in music videos, commercials, and eventually had their own workout videos.

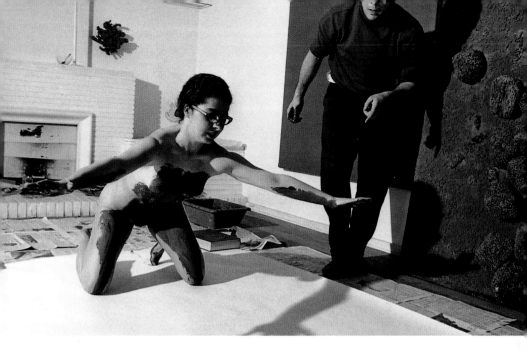

Yves Klein directing a model for *Anthropométrie* in the 1960s.

Although their look was difficult to attain, the power shift that occurred in their career put women's beauty back in their own hands.

Toward the end of the decade, Donna Karan brought fashion back to reality with simple, basic clothes that fit the natural proportions of the body. She also made black the staple of every woman's wardrobe. Karan's clothes could go anywhere, especially her body suits and leggings that were actually inspired by the fitness revolution. And women's interest in exercise affected the way they presented themselves overall. With busy and athletic lives, it was no longer practical to spend hours on big hair and layers of makeup. A decade later, Karan was one of the first to use women over fifty in her advertising campaigns and on the runway. Makeup at this time also took a turn to the natural, started by two women who felt that what was available didn't reflect a modern woman's lifestyle or taste. Former *Vogue* editor Andrea Robinson created a neutral line of makeup for Revlon's Ultima brand called The Nakeds, and makeup artist Bobbi Brown developed a matte, natural palette with her Bobbi Brown Essentials line. Sophisticated and flattering, with an effect of "heightened reality," the no-makeup look became ubiquitous for the rest of the decade, and it was not

until 2000 that color began to re-emerge. Also, for the first time, prestige makeup became more personalized and inclusive, matching foundation to individual skin tones.

The materialism of the 1980s looked glaringly grim in the 1990s. The garish displays of wealth were deemed in poor taste and lacking in ethics. The supermodels were still commanding the world's attention, but their look was toned down. Dress was chic but minimalist in line, catering to the natural proportions of the body. Calvin Klein, the ultimate minimalist and Helmut Lang, the deconstructivist, changed the direction of fashion and beauty toward the natural state of women: simple makeup and hair, sleek lines, relaxed and casual but sophisticated clothes. The music industry was the biggest force in shifting awareness and looks. The grunge look, which began unselfconsciously with Seattle's struggling bands (unkempt hair, little-to-no makeup, and thrift-store clothes layered and worn with combat

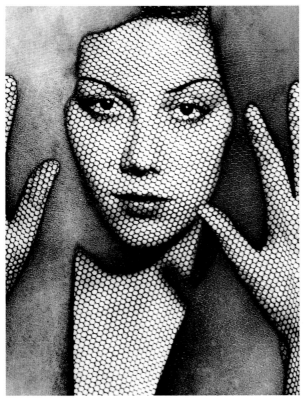

Man Ray, *La Résille*, 1931. "A solution that does not conceal, instead it accentuates the beauty of the model."

boots), became *de rigeur* in high fashion as the youth of the world embraced the bands' sound and anti-consumerist ideals. It was the perfect antidote to the 1980s. But heroin was associated with these bands, and the waif look was soon also embraced by fashion photographers, who glamorized all the "lost" women of the past: absinthe and opium addicts of the 1920s, the Chelsea Girls, and the contemporary vapid-eyed waifs. With frizzy hair, kohl-encircled eyes, malnourished frames, and beaded dresses, they posed in various dark, tragic, yet alluring

poses.

The model who emerged to epitomize the "waif" look was Kate Moss. Many reacted to her tiny, gaunt frame with horror seeing her as the poster girl for anorexia or a pedophile's dream. Others found her look liberating since she defied many of the model requirements of the day: she was shorter (a touch under 5'7"), didn't exercise, and refused the requisite breast implants that tend to detract from the gauntness of a model's frame. She was often photographed without any makeup at all. Her anti-super-model look personified the time: natural beauty, reflective gaze, and minimal in both body and style. She was boyish in the same way that male models were gaining in popularity and seeming to become more "girlish" with longer hair and skinnier frames. The ideal was essentially the same for both men and women, definitions were becoming blurred and, like the 1920s, androgyny was a mainstream style.

The children of the 1950s, armed with rock music and TV, charged rapidly through the limitations of the past. They took us from the industrial age into the computer age. As the century has drawn to a close and a new one has begun we are still trying to determine the role of technology in our lives. What once was feared as a Brave New World, is now a medium with infinite possibilities. Beauty at the turn of the twenty-first century reflects a stark contrast to the cold microchip, flourishing in the most individual way. The ease in accessing instant information and engaging in direct communication via the Internet allows "borders" of all kinds to be crossed—physical, economic, cultural—and has brought to light the beauty of new voices and visions. Individuals have greater freedom to express themselves with more ideas and looks to choose from. Madonna is the quintessential example of a modern beauty. She has reinvented herself many times to reflect what is meaningful to her at the moment, culling her looks from such diverse sources as Indian beauty and Hollywood icons of the 1930s and 1940s. And now, everyone has the world at their fingertips.

It took a century to widen the scope of beauty to where it is today; but as beauty moves to the Internet in the form of content, commerce, and community, the global flow of ideas, information, and discussion will shrink

the time it takes to progress exponentially. Today, we already see the results in the realm of appearance: a wider definition in age, size, shape, and culture seen in turn-of-the-twenty-first century icons like Madonna as well as Lauryn Hill, Gwyneth Paltrow, Jennifer Lopez, Lauren Hutton, and Lucy Liu, to name a few. Women are more comfortable with themselves and with others. The face of beauty is now more natural, individual, relaxed, and confident than ever before. Dignity is acquired, not imposed. As the supermodels took back their beauty in the 1980s, every woman can take back her beauty in the 2000s. Beauty is coming into a New Age as it moves into the new millennium and the world of New Media. A Brave New World of beauty is here—and it's beautiful.

DOROTHY SCHEFER FAUX

Beauty as seen by David Seidner, 1988.

Beauty

A Historical Overview

Beauty
in Antiquity

Have you ever envisioned for just an instant the wondrous procession of Cleopatra and Semiramis, Balkis of Saba and Bathsheba of Israel, Jezebel or Nefertiti, united at the dawn of the universe by a splendor greater than any we have ever witnessed. Their names echo a hymn to beauty throughout the ages.

Egyptian women with braided wigs, painted eyebrows and eyes. (Bas-relief from the tomb of Imeneminet, circa 1335 B.C.)

The legendary Nefertiti. Very stylized, the kohl and pigment makeup are clearly visible on this polychromatic wood head.

What woman has not lapsed into reverie while standing in the Louvre or the British Museum, admiring magnificent vessels of ointment, scoops for powder, a palette of pigments, a kohl pencil, sculpted from ivory or ebony, bone or alabaster, blown from glass, or modeled from terra-cotta or clay.

Goddesses, pharaohs, priestesses, queens and slaves...we have heard tales from the ancient Orient recounting the beauty of all kinds of women, no matter what their origins, in a language so simple that despite the centuries it speaks to us in modern times.

The Bible mentions the practice of applying makeup, and the first palettes used to grind colored powder date back ten thousand years; but it was not until 5000 B.C. that we have the first records listing large troves of makeup instruments, jars and pots containing products that were found practically intact. Archeological research has uncovered secrets hidden in the mysterious phials, allowing us to reconstruct a daily routine, a quasi-ritualistic toilette, the minutiae of which far out-rivaled our own.

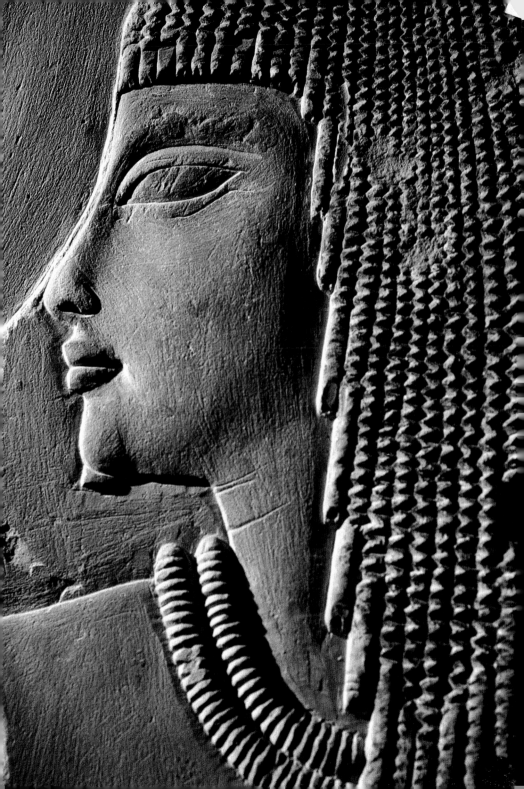

We know that in 1372 b.c., when Nefertiti was married to Amenhotep IV, who took the name of Akhenaton, she washed herself thoroughly each morning with a mixture of water and natural lime-water, rubbing her body with a clay paste made from alluvium formed by the Nile. In such hot conditions, special care was needed to combat the effects of the climate, especially the sun. Feet and elbows were frequently pumiced with very finely grained rocks that also served to regularly exfoliate the body. A bath was followed by a massage with vegetable, palm, olive, or walnut oil perfumed with a mixture of aromatic herbs that had the triple benefit of softening the skin, providing protection from the sun, and repelling mosquitoes. Sometimes, masks were prepared from ostrich eggs beaten together with milk, clay, and oil, and then thickened with flour or resin. Finally, makeup was applied to the body and face. The ritual of preparing the makeup, which was always scented, was originally monopolized by priests and associated with mortuary rites; it was eventually taken over by a secular body that jealously guarded their formulas and sold their products at very high prices. The skin was coated with a yellow ocher preparation that took on a golden sheen when illuminated, cheeks were accentuated with red ocher, the veins of the temples and the breast outlined in blue. But it was the eyes especially that were systematically made up, as seen in statues and frescoes. While the ablutions and daily care were the privileges of the noble classes in a strictly hierarchical society, even slaves painted their eyes. First kohl powder was placed on the interior of the eyes, protecting them from the wind and sand; production and expiration dates have been found on eye makeup boxes, leading to the assumption that they contained medicinal herbs meant to prevent opthalmia. The upper eyelids were always painted with dark colors: while the moszimit green, made from crushed Syrian malachite, was the most

The women of ancient Greece, like those of the Orient, are coiffed, made up, and sumptuously adorned. Kore (Parthenon, sixth century B.C.).

Aphrodite, known as the goddess of love. A perfect example of ancient beauty, the "Greek profile" is idealized by all classical Greek sculptors. (School of Praxiteles, circa 360 B.C.)

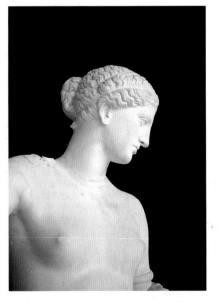

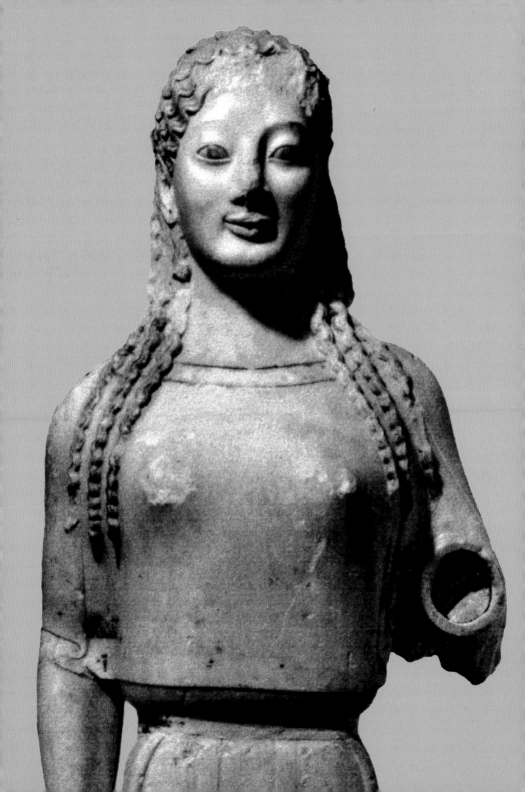

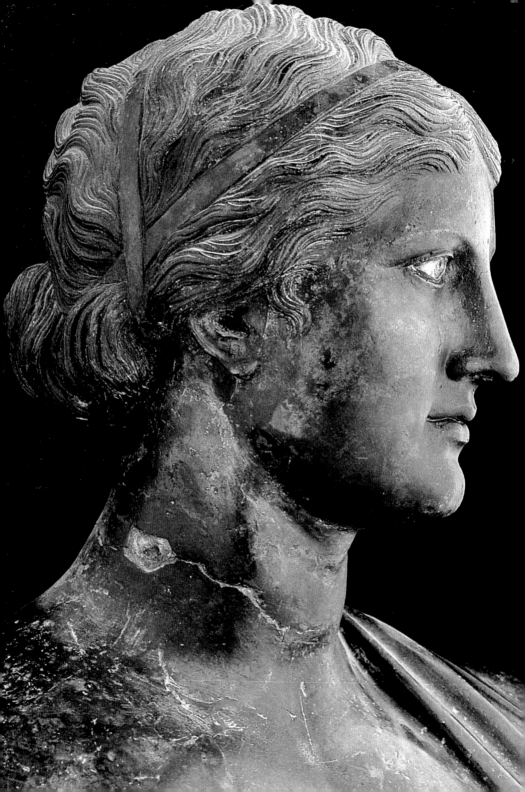

popular, turquoise powder, red, brown, or violet clay, pure or mixed with iron or copper oxides to obtain new shades, were also prized. On special occasions, the areas below the eyes were painted with a different color, as the legendary Cleopatra did many centuries later-her favorite shades were dark blue for the upper lid and sea green for below. Moistened kohl was also used to outline the eye with a long thick line to lengthen and thicken the brows. Sometimes the brows were shaved off and then redrawn. The lashes were colored with a paste of kohl and grease. A touch of mineral rouge brightened the lips. Finger- and toenails were polished and often painted with henna. As a supreme act of coquetry, women would sometimes dust their breasts with gold powder. A heavy wig with bangs, in silk or horsehair, black or dark blue, sometimes highlighted with golden threads, would adorn shaved heads or supplement hair that was considered too fine. Wigs were very straight at first, but it later became stylish to wear this false hair longer and curlier, or in small, tight braids parted on the side or down the middle. For parties or festivals, a small cone of perfumed wax was set on top of the wig; in the heat it would drip down the hair to perfume and refresh the body.

Essential oils, aromatherapy, exfoliation, clay, henna . . . our New Age beauty has gleaned the best from ancient times, bypassing the unhygienic conditions of the intervening centuries.

In ancient Greece, during the period of Ulysses' wanderings and Achilles' wrath, of beautiful Helen and horrible Medea, when gods descended from Olympus dressed as women to dally with mortals while shepherds chose who was truly the most beautiful among the goddesses, the ultimate test of beauty was based on the harmony of proportions. Classical statues have shown us the ideal forms: models were repeated in almost identical form by Phidias and Praxiteles. And from the creators of myths and Homeric epic we have learned about the cleaning rituals of the Greeks in the twelfth through the eighth centuries B.C., their social baths and perfumed oils.

The poet Sappho. Greeks and Romans were already using irons to curl their hair. (Copy, statue from the Villa of Papyri in Herculaneum.)

Blond and red hair coloring were kept within the abode of the gynaeceum. For the female citizen of Athens or Sparta-where makeup was officially forbidden-such practices were left to the courtesans. The etymology of the word cosmetics suggests that according to Greek logic it was the art of self-adornment, in which different elements were placed in harmonious order. As Hippocrates recommended, one must attend to internal and external hygiene with regular fasting, physical exercise, and frequent baths. Teeth must be brushed, hair washed, and after the bath, the body should be rubbed with a special scraper called a strigile to remove the surplus olive, almond, or sesame oil used to clean the body and to stimulate circulation. All kinds of aromatic ointments were used to protect the skin and fight perspiration. Until the third century B.C, women used little or no makeup, except perhaps on the brows, which had to touch each other and form a single arc to be considered beautiful, like those of Anacreon's mistress, to which he dedicated a poem. Admiration for this feature survived the centuries, as the poet Theocrites alluded to it some three hundred years later. Some women even supplemented their sparse eyebrow hair with hair patches.

Slowly but surely, however, the appeal of makeup and perfume, brought by the barbarians from Egypt and Asia Minor and sold by peddlers at the entrance to the gynaecea, caught on. The beautiful Aspasia, the mistress of Pericles, who ruled Athens in the fifth century b.c., wrote two works on the art of how to use makeup. Women discovered that by coating their faces with white ceruse, which was poisonous, they would appear paler. This practice was condemned by Galen. In the second century B.C., orcanette root, blackberries, and crushed figs were used as rouge for cheeks, and kohl or soot to darken the eyes. Aristophanes provides vivid descriptions mocking the effects of sweat on the faces of the "hags" who used makeup.From the second century B.C. to the triumph of Christianity, orators and poets wrote numerous satires. Lucieńis Pamphlets, Martialís Epigrams.

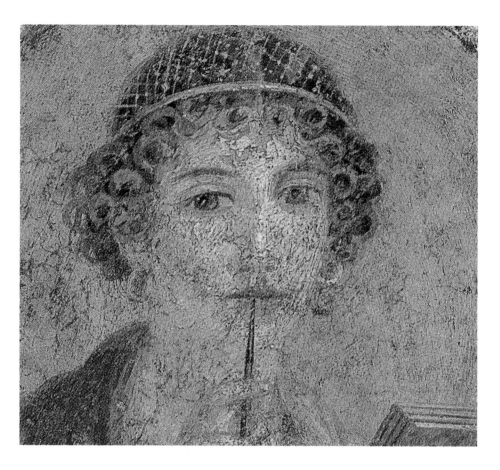

Young woman with a stylet. On the frescoes of Pompeii, a face whose beauty transcends time in its modernity.

Rome was not to be outdone. From the beginning of the empire, Roman women of high social rank, like the Athenians, used makeup, and washed themselves even more assiduously than did the Greeks. Armed with their toilette cases, they would leave for the baths. Assisted by their slaves, they would meticulously wash every orifice of their body and their faces, exfoliate their skin with pastes made from oil and sand, then brush and comb their hair over and over. They would then remove all of their body hair themselves. Next came the perfumes, the herbs that were chewed to sweeten the breath, and finally the makeup and the hairdo, a task requiring a retinue of slaves, each of whom had the enormous responsibility of handling a specific chore or part of the body.

From the second century B.C. to the triumph of Christianity. orators
and poets wrote numerous satires. Lucien's *Pamphlets*, Martial's
Epigrams, Juvenal's *Satires*-all mocked the false faces that looked like
painted enamelware, the fake ivory teeth, and wigs made of brown
hair from India and blond hair from Germania. The Romans also offered
plenty of advice: Galen, writing in the second century A.D., draws on
sources from the *Treatise on Cosmetics*, a survey of dermatological and
aesthetic knowledge recorded by Criton at least three centuries earlier.
In 4 B.C., Ovid entertained himself by composing a coquetry code
called *Cosmetics*. In witty and affectionate verse, he offers beauty
advice and pomade recipes such as an exfoliating mask made from all
kinds of ingredients including powdered stag horns, honey, crushed
narcissus bulbs, and a rose petal cream to prevent red patches on deli-
cate skin. He advised: "Do not let your lover surprise you when your
boxes are spread all over the table: art can only enhance the face when
it is not obvious."

"The European girl. " This portrait of a young girl from Antinoupolis (circa 117–38)
reflects how Roman society was steeped in the Orient and had adopted Greek and
Egyptian influences and styles. Much preparation was required every day for
the toilette, makeup, hairstyle, and finery.

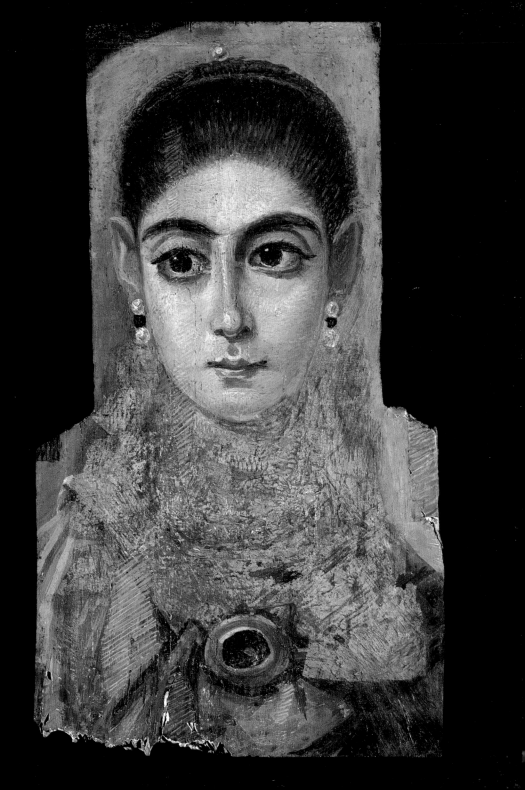

Beauty | **The Middle Ages**

Eve and Mary. Every picture, all imagery of women in the Middle Ages, refers to one of these two women. In the medieval world, the woman who ascends to heaven and the woman who was expelled from paradise are at opposite poles, much like heaven and hell.

Because of her tempting beauty, for she is irresistible and incapable herself of resisting sin, Eve, whose corrupting loveliness caused man eternal loss, bears the fault and the brand of original sin. During this triumphant Christian era dominated by the monastic world, Eve, always blameworthy and forever damned, is the incarnation of absolute evil, and her deceitful beauty is the mask of the devil, infinitely replicated in all women.

Opposed to this demonic beauty stands the Virgin, mother of the God who has atoned for the sins of the human race corrupted by the first woman. But while Christ can atone for man, Mary cannot redeem Eve. A virgin mother, she is set apart by the purity of her flesh, and her beauty resides in the tranquillity of her untouched body.

In art as in literature, the tension between these two poles resounds in the depiction of medieval women.

Romanesque pictorial art and sculpture were religious, didactic, and enlightening, with no independent existence outside their links to architecture; more moral than physical, more abstract than real, they replicated the dichotomy between the bodily and the spiritual, a split that marked the Middle Ages until the end of the fourteenth century.

Queen Uta is a typical example of the chaste and proud beauties who inspired the epics of the Middle Ages. (Sculpture by the Mâitre de Naumburg, second half of the thirteenth century.)

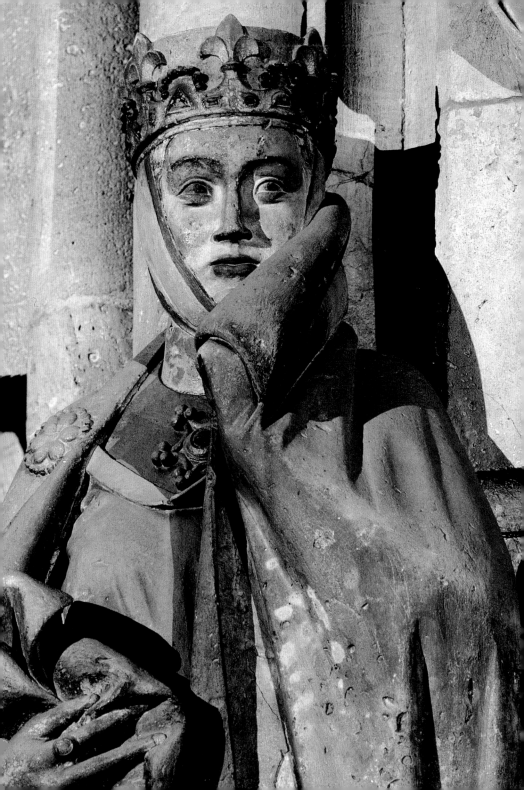

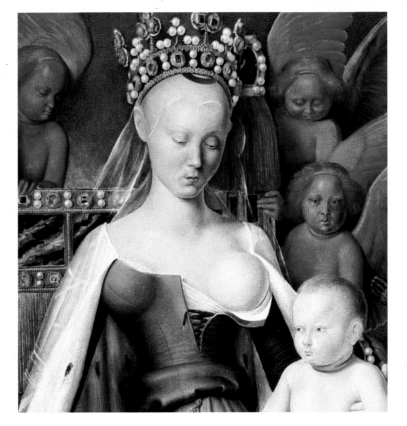

Agnès Sorel, the favorite of Charles VII, with whom she bore three children, served as a model for this virgin. (*Virgin with Child*, diptych of Melun, J. Fouquet, circa 1450.)

The individual portrait did not yet exist. The faces of virgins, saints, and the faithful, painted mainly on frescoes, were similar to the Byzantine icons, but more expressive. They were not based on living models but on symbolic conventions. Far from attempting to find pure form or to reproduce beauty for beautyís sake, these faces were at first totally impassive. Then slowly they began to show signs of suffering, resignation, faith, and beatitude, crowned in gold and shrouded in long cloaks to reflect the precepts of the Christian faith. Held in contempt by a religion that preached against the flesh and called for its mortification, the nude body, except that of Christ, was banished from representation. Heavily clothed, the body was hidden under sacerdotal robes and cloaks. Pose took precedence over form, and movement was constricted. Only the damned were naked.

From the pulpit, the great preachers denounced the mirror as the "door of hell", cursing makeup as the sacrilege that would lead to infamy, and alluding to the dragon who appeared in multiple guises to betray his enemies. To beautify the guilty nature of women was deceitful, to make up the body was diabolical, a subterfuge used by women to cover the true horror and stench of their bodies and souls, if they even had a soul. Luckily, Saint Michael was watching them.

On Judgment Day, God would not recognize these made-up women as his creatures, and they would go straight to roast in the flames of hell with their satanic accomplice. Coquetry and seduction would only lead to debauchery and lust, the weakening of man, and the failure of his undertakings.

The only color that could lend grace to women was the red blush of modesty, "the rouge of genuine worth . . . that flushes the brow of virgins and brides," according to Gregory of Nazarianze. This natural color, brought on by an uncontrollable reaction, does not lie. In fact it is a confession: the red color of modesty reveals the indelible mark of sin common to the female condition, a state of being that evokes shame in even the most honorable womenófor through the inevitable force of events she will drag man down with her.

This red mark of modesty is cleansed with the white wash of purity, the ideal purity of the Virgin. In complete opposition to the beauty of the devil, the only beauty worth beholding is the beauty that is transfigured by the love of Christ, elevating man toward the love of God. The first female Catholic saint, Agnes, was a fourth-century virgin martyr, an example of this untouchable woman: even at the stake, she tried to hide her nudity with her long hair. In another variation of bodily redemption, Jesus's pardon allowed Mary Magdalene, a sinner who regained her innocence, to display her nudity inoffensively. Such salvation led to the depiction of the sexless nude bodies that gradually began to appear in cathedral tympana.

As figureheads from a world torn between heaven and hell, stereotypes of the Christian imagination tell us little about the real women of

Following pages: High domed foreheads, plucked eyebrows, thin and redrawn, full cheeks, and small chins, the pure and unpainted faces of medieval beauties.
Left: **Judith**. (Detail, L. Cranach, circa 1530.)
Right: **Portrait of a young woman**. (P. Christus circa 1446)

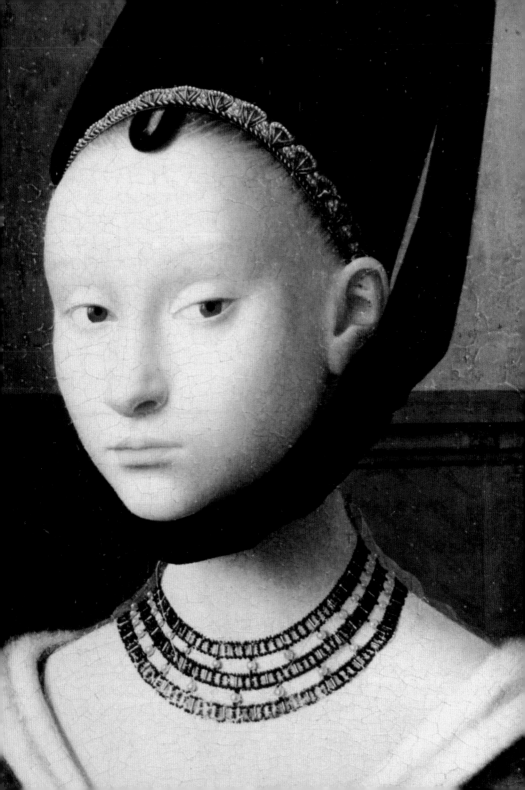

the day. At a time when the church controlled all pictorial representation, the true definition of female beauty in the Middle Ages emerges from secular literature.

Like the beauty of the virgin, the beauty of the damsel, celebrated in the songs of the troubadours, is sweet and pure. By virtue of her love she uplifts man, inviting him to surpass himself.

With their skin "as white as lilies, milk, or hawthorn blossoms," these heroines conquered the hearts of the chevaliers. Still adolescent, or at least very young, as demonstrated by "the firm roundness of their breasts," their bodies were virginal and slight, slender and swanlike, with gently curved shoulders, elongated torsos, long limbs, narrow hips, an arched back, and a round stomach swelling·below a slim waist. Nicolette, Aucassin's true love, had a waist so tiny that it could be enveloped in two hands. Curiously, large feet seem to have been highly appreciated.

The most remarkable feature of the heroine's smooth, regularly shaped face is the high domed forehead, "polished like marble," which emphasized the face from beneath the arch of "fine and thin" eyebrows-"The finest and rarest silk pressed to the skin." The space between her eyes was wide, equal to the width of an eye. Like the forehead, the delicate, translucent eyelids protruded to shade the eye, with irises that mingled several colors, resembling different jewels or enamel. The lips, small and bright red, were parted to show "teeth carved in ivory" above a chin marked by a dimple. Enhancing the whole look, the lady's blond hair was so long that "it kissed the ground" or "the braids could wrap four times around the head." It was so brilliant that "one could barely distinguish between the gold of the comb and the golden hair."

Unlike the dark peasant woman, a "base creature," this fair-faced noblewoman was always portrayed as a blonde, from Flanders to Italy. In fact, unlike Isolde, who also had golden hair, many heroines were simply called "Blonde" (Roman de la Rose, Lancelot, Percival). But such high foreheads and golden hair were not achieved without painful

measures: arsenic sulfide, quick lime, ointments of hedgehog ashes, bat blood, bees' wings, mercury, and slug slime for waxing, polishing, and whitening; decoctions of green lizards in walnut oil, sulfur, and rhubarb for bleaching. Preparations were made on Friday, the day of Venus, for better luck. Fairytale princesses were willing to suffer anything for beauty, even those things best left in the witch's cauldron.

From the courtly romance ballads of Alain de Lille, Jean de Meung, Adam de la Halle, and Chrétien de Troyes, a strictly defined profile of the feminine ideal emerges. From the eleventh through the fifteenth century, she was always depicted with the same curvy figure, sinuous and supple, topped by the same oval head tilted slightly on a long slender neck. An exact replica of this ideal can be found in the first true portraits of women, from the Flemish primitives to the Très Riches Heures du Duc de Berry.

These were the same traits that appeared in Italy in Gothic paintings and sculpture when artists, following Giotto and Duccio, began to be inspired by reality, reproducing the individuality of faces and real bodies, now sensual and no longer linear or regimented. The sentiments they expressed still served the pedagogical purposes of the church. As statues were detached from the mass of stone in which Romanesque art had immobilized them, Gothic painters were able to depict humanity in a more realistic fashion. Painters and sculptors slowly but surely began to free themselves from the European church, which was plunged into crisis as wars continually redistributed the balance of power. Beginning in Flanders with Van Eyck, and later in Italy and France, artists increasingly rendered feminine beauty in religious subjects, in the guise of either Eve and Mary.

Beauty | The Renaissance

As the Renaissance exploded over Italy, Venus erupted from Mount Olympus, breaking the vicious circle of Eves and Marys that had confined the vision of feminine beauty and the freedom to honor it.

Italy's princely courts multiplied with the country's economic prosperity, and, in a time of great geographical discoveries, the intellectual discovery of the ancient world reconciled heaven and earth. After the first translations of Plato's work, the *Banquet* in particular, by the great scholar Marsilio Ficino, a faithful servant of Lorenzo de Medici, it became honorable to believe that beauty, goodness, and truth were one. "We cannot see the soul," said Ficino, "we cannot see its beauty, but we can see the body, which is the cloud and the shadow of the soul." Through the beauty of the world and its creatures, God makes himself perceptible. Human love is none other than divine love, love between a couple is love of God, and it is through the beauty of women that man was invited to participate. Ficino, inspired by Plato's words, believed that Venus was the archetype of this beauty, which in her was both carnal and heavenly. He would recount long lists of her virtues, elevating her as the symbol of the perfect union between the body and soul.

By returning to ancient sources, the splendid naked female body was triumphantly restored as the most beautiful being in creation. Exit the devil and his retinue. Beauty was no longer synonymous with betrayal, and women were expected to be beautiful and attractive to completely fulfill the duty assigned to them by God. Exaltation of beauty and love, a mystical marriage between the spiritual and natural

Simonetta Vespucci. In Renaissance Italy plucked brows were highly appreciated. Blond hair was obligatory, braided with hairpieces and laden with precious stones and pearls. (P. di Cosimo, circa 1480.)

Eve. The S-curved figure typical of the Middle Ages is still depicted here in representations from the Flemish Renaissance. (L. Cranach, circa 1528)

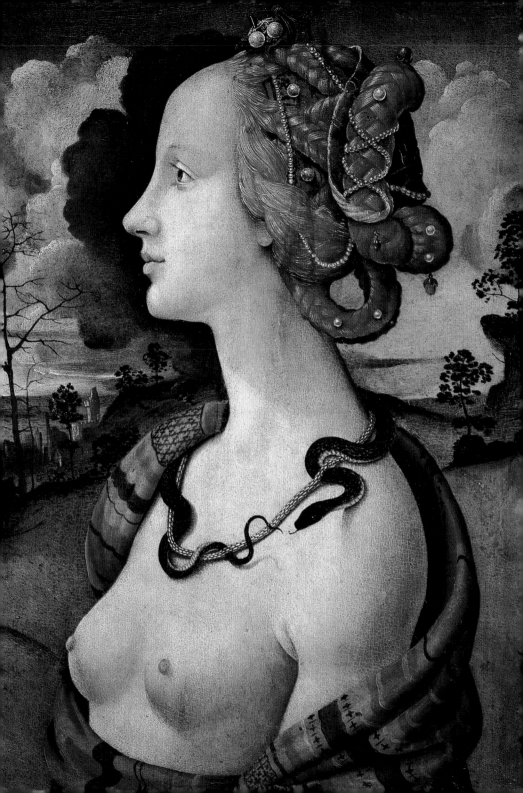

worlds, a cult of the being rather than of the Creator, received papal benediction. Through Neoplatonism, Catholicism fed on earthly nourishment.

Humanism was the guiding concept of the Renaissance, a period when the senses were fully reborn. As the world opened to trade through the great commercial routes, ever-growing knowledge put the world at man's doorstep, while reducing it to a human scale. Like the scientists and philosophers of the day, the painters observed and depicted what they saw-not what they imagined. Archeological discoveries, along with a fresh understanding of classical antiquity, and the search for perfection of form through the harmony of proportions, led to the establishment of anatomical standards, as in ancient times. Art became philosophy: people theorized about the practice and research of architects, painters, and sculptors who, caught up in the exhilaration and the proliferation of courts and academies, joined poets and scholars in intellectual pursuits.

The representation of woman was systematized. The author of the *Treatise on the Beauty of Women* (1540), Agnolo Firenzuola, conceived this female model as a ìwell-ordered accord,î a harmony of proportions, and illustrated his thoughts with a drawing of man in a square and woman in a circle with the sex organs in the center. The various beauties of the body were classified. He distinguished seven at first, then eighteen, then thirty grouped into threes. In 1539, Augusto Nifo dedicated *On Beauty and Love* to Jeanne díAragon, in which he defined very strict criteria that were inspired by her legendary beauty: the length of the nose must be equal to the size of the lips, the area occupied by the two ears should equal the same space as the open mouth, and the height of the body should be eight times that of the head. No bones should mark the chest area, and generous breasts should be shaped like upside-down pears. The ideal female was tall without the help of high heels, wide in the shoulders, narrow in the waist, with ample rounded hips, plump hands with slender fingers, round legs, and small feet.

Lucretia. Celebrated for her family intrigues and her beauty, which corresponded to all the criteria of the time, Lucretia Borgia was also a patron and protector of all the arts. (B. Veneziano, first half of the sixteenth century.)

According to these theoreticians, the perfect face must be set on a long neck, it must be fine and oval, with regular features, a high forehead, a straight and thin nose, and a small mouth. This arrangement must include three black elements - the eyes, the eyelashes, and the eyebrows, which must be shaped in a perfect arc well above the eye- and three white elements-the hands, the teeth (always small), and the skin, so transparent that when the beautiful girl drinks her wine "one must be able to see it flowing down her throat." Finally, the lips, cheeks, and nails must be red. Everyone had their say in this definition, even Machiavelli, who claimed that the hand of a woman can only be beautiful if it is "long, lined with tiny, light-colored veins, ending with slender fingers." Of course, she must be adorned with the sweetest expression and crowned by hair that is "loose and blond, sometimes the color of gold, at other times honey, shiny as the rays of the sun, wavy, thick and long, scattered in long curls and fluttering on the shoulders." For these sensuous Italians, with their matte and golden complexions and dark caressing eyes, this ubiquitous blond hair, from southern Italy to northern Holland, could only have been artificial.

To obtain their famous blond hair and to maintain their pale coloring, Venetian women would spend the entire day in the sun, wrapped in veils, their heads covered with large crownless hats, from which the hair would hang, coated with a bleaching mixture of saffron and lemon. The popularity of courtesans, who practiced their seduction on the most famous and popular artists, led to a surge in the unrestrained use of makeup, ointments, and musky perfumes. From Catherine de Medici, who started the trend in France, to Queen Elizabeth of England, the new women in power were not to be outdone. But while recourse to such techniques may have given more freedom to the emancipated women of the Renaissance, their beauty recipes, taken from ancient sources, were only slightly more appetizing than those of the Middle Ages, if one reads the account left by Nostradamus entitled *The Treatise on Makeup*. Teeth were cleaned with stomach-turning concoctions such as "dragon blood" mixed with red coral powder and

Botticellian beauty. The Italian Renaissance discovered ancient art. Painters were inspired by real models, and the Italians spent much time bleaching and styling their very long hair. (*Spring*, detail, S. Botticelli, circa 1477–78.)

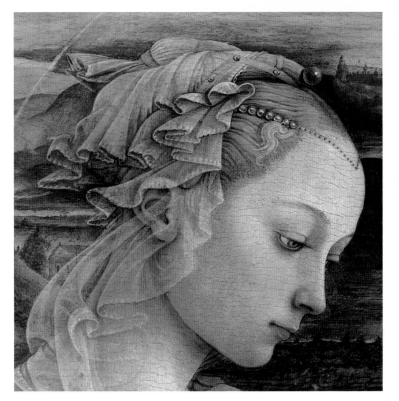

Madonna. The Renaissance glorified the sensuous traits of real beauties in its Madonnas. (Detail, Fra Filippo Lippi, 1465.)

white wine tartar, skin was whitened with blends of ceruse and sublimate, toxic solutions made from a lead and mercury base, and cheeks were painted with similar substances.

Described in song by poets and celebrated by painters, the names of these beauties have majestically traversed the ages. Real women were adopted for allegorical, mythological, and religious images. Simonetta Vespucci, the mistress of Giuliano de Medici, was immortalized by Botticelli in his painting of Venus and as Flora in the allegory of spring. When she died her open coffin was paraded through the streets of Florence so that the Florentines could admire her beauty one last time. Imperia, who was Raphael's model and the mistress of the banker Chigi, was mourned by all Rome when she died suddenly in 1511. Lucrecia Borgia was represented as Saint Catherine on Pinturicchio's frescoes in the Vatican's papal apartments.

Fascinated by form, the artists of the Renaissance were also intrigued by physiognomy and psychology. In contrast to the Middle Ages, it was no longer appropriate to fuse the particular into the universal. Instead, each unique aspect of universal beauty was scrutinized within the infinite variety of people and faces. The portrait was the instrument of this search. From symbolism and iconic images, individualism, focusing on the value of the individual, came into vogue. Every wealthy patron commissioned a portrait of himself and his favorite subjects.

Gradually the metaphysical ideal that had guided the liberation of thought since the Middle Ages dimmed in the face of physical and aesthetic reality, which was idealized in and of itself. Intoxication with life, its pleasures and its riches, engulfed every moral or religious reference. Despite the violent reactions of Savonarola, who, before perishing at the stake himself, consigned the works of Boccacio, Petrarch, and other repentant painters, including Botticelli, to the "bonfire of vanity." The love of beauty and total pleasure, in all its most voluptuous aspects, invaded the sixteenth century. In Italy, this occurred in Venice, and in France, at the court of Valois.

In the wake of the calm and proud beauty of Raphael's Madonnas came the serene sensuality of Titian, overflowing with luxury and finery. Feminine beauty appeared in all its roundness and full curves, in warm blond tones, with pink and golden complexions. Plumpness signified leisure and opulence: shoulders, arms, breasts, and hips swelled and thickened. Beauty was "succulent," breasts exposed and nipples were reddened with rouge. Plump bodies and sweet faces delineated the sexual differences required to generate love.

With Francois I, and then Henri II, France joined the Renaissance from Fontainebleau. Adored as goddesses, royal mistresses, revealed elongated naked bodies under their gossamer veils, thinner than the Italians, with high and round breasts shaped like apples, swelling thighs, curvaceous buttocks, and firm stomachs.

Throughout Europe, palaces and châteaux became abodes of pleasure and pride and the love of physical beauty pervaded every aspect of life. It was an era of graceful lines, youthful charm, pure faces, gay and modest expressions, blond hair floating onto shoulders, curled as in ancient times or sculpted in heavy coils decorated with pearls and stones, netting or mantillas. Glorified by painters and sculptors, the body also became a cult object for French poets, not only in its entirety but in each individual part. In the anthology of blazons compiled by Clémont Marot and dedicated to the female body, the wonder of each exclusive part of the anatomy is praised and described in detail: the Eyebrow, the Eye, the Cheek, the Mouth, the Navel, the Nipple, the Buttocks.

Baroque painting exaggerated this lavish image of ideal beauty even further, and churches abounded in allegories with bodies as plump as partridges, robust and large, overflowing with flesh. Full breasts and heavy thighs, broadly curving hips, and wide flanks proclaimed maternity, and a double chin added charm to women who were first and foremost wives and mothers, fertile bearers, built to engender love and give life.

Rubens was the absolute master of the period. He left a veritable treatise on the theory of the human figure in the form of aphorisms: "In the womanís body, one observes that in the traits and contours of her muscles, in the way she stands, walks, and sits, in all her movements and all her actions she is utterly unlike a man. Rather, in conformity with the most basic element, the circle, she is round, delicate, supple and completely opposite to manís robust and virile shape"; her flesh must be "solid, firm, and white, tinted with a pale red like the color that comes from a blend of milk and blood."

Sweetness and blond hair characterized the Renaissance femininity, which continued to seduce certain seventeenth-century painters in their evocations of mythological beauty. (*Joseph and Potiphar's Wife*, detail, Le Guerchin, 1649.)

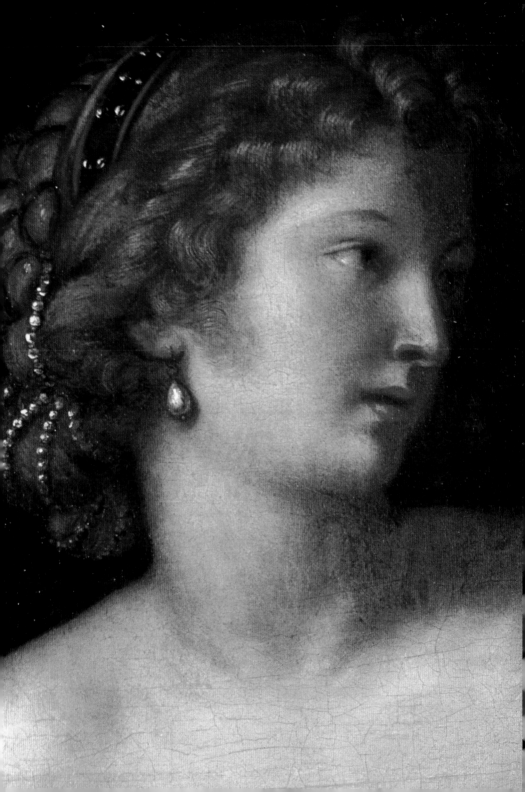

Beauty

Reformation and Counter Reformation

The exuberance of the Renaissance was displaced with the Reformation and Counter Reformation. Spain supplanted Italy, reason supplanted the senses, the mind supplanted the soul. Protestants and Catholics, men of the Reformation and of the Counter Reformation, Jesuits and Jansenists, imposed their own conformity and restraint. The devotion of the humanists contrasted with the ascetic morality of the Jansenists, but each strove to reform the dissolute, self-indulgent practices of a decadent Christian church and society.

Vice was criticized, society's lax ways inveighed against, and fleshly indulgences deplored. A sense of the forbidden burdened the body again, and loincloths and tunics modestly covered statues and paintings of nudes in public and sacred spaces. Coquetry and indecency were consigned to hellfire. Propriety reigned, underpinned by the hypocrisy denounced by Molière in *Tartuffe*. Breasts were hidden from sight, and the church condemned any displays of décolleté as a sin that only a bishop could absolve. Low necklines persisted, but the rest of the body, even the feet, disappeared under billows of fabric. Such styles only drew the eye to what was forbidden, while all sorts of accessories accentuated the shape. Flowing hair was bound into a chignon at the nape of the neck, color was extinguished by ubiquitous black, relieved only by white lace. Pearls were the only acceptable jewelry, and lean figures returned. Beauty was expected to be stately, noble, and somber.

Lace and pearls were the only permissible ornamentation in the severe, formal sixteenth and seventeenth centuries. (*The Infanta*, A.S. Coello, 1579.)

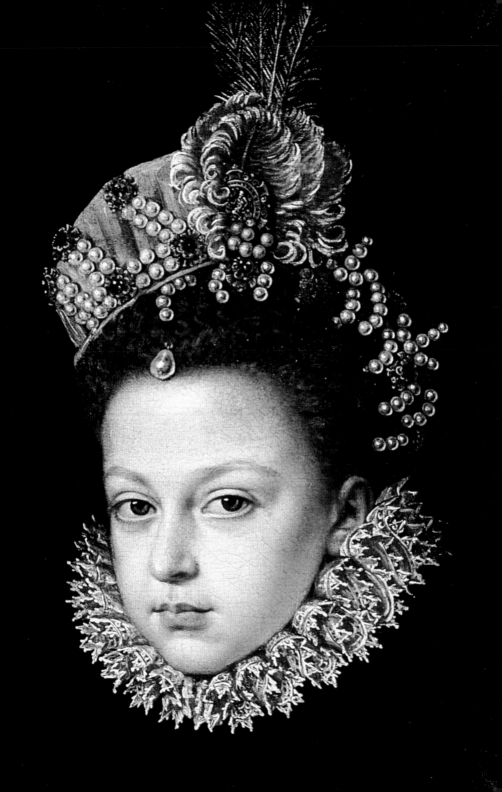

Woman at her Toilette. The absurdity of beauty patches and architectural hairdos peaked at the end of the seventeenth century. (Late-seventeenth-century engraving.)

The Infanta Maria Teresa. Dignity, power, and solemnity characterized beauty in the strict and puritanical seventeenth century. (Detail, Velázquez, 1651.)

Such restrictive measures were resisted in France, and mostly by women, the "precieuses" or affected ones, derided by Molière for their numerous shortcomings. Led by the Marquise of Rambouillet, they exemplified and defended freedom of the mind, demanding refinement and elegant manners, good style, and good taste. This group included beautiful, intelligent libertines and free thinkers like Ninon de Lenclos, and the era's elite flocked to their salons. They collected admirers up until the ends of their lives, keeping track of the twists and turns of their romantic dalliances in a *Carte du Tendre*. Such women were coquettish even in their language, using extravagant metaphors almost like cosmetics for reality. Protecting their "water-lily" complexions lest "the snow of their faces begin to melt," they were forever consulting

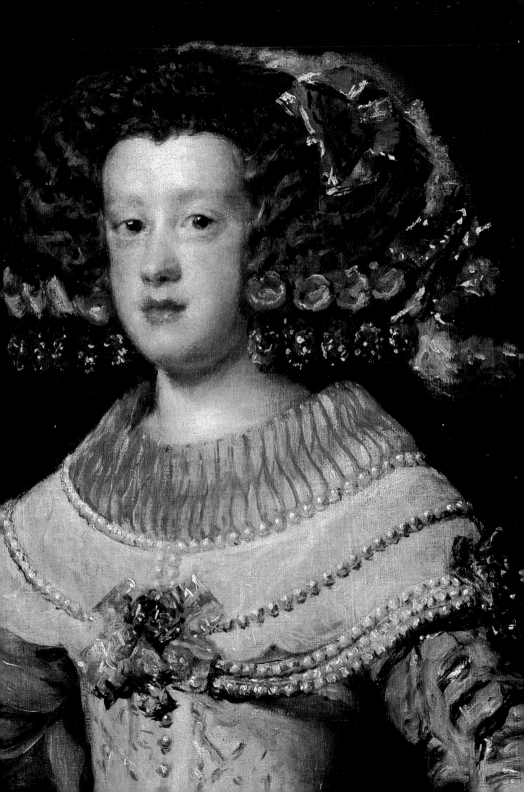

their indispensable mirrors, their "advisors on grace," to apply the black taffeta beauty spots they always wore. Their dictionary reveals the secrets of these spots: the "passionate one" went below the eyebrow, the "trickster" hid a pimple, the "impudent one" went on the end of the nose, and the "kiss" marked the corner of the mouth.

In 1635, the first ladies'hair salon, Champagne, opened in Paris. Women could choose the extravagant "hurluberlu" look, with hair cut short in the front for light curls, or "la Fontanges", swept up in a confection of waves and ribbons. Powder added blond or brunette coloring. Women were so extravagant in applying their makeup that La Bruyère exclaimed, "If their faces were really as glaring and murky as they're made to be with the rouge and cosmetics they apply, these women would be distraught." All the red and white paint made women so hideous and disgusting that Boileau advised husbands to wait in the evening until their wives had"wiped off their coloring with a cloth and dispatched the roses and lilies of their cheeks to the laundress on four soiled handkerchiefs." The sublimate, white ceruse, and Spanish red were concocted from toxic substances, including lead, which gradually ate away at the skin. But no one seemed to care, and Diderot aptly described Louis XIVís reign as a "dreadful vermilion."

Elizabeth I. In a flaming red wig, her face painted with white ceruse and vermilion, she appeared to her subjects like an icon, richly adorned in brocade and precious stones. (N. Hilliard, 1547–1619.)

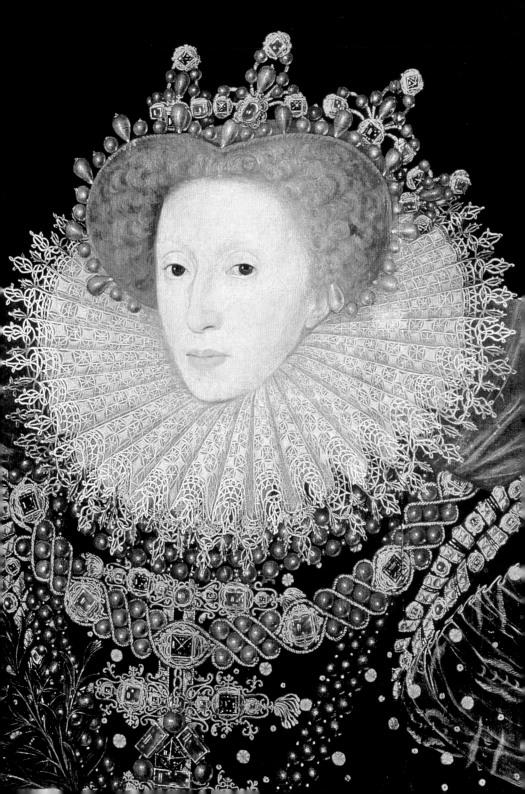

Beauty | **The Eighteenth Century and the Empire**

From head to toe, from mauve to pale pink, from madder to orange, the Sun King's court was ablaze with every imaginable shade of red. From youth until death, the color emblazoned faces like fireworks, extending even to the eyes. Versailles was a theater in which royalty was directed by an inescapable tyrannical code. Hairdressers outdid dress designers, constructing monuments out of hair with complicated accessories intended to represent various feelings or to depict current events. Around 1778, the Duchess of Chartres wore a wig decked with gauze and ribbon, incorporating a doll of her son in the arms of his nurse, watched over by a parrot, which was in turn supervised by a black servant boy! Ladies had to travel crouched on their knees to fit their monstrous hairdos inside their carriages. No one dared appear at court without makeup; it was applied even before sleep. Madame de Pompadour had just dabbed rouge on her cheeks before breathing her last. Natural appearance was banished, and heavily applied rouge became such a popular consumer item that there was a proposal to levy a tax on each pot to fund pensions "for poor soldiers' widows."

Letters from appalled English and German observers attest to the excesses in France. However, the makeup vogue took such a strong hold on Great Britain that Parliament tried to impose a law that treated seductions using cosmetics, perfumes, artificial teeth or hair, and other such devices as witchcraft, meriting the same punishment.

Madame de Pompadour. The exemplar of the eighteenth century's spirited and refined elegance. (Detail, F. Boucher circa 1759)

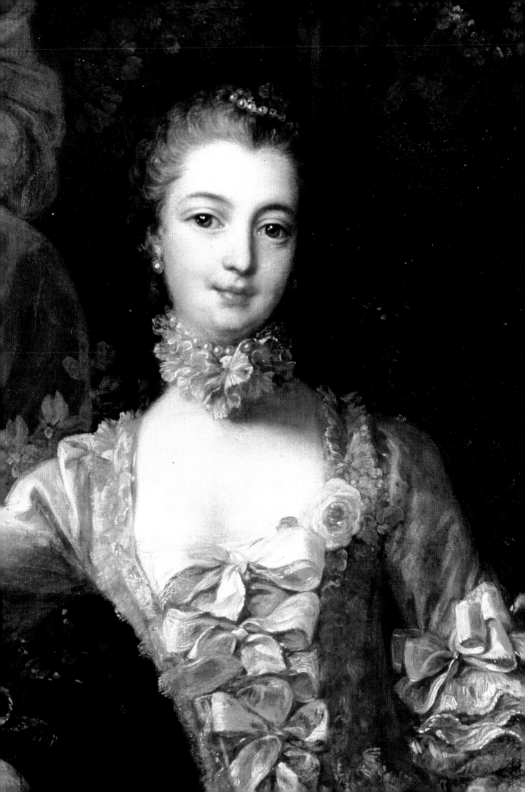

In 1776, the Count of Cagliostro and his wife opened a shop in London that purveyed makeup, aphrodisiac potions, and sexual stimulants with great success. The law soon lost its force, and women's journals such as *The Lady's Magazine* seized the occasion to publish numerous historical articles defending and illustrating the art of makeup. At the same time, a botanical rouge was introduced to New York from Circassia, a province in the Northern Caucuses. It was considered particularly natural and long lasting, and joined the ranks of rouges from France, Italy, Bavaria, and Spain, which were already very popular with the pretty pioneers in the American colonies.

Meanwhile, steeped in ugliness and grime, prudish fanatics denounced the court, with its royal adulteries and depraved makeup dictated by Madame de Montespan, calling such practices the forerunners of divine wrath. This atheistic, revolutionary fervor would later drown the aristocracy in the rouge of their own blood.

But before the revolution, beauty had a chance to assume human form again, and in just a few years the seeds of sensibility, spirituality, and intimacy that would come to full flower in the nineteenth century were sown. Under the influence of Rousseau, Diderot, Beaumarchais, Marivaux, and Milton, the era of the Enlightenment heaved a sigh of relief all the way from Venice to Versailles to London. The late eighteenth century was spiritual and lighthearted, courtly and bantering, sensuous and joyful. Gentle simplicity, emotional delicacy, natural graces, and sincere feelings were appreciated.

Beauty was dreamy, impish, and fresh; the body was plump, the face fine featured and gentle, the nose short, lips full, chin pointed, eyes dark and lively, skin porcelain white. Makeup was used sparingly, but ribbons, pearls, flowers, and Nattier blue and du Barry pink linens and organdies adorned ladies'

Marie-Antoinette, who neither wore paint nor colored her naturally blond hair, set the style for the late eighteenth century. (F.-R. Drouais, circa 1770.)

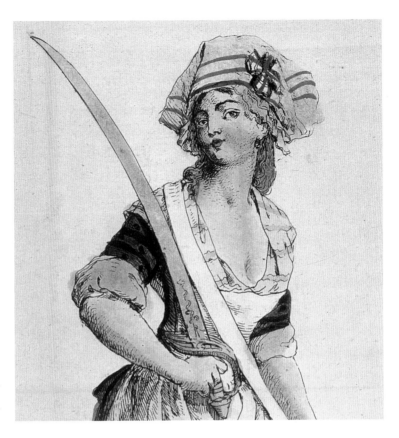

A republican, *sans-culotte* **woman.** Revolutionary fervor replaced that shameful rouge on the cheeks of revolutionary citizens.

glowing, rosy charms. Languid bodies ready for every imaginable pleasure held surprises to be unveiled in secret alcoves.

Liquid satins and airy mousselines in shades like "dove's breast" and "eager nymph's thigh" draped bosoms swelling above tiny waists, wrapped rounded calves, finely turned ankles, and little feet in playful mules. The women painted by Boucher, Fragonard, and Tiepelo were plump and laughing, naughty libertines whose faces and figures glowed with dimples and soft curls. Hair was still bound and powdered, but soon appeared in cunningly disarrayed locks in the "elegantly neglected" style introduced by the enchanting artist Vigée-Lebrun, a friend of Marie-Antoinette, whose magnificent ash-blond hair was much imitated. From Saint Petersburg to small courts in Germany, Europe closely followed every French development in beauty and fashion.

The monumental hairdos, targets of English pamphleteers and carica-turists, gave way to a ribbon or simple feather tucked in a curl. Beauty came from movement, from unconscious gestures that revealed instinctual sincerity. Regular features were not essential; liveliness of body and mind, a ready gaiety, and a delicate, charming style were more valued.

For the first time, portraiture shifted away from codified representa-tion and sought to enliven faces with emotions and feelings. Diderot admonished painters: "Touch me, astonish me, tear at my soul, make me tremble, weep, shudder, infuriate me!" Whether the artist was Watteau, La Tour, Reynolds, or Carriera, portraits of the beauties of this era inspire surprise with an ironic gaze, an angry crease above the nose, the begin-ning of a smile. Think how Greuze boldly captured the shyness of a young girl's brimming eyes, or the fleeting glimpse of nudity beneath airy linens.

While feminine beauty was of little concern to revolutionary France, the natural look had returned, and individuality prevailed over a strictly defined ideal. Better hygiene reinforced this irreversible trend, encourag-ing the growing bourgeoisie to demonstrate its superiority over the peas-antry and working classes through cleanliness. A new style of beauty appeared from the brushes of Ingres and David. The women of the Consulate and First Empire were neoclassical, with the cold, perfect sim-plicity of Reason. The self-indulgent, heedless simplicity of the earlier era had perished on the scaffold. Now hair was brunette rather than blond, bound up and falling down in short ringlets. Complexions were very pale and cool, aided by a new generation of cosmetics and colognes. But it was the silhouette, rather than the face, that defined this style. Posture was very erect, bared arms and shoulders rounded, breasts high and small, legs long and visible under thin veils of robes inspired by Greek statuary. Madame Recamier embodied the era's standards of beauty.

Madame Récamier. Her hair cut short with whimsical ringlets in a coiffeur called "á la Titus," her breastline high, and dressed in a toga-like gown, Mme. Récamier is the epitome of neo-classical style. (Detail, J.-L. David, 1826.)

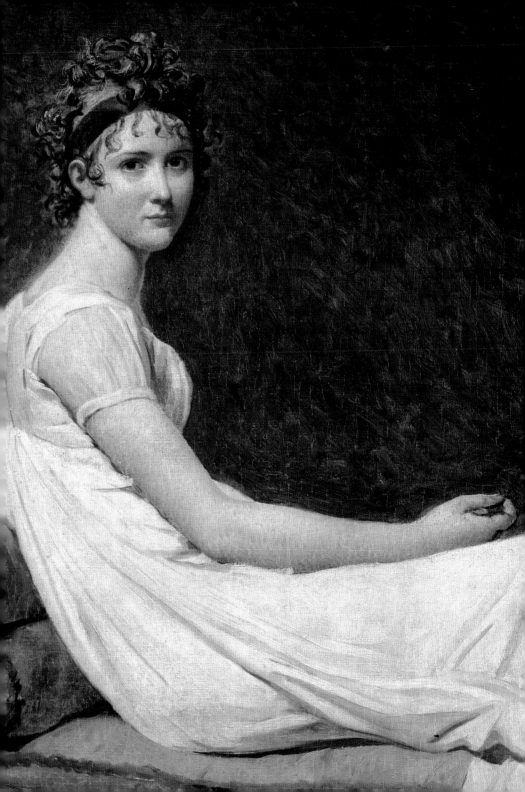

Beauty |
The Romantics

"My future mistress will be tart as a lemon, with the most fiercely arched eyebrows you can imagine, oriental eyes, Semitic nose, a small proud mouth and hair the color of her skin," proclaimed Rodolphe, the hero of Théophile Gautier's novel *Celle-ci et Celle-la, ou la Jeune France passionnée*. From England's fogs to Italy's starry nights, from German forests to the gardens of France, this was the standard portrait of the romantic muse. In the first half of the nineteenth century it was she who inspired overwhelming passion in her wooers, her eyes brimming with melancholy, her cheeks hollow,"drunk with poetry and love," dragging life as a slave drags his chains," as she was described by Gerard de Nerval. To resemble this muse and to achieve her look, so admired by Barbey d'Aurevilly, "carved from marble, with a greenish, bruised pallor beneath black ribbons," women drenched their faces with potions concocted from saffron or tinted with blue ink and boldly imbibed vinegar, consumed quantities of lemons, and fasted to the point of wasting away. These efforts were intended to chase away rude, shameful excesses of good health, to quickly achieve the lofty distinction conveyed by the spectral presence of suffering consumptives. At luncheons they manifested their disdain for material pleasures, sucking on a chicken wing with pale lips or nibbling a piece of fruit. In any case, little else was offered. In his *Nouvelle Théorie du dejeuner*, Balzac described the elegant menu of eggs, salads, and strawberries, accompanied by muffins and soda water imported from England (whose mysterious gardens scattered with Gothic ruins were equally admired).

Elizabeth of Austria. Who could embody the proud romantic beauty better than Sissi? (F. X. Winterhalter, 1864.)

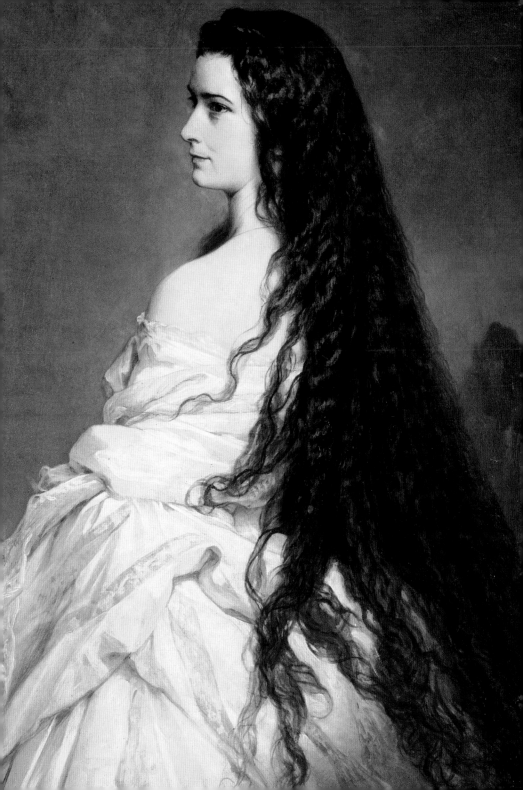

Like the stormy, rebellious Princess of Belgiojoso, who spurned Alfred de Musset, these shadowy beauties, with their swanlike necks bowed beneath heavy masses of long black hair, gazed out at the world inconsolably burdened with melancholy. Their large sorrowful eyes were black or deep blue, always moist and violet-rimmed, with a darkly glowing gaze, sickly and feverish. Without even a raise of their fine, lightly marked eyebrows, they employed virulent poisonsó-belladonna, atropine, and datura-to give a haunting intensity and mysterious depth to their pupils, a gleam that revealed the ardor and passion of their souls, "burning with an inner flame, as the reflection of death passes by," wrote Arsène Houssaye.

When they walked, they moved through space like phantoms. "Crystalline, diaphanous," seemingly without limbs, supple as a vine and light as air in motion, they evoked the"fluid flight of the cherubim," reported *La Flâneur Parisien*, a journal of the time. They were called "weasels" or "dragonflies" in current parlance, because of their wasp waists and supple, spindle-thin bodies. Angelic fragility was accentuated by vaporously white mousseline gowns introduced by the Italian dancer Maria Taglioni, a triumph at the Paris Opera. When in motion, they avoided any sudden movement that might suggest spontaneous, natural gaiety; instead, they quivered with barely restrained torments. For the surrealists, beauty would be distorting. For the romantics, beauty provoked quivers. Both sylphs and daughters of fire at once, these women expressed a subtle enchantment of spellbinding perversity, glowing through their alabaster skin with a blue network of veins throbbing beneath.

A flat bonnet and ribbons in the Italian style. Young romantics drenched themselves in potions concocted from saffron and ink to achieve bluish shadows and dark reflections.

The Princess of Broglie. In the salons of the Faubourg-Saint-Germain, romantic beauty retained an ivory complexion and ebony hair, but it regained a sense of a splendor greater than any we have ever witnessed. (Detail, J.A.D. Ingres, 1853)

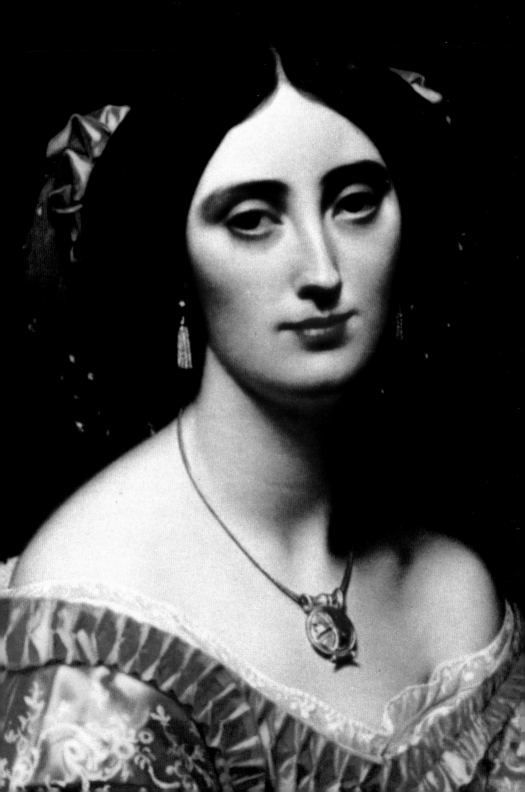

Romanticism also looked back to the Middle Ages, but it merged the medieval angel/fiend dichotomy into one woman, the type exalted by Goethe, Musset, Keats, Beaudelaire, and all the dandies who followed them. These women were innocents but fatal, seductive, and dangerous, with tigress teeth behind their coughing fits and a spectral immateriality that emitted a haze of perdition. But what did that matter? From Byron's time on, lovers of the melancholy knew that nothing was more satisfying than the aura of despair.

Phosphorescent, ablaze, suffocating, destructive, volcanic, satanic, queenly, stunning, Babylonian, Egyptian, Gothic. The descriptive terms of romantic language spoke of the mysteries of these evanescent beauties garbed in shades such as "eau de Nil, daybreak, wild thoughts, Vesuvian lava, frightened mouse, dreaming flea, toad-in-love, spider pondering a crime"...walking about gloomily in "hellsmoke, raven's wing, Marengo black, bottom of the bottle, or capuchin's habit." Hair was crimped, waved, tousled, and caught up in chignons high on the head, with locks allowed to frame the face. (The English recommended a shampoo at least every two months.) In winter, hair was crowned with a peaked cap, reflecting an infatuation with the Middle Ages of legend. For summer 1838, the romantic poet and mastermind Louise Colet, who was also a fashion reporter for *Monde Illustré*, advised women to wear an Italian straw hat with broad brims bent up like a musketeer's, lined with silk and adorned with a jumble of gauzy chiffon, ribbons, and lace. As a journalist of the era aptly said: "Dreaming in a sky blue hat is still permitted, but weeping in a pink hat is forbidden."

The Countess of Castiglione, Napoleon III's mistress, had her beauty immortalized in a very early photograph. (*Elvire a la psyché,* P. L. Pierson, 1861–67.)

Nana. The rise of "demi-mondaine" encouraged the use of makeup in bourgeois society. (E. Manet, 1877.)

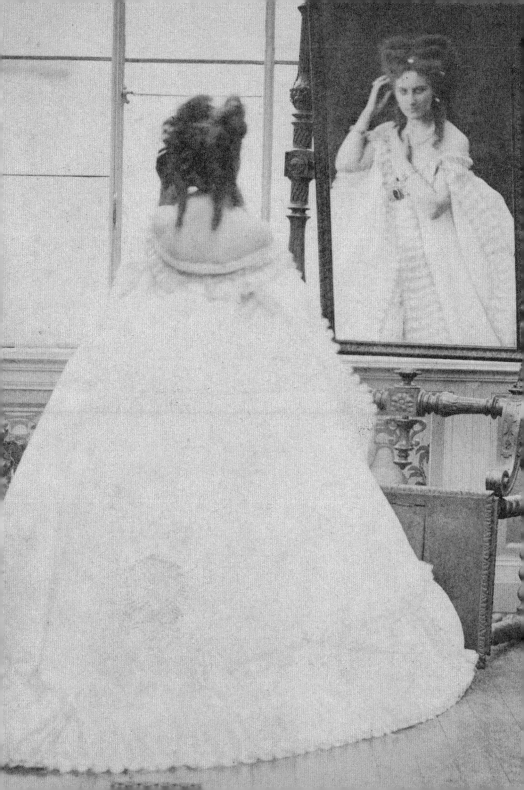

Slightly later, inspired by the actress Marie Dorval, interpreter and mistress of Alfred de Vigny and then Alexandre Dumas, women wore their hair in smooth, simple bandeaux, which covered their ears and were knotted into a heavy low chignon punctuated by a lily or a rose. Their eyebrows were thickly lined in the fashion of Andalucians and Neapolitans, whose matte complexions evoked the East, an East that began with Grenada and ended in the sands of Delacroix and the harems of Ingres. While France dreamed of the East and its odalisques, England took refuge in an idealized past woven from Arthurian legends, the quest for the Holy Grail, the Round Table, and the aesthetic perfection of the Renaissance. The puritanical Victorian era advocated a modest beauty, restrained and without makeup. However, the pre-Raphaelites painted beauties who let their thick wavy red or brown hair float free, like Jane Morris, Dante Gabriel Rosetti's muse, with her dark, well-defined lips, strong nose, and deep, tragic gaze. Slender, but tall and stately, languid and tempting or reserved and haughty, they inhabited a universe more allegorical than real. They were half-angel, half-goddess, part flower women and part flowers of evil, and they emerged from artistic imaginations, transported more from the ecstasies of paradise than from the prosaic precincts of daily life.

Romanticism ceded to reality, which might be royalist or republican, but was always bourgeois, industrial, health-conscious, and conformist. Still, the vital force that breathed life into Europe by liberating its sensibilities was irrepressible.

Like all sociological phenomena, the polemical debate over makeup was charged with the tension between triumphant conservative bourgeois values and the liberal tendencies that opposed them. Reacting against the excesses of the eighteenth century, women of nineteenth century used cosmetics less, but did not abandon them completely. The typical bourgeois beauty was well fed and substantial, with a plump back, sloping shoulders, and heavy arms, as portrayed by Daumier and Flaubert, whose Madame Homais had the generous bosom of an honest woman and good mother. She confined herself to white powder,

Pre-Raphaelite beauty was inspired by both the Renaissance and medieval legend. (*Aurelia*, D. G. Rosetti, 1863.)

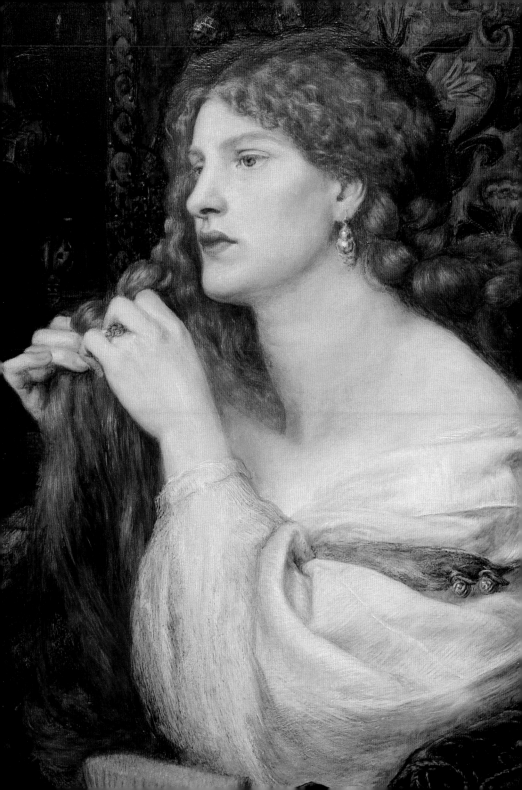

the best of which was limited to the most wealthy, as it was obtained by crushing fine pearls.

Crushed mother-of-pearl was more economical, and most commonly a bismuth base was used. Beyond face powders, makeup was reserved for prostitutes and actresses who wore it only on stage.

In France, as in England and the United States, emphasis was placed on hygiene and care. Fashion magazines were filled with advertisements promoting all kinds of products whose oriental names conformed to the current vogue. Topics ranged from recipes of society ladies and great actresses to advice from medical specialists warning against the dangers of industrial cosmetics, which often included toxic substances such as lead. The first books solely devoted to the toilette and ways of maintaining natural good looks appeared in Europe and the United States and were translated into various languages. Even the scandalous Lola Montez entered the ranks. In her book, *The Art of Beauty* or the *Secrets of a Lady's Toilette*, published in New York in 1858 and in Paris in 1879, she forbade the use of anything but rice powder and a touch of rouge applied to imitate a natural blush. Like the most straitlaced Anglo Saxons, she emphasized the use of soap and water, bran baths, orange and jasmine waters, and massage, mistrusting mass-produced creams and recommending homemade preparations, egg-white masks, and the application of a fine film of beef suet to preserve a fresh complexion and conceal wrinkles. Strong resistance persisted against patented products, such as Pond's cream, which was first marketed in the United States in 1846.

As some women continued to use makeup while pretending not to, certain authors felt it was important to provide advice on how to prevent poisoning. There were innumerable publications on the subject by the end of the century. Guerlain had produced a good-quality tinted lip balm since 1828, and in 1866 a process was developed to produce a harmless zinc oxide powder to supplement the Japanese rice powder already popular in the West. However, there were still numerous charlatans who opened makeup salons from which women emerged, their faces coated

Young girls still had the natural look favored by Proust. (*Young Girl in a Black Hat*, P. Helleu, second half of the nineteenth century.)

in masks of cosmetics, with suitcases full of products that not only cracked and ran, but also caused irreversible damage to the skin.

Fierce offensives were mounted by prudish opponents of the make-up industry from all over the world. But temptation was too strong, and progress in chemistry made it possible to bring safe beauty products to the growing number of women who longed to be as seductive as the courtesans they simultaneously scorned and envied.

In this spirit, Beaudelaire published "In Praise of Makeup" in *Le Figaro* in 1863, describing and defending these artifices: "A woman is fully within her rights and actually performs a sort of duty in trying to appear magical and supernatural...It matters little that the guile and artificiality are known to all if they produce a successful result and an irresistible effect." Little by little, symbolist, naturalist, realist, and impressionist writers and painters gained an entrée for women from a

very different world.

These were the creatures vilified by bourgeois ladies and lusted after by their husbands: courtesans, call girls, women who had lost their reputations, dancers, and other "grandes horizontales," as Flaubert called them.

At the opposite end of the social scale were the little grisettes, artisans whose name derived from the coarse gray fabric from which their dresses were made. These were the laundresses and other Mimis, so appealing to the Bohemians, whose common graces were ennobled by artists such as Zola and Toulouse-Lautrec.

The heavy crinolines and cashmere shawls that had confined and concealed the body so despised by the puritans disappeared magically. An hourglass silhouette emerged, sculpted by corsets, bustles, and innumerable and implausible prostheses, such as breasts made of perfumed rubber that felt lifelike when fondled. But the Proustian heroine's artificial body, elaborately gowned, hatted, gloved, and redolent of academic painting, no longer had the upper hand. The portals were open wide to welcome women with smooth waists, curved thighs, the Olympia's and Maya's full breasts, strong necks, sturdy hands, and the full-blooded robustness of Renoir's country girls.

Photography now made it possible to crystallize the endless variety and countless surprises in an anonymous crowd of women, completing the democratization of the feminine beauty ideal.

FABIENNE ROUSSO

The art of the portrait. Photography, which was more accessible, in time democratized portraiture, gradually replacing painting. (Ginette Lantelme, photographed by Reutlinger.)

Beauty | **The Decades**

Beauty |

The 1900s

Remnants of the nineteenth century lingered into the twentieth, but only for a very brief while. A revolution was already sweeping across Europe. The changes, which began in England, affected economies, industries, and the arts, altering conditions of life at an unprecedented pace. New concepts of feminine beauty, new seductive wiles, and new ways of cultivating distinction developed at the same accelerated pace.

The Universal Exposition attracted visitors from all over Europe to Paris, which was the uncontested capital of elegance and refinement. Great actresses, dancers, and seductresses like Eve Lavallière, Cécile Sorel, Sarah Bernhardt, Cléo de Mérode, La Belle Otéro, Émilienne d'Alençon, and Liane de Pougy held sway over the Belle Époque. They rivaled each other in beauty and opulence, exciting society with their showy eccentricities. Liane de Pougy, called "the loveliest woman of the century" by Edmond de Goncourt, was Proust's model for Odette de Crécy. Described as "the ideal lover with pensive amethyst eyes" by a writer in the review *Gil Blas*, she created a scandal when she appeared at a soirée almost naked, in a white mousseline robe, while her lady's maid trailed behind carrying one of her bejeweled gowns. She was a sensation! (Émilienne d'Alençon and La Belle Otéro, ardent brunettes with pale complexions and soft, rounded figures, evoked the Eastern type of beauty still in fashion, but Liane de Pougy had a tall, slender silhouette and a delicate face surrounded with breathtakingly fair hair in a cloud of ringlets. In any case, brunette or blond, the complexion was always pale and

Liane de Pougy, one of the most famous Parisian courtesans, immortalized by Nadar in 1895.

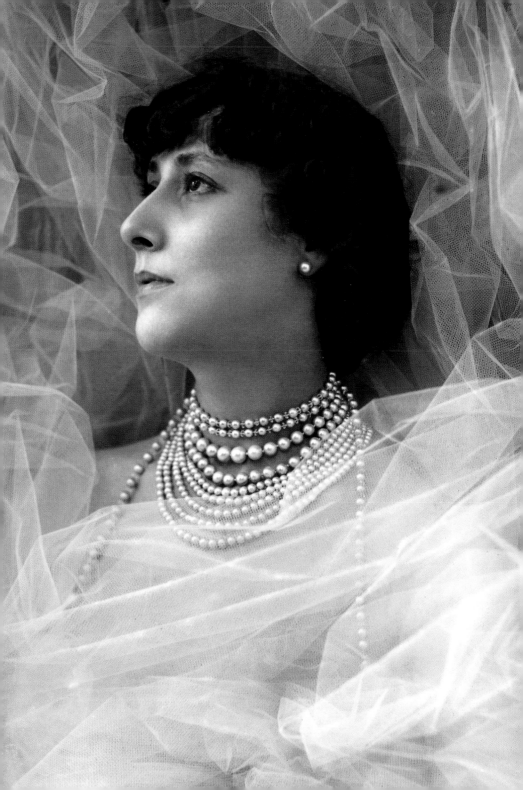

Virginia Woolf. The unusual grace of the famous author is matched only by her modernity (1902).

translucent or even "diaphanous," the name of a rice powder, which was the favorite of La Grande Sarah. Like other beauties, she posed for early photographs to promote various cosmetics, particularly powders. These women were also sought after by magazines such as *La Mode pour Tous*, *Le Petit Écho de la Mode*, and *Les Modes*, which first appeared in 1904. There they revealed their beauty secrets, because, apart from Crème Simon, flower waters, and Guerlain's skin-softening creams, cosmetics were still made at home, frequently from dangerous recipes. In these magazines, recipes were exchanged for poultices and plant vinegars to eliminate wrinkles, smallpox scars, and blotches.

At the turn of the century, there were at least a dozen aristocrats successfully promulgating their advice in works on beauty. The Countess of Tramar was the author of *Bréviaire de la Femme*, a beauty manual published in 1902, which was an immediate success in Paris and New York.

She declared: "My sisters, our only goal should be the conquest of man! In this campaign, use any means, even the most startling. Overcome your reluctance!" Magazine pages were full of advertisements recklessly boasting about the virtues of mail-order beauty products and mechanical processes. Why not apply these revolutionary, miraculous strips filled with wrinkle-reducing cream, or the pomade-saturated rubber mask to counter the ravages of age? Ladies afflicted with a double chin could seek help from a chin support, and those with unattractive noses could resort to devices promising to realign, narrow, or lower them. While cold cream remained the standard for daily care, cucumber-based lotions or masks concocted from veal escalopes held in place overnight with bandages assured an incomparably dazzling complexion. These concoctions were undependable and unattractive, and carried potential health hazards and undesirable side effects.

Cléo de Mérode, a dancer and aristocrat, was considered by Parisian society to be the loveliest woman of her day (1894).

But such drawbacks scarcely mattered, because a gorgeous complexion, pink and white as the skin of a very young girl, was a society woman's foremost concern. Powder was the most frequently used cosmetic; following the famous Craie de Briançon, rice and talc powders, perfumed with rose or lavender oil, were used to achieve a youthful paleness. Ladies smoothed their complexions by peeling a Java powdered paper from a satin-covered booklet. To emphasize the fine veins near the eyes, they cunningly used a bluish pencil. Meanwhile, rouge, generally judged to be vulgar, was applied behind closed doors. Articles on fashionable beauty followed this development closely, competing with each other to offer advice on how to apply rouge, whether in liquid, compact, or dry form, in the most imperceptible way, an often impossible objective.

Bold ladies would try out the new lip crayon, recently introduced in Paris, by candlelight. If the eyebrows (which were never to be plucked) were

not heavy or thick enough, a sweep of a special pencil replaced the old-fashioned charred clove. Giving a blush to the ears with a bit of cochineal was permissible.

The supple, sleek, slender silhouette of the flower woman became popular during the Belle Époque. The real woman, however, was laced into a corset that strangled the waist and forced out her breasts and bottom, which were unhesitatingly enhanced by padding if required. The highlight of this hourglass figure was the waist, just eighty-two centimeters for the singer Polaire, Colette's friend. Some women actually resorted to surgery to shift or even remove a few ribs, lacing their corsets so tight that they fainted.

This artificial silhouette, immortalized by academic and impressionist painters, was topped off by the inevitable chignon, also enhanced by false hair in swatches or braids when nature was lacking. The whole coiffeur was garnished with spangles and bone combs or with jewels for the more prosperous, who bought exquisite Lalique art nouveau pieces decorated with anemones and insects. Ladies went to wigmakers, or had their hair done at home. In daytime, a woman went outside sheltered by a huge veiled hat, loaded with lace, flowers, and feathers, a symbol of her social status. (Only working-class women went bareheaded.) At night, a cloud of silver or gold powder cast a halo around breathtaking coiffeurs, which gleamed in candlelight or the new gaslight. La Belle Otéro, Anna de Noailles, and Sarah Bernhardt had their hair done by Antoine, a gifted young Pole just twenty years old who became the darling of Paris society. A few women ventured the new look introduced by Cléo de Mérode that suited her classic features perfectly: hair was parted in the middle and swept back in smooth bands over the ears.

Her extraordinary beauty earned her the privilege of being the most photographed woman of the era. The Roman singer Lina Cavallieri, who performed a version of Manon for the silent screen, was just as cel-

Colette. She was one of the first women to cut her hair short.

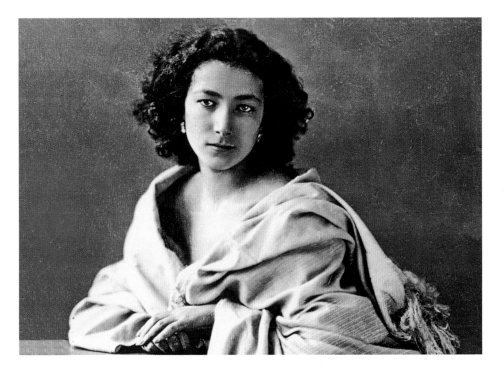

Sarah Bernhardt at the beginning of her career and at the peak of her fame, photographed by Nadar.

Following pages: Left: **The art of posing.** Fashion adopted mannered attitudes, with waved hair and hats (circa 1900). Right: **Lina Cavallieri** (1908). Considered one of the great beauties of her time, this Italian diva later opened a beauty institute.

ebrated for her great beauty and fabulous wealth (the fruit of a succession of marriages with wealthy Americans). She not only revealed her beauty secrets in a 310-page book, published in 1914, but several years later opened an institute in Paris and introduced a line of makeup and skin care products.

Beauty and seduction, however, were not always accompanied by hygiene. Hair care was limited to use of a perfumed comb at best. Shampoos were just being introduced in the United States and England. They were initially formulated with a base of black soap boiled down with soda crystals, which left unpleasant residues in the hair. Starting in 1904, formulas using potassium soap with coconut or olive oil appeared, but they were still quite harsh.

After the end of the Middle Ages and the closing of public baths, which were suspected of contributing to the spread of great plague epidemics, personal hygiene was considered dangerous to public health. At the beginning of the twentieth century, people still washed very rarely.

The Academy of Medicine in Paris recognized the benefits of "the waters," but warned against regular bathing, which was prone to "swell the flesh, discolor the skin, impair fertility, and cause depression." Bathtubs were forbidden by law in many American states. Elegant dressing cabinets featured a dressing table, a basin for washing, and, often concealed behind a screen, a bidet. People only rarely washed themselves, standing in front of the basin, with the body as little unclothed as possible, and almost never in wintertime. Only a very few avant-garde, wealthy people in Paris and London could relish the joys of hot baths in dwellings equipped with bathrooms and domestic servants to haul water. The portable Turkish bath was popular, with pots of boiling water poured into vats to give off beneficial vapors. After a long sojourn in purgatory, the practice of bathing was finally reintroduced by the English.

Should the face be washed or not? The question was hotly debated. Some experts claimed that alternating gloves soaked in warm then cold water would have an astringent effect. But bending over a basin would cause swelling, objected others. Soap, except for the olive oil type manufactured in Nice, would dry the skin, asserted Harriet Hubbard Ayer, who was the first to seriously advance the development of cosmetics. Most people preferred vials of sweet almond oil, or the ever popular Crème Simon, generously applied, then wiped off the face with a cloth soaked in lavender tonic.

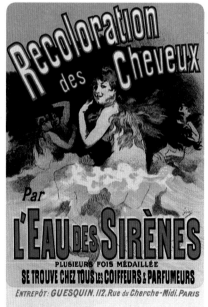

Advertising. With developments in chemistry, hair colorings became more available to the public. (Poster designed by Jules Chéret, 1899.)

With the help of women such as Harriet Hubbard Ayer, who was soon followed by Elizabeth Arden, advances in chemistry and the increasing boldness of forward-looking women, body, face, and hair care products were given increased attention. The development of the cos-

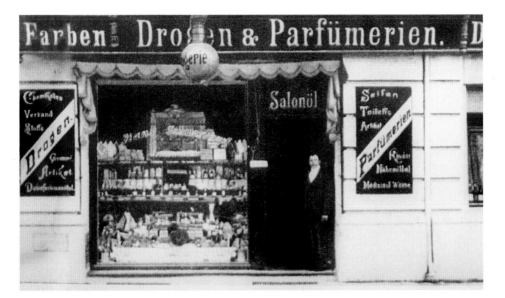

Hans Schwarzkopf's grocery and drug-store in Berlin. This German dominated the hair-care industry for fifty years.

metics industry has never slowed down since.

The concept of freedom of movement gradually gained acceptance, owing in part to the introduction of the bicycle. Then the couturier Paul Poiret shook the foundations of the fashion world. Even before Madeleine Vionnet, he waged a war against the corset, creating the first gowns that could be adjusted with ties, and he revealed ladies' ankles. Inspired by this breath of fresh air, the corset maker Herminie Cadolle invented a new kind of undergarment in 1889, which quickly became commonplace and made its appearance in the 1904 edition of *Larousse*: *le soutien-gorge*, the bra.

Actresses were the first to crop their hair when roles demanded it, such as Eve Lavallière and Sarah Bernhardt in *L'Aiglon*. They were joined by the young, provocative Colette, who created a sensation when she decided to cut her curly mane to chin length, dress like a man, parade around with women, and divorce her mentor, Willy.

But although actresses, dancers, singers, and avant-garde writers, including *Loïe* Fuller and Isadora Duncan, ventured to violate contemporary codes of style and femininity, the average woman was unwilling to part with her traditional crowning glory until 1920.

With the introduction of Roja shampoo in 1909, it became much easier to wash hair. And a revolutionary appliance, the hairdryer, had recently appeared in hair salons. It was an enormous machine that bore a close resemblance to a portable factory. Another revolutionary development destined to transform hair care came in 1907: the young chemical engineer Eugène Schueller invented the first hair-coloring formula, the ancestor of all modern hair dyes. To develop the desired shade of hair color, an alkaline agent was used to oxidize colorants. A complete range of shades emerged, from Nordic blond to deep black. At first he mixed his products by night and sold them by day to a few hairdressers, but three years later Eugène Schueller founded Le Société Française des Teintures Inoffensives pour les Cheveux (The French Harmless Hair Coloring Company). It was later renamed L'Oréal, and became the highly successful company it is today. The same year, *Vogue* announced a new product that made nails sparkle: a transparent liquid to be applied with a brush and then polished with a chamois skin to produce a highly prized shade of pink. Hands were given more care than the face, and the great aestheticians, led by Harriet Hubbard Ayer, launched their careers in manicure salons.

The "prehistoric" era of beauty products was drawing to a close; their epic story was about to unfold. In 1908 and 1909, respectively, Elizabeth

Arden and Helena Rubinstein each opened a beauty salon, and took cosmetic production out of household pots and pans. Led by these pioneers of the cosmetic industry, makeup also emerged from the shadows.

La Toilette. Running water was available in affluent homes. Bathing, however, was still a luxury. (A Guillaume, 1909.)

The bathroom: jars of cold cream, and flower tonics, rice powders, and their powder puffs, arranged on a dressing table.

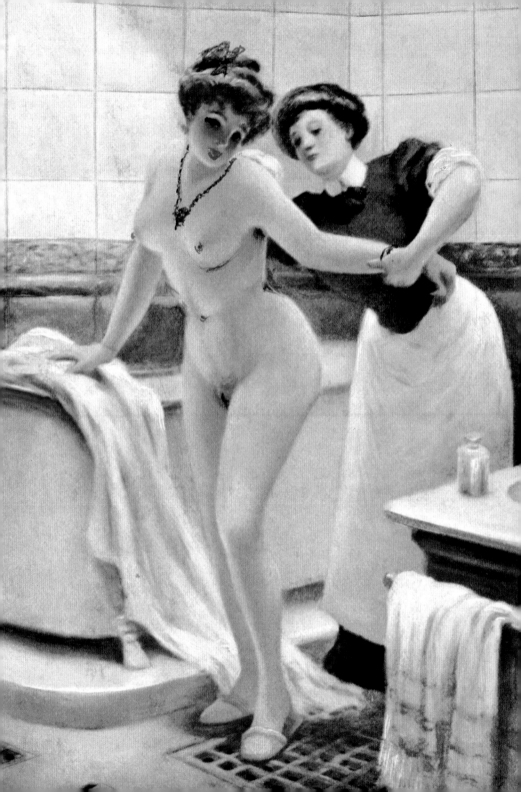

ELIZABETH ARDEN

SHE MADE BEAUTY
A BUSINESS
AND AN
OBSESSION

...ke Sigmund Freud,
...beth Arden
...erstood what women
...ed: to be steamed and
...sed in paraffin, to be
...ered with fluffy
...retta face cream and
... by Ardena Skin
...c, to reek of Mémoire
...ic perfume—to be
...g and beautiful.

...orn Florence
...ingale Graham on a
...dian farm (she later
...me a U.S. citizen
...arriage), she took a
...ame from the
...nyson poem "Enoch
...n" and began to
...et her exclusive,
...-body "treatment"
...w York's wealthy in
.... Her opulent
...s had a trademark
...oor, but her favorite
...r was pink. She
...aged her 300
...ties of creams and
...etics in it. She
...red it for the decor of
...aine Chance Farm
...where society dames
...for exercise, and at
...Kentucky spread,
...e Thoroughbreds'
...were treated with
...ight Hour Cream.
...rden said that women
...racehorses were alike:
...y must be petted
...ared for the same
...' Her horse Jet Pilot
...he 1947 Derby. Her
...ess, which sold for
...y $40 million after
...eath in 1966,
...e the first American to
...age beauty perhaps
...nost successful U.S.
...le entrepreneur ever.

1. **Elizabeth Arden**. Beauty becomes a business.
2. **The Elizabeth Arden Institute**, 7 Place Vendome.
3. **The Ardena line**, 1966 advertisement for Elizabeth Arden.
4. **Promotion for Valaze cream** created by Helena Rubinstein's first husband, Edward Titus.
5. **Helena Rubinstein** in 1913, dressed by Paul Poiret.
6. **Apple Blossom and Heaven Scent**, scented powders created by Helena Rubinstein in 1957 and 1961.

ELIZABETH ARDEN
a le plaisir de vous annoncer le
transfert de ses salons de paris
7 PLACE VENDÔME

"Being a beautiful woman is a profound responsibility"

Who knows better than Elizabeth Arden there are no short cuts to a lovely skin. Achieve the...
loveliness by following these three steps daily: Cleanse with Ardena Cleansing Cream. Dry...
Ardena Skin Lotion to tone and refresh, then dry again. Finally smooth on Crème Extraordinaire...
firm gentle strokes—it does near-miraculous things to tiny wrinkles and moisturizes your skin a...
sleep. Strange what a delight this responsibility can be! Perfection is two words: Elizabeth A...

JULY
AUGUST
SEPT. 1966

Elizabeth Arden
NEW YORK LONDON PARIS

The Business of Beauty

Harriet Hubbard Ayer was among the first to open a beauty salon, on New York's Fifth Avenue at the turn of the century. Arden received her training there before opening her own boutique in 1909. Rubinstein had preceded her by a year in London. Under their leadership, skin care achieved a higher status and gave birth to both a new industry, cosmetics, and a new profession, the aesthetician. One basic principle prevailed: every woman had the right to be beautiful and to preserve her beauty as she aged. As a corollary, beauty would be marketed in a luxurious, calm, and pleasurable manner. Personalized advice, attentive concern, and spa-ike care evolved. Arden and Rubinstein, both exceptional businesswomen, engaged in a legendary rivalry throughout their lives without ever actually meeting. Their careers followed almost identical paths. Both began with nothing and went on to achieve international fame and a vast fortune. Energetic and authoritative, both married a second time to a Russian prince after first marrying an American. Both lived to a very advanced age, dying just a few months apart, and worked right until the end.

5

6

4

VALAZE
PASTEURIZED
CREAM
*for Cleansing, Massage
and Nourishing*

Beauty | **1910 through 1920**

In 1910, Serge Diaghilev's Russian Ballet arrived in Paris. "It is almost impossible to grasp the impact of this theatrical group on European fashion," the photographer Cecil Beaton described years later. In an era dominated by academic aestheticism, the public discovered a world made of startling colors. As Helena Rubinstein recalled in her autobiography, "The electrifying combination of golds and purples excited me more than you can imagine. They were hot, passionate colors, as far from my virginal whites and impersonal greens as you can imagine. After the ballet, I went into my living room and took down my white brocade draperies. I insisted they be replaced by the brilliant, colorful designs I had just literally fallen in love with."

But the war put an abrupt stop to this enthusiasm, which was stifled until the arrival of "les Années Folles" (the crazy years). In the meantime, fashion and advertising was inspired by the Orient, and Europe opened up to the magic of the south. *Vogue* emphasized the lure exerted by distant cultures in 1911: "Turkish women use henna to outline their eyes. Desert dwelling Arab women blacken the corners of their eyes with black powder, then outline the eyes to make them appear larger." Silent films explored the fabulous precincts of these exotic worlds. The beauties of the desert, sensuous and hot-blooded, inspired the image of the "vamp" (short for vampire), a narcissistic seductress who showed no mercy for her suitors.

Mary Pickford, one of Hollywood's first stars, seen here in 1918. With the face of an angel and blond ringlets, she owed her look to the foremost make-up artist of the cinema, Max Factor.

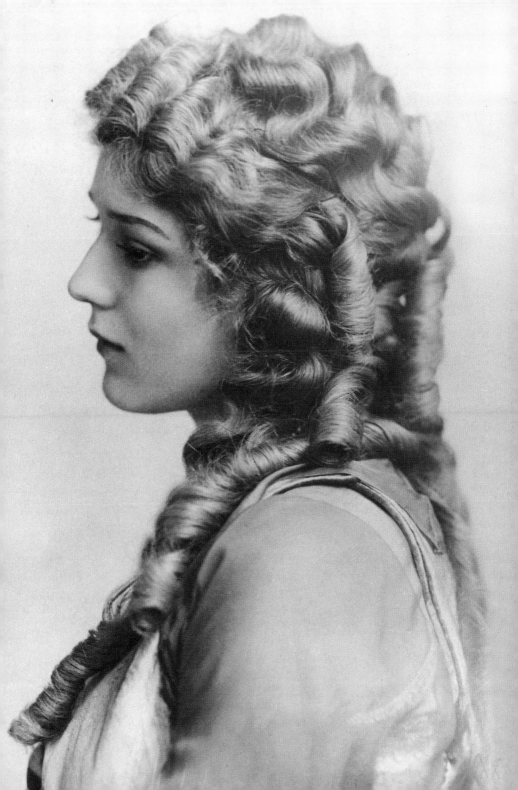

The first such creature in the United States was Theda Bara, who appeared in wanton poses, a pallid creature with smoky eyes and a jewel in her navel. Lavishly arrayed with the accessories of a barbarian priestess, she starred in *A Fool There Was* in 1915. Her counterpart in Denmark, Asta Nielsen, a haughty brunette with black eyes sharply contrasting with her alabaster skin, became "the vamp of the North." She dominated German cinema for fifteen years, and was the first to play the roles of Mata Hari, the spy who was executed in 1917, and Loulou, several years before Louise Brooks. Her great rival was the Polish Pola Negri, whose fiery acting skills were recognized by Ernst Lubitsch when he cast her in two films that were to make her an international star. Famed for her role as an enchantress of the harem, this dark-haired beauty, her fine lips outlined with dark red and her gaze intensified with kohl, set off a wave of suicides.

Pola Negri in 1916. The Polish actress emphasized the contrast between her jet-black hair and extraordinarily pale skin.

Lillian Gish and Mary Pickford were from a completely different ilk, vestal virgins with flowing hair and angelic faces. Their appearance, which varied little from film to film, was meticulously engineered to satisfy the public's taste for pre-Raphaelite maidens. The face was a white,

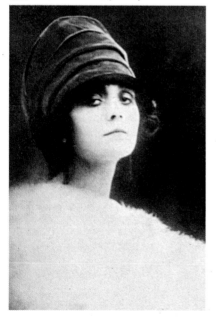

powdered mask, the mouth was small, with lipstick applied within the lip line, and the eyelids were lightly tinted, with abundant false lashes.

Italian cinema also introduced its "divas," the name given to the adored singers and actresses of the day. They brought artifices to cinema that were different from those of the theater and served as a transition between the hidebound past and the boyish era ahead. Worldly, post-symbolist melodramas featured femmes fatales in extravagant costumes, languid poses, and convulsive undulations, forever pursued by an evil for which they must atone. Francesca Bertini was the most extraordinary diva.

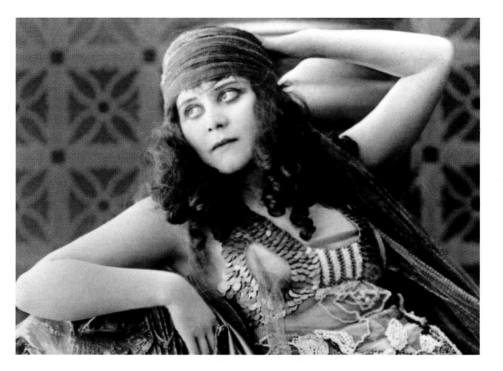

The American actress Theda Bara, known as "the vamp" in Hollywood. She was, without a doubt, the very first femme fatale of cinema.

She too was a small-boned brunette with delicate features, the ideal of her time. Her body was supple despite her corsets, and she had the charm of one of Gustav Klimt's models. She founded Bertini Films in 1919, and was active in film production, earning a legendary place in the history of Italian cinema. Feminine roles proliferated in films during the decade, and young actresses attained a new status, that of stars. Magazines were already embellishing their biographies and adding up their credits.

During this time, women gradually liberated their bodies from the demands of the past. Poiret, followed by Vionnet and Chanel, paved the way for split skirts, sheaths, and scooped necklines that women increasingly accepted. For health reasons, the corset was abandoned and was gradually replaced by the girdle. Stiffened with whalebone, buttoned in front, and thoroughly covering the hips to "create or preserve a woman's natural silhouette," it became less structured as women gained a taste for freedom of movement. The first girdle appeared around 1913 and was named the "tango" after the popular dance.

Hats dwindled in size, their turned-up brims clasped with egret or other feathers. They covered heavy chignons worn low on the neck during the day and higher for evening. The forehead and ears were covered with ringlets.

A pharmacist in Hamburg concocted a cream that he baptized "Nivea" (from the Latin for "white as snow"). The first inexpensive cream, it set off a real economic revolution, but also forged a technical turning point: Nivea was the first "oil and water" emulsion. Although dermatologists admitted it was a somewhat greasy formula, it was the only one they could find to slow the evaporation of water from the skin. The new concept of hydration was introduced. Nivea was initially packaged in a round yellow jar with decoration inspired by art nouveau.

Of course, the budding cosmetics industry had its flaws and frauds. Some creams that were purported to be nourishing really contained nothing but Vaseline mixed with fragrance, and a number of skin brighteners consisted of nothing more than a solution of borax and orange flower water. Some were actually dangerous, loaded with lead and capable of inflicting lead poisoning, a serious illness.

Nivea in 1911, in its first little container, inspired by art nouveau. It was the earliest example of a skin-care product made in an industrial fashion.

New discoveries in chemistry, particularly Berthelot's synthesis of organic bodies, progress in hygiene and medicine, and the banning of ceruse in 1913, contributed to improvements in the production of cosmetics and the development of new bases. As products modernized, more and more companies entered the market. Sales of cosmetics took off. In the United States, for example, revenues from beauty products, estimated at several hundred thousand dollars in 1910, had soared to hundreds of millions of dollars ten years later.

Judith II. The symbolic aestheticism of the era. (Gustav Klimt, 1909.)

Plastic surgery also made a promising debut. Women had been practicing an early version of facial peels since 1886. Using acid in combination with electric currents, they removed the outer layer of the epidermis to eliminate scarring or give a fresh look to the skin. Actors and actresses frequented these "peeling" salons at the beginning of the century, according to the English magazine *Ladies Home Journal.* Another technique involved injecting paraffin to round out the cheeks or eyelids. Great strides were made in reconstructive surgery during the war, when it was used on wounded soldiers. After the war, progress in plastic surgery led many a woman to fix her nose, reshape a prominent chin, or eliminate wrinkles.

New developments in makeup kept pace with the times. Emerging definitively from ill repute and taking their place in the contemporary world, cosmetics exploded with color and new ideas. A glowing paleness, which symbolized good health, remained makeup's primary objective. Powders matched natural skin color more and more accurately, ranging from pink, to white, to the famous "Rachel" shade, a deep beige achieved by blending mauve, ocher, and orange. Although every country had its own competing brands, the French companies Coty and Caron were the very best, renowned from the United States to still-imperial Russia.

Coty made a loose powder called Air Spun with a unique process that made it exceptionally fine. Available in numerous scents and colors, the product was marketed in a splendid cardboard box covered with gilt powder puffs. It was all the rage.

Around 1914, the first pressed powders were introduced, sold in little metal containers with a mirror inside the cover and a powder puff included. Coty sold thirty thousand of its compact Air Spun powders a day. Rouge was also prepared in compact form, rather than in liquid, cream, or tissues. In 1912, the Frenchman Bourjois was the first to package a pressed dry powder form of blush, sold in a small round container. It was called Fard Pastel and came in a dozen shades, one of which, *cendres de rose* (rose ashes), is still sold today. Eyebrow pencils and lip coloring in stick form appeared. In 1915, the first lipstick, a rod of color in a gilded metal base protected by a cover, appeared on American dressing tables. Also, for the first time, powder and rouge were packaged together. These "traveling cases" were created for the elegant woman who took to the road in an automobile. Crafted from black leather, they held the creams, lotions, and cosmetics she required to confront wind and dust without damage to her skin.

Irene Castle. *Vanity Fair's* candidate for hosting the grandest ball of 1919, she embodied the finest style of the era with her careless beauty and sophisticated taste.

Air Spun. François Coty's loose powder. His exclusive process made the powder exceptionally fine.

"AIR SPUN"

COTY

In 1914 the war tolled the knell of the Belle Époque. Women were obliged to take control over daily economic and family life, and many began to work. They controlled machinery in wartime factories, drove trams, and harvested the fields. These new living conditions helped free them from constraints on their movement. In the midst of war's torments, the corset disappeared once and for all, and skirts widened into bell shapes to facilitate walking—and at the same time became shorter, due to wartime fabric shortages.

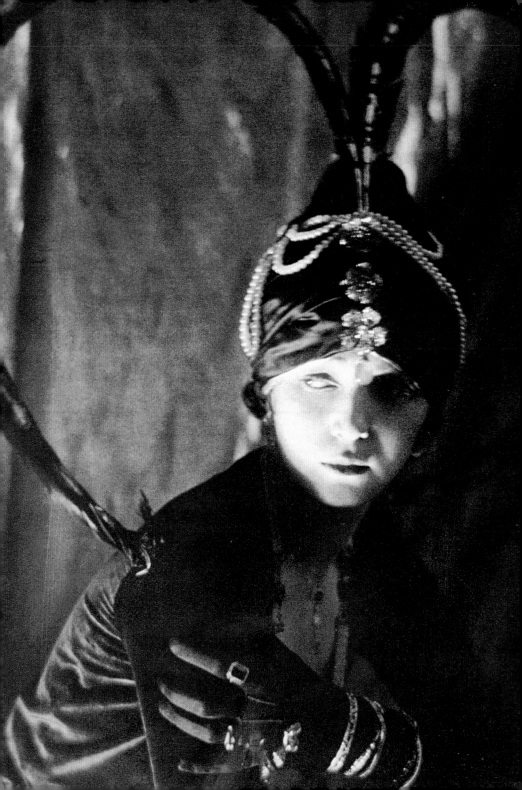

Dark suits became indispensable for women, reflecting their entrance into a world formerly reserved for men. They wore a bra rather than the less comfortable girdle beneath their blouses. To hold up their stockings, there was a practical new invention: garters. Meanwhile, necklines descended to depths hitherto unknown, to the point where humorists took up the subject: "The Marechal Foch neckline . . . it stops at the Rhine!" quipped the journalist Paul Jarry.

Austerity prevailed in skin care. Potatoes, raw or cooked, mashed or grated, sometimes mixed with almonds, had to serve for toilet water, whitening pastes, and softening ointments to treat itches, cracks, and chapping. Patriotic citizens were encouraged to revert to dental soap, a brownish block smelling of carbolic acid that replaced Eau de Botot. Gellé, the first French toothpaste manufacturer, did not hesitate to take advantage of the crisis, boasting in advertisements especially directed at the "doughboys" that their product "triumphantly defends the teeth." Notions of hygiene made sporadic progress. Much of the improvement was owed to the "white angels," upper-middle-class women who took the white smock of the Red Cross to bandage soldiers' wounds and advocate the merits of aseptic conditions.

The first real hair dyes were created by L'Oréal in 1908, and would make a fortune for the company.

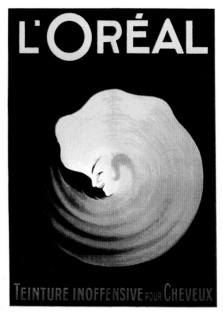

In the new Russia, Madame Molotov, wife of the general who gave his name to the incendiary device, was placed in charge of the Department of Women's Affairs. She produced and sold perfumes alluringly named The Red Star Is Rising and Polar Express.

In France, women were making appointments with their hairdressers to emulate the style introduced by Gabrielle Chanel.

A society wedding in fashionable New York (1910). Elegant women sport frothy chignons swept into headbands.

Gradually, women began cutting their hair very short. It was the same look worn by American nurses who were sent with the expeditionary forces to Europe, who were obliged to crop their hair because of fleas, not coquetry. Ultra-chic new hair curling devices were created. Gone were the curling irons that scorched hair, curling papers, and short-lived ringlets. The predecessor of today's permanent was introduced by a collaboration between two hairdressers, Gaston Boudou (Gallia) and Eugène Sutter (Eugène). Eugène was to have a long career, and twenty years later he was one of the world's leading producers of hair-care products. Before his success, though, the flappers must enter the scene.

NATHALIE CHAHINE

1

At the beginning of the century, makeup labels glowing like illuminations, were frequently designed by great painters such as Mucha and engraved by the best craftsmen such as Draeger for Coty. These enchanting labels decorated beautiful vials and containers, reflecting the dreams and passions of each era. Guerlain, Coty, Bourjois, Roger and Gallet, and Le Clerc each appealed to a different clientele, and designed packaging for their markets, all works of art.

2

3

4

5

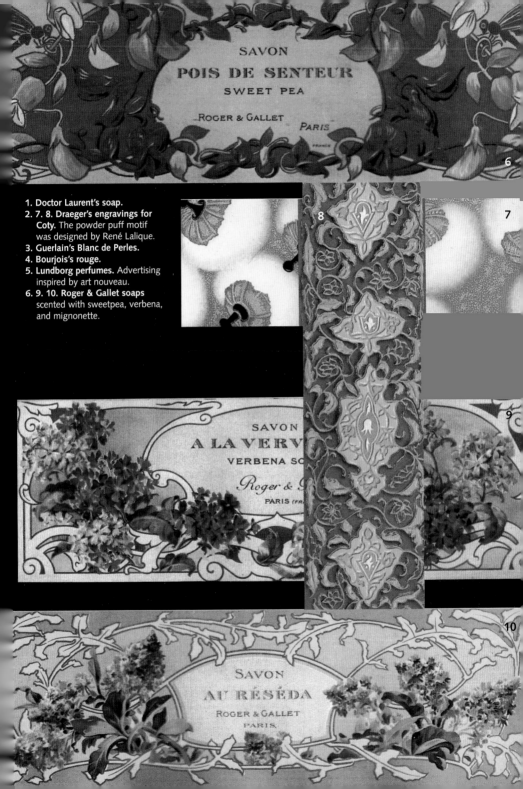

SAVON

POIS DE SENTEUR

SWEET PEA

ROGER & GALLET

PARIS

FRANCE

6

1. **Doctor Laurent's soap.**
2. **7. 8. Draeger's engravings for Coty.** The powder puff motif was designed by René Lalique.
3. **Guerlain's Blanc de Perles.**
4. **Bourjois's rouge.**
5. **Lundborg perfumes.** Advertising inspired by art nouveau.
6. **9. 10. Roger & Gallet soaps** scented with sweetpea, verbena, and mignonette.

8

7

SAVON

A LA VERV

VERBENA SO

Roger &

PARIS (FR

9

10

SAVON

AU RÉSÉDA

ROGER & GALLET

PARIS

Beauty | The 1920s

Peace at last! After so much death and mourning, a hectic gaiety pervaded life. It was an audacious decade characterized by the search for fun, exhilaration, and the emancipation of women. Everyone competed to live harder and faster in a world swirling with the magic of aviation, jazz music, the Charleston craze, and racing convertibles. André Breton published his *Manifeste du surréalisme* and introduced dreams and the unconscious into art. The art deco spirit was expressed in furnishings and objects as well as in jewelry and fashion.

Spearheading this sense of freedom, *La Garçonne*, a book by Victor Margueritte, created a scandal in 1922. For years, this novel continued to symbolize the new kind of woman, who bobbed her hair and smoked in public. The heroine, who strives for independence and is disillusioned by men, leads an independent life, heedless of contemporary mores. Although the book was not of great literary quality, it was a true bestseller, with over a million copies sold in seven years.

The American actress Louise Brooks incarnated this ideal, on the screen and in life. With her boyish hairdo, cut square with short bangs framing a face of youthful charm, she was discovered by Howard Hawks in 1928. Within a year, she had become an international star thanks to Pabst's *Loulou*, in which she played an androgynous seductress irresistible to both sexes. After she had made some twenty-five films, her rebellious spirit and refusal to bend to Hollywood's yoke led to her rejection from the star system.

Solange David, photographed by Jacque-Henri Lartigue in 1929.

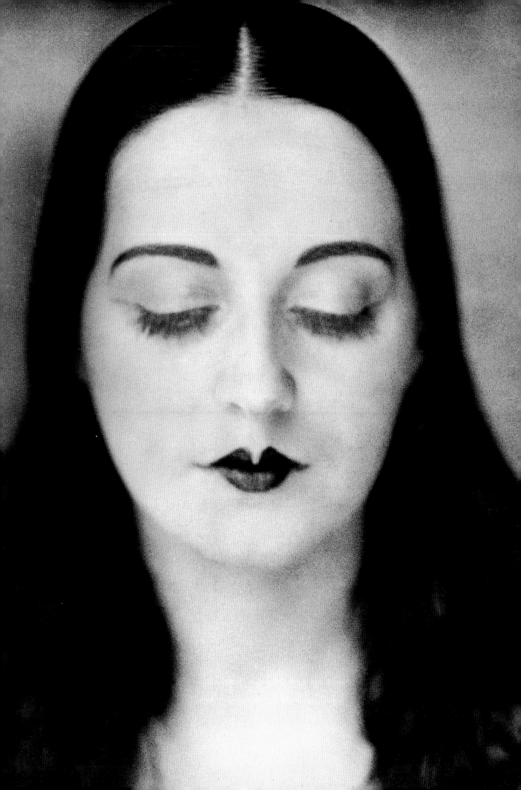

Jazz revolutionized the United States and stirred up Europe. Louis Armstrong recorded his first record and, in the new dance halls, the public frolicked to the Charleston. From 1925 on, Josephine Baker, "the ebony Venus," delighted the French with her exotic eroticism in music hall performances. Born in the American South, she was snubbed by New York audiences. It was in Paris that the first black star met with triumph in her Revue Nègre, which awakened a new interest in African art in France. Dressed in a belt hung with real bananas, her lips painted black, her close-cropped hair plastered down with hair cream at the hairdresser Antoine's suggestion, her dances and strangely animalistic style made her a great star in the course of a few days. Breaking with the traditional presentation of blacks in vaudeville, Baker, the muse of photographers and painters, applied beige powder to her face and rimmed her eyelids with kohl. When she traveled, "she received her guests flanked by two dogs, Fifi and Bebe, in the midst of fifteen trunks containing 196 pairs of shoes, 1,367 outfits, various furs, countless dresses—and 64 kilos of powder," reported her biographer. Needless to say, the powder was formulated exclusively for her.

Louise Brooks, Pabst's insolent Loulou, launched the fashion for boyish hairstyles.

Josephine Baker, the American "Ebony Venus" and first black star, made her career in Paris.

The beauty contest, a new phenomenon, was born in the United States, where the first Miss America was selected in 1921. Six years later, Roberte Cusey, Miss France of 1927, made news when she appeared with scarcely any jewelry or makeup on her magnificent, classically beautiful face. The beauty-contest craze spread like spilled powder, driving social climbers to dream. The frequent marriages of beautiful contestants to wealthy men of power gave credence to the myth. These competitions gave young women an opportunity to become models and gain an entrée into the world of fashion.

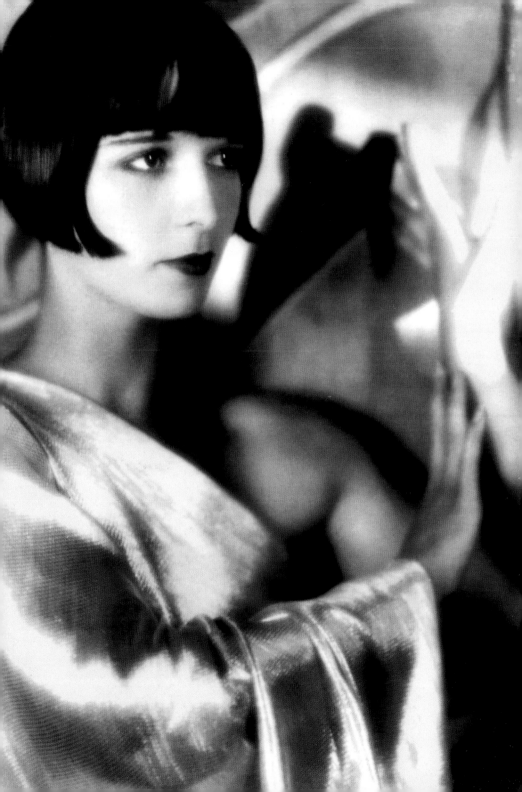

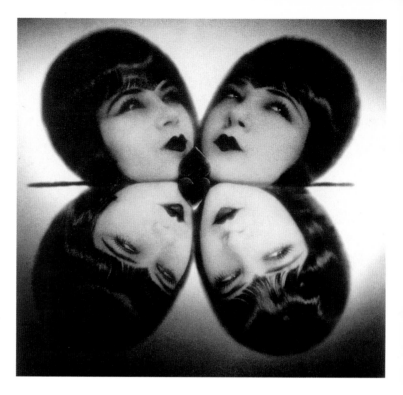

Beneath sculptured, squared bangs, arched brows, made-up eyes, and a vivid mouth gave drama to the face (around 1930).

Kiki de Montparnasse, the painters' muse, photographed by Man Ray in 1926.

Formerly confined to acting or dancing with no future, they were suddenly thrown into a life of adventure, pampered and freer than ever, even though their renown was still very modest. Many models were Russian aristocrats, escapees from the Russian revolution. In Chanel's salons, where many deposed countesses and baronesses were employed, Russian was heard as much as French. This Slavic influence was the origin of "pearlized" makeup, the art of placing a drop of liquid wax on the end of each lash to make a little row of pearls. There were horse and car races, princely ocean crossings, fashion parades for their couture houses, and press photos. The role of the early models was to represent their employers or enliven a soirée, but the libertine image of their private lives was too far removed from the woman in the street to capture her imagination. In 1923, John Robert Power established the first modeling agency. Formerly the object of disapproval, the model gradually became an object of envy.

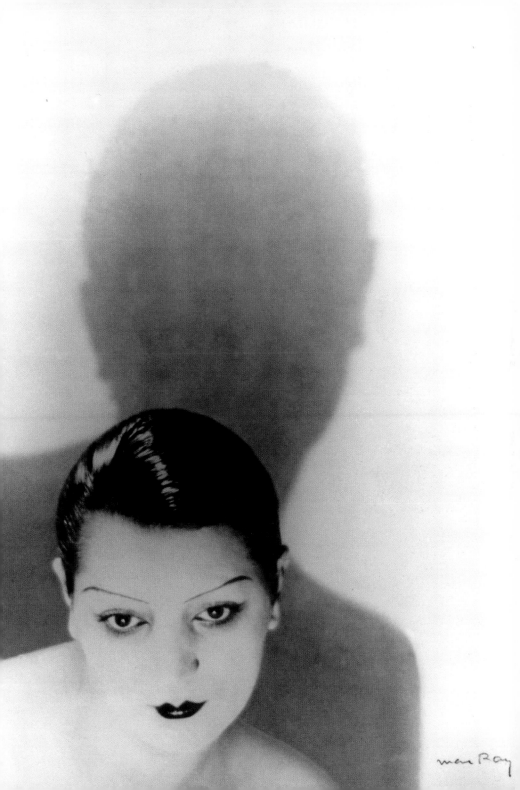

Parisian women drew upon the treasury of their imaginations to keep up with fashion at low cost, cutting and sewing their own stylish clothes. Garments had become more functional and less ornamental, and were thus easier to reproduce. In magazines, women could even find patterns for hats. The do-it-yourself approach, which was boosted as much by the poverty that followed the war as by consumer appetite, was highly encouraged, reaching its peak after World War II. Skirts became so short that they brushed the knees. Dresses, fluid with a lower waist, were designed for boyish figures. However, this new freedom brought with it a new constraint: the string-bean figure. Girdles compressed the hips and "breast flatteners," created in Paris by Herminie Cadolle's granddaughter, attempted to erase the bustline. Elsewhere, elegant women strangled their curves in a heavy swath of wraps. Ten years later, with breasts permanently reduced to the state of limp washrags, a fair number of these models and coquettes would bitterly regret their subjection to the fashion of the moment.

During the 1920s, women expressed their freedom by attempting to resemble men. Less costly than clothing, hairstyles were the first to challenge the established order. "The die is cast. Hairdressers, you must cut!" proclaimed the magazine *La Coiffeur de Paris* in 1924. Following the example of the hairstylist Antoine, who had introduced the boyish cut and revealed the nape of Coco Chanel's neck in 1917, everyone sheared their locks. Even little girls adopted Louise Brooks's square cut style with neat bangs well above the eyebrows, a classic look today. In professional journals, hair was slicked back with hair oil over an almost shaven nape.

Coco Chanel in the avant-garde. She had already bobbed her hair in 1917. At Deauville she introduced the fashion for tanning in 1925.

Curling hair with steam (London, 1929). Hair salons offered the first sets.

The following year, adjustments were made to soften the look. René Rambaud coaxed a kiss curl over the cheek or let little ringlets made from the first hair "sets" escape from cloche hats. Léon Agostini shaded the forehead with a broad wave looping decoratively back toward the ears. The predecessor of the hot process permanent wave developed by the London hairstylist Karl Nestlé covered the whole head with waves.

With the popularity of short hair, which dominated fashion for many years, the hairstylist's role changed and entered a period of unprecedented growth. The associated industry of hair-care products kept pace. The Ströher brothers, patent holders for equipment used for the permanent and founders of the Wella company, also manufactured products that maintained hair and prolonged curls.

The competing company, Eugène, specializing in liquids used for the permanent, opened "Eugène Clubs" in large cities, tied by contract to headquarters. In 1927, Eugène introduced the first treatment cream for hair, Biorène, whose advertising promised "the silken hair of a sixteen-year-old." With haircoloring now widely accepted, L'Oréal introduced the first dye for white hair, and it was once again the hairdresser who was responsible for its delicate alchemy.

"These days it is essential for any well groomed woman to know how to properly use rouge as well as powder," stated *Vogue* in 1921, following up with advice on makeup. After applying a base, a darker powder on the upper part of the face brought out the eyes; from cheeks to chin, a lighter powder was used; blush was applied to the cheeks and blended with a camel's hair brush; then the eyelashes and brows were brushed. The first eyelash curler, the Kurlash, was extremely popular, though expensive and difficult to use.

Valentine's Kiss, in about 1920. The eroticism of reddened lips was finally considered acceptable.

The first tubes of lipstick and their metal containers. Introduced in 1920, Guerlain's Ne m'oubliez pas (forget me not).

Cinema would have a great influence on trends in makeup and hairstyling from now on. George Westmore, who was initially a hairstylist and wig specialist for the Hollywood studios, eventually became a pioneer of film makeup, and the presence of a makeup artist on sets became fundamental. His five sons succeeded him and managed Makeup Services, exerting a strong influence on Hollywood's criteria of beauty right up to World War II.

Toward the middle of the decade, makeup, particularly for the eyes, became bolder, inspired by the heroines of the big screen. For the lashes, mascara, in cake or cream form, was applied with a brush. It was now also available in a waterproof version. The corner of the eye was marked with a special pencil, which was then blended with the fingertip.

Then came eye shadow, which matched eye color at first, but later was coordinated with clothing. The mouth,

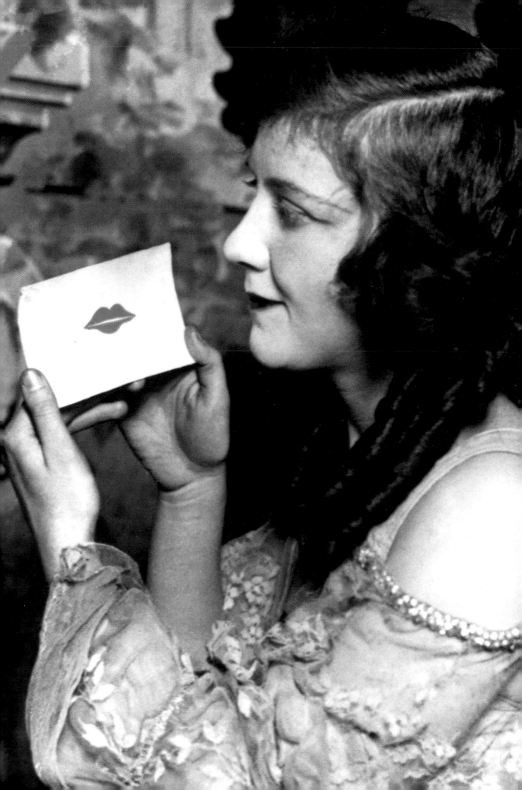

which until now had been only lightly emphasized, was painted with strong dark colors. Progress in the German chemical industry combined with the metal container invented in America by Maurice Levy led to broad availability of lip color after the war. Women favored brilliant shades, scented with cherry. The first indelible lip color, Rouge Baiser (red kiss), was invented in 1927 by Paul Baudecroux; however, this product had to wait for the addition of wheat powder to the pencil, fifteen years later, to achieve true success. Ten years later, the lip color Guitare (guitar) used the same formula, adopting the slogan "Gone are the kisses that betray themselves. Guitare lip color is long lasting and won't rub off."

The long dictatorship of pale skin was under siege. In the United States, from about 1919, the passion for sports meant that a light tan was acceptable during the summer months. People realized that it was becoming and brought out the brightness of eyes and teeth. And there was no need for concern: certain powders lightened tanned complexions and, if necessary, there were bleaching creams and masks that would completely eliminate any excessive tanning. Coco Chanel and Jean Patou made the tan truly fashionable in France in 1925, and it became particu-larly popular among the wealthy elite who summered in Deauville or on the Côte d'Azur. Wearing knit tops and wide, fluid pants, women paraded up and down the boardwalk, with bags containing Miss Chanel's striped bathing costume and Patou's Huile de Chaldée, the first sun lotion. Gradually standards of facial beauty changed, with a return to the natural look around 1928. Daytime makeup was more discreet, not because of puritanical disapproval, but because women wanted to seem free-spirited and in good health. On the other hand, every imaginable eccentricity was permissible by night.

NATHALIE CHAHINE

Brown, blond, red. Hair-dye manufacturers played off the era's lighthearted spirit and turned color into a style that could be changed like clothing.

The Westmore residence, home of the great Hollywood makeup dynasty.

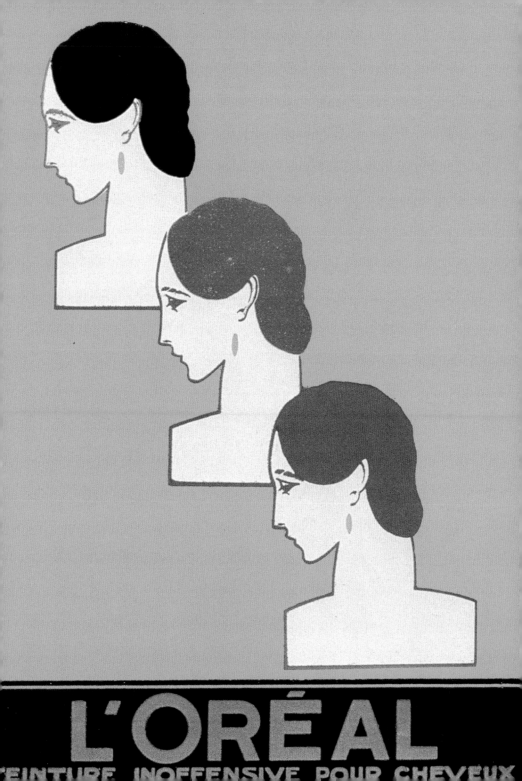

MISS GERMANY 1931

MISS ENGLAND 1929

MISS PERU 1932

MISS EUROPE 1929

MISS HUNGARY 1932

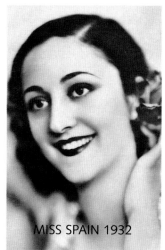

MISS SPAIN 1932

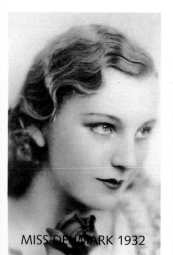

MISS DENMARK 1932

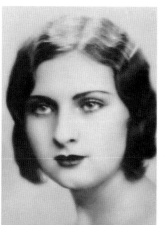

MISS ITALY 1929

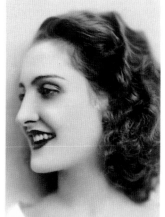

MISS ARGENTINA 1932

MISS YUGOSLAVIA 1930

From Gymnastics to Electricity

Nadia Payot arrived in Western Europe from the Ukraine in 1920 with revolutionary ideas. Her medical background gave her a fresh perspective on beauty care. A meeting with the famous dancer Anna Pavlova set her course. Struck by the contrast between the dancer's flawless body and the aging already apparent in her face, Dr. Payot found a remedy: exercise the facial muscles like those of the body. "Gymnastics" for the face and throat was introduced. The medical field also inspired Jeanne Piaubert. This French kinesthetic therapist invented the first applications of electricity in the field of beauty care and perfected two devices intended to reshape the figure, with an emphasis on slimming and firming. She opened an institute that offered "dermoplasty" to help busts that had been squashed into the string-bean look of the 1920s. Both these pioneers independently developed a line of products compatible with their treatments.

1. **Anna Pavlova,** about 1920.
2. **Back massage.**
3. **Facial massage,** 1928.
4. **The "Vibrion"** ultrasonic massage.
5. **Pumice** smoothing on legs, face, and body.

Beauty | The 1930s

The powerful wind of freedom that blew across the 1920s had died down. The dawn of the 1930s saw the rise of fascism. Despite the Great Depression in 1929, the film industry continued to grow, barely shaken by political and economic developments. For audiences living in this grim era, movie stars offered an escape into fairytales. With the emergence of sound in film in 1931, Greta Garbo's voice was heard in *Anna Christie*. Hoarse and sensuous, it created a sensation.

Unlike her sisters in the business, Garbo, with her restrained style and natural elegance, eschewed nail polish and lipstick, skillfully shading her own eyelids. If she wore a little hat tilted over one eye on the screen, women everywhere did the same. When she was photographed in a beret, berets adorned every head. Secretive and private, the "divine Garbo" captured the imagination of her contemporaries more than any other star of her day. Marlene Dietrich, another heroine from northern Europe, became the archetypal femme fatale, her image shaped by her husband, Josef von Sternberg. With hairline tweezed back for a more prominent brow, lightened hair, carefully plucked eyebrows arching over huge eyes, lashes cunningly curled, and wisdom teeth extracted to hollow her cheeks, she embarked on an endless diet, affecting a weary air of languor and a deep voice to transform herself from the plump singer of *The Blue Angel* into a breathtaking apparition in sumptuous furs. Dietrich and Garbo contributed to perpetuating the 1920s myth of the femme fatale. Joan Crawford, another beauty with a strong personality, was the "most imitated woman" of 1932.

Jean Harlow, the "platinum blonde," made her debut in Frank Capra's film of the same name. With her eyebrows completely plucked and redrawn, and peroxide-bleached hair, she launched a trend that would continue for some twenty years.

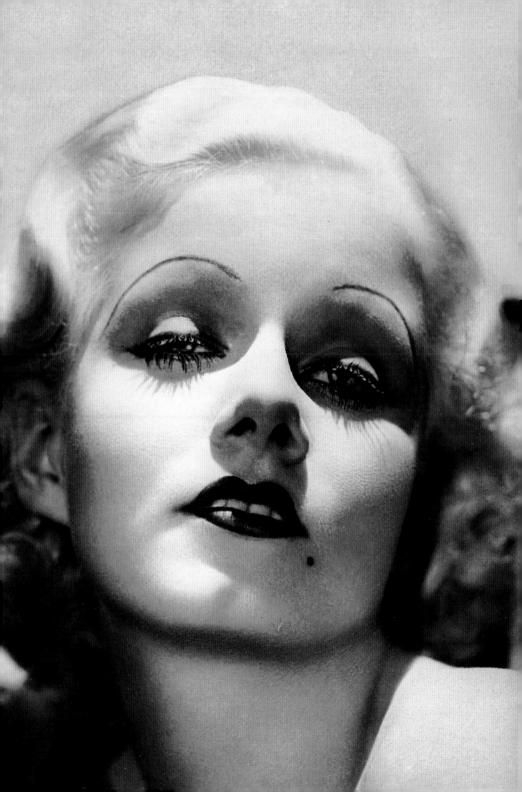

The French actress Arletty. With her typically Parisian cheekiness and lovely face, she immortalized the joint talents of Prévert and Carné on the screen.

Colette in her Parisian beauty salon, on its opening day in 1932. It was an experiment that did not survive the war.

She owed her sex-symbol aura to two discoveries: makeup applied to the upper lip and a jacket with padded shoulders and a cinched waist, which managed to conceal her generous hips. This style was extremely fashionable until the end of the 1940s.

Jean Harlow, the "platinum blonde" introduced in the Frank Capra film of the same name, inaugurated a trend that culminated with Marilyn Monroe thirty years later. From 1930 until 1936 (she died of uremia the following year), she was Hollywood's favorite blonde, with blood red lips and completely plucked and redrawn eyebrows. She embodied a new style of seductress with her sophisticated, provocative beauty. In order to imitate that impossible fairytale blondness, women ruined their hair, stripping it with harsh bleaches, and suffered the martyrdom of plucking every last hair from their eyebrows. Women's magazines were filled with advice for dry-hair treatments and suggested an ether-soaked pad to mitigate the pain caused by plucking.

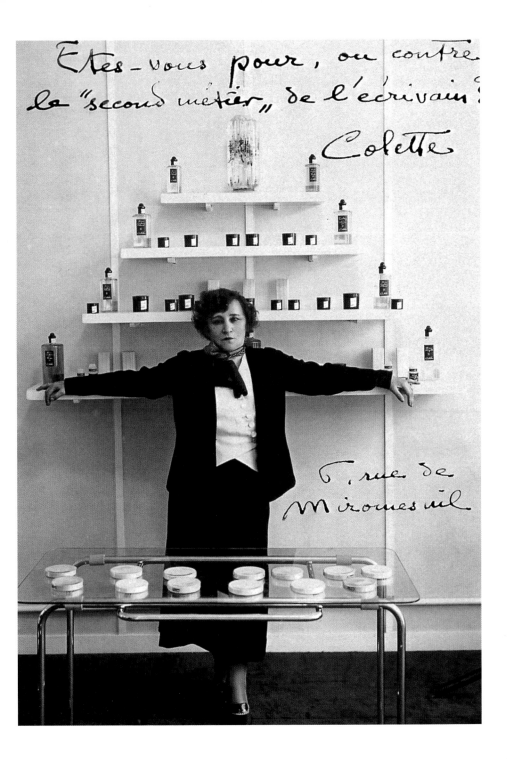

Êtes-vous pour, ou contre
le "second métier" de l'écrivain?

Colette

6, rue de
Miromesnil

It was not until 1938 that Hedy Lamarr launched a counteroffensive. The perfect model of the torrid brunette, she reversed the trend and even had blondes darkening their hair.

People were not yet talking about stars in Europe, but some emerging vedettes such as Michèle Morgan and Arletty became models for the majority of women who were now influenced by the big screen.

Stars set the styles. Women wore Katharine Hepburn's suits or Carole Lombard's wide trousers. Clean lines and matching fabrics flattered long, slim silhouettes. Clothing was simple, sumptuous, and very feminine. Beneath kid gloves that matched her hat or shoes with Louis XV heels, a woman wore blood-red nail polish, finished with a silvery topcoat. Smooth helmets of hair had disappeared, along with bangs. In 1932, the Parisian hairstylist Henry Goumy introduced the cut for "small heads," a wavy coiffeur smoothed down with pomade. A mannerism inspired by ancient Greece made its way into Parisian soirées: hair was worn waved, brushed back from the face and caught up at the nape to draw attention to gowns' plunging backs. The hairstylist Guillaume, on the other hand, drew inspiration from Italian painting for his "angel hairdo," a halo of smooth

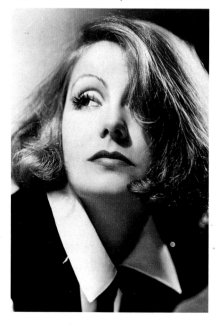

Greta Garbo, the "divine," whom the photographer Cecil Beaton placed at the pinnacle of elegance.

hair in little ringlets all around the head. Hair became longer and waves began to appear—plastered down at the middle of the forehead and tucked in at the nape, the most popular style for the next ten years. Though controversial with the woman in the street, the platinum color introduced by Jean Harlow spurred the imagination of dye manufacturers, especially L'Oréal. "Men prefer blondes and that's who they marry. Why? They inspire deep love and lasting admiration," proclaimed a 1932 advertisement for the dye L'Oréal Blanc. Progress in chemical dyes now made all sorts of evening fantasies possible. With just a vial of Coloral, a woman could "jazz up her hair for a few hours" with gold, blue, or mauve.

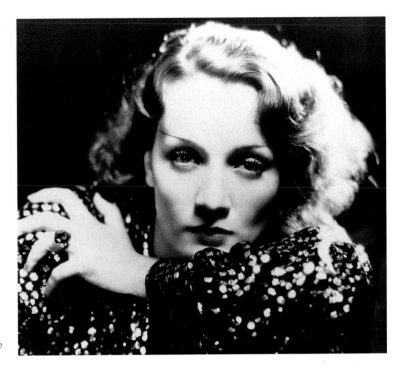

Marlene Dietrich's image was created to compete with Garbo's. Magnificently dressed by the couturier Travis Banton, she was named "the most imitated woman in the world" in 1934.

Ground up "crystal" haloed the head with gold or silver dust, or just added shine, while at the same time controlling the hair. Several permanent wave methods were now available, including the Eugène, Perma, and Gallia processes. Longer lasting and more affordable, wavy hair attracted a more modest clientele who were influenced by women's magazines. Head coverings reached the height of elegance. Truly graphic creations in monochrome tones and clean lines adorned heads with unequaled style. The beret made a comeback and turned into a feminine accessory, hats became tinier and tinier until they were just symbolic discs of felt, topped with a feather that lightly shaded the forehead. For the beach, straw hats as big as parasols were all the rage.

Suntans, formerly reserved for the privileged, became an accessible luxury. Associated with leisure, pleasure, and freedom from daily frustrations, the look was to remain popular. A new product, Eugène Schueller's Ambre Solaire by L'Oréal, accompanied the democratization of the tan.

The open air of the Atlantic also inspired the first sunglasses. The idea originated with Lieutenant Mac Cready, who crossed the ocean by balloon in the 1920s. To combat the vibration, wind, and fog, he had protective glasses made. Bausch and Lomb's research for army air pilots resulted in the first sunglasses, which were green, and filtered ultraviolet rays without distorting colors. Ray Bans ("they banish the rays") reached the American public in 1937. Women first appeared in sunglasses on Hollywood screens. Ray Ban Myth and Ray Ban Sun Gay, which had heavy frames, tapering at the top, and very dark lenses, enhanced the mysterious look favored by starlets. Physical activity in the open air became very fashionable in Europe and in the United States. In Germany, nudism, which was viewed by John-Carl Flügal as "a stage on the journey to a superior culture," won numerous converts. The tennis champions Suzanne Lenglen and Helen Willis and the Norwegian skater Sonja Henie adorned the covers of magazines. Amelia Earhart was the first woman to make a solo flight across the Atlantic. When interviewed after this exploit, she voiced only one regret: the lack of a boudoir where she could powder her nose. In the future, planes would have to offer more creature comforts! Beauty trends shifted between Paris and New York. Paris remained a symbol of refinement, prestige, and avant-garde style, but New York gradually gained ascendancy, dictating a contemporary, modern image of the seductress with the help of its movie stars. When Black, Star, and Frost introduced a gold compact with a diamond clasp, Van Cleef and Arpels countered with a container that combined a compact, mirror, lip color, and cigarette case. Both accessories and jewelry, these new objects symbolized the unprecedented growth in beauty products that had finally won acclaim. Women could now openly apply makeup without a second thought.

Ambre Solaire was introduced in 1935, a few months before the summer holidays.

AMBRE SOLAIRE

HUILE FILTRANTE

The first ultraviolet tanning cabins. A tan: What could be more chic?

Beauty salons appeared everywhere. Based on a solid reputation for luxury and good quality, Helena Rubinstein and Elizabeth Arden ruled the universe of beauty care products. Among the best-sellers of the decade were two Arden lip colors and Rubinstein's silver box containing blush, powder, and an assortment of eye shadows. The development process for these products had also progressed. By the mid-1930s, almost all new offerings were thoroughly tested before they were sold to the public. Sun creams and lotions were dabbed onto backs under ultraviolet lamps, creams passed time and time again through the oven or refrigerator, and new nail polishes were tried out under real-life conditions. The first test candidates were usually factory employees, but soon a growing pool of volunteers participated.

The real stars of the 1930s face were the eyes—visible under the tiny hats of the era—and great attention was given to their care. Eyebrows were completely plucked, dyed, and redrawn with pencil.

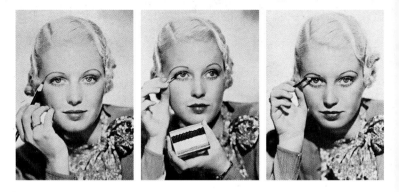

A makeup lesson
from the starlet June
Vlasek (1934). Her
hair was parted with
combs and slicked
with Brillantine.

Renée Ciboure. The
wife and muse of
Jacques-Henri
Lartigue, in 1930.
She embodied the
essence of 1930s
elegance.

Following pages:
Joan Crawford,
before and after
touchups. On the
negative, skin flaws,
shadows, and hair
color have been
reworked.
Photographs by
George Hurrell.

The range of beauty tricks expanded. Powdered eye shadows came in every shade from browns to grays, and even black for evening. The first cream eye shadows in little pots or sticks went on with a touch of the finger right up to the arc of the eyebrow, accentuating the convex curve of the eyelid and lending a slightly melancholy air. Metal curlers were used for lashes, which were then thickened with mascara, now available in liquid form. Mascara came in blue and blue-green shades, but most women preferred brown, with a touch of black added at the tips. To be sure of getting that femme fatale look, a woman could imitate Dietrich or Garbo with very long false lashes, half-closed lids, and the head thrown back. To avoid vulgar excess, makeup for the mouth was more subtle. Purplish and bluish reds were abandoned for warm reds and pale pinks, which created a more natural look. To make the upper lip protrude for the sexy "bee-stung" pout, women were urged to give it a vigorous pinch between the thumb and forefinger before applying color. Cleansing pads (Pond's made the best) wiped off every trace of color while leaving the lips silky smooth. But the greatest invention was indisputably Max Factor's Pan-Cake Makeup. Originally made for Hollywood, this first foundation was tremendously successful. It evened out the complexion, which was then given a matte finish with powder. The cheeks received a hint of beige or very light brown blush, applied in a triangle from the middle of the cheek to the temple to emphasize the cheekbones and give a dramatic intensity to the face.

NATHALIE CHAHINE

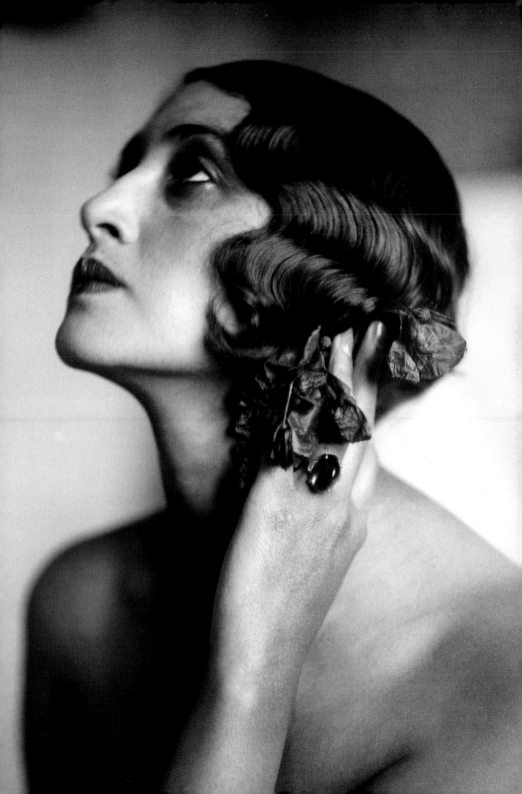

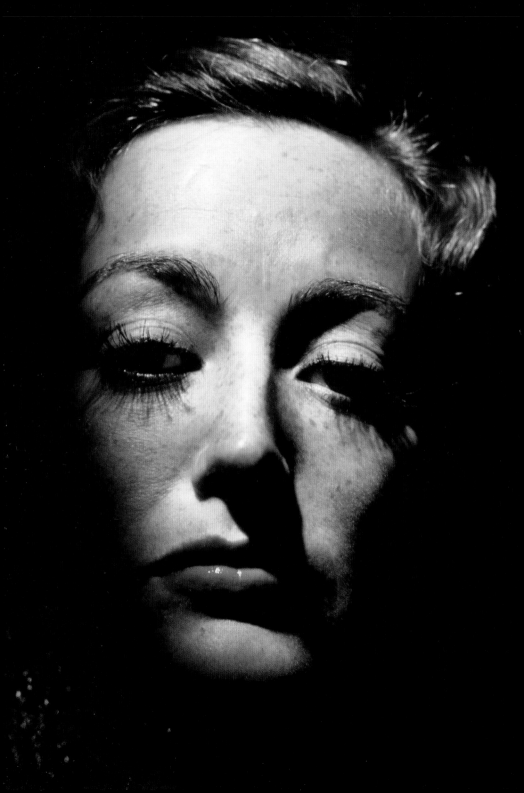

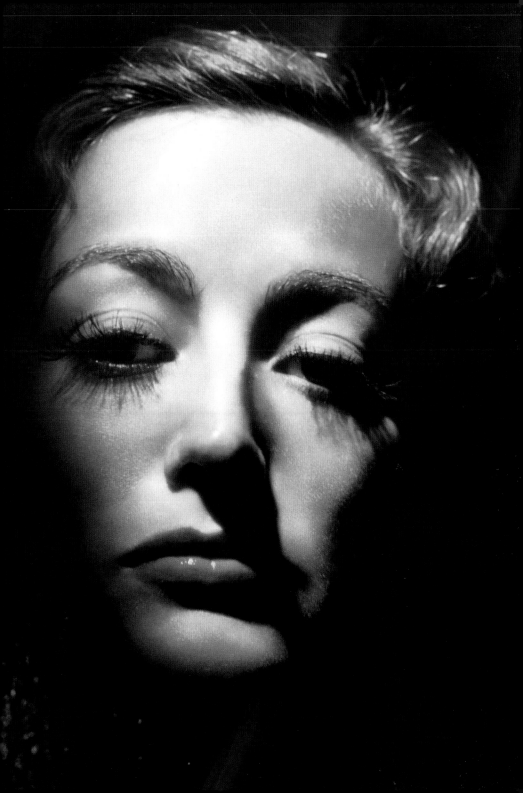

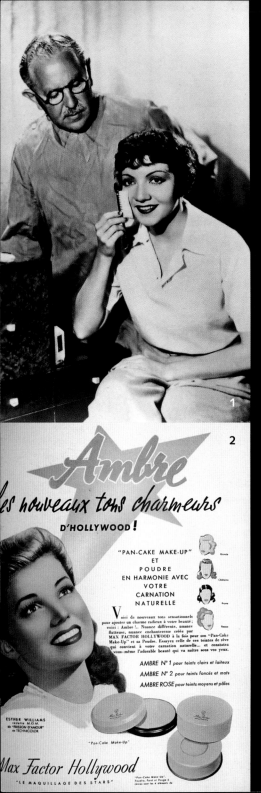

1

2

The Triumph of Max Factor

In search of his fortune, Max Factor left his native Russia for the United States in 1904. He opened a theatrical makeup shop in Los Angeles. Early film actors naturally turned to him after 1910, and in 1914 he invented the first foundation specially made for the camera, Flexible Greasepaint. It had a creamy texture and replaced the thick pasty crayons, loaded with dangerous amounts of lead, that were still in use at the time. The same year, he introduced his "dermatographic" eyebrow pencil and eye shadows. Without skipping a beat, Max Factor expanded his product line for the mass market and in the process became a celebrity. He was the makeup artist for the first stars of the big screen, working right on the Hollywood sets and originating many looks that were subsequently imitated across the country. He was the inventor of the first lip gloss, worn by Lillian Gish in 1928. He shaped the style of stars like Theda Bara and Jean Harlow, and he perfected the glamorous makeup of the 1930s. The arrival of Technicolor in 1935 gave him the opportunity to develop Pan-Cake, his signature product. The first pressed foundation, offering complete, natural-looking coverage, it was the basic makeup used by stars until the end of the 1950s. When Max Factor died in 1938, his son (who assumed his father's first name) took up the torch. When the first television studios opened he obtained exclusive contracts to make up announcers and starlets.

1. 3. Max Factor in Hollywood.
2. The famous Pan-Cake.
4. **Max Factor's Beauty Calibrator,** a device to measure the "ideal face."
5. **Joan Bennett** promoting the merits of Pan-Cake.
6. **Hedy Lamarr** for Max Factor.

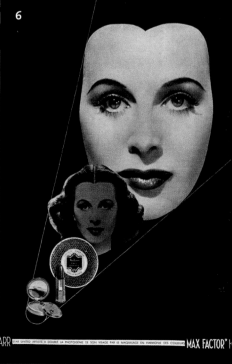

Beauty | The 1940s

Shadows fell across Europe. Fleeing from the Nazis, many artists settled in New York, which became the new European capital. Others took refuge in the unoccupied zones of Europe and exile nourished their creativity. In 1942, Marcel Carné and Jacques Prévert created one of their greatest masterpieces, *Les Visiteurs du soir*, in Nice; it was a poetic allegory of German oppression set in the context of a medieval fable.

In Paris and London, old clothing was recycled, dresses shortened, and skirts slit to facilitate bicycle riding, while coats narrowed. With leather in short supply, shoes were made with jointed wooden soles and stacked heels. There were no more stockings; women went barelegged. To create the illusion of coverage, they dyed their legs with chicory, tea, or nut extracts, carefully drawing a seam up their legs with a black pencil. Elizabeth Arden's wonderful product Le Fin 200, a lotion that gave the impression of stockings, did not stain clothing and was water-resistant.

Running water was no longer a rarity, and well-off women now had bathrooms. Shampoos were revolutionized when the industry adapted by-products of oil refining for hair care. (Surface-active agents cleaned and made suds while ammoniums untangled the hair.) In France, women used Dop, the first mass-market shampoo without soap. It was introduced by Eugène Schueller, who encouraged good hygiene through the mass media. This shampoo remained a family favorite for the next thirty years.

Lauren Bacall. With her hair waved with a curling iron and trained into smooth curls, she introduced the style that was known by her name.

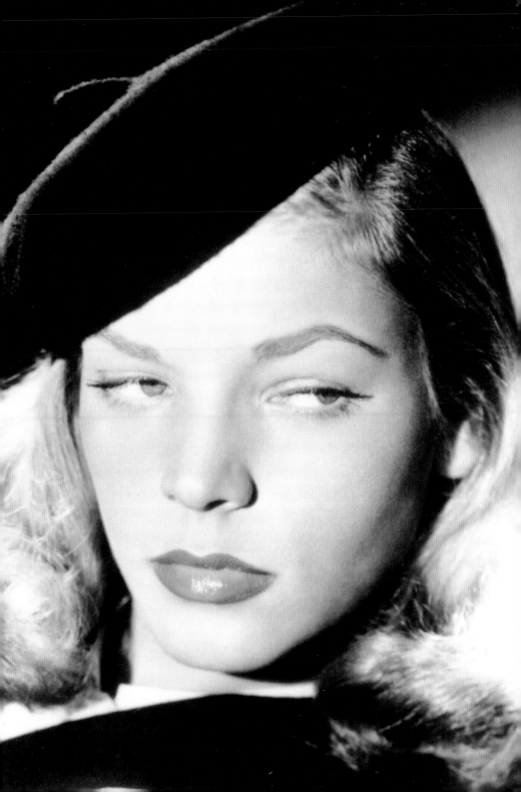

Yardley bath products were found in every English household. Deodorants in spray bottles like colognes were in common use in America, but were not adopted in Europe until after the war.

Women were slim, then slimmer and slimmer. The concern was not losing weight, but maintaining weight loss. Beauty magazines, led by the French magazine *Votre Beauté*, were packed with advice on how to prepare oyster plants, rutabagas, nettles, wild carrots, evening primrose, and cardoons. Conveying Petain's doctrine of "work, family and country," the magazine introduced the tennis player Jean Borotra and his "national physical education doctrine." Its stated goal was "to shape young girls of robust health and good character through general physical training and to develop women who are strong but graceful, who will be the charmed center of a large family household." Beauty, synonymous with health, had become a patriotic duty. "Worry, rationing and suffering threaten your health more than ever. More than ever, your duty is to keep yourself in good shape, healthy, stable and clean," the senior editor of the magazine wrote in 1942.

Votre Beauté, first published in 1933, was the first magazine devoted entirely to beauty.

Women in Europe faced the situation in their own ways. If there were no cleansing lotions or day creams, butter, milk, vegetable fat, or any

fatty substance from the kitchen could do the job. There was no cotton to wipe off the excess, so tissue or blotting paper were substituted. If these two staples were lacking, magazines offered a clever and thrifty alternative: cover the face with oil, and run a letter opener or fruit knife across it like a razor blade. In England, boot black stood in for mascara, charcoal for eye shadow, shoe polish colored the eyebrows, and rose petals soaked in alcohol produced a liquid blush equal to Victorian standards. Only powder was not in short supply.

A permanent wave and manicure in a Parisian salon in 1944.

The hat was the only accessory that eluded austerity. It became the last refuge for extravagant whimsies, finding uses for otherwise useless things: fabric, of course, but also paper, cheesecloth, wood shavings, and rabbit skin. Pauline Adam was the shining light of these troubled times. The last great milliner before head coverings were abandoned, she invented the turban, which never seemed to leave Simone de Beauvoir's head. She remained the queen of fashionable little hats until the 1960s. Beneath the hats, hairstyles became longer. Women rarely went to salons, instead washing their own hair with black soap. To dry their hair, they stood in front of the oven, shaking their heads upside down to guarantee fullness. For waves, curling papers shaped like butterflies replaced rollers. Until the end of the war only a few women could take advantage of a process that had been invented in 1942: to set a permanent, it was no longer necessary to heat the hair. Instead it was soaked in an ammonia solution, then wrapped around rollers attached to an electric apparatus by wires.

With Paris isolated, New York moved to the forefront of fashion and style. The effects of war were felt there too, but to a far lesser extent. The raw materials needed to fabricate perfumes and cosmetics were indeed scarce, and plastic and paper were replaced by metal for powder boxes and tubes of rouge. However, these shortages did not really slow down progress in America. In 1942 the government had eliminated cosmetics from its list of "essential commodities," but it quickly reversed this decision because of the disastrous effects on the morale of female recruits participating in the war effort. Sales thus continued to rise. On the commercial battlefront, Paris lost its leadership role in the cosmetic and perfume industries, and Germany lost its top ranking in chemicals and its world-class expertise in dyes. According to the *New York Times*, twenty million dollars' worth of lip color was sold in the United States in 1941, a figure that increased throughout the war. Not a single navy nurse evacuated from a submarine without her lipstick. It was during this period that lipstick became what it remains today—the most widely used type of makeup.

Hollywood's star system, a dream factory, embarked upon its golden years. Films were encouraged to improve troop and civilian morale.

The hairstyle of a decade: parted on the side, with soft curls falling over the shoulders. Shown here in an advertisement for L'Oréal hair coloring.

Painted lids and lips, models adopted the style of their time.

Female stars created strong characters, touching on themes of war, courage, and devotion against a backdrop of romance. Jane Wyman gave her soldier one of the longest kisses in the history of cinema in *You're in the Army Now*. Other actresses entered the field. Marlene Dietrich, who was fiercely anti-Nazi, visited soldiers at the front and organized performances for them. Max Factor Jr. adapted his products for the army, transforming his foundations into camouflage paint for GIs. Revlon made first-aid kits. Helena Rubinstein received encouragement from President Roosevelt: the pursuit of beauty helped the war effort.

Novembre 49

La mode
est aux nuances douces

les Gris,
les Roses,
les Cendrés

IMÉDIA

LES PLUS BELLES NUANCES DE CHEVEUX

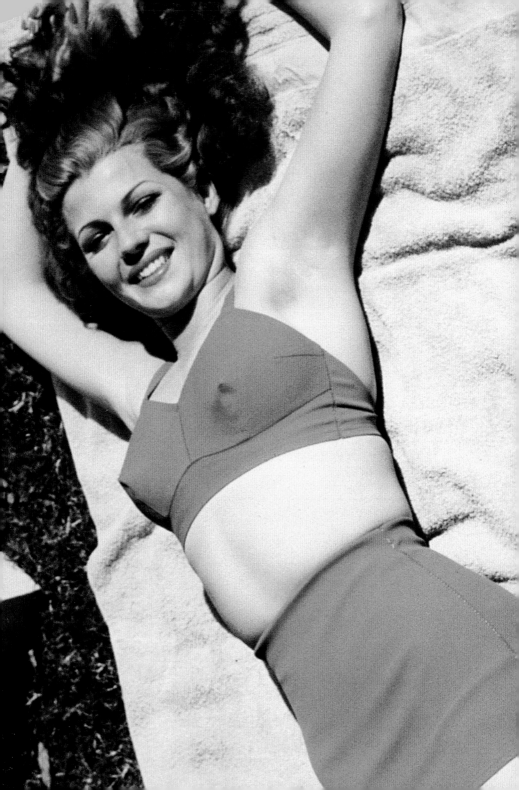

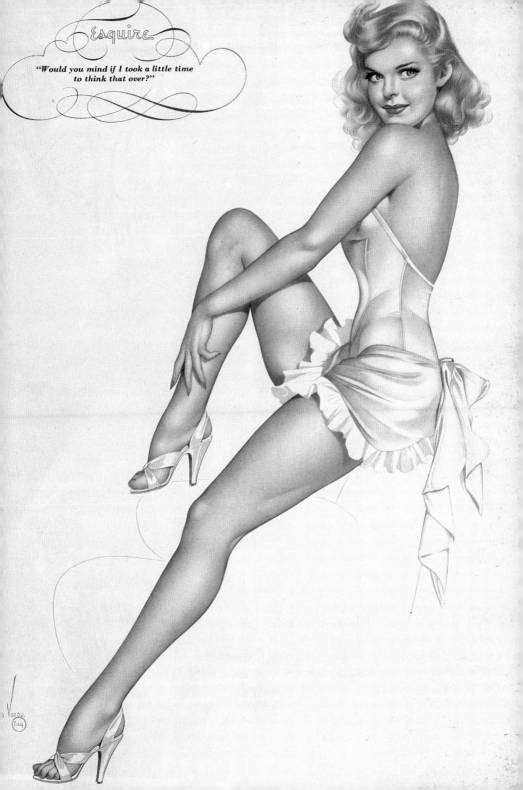

*"Would you mind if I took a little time
to think that over?"*

Hélène Rochas. The wife and muse of Michel Rochas, she turned down offers from filmmakers, but took over the management of Parfums Rochas after her husband's death.

Shell-shaped, long locks, upside-down banana—hairstyle was the defining element of fashion.

Preceding pages: **Rita Hayworth** inaugurated the era of glamour with *Gilda*. **The pin-up:** compensating for wartime deprivation, her perfect form flourished during the war years.

Throughout the conflict, stars wore their hair fairly long, to express femininity at a time when many other methods were unavailable. Women immediately copied Bette Davis's curls, Betty Grable's topknot with ringlets, and Rita Hayworth's gleaming waves. It was Veronica Lake, however, who created the greatest sensation. Her lock of hair covering one eye was so widely imitated that the American Commission on Human Rights in Wartime had to ask her to change her hairstyle before it caused serious accidents among her thousands of admirers who were operating heavy machinery in factories. "Any woman who wears her hair over her eye is an idiot. I certainly don't do it, except in films," she graciously responded.

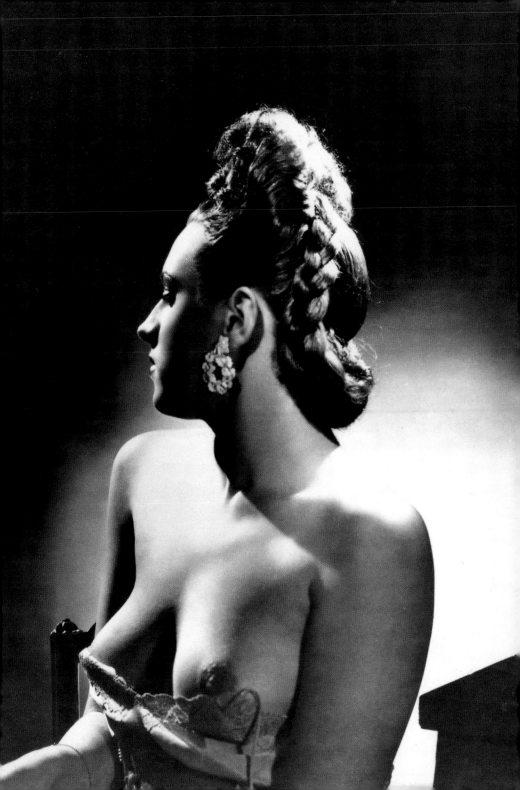

As if to compensate for the era's frustrations, the pin-up flourished during the war years. Its first prototype appeared in 1943, when Howard Hughes designed a bra with pointed cups for the actress Jane Russell. Betty Grable, admired for her "million-dollar legs," was the most famous of all. Lana Turner, who posed in snug pullovers, gave a boost to the knitting industry.

Known as the "twentieth-century's love goddess," Rita Hayworth, already famous during the war, became a true legend after making *Gilda* in 1946. The same year, she introduced the bikini, which had been invented by Louis Rénard. (He named it after the atoll where the American army tested its atomic bomb.) A new kind of vamp came to life in the United States at the end of the war. In the realm of film noir, this rebellious and frighteningly alluring seductress inaugurated an era of glamour and created a new model of femininity that was revived repeatedly, well beyond the 1940s. Rita Hayworth was not alone. Lauren Bacall in *Dark Passage*, Gene Tierney in *Laura*, and Lana Turner in *The Postman Always Rings Twice* were also femmes fatales who contributed to the creation of a new feminine archetype. Whether titillating or somber, other starlets who differentiated themselves from Hollywood style

Veronica Lake and her legendary lock of hair covering one eye.

Michèle Morgan was eighteen in *Quai des Brumes*. Her eyes were the most beautiful in French film.

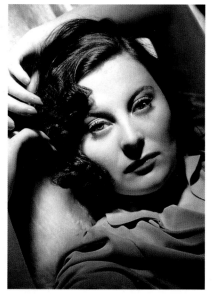

appeared in European cinema, which was reborn after the end of the war. There were many new faces, including Arletty, Michèle Morgan, Maria Casares, Micheline Presle, and Simone Signoret. In Italy, "earthy vamps" made their appearance. Dark beauties like Anna Magnani and Silvana Mangano in *Bitter Rice*, full-fleshed and natural, often molded into scanty, soaking garments, embodied the great period of postbellum Italian realism.

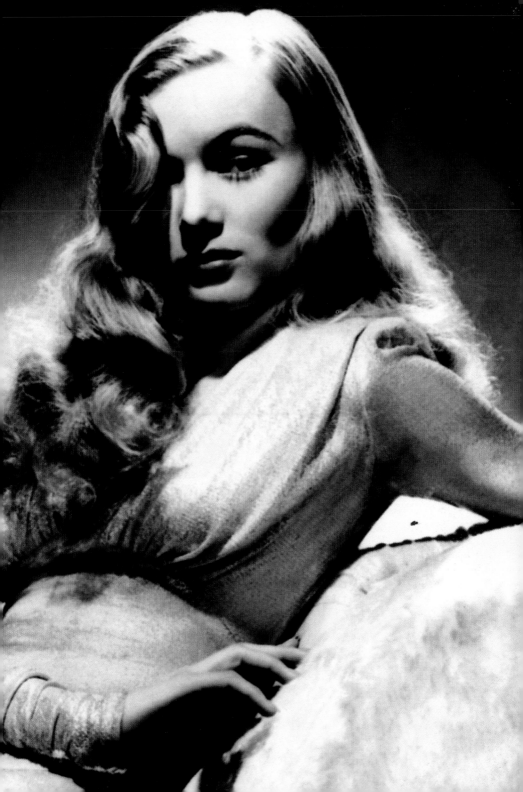

Anna Magnani in 1951. Italian neorealism featured stars who were the absolute opposites of Hollywood heroines.

Juliette Gréco. A seductress straight from Saint-Germain-des-Pres, this singer created a look that would be copied by existentialists.

Christian Dior invented the New Look in Paris in 1947, signaling a nostalgic return to ladylike femininity. People needed some sweetness to put up with the war, and fashion and beauty set out to provide it. Helena Rubinstein introduced a sophisticated foundation concocted from silk fibers. Isabelle Lancray opened her salon with the fetching slogan "Beauty is a joy to share." Georgel imitated the effect of sun-kissed hair, streaking just a few strands. Marcel Rochas created a perfume that he baptized "Femme" for his very attractive wife. In contrast to the doe-eyed "pretty lady" who promenaded her new silhouette on Paris's Right Bank wearing flats and a little hat, stood the artistic, intellectual youth. This archetype was represented by Simone de Beauvoir in her inescapable turban, and later by black-clad Juliette Greco. They chose Saint-Germain-des-Pres as the place to express the ideas, spirit, and style of a new generation.

NATHALIE CHAHINE

Pour les Dessous et les Bas

LUX

1

EMPLOYEZ **LUX** SOLUBLE A L'EAU FROIDE

In the postwar years, a commercial giant took over the lion's share of the hygiene field, which was still greatly in need of development. In 1925, Unilever had introduced Lux soap. The advertising genius J. Walter Thompson associated this product with an image of accessible luxury for over fifty years. It was a novelty amid all the innovations that cosmetic and perfume companies pitched at women. Benefiting from modern means of communication, Lux used low pricing and movie stars to conquer half the countries on the planet. Its first high priestesses were Pola Negri and Louise Brooks. Other admirers of the little white soap included Lauren Bacall, Joan Crawford, and Marlene Dietrich. Despite tough competition from Camay, Lux's popularity continued to grow until the 1970s.

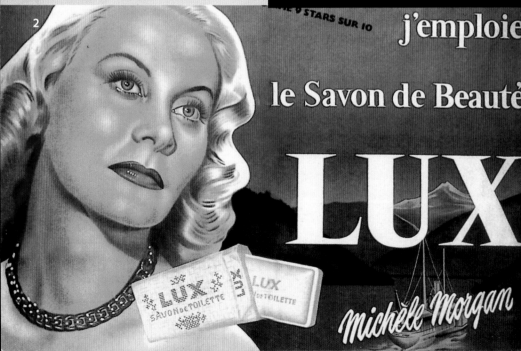

2

9 STARS SUR 10 j'emploie

le Savon de Beauté

LUX

Michèle Morgan

LUX SAVON DE TOILETTE LUX DE TOILETTE

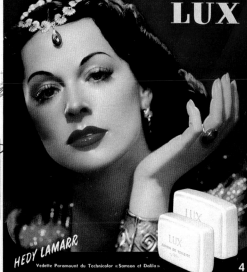

Beauty | The 1950s

Elegance above all! In the uncertain times following the war, tradition and conservative values made a big comeback. After the deprivation and loss of creature comforts, domestic pleasures and rediscovered husbands were a source of delight. Couples married early and started families right away. Until the mid-1950s, the birth rate in the United States exceeded that of India. Model wife and mother, a woman's primary goals were to please her husband and keep her house in good order with the help of her new washing machine and vacuum cleaner. Simone de Beauvoir, author of *The Second Sex*, which was published in 1949, and her followers reacted against this disconcerting regression into domestic bliss. Christian Dior lengthened skirts by ten centimeters and attracted feminist thunderbolts, but they had little effect. To achieve the narrow waist and high rounded bust of the pin-up girls, women used a cinch devised by Marcel Rochas, a modern version of the Victorian corset. Shod in Roger Vivier's stiletto heels, women took baby steps.

The doe eye, created with shadow on the lids, eyebrow pencil, mascara, and, most important, eyeliner, became fashionable in 1949 and remained popular for the next fifteen years. The importance of eye makeup led to a flood of new products and reformulations. Makeup emphasized a pale complexion and intensely colored lips. Blush, the antithesis of the femme fatale look, disappeared. Loose powders prevailed on dressing tables, while every handbag held a compact. The French cosmetics company Rimmel introduced a range of lip colors that included a mirror and little brush, and Gala, a New York makeup producer, came up with the innovation Thick and Thin, two lip pencils connected by a little chain.

Bettina, the legendary model of the decade, was the symbol of the New Look. She did her own hair and makeup for her photo shoots.

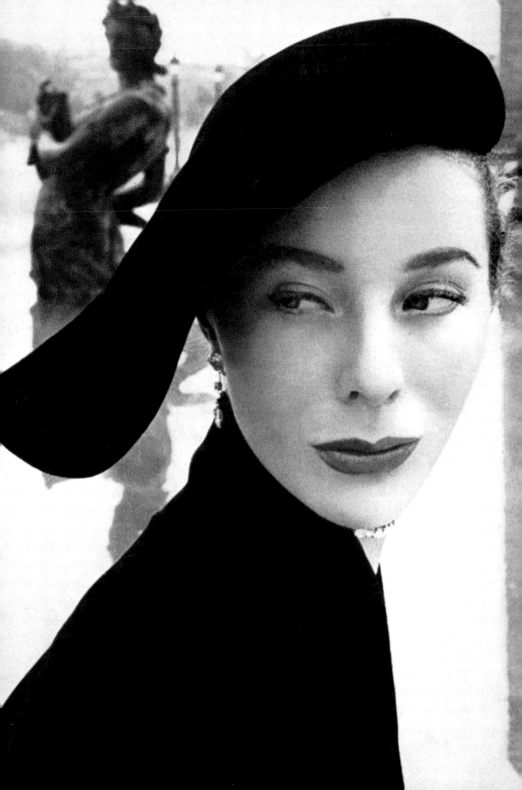

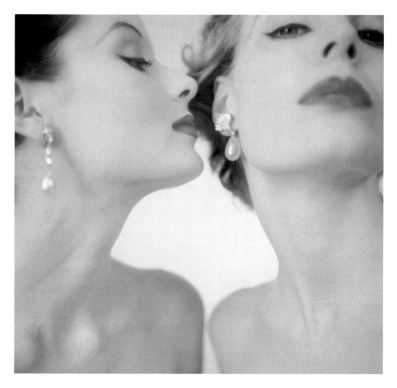

Doe eyes. Eyeliner and the "Rimmel" contributed to the sophistication of the New Look face.

As before the war, makeup colors were coordinated with clothing. This practice, which was criticized by Hollywood makeup artists, was established by the Frenchwoman Germaine Monteil. Unable to find eye shadow or lip coloring that matched her outfit, she was the first designer to manufacture cosmetics. This venture was so successful that she soon abandoned couture.

The jet set emerged in the 1950s, living a life of luxury, pleasure, and elegance. People could follow these lifestyles from moment to moment, thanks to television, which could now transmit daily events, both significant and trivial. The marriage of Princess Elizabeth and the Duke of Edinburgh in 1947 launched a decade of fairytale weddings.

The marriages of Prince Rainier and Grace Kelly, the Shah of Iran and Soraya, the Aga Khan and Rita Hayworth, King Baudouin of Belgium and Fabiola, not to mention the spectacular union of John F. Kennedy and Jacqueline Bouvier, were magical events that captured the imaginations of every shop girl in the 1950s. In the wake of these events, couturiers, hairdressers, and makeup experts acquired new-found prestige. Alexandre de Paris's salon, which numbered Marie-Helene de Rothschild, Liz Taylor, and Jacqueline de Ribes among its clients, was never empty. The Hermès scarf tied over Audrey Hepburn's hair, the Chanel No. 5 that perfumed Marilyn's nights, and the Coronation Pink lipstick introduced by Helena Rubinstein in honor of the crowning of the Queen of England were emblematic of the last words in chic. Beauty and a perfect complexion were evidence of success. Hadn't the Duchess of Windsor repainted her walls in a shade that harmonized with her powder?

New muses were born. From the lenses of the great fashion photographers—Richard Avedon, Irving Penn, and William Klein foremost among them—models were elevated to star status. Revlon's favorite models, Bettina, the quintessence of Parisian chic, the gorgeous Parker sisters, and Barbara Britton, along with Lisa Fonssagrives, were the forerunners of today's top models. With makeup artists or hairstylists rarely

Nails were long and red, a trend born in America. Shown here, an advertising poster for Peggy Sage.

behind the scenes, models usually created their own looks. Bettina recalled the period: "Other models taught me how to use makeup, always harmonizing with the style of my clothes. But some designers liked to be surprised. Jacques Fath, for example, loved innovation more than anything and gave us complete freedom."

Guillaume, a former student of René Rambaud, gathered great designers, milliners, and members of the press together in the salons along Avenue Matignon in Paris to display his hairstyles on models walking the runway. This approach, hitherto unknown, was the talk of the town. Two years later, Christian

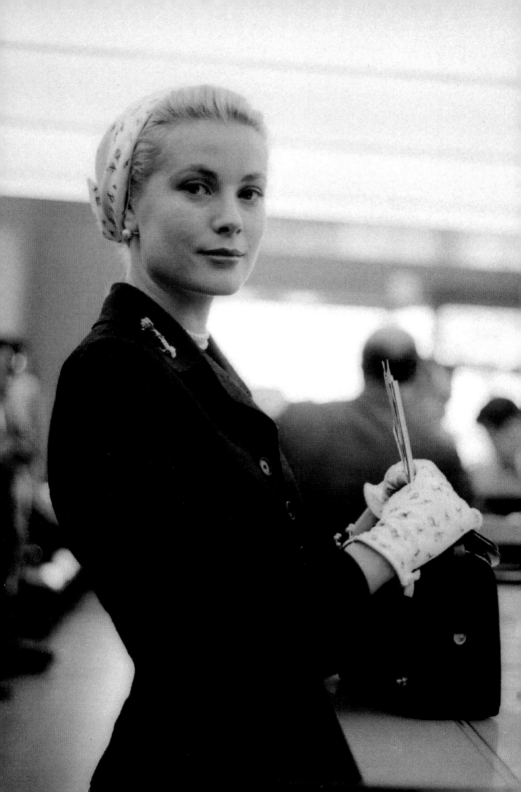

Dior turned to Rambaud when he presented his first collections. The two collaborated for sixteen years, and Guillaume designed all the coiffeurs for Dior's shows. He brushed hair back from the forehead and simplified styles, taking refinement to the ultimate with the art of his "Renaissance" and "Versailles" upsweeps.

At that time there were rarely makeup artists for magazine shoots. "Models brought their own makeup kits and did everything themselves. They were real professionals. Girls like Sunny Harnett and Joan Patchett instinctively knew what makeup to use, and how to use it," said Eileen Ford, whose agency opened in 1946. If there was no hairstylist, the fashion editor would take over. Women favored upsweeps or the ponytails Brigitte Bardot wore at the start of her career. If hair was short, it ended in pin curls over the cheeks. This was the beginning of hair coloring for the mass market—the number of users increased from 500,000 to two million. Conditioners and setting lotions kept pace with this growth. Bangs reappeared with the American actress Audrey Hepburn's gamine look. Charles Revson, Revlon's chairman, proclaimed, "The new American beauty is tempting and seductive, dynamic and restrained. To men, she's the sexiest woman in the world!"

The actress Grace Kelly showed that blondes could be well behaved, and that seduction could accompany good taste. She created the "chic blonde" look.

Ava Gardner's incredible physical perfection and provocative ways gave her a leading place among famous brunettes.

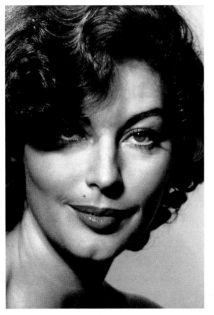

Cosmetic brands dedicated growing budgets to promoting their products. To introduce her new fragrance Heaven Scent, Helena Rubinstein flooded New York's Fifth Avenue with sky blue balloons. Revson, whom the formidable Rubinstein dubbed "Nail Man," dominated the decade with his mastery over cosmetic artifice, right down to the nails, which were red, very red.

Estée Lauder gained market share in skin-care products with her Youth Dew line. She became a millionaire by creating the world's most expensive cream, Re-Nutriv. Refusing to meet his rival, just like Elizabeth Arden and Helena Rubinstein thirty years before, Revson lashed out: "I don't meet

with the competition. I crush it."

In Europe, new brands made more discreet debuts. Roc launched the first line of hypoallergenic cosmetics in 1950. Two years later, dermatologists at Molitg-les Bains developed Biotherm, a line of creams with a plankton base. In 1954, Clarins established itself as a company that specialized in plant-based products. This was the beginning of a trend that would strengthen over time.

The era's ideal face, its paleness carefully created with makeup, with features graphically emphasized, perpetuated the image of the household goddess, a slender, ab-so-lute-ly perfect object. *Time* magazine described her beauty ritual as follows in 1958:

Audrey Hepburn introduced the "Audrey look" on the screen and city streets. Her style would outlive her.

Fifties archetypes. Hair was set in smooth waves, set off by dark eyeliner and red nails.

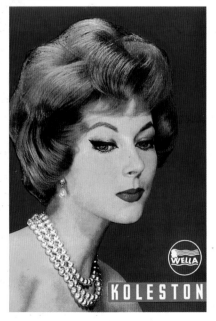

"It's 6:45 a.m. and her husband is still asleep, but pretty Mrs. James Locke is sitting at her dressing table in her three piece suit from San Francisco, her blonde hair covered with a nylon net. Surrounded by numerous fragrant bottles, tubes and sticks, she sets to work like an alchemist. She removes her night cream, dampens her skin with ice water—and for just a brief moment exposes her true face. She applies foundation all over, creating a pale expressionless mask. A cloud of flesh colored powder follows, then turquoise shadow for the eyelids. A dab of perfume goes behind the ears, and on the temples, wrists and elbows. She redraws her eyebrows into lively arcs with a dark pencil and brushes mascara onto her lashes. Twenty minutes later, she is ready for the final touch: an orange toned lipstick coordinated with the polish that covers her very long nails."

Now ready to face the day, she leaves for her office. Ladies like Mrs. Locke, especially those who worked, spent four billion dollars on their "beauty rituals" per year.

Launched by film and fashion magazines, notably Helene Gordon-Lazareff's *Elle*, a different and contrasting look emerged: the ingenue. She

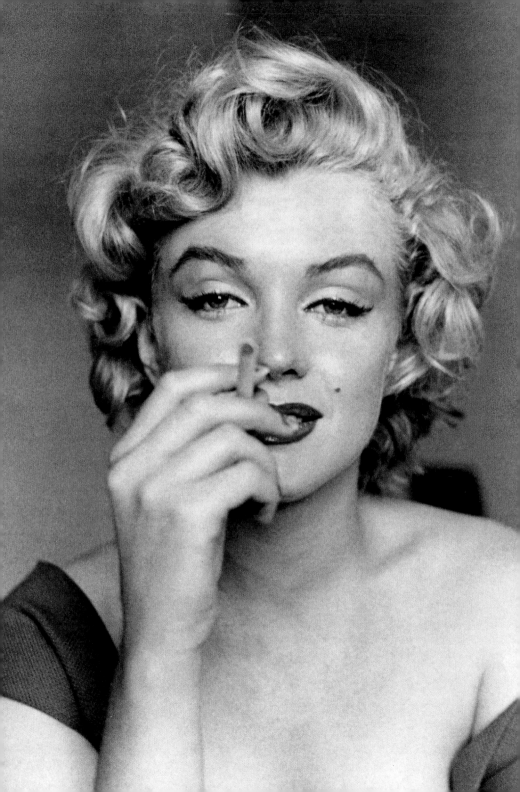

was incarnated in chic versions by Grace Kelly, Vivien Leigh, and Audrey Hepburn. June Allyson and Debbie Reynolds represented her in the form of the girl next door. Her weapon was a fresh, natural look. With eyebrows only lightly colored, pale lipstick, and hair framing the face, this model of beauty coexisted with its opposite, which was all flesh and fire, as typified by Rita Hayworth, Ava Gardner, and Gina Lollobrigida.

These two opposing stereotypes merged in the person of Marilyn Monroe. The star of stars, she was the universal sex symbol of the decade, and she conveyed a devastating, liberating eroticism with her provocative ingenuousness. Her makeup was finely tuned to be more natural than that of the temptress, but more flattering than that of the girl next door. It took three hours to apply: foundation, powder, eye shadow, mascara, false lashes, eyeliner, lipcoloring with a gloss of Vaseline to give the mouth a voluptuous pout—all conspired to create an unrivaled look. At the same time in France, the young actress discovered by Roger Vadim in *And God Created Woman* (1956) also became a sex symbol of the decade. She had the same duality of ingenuousness and sensuality, and was none other than Brigitte Bardot, the prototype of the child-woman. She was eighteen, and didn't try to look thirty. The face of beauty had begun to change as the youth cult emerged from the cafés of Saint-Germain-des-Pres and the studios of Greenwich Village.

NATHALIE CHAHINE

Marilyn Monroe on the set of *Niagara* in 1952.

Brigitte Bardot invented the Sauerkraut (or *choucroute*), a cunningly constructed hairstyle with curly waves.

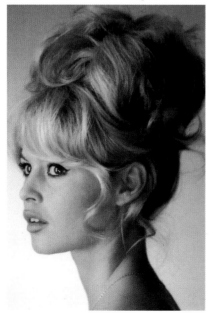

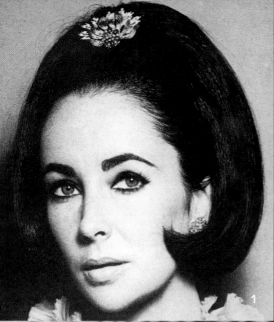

Alexandre of Paris

His mother, who had wanted a girl, made him wear dresses and long hair as a child. Alexandre Raimon remembered finding his vocation early, while arranging the hair of his dolls. Leaving school very young, he learned his trade with a woman hairstylist, then joined Antoine in 1939. During the war he met Begum, for whom he created the "historic chignon." The first version mixed golden artificial braids with real hair, and was followed by numerous variations during the 1950s and 1960s. He opened his own salon in 1952, calling it "Alexandre de Paris," and was soon the preeminent stylist for crowned heads and stars. At the end of the decade, he introduced back-combed short hair, which remained the most popular style in France for the next ten years.

1. **Alexandre coiffant Joan Collins (**Van Hasselt /Sygma)
2. **Alexandre.**
3. **Coco Chanel and Alexandre.**
4. **Jean Shrimpton** in 1968, in the Carita sisters' "sun shine" coiffeur.
5. **The Carita sisters.**

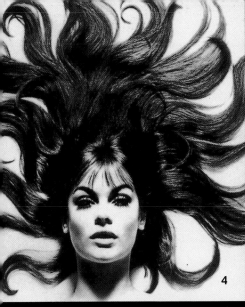

The Carita Sisters

They were advisors and hairstylists of the greats, responsible for the looks of Brigitte Bardot, Jean Seberg, and Catherine Deneuve. Maria and Rosy Carita, daughters of Spanish immigrants to France, started out in Toulouse, opening their first salon in their teens. In 1946, they set up shop in the rue du Faubourg-Saint-Honoré in Paris. They reviewed and altered every aspect of a client, including makeup, style of dress, skin condition, and choice of accessories, as well as morale. They established a school for aestheticians and launched a line of accessories before tackling an area thus far unexplored: hairstyling for men. After the two sisters died, Shiseido took over the business in 1986.

Beauty | **The 1960s**

London reigned over the Swinging Sixties, dictating every beauty and fashion trends. Jean Shrimpton, discovered by the English photographer David Bailey and nicknamed "the Shrimp," appeared on over thirty magazine covers in 1965 alone. She personified the "Chelsea Girl," with her adolescent figure, miniskirt and long legs, long hair worn with bangs, and heavily made-up eyes. Other typical Chelsea Girls included Julie Christie, Patti Hansen, Penelope Tree, Cynthia Hampton, and later Jane Birkin, Françoise Hardy, Françoise Dorléac, and Catherine Deneuve.

After signing a contract with Yardley, "the Shrimp" shook up the venerable brand's image. The company gained fresh popularity despite her unconventional appearance. Dressed "in a skirt above her knees, and without a hat and gloves," she shocked Melbourne during a publicity tour for a textile company. Twiggy , according to the *Times*, "evoked images of Garbo and Carole Lombard." She revolutionized the world of beauty and fashion. Sporting a cropped boyish cut created by Leonard, the quintessential celebrity hairdresser of swinging London, with heavily lined "banana-like" eyes and darkened lower lashes, she struck a doll-like pose. Her boyfriend and mentor, Justin de Villeneuve, claimed she seduced an entire generation. The caption "Boy or girl?" appeared below a photo of Twiggy on the cover of *Paris-Match*. "This is the face of 66," boldly declared Deirdre McSharry, the editor of the *Daily Express*.

Twiggy. Not as naive as she looks: candid mouth, childlike dimples, false lashes, and real lashes painted to enhance the eyes.

"She finished school three weeks ago and she is already earning one hundred pounds a week!"

Vidal Sassoon, the most celebrated hairdresser of the sixties, first established himself at Raymond's, a popular London salon. Vidal Sassoon's "shape" was a graphic cut with asymmetrical lines, an uncompromising style: "If they are not happy with it, they can leave." Once he had set up his own salon on Bond Street, he exposed the nape of the neck, framing the face with an angular cut. Peggy Moffit, Rudi Geinreich's muse, fueled the look's popularity with her appearance in *Qui êtes-vous Polly Maggoo?* (*Who are you, Polly Magoo?*) along with other "models" in the film from the famous op-art makeup scene.

In 1963, Vidal Sassoon introduced the "bob" cut, which Mary Quant adopted. Quant was known for creating a democratic, international unisex style for the Chelsea Girls. In her boutiques teenagers could find clothes created especially for them at prices they could afford: miniskirts, "poor boy" sweaters, high boots, and from 1965, a line of cosmetics made by Gala that was the first to cater to the specific tastes and desires of young girls.

Mary Quant revolutionized packaging with the presentation of her products—black plastic boxes and cases, stamped with her famous white flower—and she enlivened the language of advertising. She was enormously successful with $12 million in exports. She revived the use of color pencils, called Caran d'Ache. She invented amusing names such as Come Clean Cleanser, and added the Paint Box to her collection, a square black box containing pencils, powder, lipstick, and brushes. In 1970, she went even further: her new international advertising campaign featured makeup for "making love." Here was a new social revolution. According to Sue Stewart, assistant creative director for Mary Quant, "We want to introduce products that a girl can use when she's making love with a man without having to worry about ruining her makeup in bed."

Jean Shrimpton was imitated by an entire generation of girls mesmerized by the Chelsea look.

Penelope Tree posing for a Mary Quant cosmetics ad.

TO THE NAKED EYE IT'S A NAKED FACE.

Mary Quant's Starkers.
The make-up that looks like it isn't there.
You can get it in three semi-matt skin tones. Bare light. Bare dark. Bare bronze.
And even if it's hiding anything, it won't look as though you have anything to hide.
To the naked eye.

MARY QUANT

Synthetic coloring in hair dyes led to ads such as this one for Belle shampoo (1960).

The colors were vivid, pure, true: Day-Glo pink, gold, green, violet, and orange. The pencils could be used anywhere on the face, even to draw flowers around the eyes. Gels replaced powder to prevent clogged pores. All of these novel and affordable products were integrated into the new pop vocabulary.

The United States, like the rest of the Western world, was captivated by this exceptionally imaginative British flair. Success turned to mass hysteria when the Beatles and Twiggy arrived in America, which was already enthralled by Elvis Presley and the Beach Boys. With her black tights, Sassoon bob, and round charcoal eyes, Eddie Sedgwick, Warhol's protegée, became the image of the young "underground" generation and its degenerate lifestyle. Meanwhile, *Glamour* revolutionized journalism by addressing teenagers directly. It taught young people outside major cities

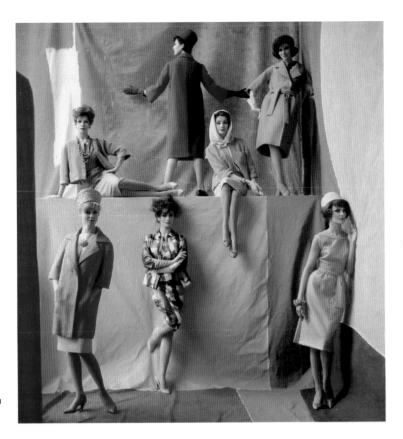

Fashion photographed by Milton Greene in the 1960s.

how to slink into the sixties look. The hairdresser Kenneth created the innovative "bouffant" hair look, and Giorgio Sant'Angelo invented a new and iconoclastic style. Ali MacGraw made the whole world cry in *Love Story*, casting her charm over the decade.

In France, the phenomenal success of Daniel Filipacchi's program on Europe 1, *Salut les copains*, established the new slogan: "Make room for the next generation." This refrain was amplified by the media's increasingly active role. Emanating from rock music, pop culture inspired the entire generation. The new English magazine *Honey* adopted an irreverent tone, scoffing at makeup that was too old-fashioned, conventional, or out of style. Readers lapped up anything to do with the eyes, including false eyelashes—even double and triple layers! The fashion photographer Guy Bourdin even glued fly wings around a model's eye, then used

eyeliner to add additional effects. Jean-Luc Godard made Jean Seberg famous in *Breathless* (*Á bout de souffle*). Fresh, neat, blond, and sporting very cropped hair, she was a stand-out in the fashion world, soon joined by Mia Farrow.

Brigitte Bardot's personal style was a sharp contrast, although equally liberated and deliberately sexy. At her zenith, she embodied the other face of the period. Young women tried to imitate both her long, straight "wild girl" hairdo and the lavish "choucroute" style created by her hairdresser at Dessange, Jean Berroyer. In an interview in *Elle* magazine, she announced a preference for dry shampoos and pale lipsticks. "I put on my makeup in five minutes. Three swipes with a pencil and I'm done." As with most young women in the sixties, eye makeup was the most important part of her routine. She used a black pencil to draw a banana-shaped line in the contour of her eye, and then applied eye shadow with her fingers. Others used false lashes or relined the lashes with eyeliner. The eye had to look big and black. No wonder Helena Rubinstein's Long Lash Waterproof Mascara, introduced in 1964, was so popular.

Op-art for Paco Rabanne: an angular cut wig and makeup extending to the brow to resemble a pendant.

But the art of makeup was pushed to its limits by the six-foot-tall

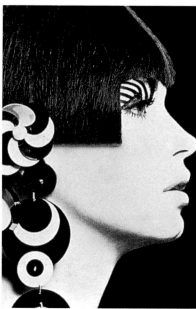

German model Veruschka, born Countess Vera Gottlieb von Lehndorff. Photographed by Rubartelli, David Bailey, Irving Penn, and Richard Avedon and immortalized in 1967 by Michelangelo Antonioni in the film *Blow-Up*, she had a theatrical air. With consummate art and a remarkable ability to transform herself, she made each of her photos into a unique event. Veruschka appeared on the covers of all kinds of magazines, and her metamorphoses fascinated her audience, particularly when she opted for the beautiful feline "Jungle Look." Always using foundation to smooth her complexion, she paid special attention to her eyelashes, gluing false lashes on with a toothbrush. Incessantly creative,

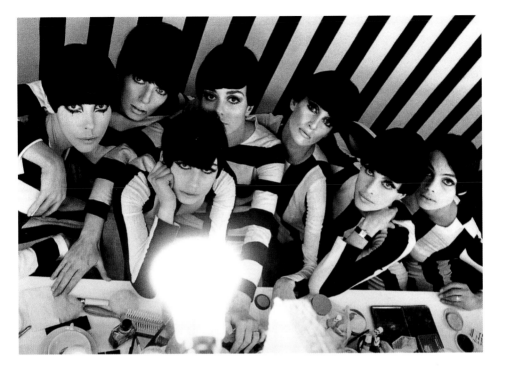

Veruschka did not stop there. She broke new ground with the camouflage makeup called "body paint," covering her entire body with a mix of gold powder and paraffin.

Consumerism reached an important turning point as a huge number of new cosmetic products, increasingly specialized, diversified, and constantly updated, flooded the market. The creative genius of three strong-minded women, all adept at business and superstars in the beauty world, led this drive: Helena Rubinstein, Elizabeth Arden, and Estée Lauder. They turned cosmetics into an industry that played an important role in the market economy.

The cosmetics brands began to associate themselves with young makeup artists who were to become increasingly popular over the next decade. In 1968, Christian Dior chose the talented Serge Lutens to create his beauty image. Jacques Clement, who was to become the top makeup artist at Elizabeth Arden from 1978 to 1982, was already sought after by Peter Knapp, the artistic director of *Elle*. Tyen, Revlon's makeup artist,

designed an entire palette for lips and nails that would make the company an international leader in lipsticks and nail polishes.

The sixties was an era of glamour clichés, promoted by the fashion magazines of the day. Fashion photographers aimed to ennoble beauty. Consumers were in a buying frenzy. Makeup products defined the image of the various companies and reflected two distinct trends: on the one hand, some attempted to perfect the illusion of a natural look, and on the other hand, specialized cosmetics offered extremely sophisticated colors. In 1965, the miniskirt and Yves Saint Laurent's "Mondrian" dresses made a spectacular debut into the world of haute couture, at the same time that French rock star Johnny Hallyday appeared at Olympia. Courrèges introduced a whole range of beauty ideas with his clothes. "I use colored Dynel wigs like makeup, emphasizing the artificiality of their geometric shapes, together with heavy eye makeup." Leclabart could not keep up with demand despite the ten thousand hairpieces and wigs it produced each year. Wigs made from a new synthetic fiber called kanekalon were delivered at a rate of ten thousand per month.

In 1966, photographer and filmmaker William Klein painted a satiric behind-the-scenes picture of the fashion world with the film *Qui êtes-vous Polly Maggoo? (Who Are You, Polly Magoo?)*, which is still one of the most captivating and accurate accounts of the day.

Jean Seberg (1961). Her boyish cut made a big splash in the Jean-Luc Godard film *Breathless (À bout de souffle).*

Mia Farrow (1968). With Vidal Sassoon, she found her "own" look.

Marisa Berenson
photographed by
her sister Berry for
Vogue (1970). A
covergirl adored by
photographers, she
successfully
launched a film
career with the help
of Luchino Visconti.

The 1960s were above all a period of awakening for the younger
generation; shamelessness, mockery, and freedom were the order of the
day. The television programs reflected the mindset at the end of this
decade, with its hippie fashions and psychedelic makeup in vivid colors.
The counterculture of the sixties shaped new images of beauty and gave
birth to ethnic styles, body art, pop art, and flower power. Slowly but
surely, the image of the young adolescent fell out of fashion. More com-
mitted and less frivolous, the generation of the 1970s was on its way.

Veruschka. Flower
power makeup in
American *Vogue*,
April 1964.

Serge Lutens

The 1960s propelled a talented young makeup artist to the forefront of the international beauty and fashion scene. Serge Lutens worked with the great photographers of the day, from Avedon to Guy Bourdin, transforming the most beautiful models, from Veruschka to Jean Shrimpton. In 1968, this young prodigy was asked to work at the house of Dior, where he was a very successful. In 1980, the Japanese company Shiseido named him artistic director responsible for its international style and image. Besides being famous for his skills as a makeup artist, Serge Lutens became a cult figure in the beauty world, creating cosmetics, makeup, and perfumes, as well as photographs, publicity films, books, and exhibits. In all these efforts, he reflected an infinite number of imaginary figures that represented the quintessence of idealized femininity. "Everything that I ever wanted in this vast world of beauty is part of a vision, the vision of a moment in my continuing story. I make no excuses."

Above: **Serge Lutens,** self-portrait.
Left: **This slender form is absolutely incredible!**
Illustration for Shiseido created in 1997.
Right: **Dior makeup (1968).** Face outlined in yellow, with veiled hairdo.

Beauty | **The 1970s**

The musical *Hair* triumphantly announced the arrival of the 1970s, a period hailed for breaking all taboos and taking all liberties. *Hair* was the symbol of the period, the buzzword of a new generation in search of change and recognition. Hair had to be long, natural and above all free. Men grew their hair long and the Afro became popular among blacks. While the radio still hummed ads for hair coloring shampoo, new hairstyling techniques began to develop. Using variously sized curlers to set wet hair, highly teased hairdos were created, called the "artichoke style." Hair could be dried using a brush or blower, as in men's barber shops, allowing the hair to be fluffed, smoothed out, or curled. This new technique, called "brushing" by the Lorca salon, gained worldwide renown after the international success of the 1975 film *Shampoo*, in which Warren Beatty portrays the glamorous Hollywood hairdresser-hero inspired, some say, by his contemporary Gene Chacove. At the same time, Vidal Sassoon's influence continued to spread. After launching his razor-cut style and creating real hair sculptures (Jean Seberg, Zizi Jeanmarie), he continued to innovate and remained at the forefront of the scene throughout the 1970s. Young hairdressers emerged, distinguishing themselves by the bold looks they created, cutting hair by hair. Maniatis, Harlow, and Jean-Louis David, to name a few, opened salons and affiliates. Voluminous manes and unisex geometric looks were created side by side. The number of hair products multiplied. Elnett hair spray and Petrole Hahn lotion, invented by a Geneva pharmacist and a French druggist, were rubbed into shaved heads as well as long hair. In France, Patrick Alès created Phytoplage in 1974, the first line of hair products for the

Farah Fawcett (1976). This splendid cascade of freely falling curls launched the blond layered look. The actress's hair was insured for $150,000.

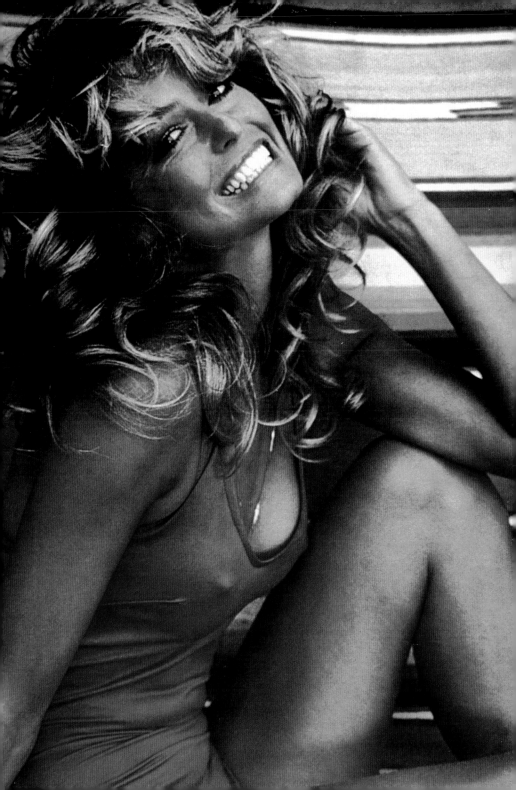

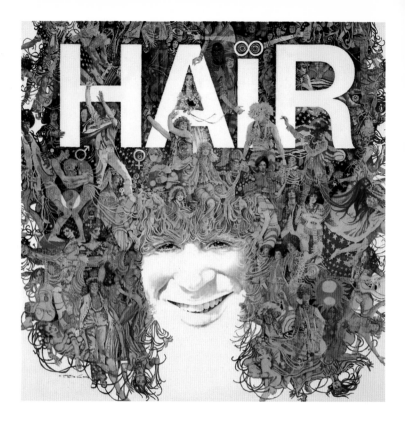

**Poster for the G.
MacDermot film**
Hair (1969).

sun, and with it, the inevitable road to sun worship had been paved.
Obsessed with tanning, women of the 1970s paid no heed to the damaging
consequences that could result from exposing unprotected skin to the sun.
Nude breasts appeared on the beach. While the topless trend spread across
beaches from Pamplona to Saint-Tropez around 1964, it was in Los Angeles
that the Viennese couturier Rudi Gernreich introduced the "monokini." This
succeeded the bikini of the 1950s and consisted of a simple bottom, leaving
the top bare. This liberation of the body was more than a fashion; it was an
attitude symbolizing the power of the new woman. "Develop your body"
became the new slogan, allowing women to go braless under sheer Yves
Saint Laurent blouses.

Magazines teemed with articles about slimming diets and exercise
programs. Now the body needed as much attention as the face, neck,
and décolletage. Specialized and diversified products appeared—including

Karen Graham (1970), photographed by Victor Skrebneski. From 1970 to 1983, they created some of the most beautiful ads for Estée Lauder.

royal jelly, ginseng, and sea urchin sex glands—and people learned how to use them. The moral and psychological aspects of life became important; while anxiety, worries, and nerves were found to cause skin problems, the complexion could also benefit from methods of relaxation. The world became aware of pollution and compared it to a "slow collective suicide." "Find your colors, your style, be yourself and no one else. There are no ugly women, there are only women who do not know themselves," the Italian princess Marcella Borghese was quoted as saying. A partner of Charles Revson, she had just created a line of twenty-four vibrant and luminous lipstick colors.

A strong movement was under way in which women were urged to seek reconciliation and improve their image, each in her own individual way. *The Body Has Its Reasons* by Thérese Bertherat was more than a book of advice, it offered disciplines that could liberate your unused ener-

gy. Two books illustrate this great zest for freedom: *The Scorned Body* by Alexandre Lowen, the leader of a new body of practitioners, and *In Search of the Lost Body* by Jane Howard, a brilliant reporter at *Life*, who recounts her "life odyssey as part of the California movement aimed at finding real life." Revlon's Charlie ads personified this new beauty image. The young and energetic figure, clad in a pantsuit, embodied the young woman of the 1970s. For the first time in the evolution of beauty, men and women could choose their look according to their own personal style, breaking away from the demands of fashion. Makeup became a way to express oneself. Photographs of beautiful people reflected an attitude, a lifestyle, a history, or a comment on society. Art and fashion joined together to capture the ephemeral, as exemplified by Andy Warhol's portraits of the most beautiful women of the time: Marilyn, Jackie Kennedy, and Hélène Rochas. Warhol illustrated a culture that blended fashion and social movements.

Lauren Hutton. This popular star of the 1970s appeared on every magazine cover, including *Esquire*, known for its creative covers (December 1968).

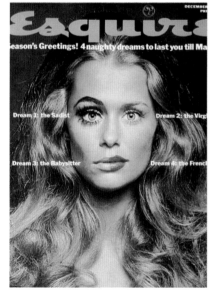

Botanical medicine made its debut at this time. France, where aromatic plants had been growing in the Midi region for many years, led the aromatherapy movement, having long dominated perfumery. Various products were developed: seaweed baths (Marinea), wheat germ (Léonor Greyl), and hops serum and lily-based makeup (Sisley). The first international symposium for bust-care products was held in France in June 1976. Clarins held the lead in this field.

Collagen and silicone were discovered. Cosmetic surgery became available to the masses. People asked about fresh cells for rejuvenation (La Prairie) and were surprised to learn that caviar eggs had stimulating effects (Ingrid Millet, Perles de caviar). Tested at a height of eight thousand meters by Lionel Terrey in 1976, Stendhal's "Varesse" line, made from coconut oil and flower extracts, claimed to provide the skin with a self-defense and protection system. Estée Lauder's

ultra-light Re-Nutriv cream, introduced in 1978, worked to counter the effects of the sun through a layer of sunblock invisible under makeup. At the same time that Sisley debuted its Soins Botanique, including its famous lime blossom mask, Lancaster introduced a line of a dozen sun beauty products to the market.

The new concept of skin care developed in the United States conjured up the same images of purity and precision that Courrèges had a few years before with his whites. The beauty regimen was extremely simple, with only seven products that could be used by any woman, even if she had allergies, or ultra-sensitive and fragile skin. Resulting from very advanced dermatological studies in the United States, this line had a simple name that carried medical connotations: Clinique. It offered a "beauty prescription" for each woman's individual skin. The name behind this brand, which has since inspired many imitations, was none other than

183

Estée Lauder, whose indefatigable flair and insatiable curiosity and research had once again created an innovative product.

This was also the golden era for models with strong personalities. After Veruschka came Marisa Berenson, Lauren Hutton, and Margaux Hemingway, then Cheryl Tiegs and Christie Brinkley, who embodied healthy and athletic beauty, the archetypal American ideal. In 1972 Revlon agreed to pay Lauren Hutton $175,000 a year to promote their Ultima II line, while in 1970 Estée Lauder had chosen the elegant Karen Graham, photographed by Victor Skrebneski. In France, the major couturiers entered the cosmetics market, backed by big advertising campaigns. Dior had awarded the development of its makeup lines and beauty image to Serge Lutens in 1968. Chanel's first makeup line made its debut in 1975, with twenty-six lipstick colors. Yves Saint Laurent followed in 1978, with the strongest and most sensuous shades ever seen. Attention turned to creating creamier and smoother lipstick textures, and the first glosses appeared. Terry, the creative mind behind Yves Saint Laurent's products and colors, who was still working for Carita at that time, recalls Gloss No. 19, an extravagant fuchsia shade, Estée Lauder's brillant à levres éclat doré, and Revlons's Face Gleamer Golden Glory.

Cuts and hairstyles from the 1970s, featuring the famous "Stones" cut in *Votre Beauté*.

Elnett hair spray was initially considered a tool for professionals (1975).

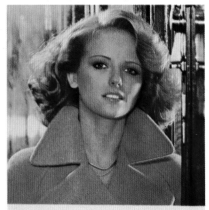

The bright lipstick colors were formulated with wheat germ glycerides and sesame oil, and reinforced with a sun protection filter. Marisa Berenson was a great fan of the new makeup line called On Stage, a unique product housed in the Sunstroker bottle that was neither a gel nor a tinted cream. It contained suspended golden sparkles that could be applied on the arms or décolletage for a gleaming bronzed look.

Cette jeune femme, soucieuse d'être bien coiffée et d'assurer la tenue de sa coiffure avec une laque de haute qualité, utilise chaque jour Elnett.
Son coiffeur, aussi exigeant qu'elle, ne « connaît », comme elle, qu'Elnett.

Elnett
la laque des professionnels exigeants.

L'OREAL

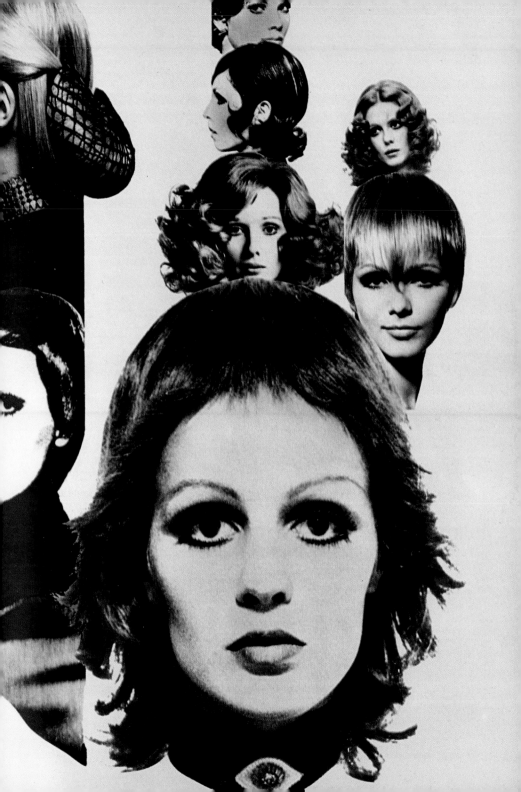

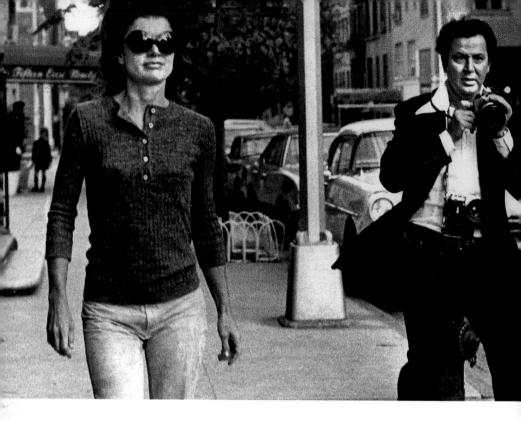

Jackie Onassis and the photographer John Galella. With her famous black sunglasses, she created the natural chic look.

Mariel and Margaux Hemingway. Margaux signed a million-dollar contract in 1975 to promote Babe cosmetics.

Everyone was trying out new powders, ranging from the opalescent to the iridescent, with pearlized pigments. Loose and healthy hair, bronzed or sparkling skin, glossy lips—dazzling beauty was all the rage in the 1970s. Farah Fawcett epitomized the image of the decade. As these exuberant years drew to a close, a new youth phenomenon began to emerge: the punk movement.

Breaking away from society, the punks created a deliberately shocking, provocative look. Their slogan was "no future," and their open displays of bad taste and iconoclastic get-ups exemplified their lack of faith. Their ultra-garish style was punctuated by spiked hairdos, dyed fluorescent blue, red, and green, shaved and tattooed scalps, and spectacular makeup. They strove to be as vulgar as possible, wearing studded leather bracelets and necklaces and safety pins in their ears. Associating with the

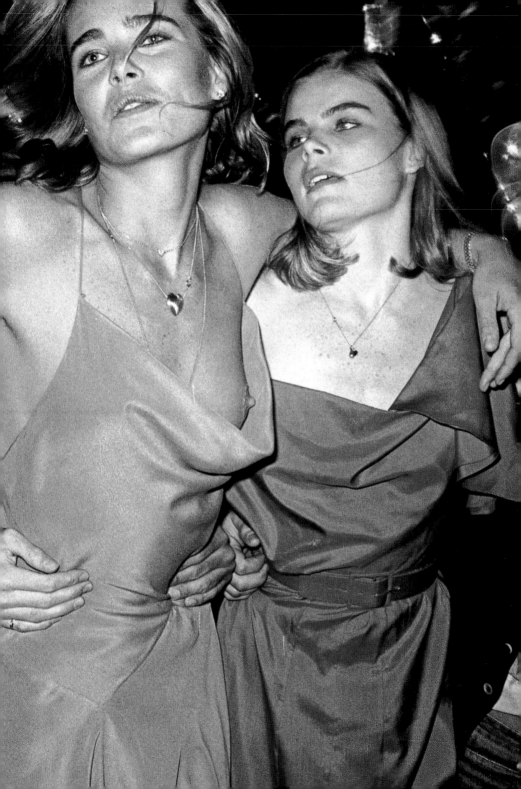

Bo Derek in the film *Ten*. She made corn-row braids popular.

Romy Schneider. The French voted her the most beautiful woman of the century in a *Figaro* poll in 1999. (Rue des Archives)

violent rock music of groups such as the Sex Pistols, they also identified with Stanley Kubrik's *A Clockwork Orange*. Radical in nature, this movement quickly spread throughout the world, leaving a definitive mark on the end of the epoch.

While occupying a marginal role at this time, Vivienne Westwood would exercise a strong influence on the already emerging style of the 1980s.

FRANÇOISE MOHRT

Black Is Beautiful

Toward the end of the 1960s, the Black Power movement emerged. The singer Miriam Makeba started a trend by appearing on tour with her natural hairdo. The actress Cicely Tyson adopted the same style for a television interview. Sporting her Afro hairdo, Angela Davis proclaimed that black was different but just as beautiful as white. The model Naomi Sims, who published her book on black beauty in 1976, was named a top model by *Life* in 1969, while Beverly Johnson was the first black woman to appear on the cover of *Vogue*, in 1974. Paco Rabanne's muse, the magnificent Donyale Luna, was the first black person to walk down the haute-couture runway. She fascinated the Western world, asserting proudly that "black is beautiful."

1. **Pam Grier** in the film *Foxy Brown* (1974).
2. **Beverly Johson** on the cover of American *Vogue* (1974).
3. **Diahann Carroll** in the 1970s.
4. **Diana Ross** in the 1960s.
5. **Donyale Luna** (1966).

2

3

4

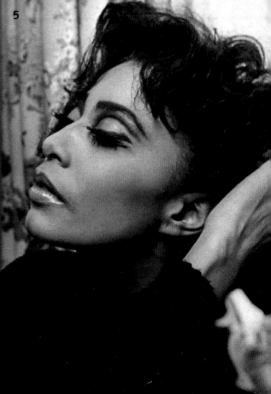

5

Beauty | **The 1980s**

Conflicting trends marked the beginning of the 1980s. These were the last days of disco and the golden era, when young people, decked out in spangles, gyrated on the dance floor of Palace in Paris and Studio 54 in New York. With outrageous abandon, the heroines of the night pulsated under disco balls flaunting ultra-red lips, electric-blue eye make-up, and cheekbones highlighted with brick-red blush. The new titans, Bianca Jagger, Diane von Furstenberg, and Jerry Hall, reigned in Paris and New York. Meanwhile, Grace Jones had met Jean-Paul Goude, her Pygmalion, who would reshape her image—cheekbones, hips, nose, and eyes. She became an ultra-woman.

On the other hand, the typical woman of the 1980s assumed the role of superwoman. Shod in low heels, clad in a gray suit like a businessman, with nails and hair impeccably groomed, she set out to conquer the business world. From the boardrooms of Wall Street to the talk-show stage, the same refrain was heard: the laid-back, natural, unpolished look is out. The era of excess had begun. If you wanted to make an impression, you had to be fully made up. In the United States in 1983, Elizabeth Arden launched one of the best-selling products in the company's history, Lip-Fix, a miracle gel for longer lasting coverage. The lip color of the day was scarlet, but soon brown, or chocolate, came into vogue. Increasingly, beauty looks changed with the season. Makeup artists were called artistic directors at the major houses: Thibault Vabre at Lancôme, Terry at Saint Laurent, Heidi Morawetz at Chanel, Tyen at Dior. Women used lip gloss, soon followed by iridescent and even metallic colors. Eye shadow changed from brown to dark purple, from rainbow colors to

Iman and Jerry Hall
photographed by
Horst. The top models of the 1980s
were also queens of
the night.

monochrome tones. Lashes were extended with waterproof mascara in grass green or pool blue. Cosmetics added color to a world that was basically black-white-gray, decorated furnishings that were metallic, industrial, and cold although the media insisted the look was simply "hip."

From the basements of concrete lofts, the dream apartments of city dwellers, punks bellowed "No future!" shaking up Paris, London, and New York. Meanwhile punkettes paraded their leather, sex-shop lingerie, purple lipstick, uncombed hair, and dark humor. Soon, the singer Siouxsie Sioux, with her pale complexion, smoky eyes, and gothic priestess get-up, became the hero of the Cold Wave generation. But Madonna reached the top of the pop charts. Whether singing "Like a Virgin" or acting in *Desperately Seeking Susan*, she was definitely over the top. With her heavily shadowed eyes, bleached hair with dark roots, charm bracelets, bare midriff, and exposed lingerie, Madonna sported a venturesome look. Cher tried to make a comeback with a totally new body, remodeled by a cosmetic surgeon's scalpel, but she still missed the mark.

Grace Jones. After modeling, Jean-Paul Goude's protegée moved into advertising, film, and singing.

Jane Fonda's video approach. You have to feel the pain to look beautiful—very beautiful.

Beauty had become a competition. Looks and appearances had to be well maintained. The body had to be perfect. "I want muscles," crooned Diana Ross, and Jane Fonda became the priestess of aerobics. Her exercise tapes were snatched off the shelves. "And one, and two, and three. . . ." Dressed in a fuchsia leotard, the star showed women how to obtain the dream body, hard as a rock. Jogging also became popular. In Central Park, in Hyde Park, along the Seine, joggers appeared, walkmen plugged into their ears to keep the beat. Weakness was verboten: to be beautiful you had to feel the pain. Especially if you wanted to be beautiful all over.

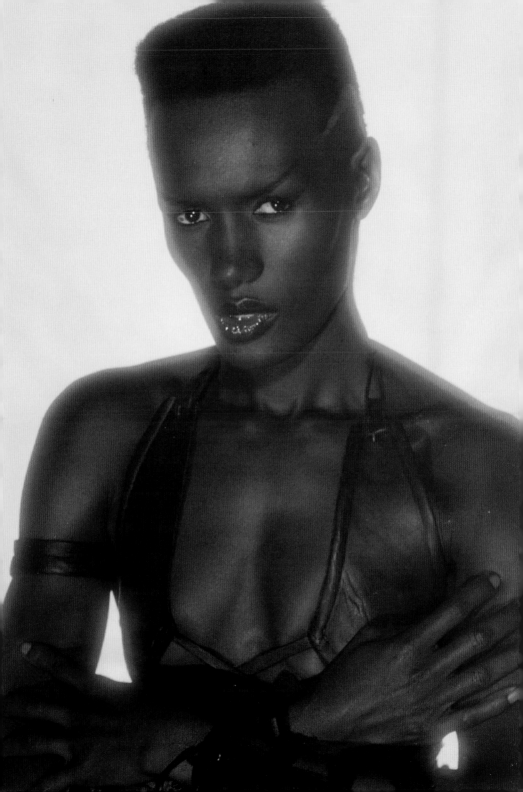

Pat Cleveland, Marie Helvin, and Sayoko after a Mugler fashion show. Fashion loved excess.

Attention also turned to hair fitness. In France, Jacques Dessange and then Jean-Louis David, with his "just a cut," created standard cuts and invented on-the-go styling.

The supermodels of the eighties were known by their first names. Everyone was talking about Elle (Macpherson, of course). Every magazine displayed the beautiful Australian flower with her high breasts, ultra-long legs, firm stomach, and bronzed skin. Elle was "the Body." In other words, she was perfection, young and athletic. Women dreamed of being like her. Paying no heed to love handles, fashion dictated that they squeeze their bodies into clingy Lycra tights and leggings. And if the gym was not enough, beauty could be sculpted with a scalpel. Cosmetic surgery began its inexorable rise. In the United States, surgery increased by 63 percent in 1988 alone. The offices of these new magicians were

flooded with patients clamoring for liposuction, collagen injections in the lips, nose jobs, eyelid tucks, and breast lifts. In the "People" sections of magazines, celebrity lips appeared extraordinarily full, breasts extremely pert, and cheekbones perfectly smooth. Real or fake? Asking the question was still taboo.

Cosmetic counters were replete with beauty products that performed better than nature. It was the decade of self-tanning. Guerlain triumphed with Terracotta, introduced in 1984. The tanning powder was applied on the brow, cheeks, or between the breasts. The objective was to look relaxed, even in the month of December. Three years later, Guerlain repeated its feat with Météorites, multicolored little spheres that were blended for optimal effect: mauve to attract light, white to give a healthy glow, green to fight redness. Creams were available to prevent wrinkles and cellulite. In the 1980s, most women had purchased anti-cellulite products at least once in their life. In 1988, Clarins saluted the arrival of a firming gel for the bust (a reformulation of a product introduced in 1976), which could help firm and improve the bustline. The timing was perfect, since large breasts were back in style. Rosemary Mac Grotha, with her lilac-colored eyes, alluringly exposed her décolletage on ads

Lypsinka, drag queen and performer, photographed by Roxanne Lowit (1989). Transvestites moved stage front.

everywhere, sending both men and women into reverie. The lingerie shelves of large department stores were stocked with push-up bras, referred to more politely as "demi-cups." Travelers brought home the Wonderbra from London, where it had been first introduced in the 1970s. Its catchy slogan was "Say good-bye to your feet." Rather surreptitiously, curvy figures had eclipsed the image of the superwoman with her shoulder pads, narrow waist, and geishalike makeup. Jean-Paul Gaultier celebrated the curvaceous look with his grandmotherly corsets, dyed deep pink.

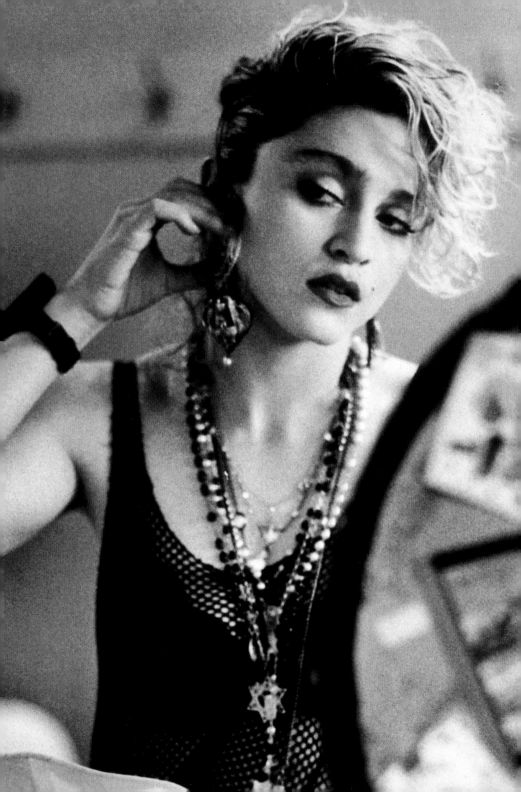

Swedish rock punkers. "No future!" The punks upset standards of beauty.

Madonna. Everything she does is over the top and to perfection. She is shown here in the Susan Seidelmann film *Desperately Seeking Susan*.

The photographer Jean-Baptiste Mondino and the makeup artist Topolino galvanized the spirit of the times with their lively, witty, and poetic photos. Images of female butterflies and retro styles had gained a stranglehold on the fashion world.

Bathrooms filled with even more high-tech beauty products. In the 1980s, the refinement of beauty moved from the boudoir to the research laboratory. In 1986, Lancôme created a stir with Niosôme, the first cream containing liposome agents that delivered active ingredients to the skin. Great progress was made in developing anti-aging mechanisms, leading the beauty industry, from couture houses to mass marketers, to put the finishing touches on their offerings. The beauty care market had become enormous. There were even products for men. In France in 1987, Paco Rabanne released the first male anti-wrinkle product, called Concentré Actif Restructurant, while Aramis (an affiliate of Estée Lauder) began to

market skin supplies for men. But for the most part, women remained the buyers. Halfway through the decade it was estimated that the cosmetics industry represented about $2 billion in annual sales in the United States. The French giant L'Oréal bought Helena Rubinstein, at a time when women were demanding more from their beauty products.

The beauty regimen extended to eating habits. Not content to just sweat it out at the gym, women discovered the virtues of balancing food types and put themselves on diets. In France, everyone was talking about chef Michel Guérard's *cuisine minceur*. *Lean* was the watchword of the day. The American food industry entered the calorie battle with diet products. Labels on fat-free products seemed to order consumers to get in shape. Slowly but surely, people began to believe that their food could be a source of beauty. Americans discovered the benefit of vitamins and nutritional supplements. Vitamin cocktails called Juvamine were already stocked in pharmacies. These products were just forerunners of what was to come.

Rosemary McGrotha. With lilac eyes and generous breasts, she appeals to both men and women.

Leslie Winner, androgynous beauty. The star model of the 1980s later turned to a music career.

To accompany their bodies of steel, ample breasts, colorful makeup, and perfectly hydrated skin, women wanted powerful fragrances. Scents of roses from Paris, created by Yves Saint Laurent in 1983, or the sophisticated touch of Coco, introduced by Chanel in 1984, wafted in their wake. But when in 1987 Clarins presented the world with l'Eau Dynamisante, a fragrance that evoked herbs, fruits, and roots, a new concept was born. For the first time, perfume had a purpose other than smelling good. This perfume could stimulate and had all the attributes of a health care product. Beauty was no longer just adornment. A new era had begun.

MARIE-PIERRE LANNELONGUE

Star Makeup Artists

With the craze for makeup and beauty tricks in the 1980s, professional makeup artists were automatically consecrated as the new beauty stars. Emerging from the shadows of the 1970s, the pros eventually became artistic directors at the major cosmetics houses. They set the company style, supervised the creation of new products, dictated the season's color palette, and defined the image in advertising. Some even produced the photography. This was the case with Serge Lutens, who went to work at Shiseido in 1980, where he established himself as a true artist, creating ultra-sophisticated images. At Dior, Tyen was the photographer–makeup artist who presided over the creative side. Trained at the Paris Opéra, he made up the queens of Dior style, from Isabelle Adjani to Emmanuel Béart. The master of colors at Lancôme was Thibault Vabre. The Austrian Heidi Morawetz arrived at Chanel in 1982, and Terry joined Saint Laurent in 1985. At Givenchy, which launched its makeup line in 1988, the department was directed by Olivier Echaudemaison. Carlos Villanova was given the reins over makeup at Helena Rubinstein in the United States. But not all top makeup artists were affiliated with a specific company. In France, Jacques Clemente earned his stripes by doing Coco Chanel's makeup at the end of her life, and made up some of the world's most beautiful women, including Isabella Rossellini and Carole Bouquet. At the end of the 1980s, the arrival of the impertinent Topolino ("the mouse" in Italian) revolutionized the closed circle of star makeup artists.

1. **Dior makeup** by Tyen.
2. **Yves Saint Laurent makeup** by Terry.
3. **Lancôme makeup** for Catherine Deneuve by Thibault Vabre.
4. **Chanel makeup** by Heidi Moravetz.
5. **Givenchy makeup** by Olivier Echaudemaison.

Beauty | The 1990s

"I wouldn't get out of bed for less than $10,000." With this famous statement, Linda Evangelista set the triumphant tone for the supermodel of her day. Beautiful, rich, and famous, Cindy Crawford, Stephanie Seymour, Tatjana Patitz, and Naomi Campbell were the goddesses of the early 1990s, with popular followings greater than any movie star had ever imagined. In his film *Top Models*, photographer Peter Lindbergh immortalized the divine creatures in glamorized sepia images, Hollywood-style. Linda Evangelista was the talk of the town with her regularly changing look: she switched between blond hair and red hair, boyish cuts and long, flowing tresses in the blink of an eye. In the press, models moved from the fashion pages to the society pages. The public were privy to the details of their personal lives.

But Kate Moss, the new runway sensation, spearheaded a reaction to the supermodel look. Less scintillating, more decadent, she was a skinny Lolita, her prepubescent body and waiflike face arousing conflicting feelings. At 98 pounds, her 5-foot, 7-inch frame upset the definition of beauty. Claudia Schiffer's very healthy, blond look had almost lost its fashion appeal, for the sticklike Kate reflected a worried, changing society. Newspapers were filled with stories about AIDS, unemployment, and crises. Moss was featured in Calvin Klein ads filled with scrawny, androgynous young girls and boys looking almost like junkies. The "heroin chic" look was in. Many considered the trend scandalous. A slew of skinny models followed in Kate's wake: Stella Tennant, Joddie Kidd, and Trish Goff. The controversy grew as slightly less skinny models paraded down the runway in "Fighting anorexia" T-shirts. Sociologists identified the look as "fin de siècle beauty."

Kate Moss. With her tiny body setting a disturbing standard of beauty, she was the heroine of the 1990s. (Ad campaign for Obsession, the Calvin Klein perfume, 1994.)

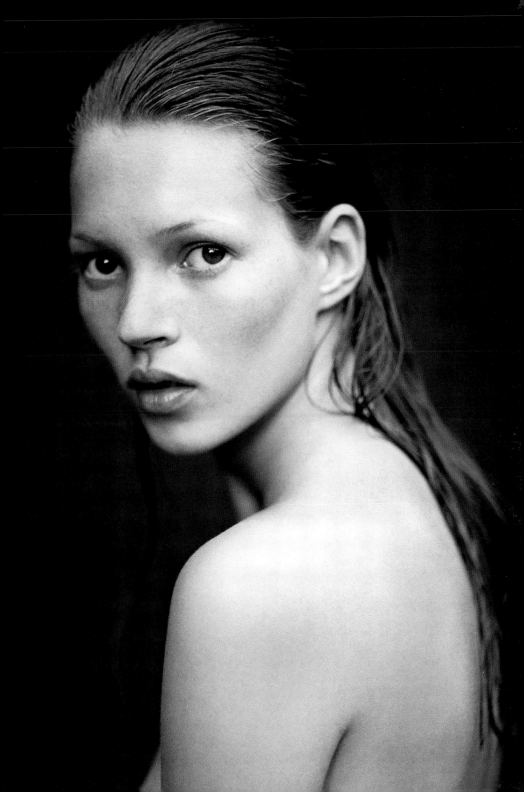

Tattoos. The skin became a territory for self-expression. Nadja Auermann photographed by Mario Testino.

Body piercing and provocative attitude: the techno generation photographed by Pamela Hanson.

Following pages: **The most beautiful women in the world by Peter Lindbergh.** (*Cronaca* series, photos created by the Beaude studio for Italian *Vogue,* January 1998.)

These wiry girls fell in perfectly with the grunge movement popular in the music world. While they did not adopt Courtney Love's smeared makeup and dirty hair, they did get tattoos, the new emblem of femininity. The more playful sported butterflies or ladybirds on the shoulder or the small of the back. In a more radical gesture, the model Eve shaved her head to better display the dragon tattoo on her skull. The style soon shifted to temporary henna tattoos on the hands and feet, skin stencils, and Indian bindis that singers like Madonna and Gwen Stefani from No Doubt glued along their eyebrows. It was playful, it was ethnic. Every brand from Estée Lauder to Agnès b. offered decals. Skin was decorated and adorned. The body became a new field for expression. In a more outrageous development, piercing came into vogue. Whether in New York, London, or Paris or on the beaches of Goa, where thousands of "ravers" went to dance, youth of the techno generation were piercing their tongues, noses, navels, and eyebrows.

Globalization was well under way. With the advent of the Internet and other developments in communications, national and cultural borders made no difference to the fashion world. Did everyone look the same? The Gap had not yet coined its slogan "the world in leather," but designers in 1996 and 1997 dreamed of a universal female. In a backlash against the excesses of the 1980s, as well as the deprived waif look, fashion and beauty turned to minimalism. The trend was to look sleek and serene: knee-length skirts, neutral colors, heavy cashmere, straight hair, and invisible makeup. Style dictated that the skin should look hydrated, the lips slightly glossed. Skin tone and clothes were beige, and faces were to appear makeup free; the nude look was in vogue. Clinique topped the charts in makeup revenues, selling 14 million bottles of foundation a year. Its best-selling product was called Balanced Make-Up, and it was an extraordinary success. In the fashion capitals of the world, Paris, New York, London, and Milan, the new heroines affected the coolness of Hitchcock's leading ladies, and Calvin Klein, Prada, and Gucci echoed the style. The blonde Gwyneth Paltrow, hair parted down the middle, popularized the bustier dress, which exposed her slender shoulders, wearing it with a pashmina shawl draped over her arms. The other blonde of the moment, Carolyn Bessette Kennedy, became an icon of nineties chic with her porcelain coloring, eyes highlighted by just a touch of mascara, matte red lips, and skillfully subdued blond hair, described by magazines as dirty blond. It took someone with the class of Ms. Bessette to make dirty blond synonymous with elegance.

Anything heavy-handed was considered passé. Only the natural look was acceptable. However, backstage at the fashion shows, the makeup artists Dick Page, Pat McGrath, Topolino, Fred Farrugia, Stéphane Marais, Tom Pecheux, Linda Cantello, and Kevyn Aucoin, and the hair stylists Orlando Pitta, Sam MacKnight, Julien d'Ys, Odile Gilbert, and Garren, spent countless hours perfecting this "barely there" look. To better understand the look, magazines sent their reporters into the dressing rooms, the new laboratories of beauty. Fashion itself was fashionable: makeup artists and hairdressers were no longer just stylists, but stars

Carolyn Bessette Kennedy attending the Warhol soirée at the Whitney Museum of American Art in New York. The icon of minimalist elegance.

themselves. Ten years after the Mac makeup line was introduced, the makeup artists François Nars and Bobbi Brown created their own cosmetic lines. Stripped-down packaging gave an ultra-professional look of maximum efficiency.

While makeup was meant to be invisible, cosmetology had rapidly advanced. In barely fifteen years, it had become a highly developed technology. Prestige companies such as Lancôme, Clinique, Estée Lauder, YSL, Chanel, Dior, and Rochas, as well as the more affordable brands such as L'Oréal Paris, all made enormous progress. Like Avène with its Ysthéal product, many companies turned to Vitamin A acid and retinol for their superior anti-aging capabilities. Following on the heels of Estée Lauder's famous Fruition, the exfoliating action of AHA fruit acids was discovered, and Clarins was the first to use a pollution-protection formulation in

1990. In 1995, researchers were able to stabilize Vitamin C in a cream, and Helena Rubinstein introduced the pioneer product Force C. The French magazine *60 Million de Consommateurs* conducted a test with shocking results, finding that consumers thought that one of the least expensive products on the market, Nivea Vitamin E cream, was also one of the most effective. These findings had little impact, and lotions continued to be marketed as intelligent products capable of treating whatever needed treatment. L'Oréal employed more than two thousand researchers to combat the effects of aging. Chanel established Ceries, the Center for Sensory and Epidermal Research and Studies. People were learning that beauty reflects human psychology and that attention must be given to the inner as well as the external self, that well-being is as important as appearance.

As a sign of the times, aerobics gave way to yoga, and jogging was replaced by shiatsu massage and reflexology. Following the lead of Clarins and Aveda, a newcomer to the beauty industry, lotions were enriched with plants and flowers. Through aromatherapy, women discovered the merits of essential oils that aided sleep, relaxation, and the fight against stress. In other words, they improved life. Make peace with your body, discover harmony, sublimate yourself rather than transform yourself: beauty converted to a Zen philosophy. People expressed themselves differently.

Ten years after it was introduced, l'Eau Dynamisante sold ten million bottles around the world. In 1997 and 1999, Shiseido made a big hit with its *eau de soin*, Relaxing Fragrance, in an aqua green flacon; it was followed by Energizing Fragrance, housed in an earth-toned bottle. Water-based products were suddenly all the rage. The aquatic vogue continued, and sprays made a big splash. In 1997, Avène sold 4 million sprays, over half of them in Japan. The ultra-chic Paris boutique Colette opened a water bar. Mineral waters became associated with beauty through such bottlers as Contrex with its "slimming contract" and Evian with its blush pink packaging. Men and women thronged the luxurious but ascetic-looking spas for body-care treatments, massages, and relaxation sessions. In 1999, this country boasted six hundred such spas,

Shalom Harlow made up by Kevyn Aucoin. The "no makeup look" often required great effort.

compared with only thirty at the beginning of the decade. Many major hotels opened their own spas, while people looked forward to the arrival of Bliss, the institute where Demi Moore, Julia Roberts, and the top model Amber Valetta go to enjoy ginger massage treatments. It was a sign of the times when LVMH, the largest luxury company in the world, bought Bliss.

With New Yorkers topping the list, Americans take their bodies very seriously. Many have their own coaches and relentlessly practice Pilates, the latest exercise discipline. Madonna had her baby with her personal trainer, Carlos. Although the United States is the newest El Dorado of beauty, the French began their conquest of New York in the 1990s: leading the influx from France are the makeup artist François Nars, whose career was launched by Polly Mellen at *Allure* and who has now introduced his own line; Frédéric Fekkai, whose salon attracts the most elegant women in Manhattan; the makeup artist Laura Mercier, who also introduced her own makeup line; and the Chantecaille family, whose cosmetics are a "must" at the latest chic store Jeffrey's in the meatpacking district. Meanwhile, in Europe, anything from the United States is in demand: Maybelline mascara, Clinique's eau de toilette Happy, and the very expensive Re-nutritiv from Estée Lauder. Beauty victims and the cosmetics maniacs have been converted to Kiehl's or Philosophy, the leading line of "mental beauty" products

Top Model. A phenomenon of the 1990s, top models had their own magazine. Christy Turlington photographed by Gilles Bensimon.

featuring Hope and Prayer anti-wrinkle cream and It's All in Your Head shampoo. These products are sold in select stores such as Colette in Paris and Space NK in London, or they are brought back from New York or ordered on Internet sites such as gloss.com and beauty.com. Consumers spend hours shopping at the French Séphora, which, after opening in Paris and Barcelona, conquered the Big Apple with its flagship 9,350-square-foot space at Rockefeller Center.

Chic but intimidating cosmetics stores have fallen out of vogue. At Séphora, which bills itself as a self-service beauty store, you can test anything, trying out

La Casta. Apricot shades and full lips, the natural look again.

the craziest mixtures making it fun to shop there. This comes as no surprise; as the century draws to an end, any attempt to dictate fashion is scorned. It seems that anything goes. Men are no longer afraid to take care of themselves. The sale of cosmetics for men has taken off. Salons such as Nickel in Paris, solely for men, are reasonably successful, and more men have turned to cosmetic surgery. Anything goes. Girls seem as comfortable in their Nikes as in their Manolo Blahnik high heels. They know the dangers of the sun by heart but continue to sport a tan, whether real or fake. At the same time, whitening or depigmenting creams such as Blanc expert from Lancôme or Linge Blanc Absolut from Yves Saint Laurent, which create the porcelain complexion of a Chinese doll, are winning converts. While Gwyneth Paltrow, Cameron Diaz, and

Kate Moss became brunettes, magazines continue to glorify the brushed blond look of Farah Fawcett, which Orlando Pitta proclaimed the style of the century. In nail salons, Chanel's best-seller Rouge Noir continues to be popular, but pom-pom pink, transparent beige, gold, and silver gilt are in high demand.

At a time when beauty products abound on the Internet and new ones are introduced on a worldwide scale, women have rediscovered the charm of old-fashioned products, retro packaging, and little-known brands of perfume. The boutiques of Nolita in New York, hip department stores in major cities, and chic cosmetics shops are stocked with Acqua di Parma, Elizabeth Taylor's favorite eau de cologne from the 1950s, Creed, a line created in Paris at the end of the nineteenth century that Donatella Versace is crazy about, Kiehl's lotions, produced by a pharmacy that has been established on Third Avenue since 1851, and Le Clerc powder, which has been around since 1881. Many other traditional products are still popular, including Patou's Joy perfume, Crème de la Mer, developed by NASA in 1965 and relaunched in 1996 by Estée Lauder, or even the very affordable Bourjois cosmetics created in 1883.

From Paris's Palais-Royal gardens, Serge Lutens created successful haute couture perfumes such as Iris Silver Mist and Ambre Sultane, based on scents that had been mostly forgotten. In the Vivienne gallery, Terry, the makeup designer at Saint Laurent, opened By Terry, a salon where makeup is custom blended. Beauty is priceless. Uniqueness sells well.

Hair extensions creating great manes of hair have become all the rage. Every shade of hair color has appeared, thanks in part to the introduction of Féria, the leading L'Oréal product. Women have gotten used to all kinds of hair dyes, after witnessing Sybil Buck's bright red head, the Parisian hairdresser Massato's turquoise tips, and Dior's mascara for hair. Beauty has taken over new ground. With the advent of new fibers, so-called intelligent fabrics have made textiles almost like cosmetics. Stockings can moisturize and lingerie can be perfumed with microcapsules of essential oils.

The mixed ethnic beauty of Devon, done by Topolino and photographed by Éric Traoré for *Vogue* France.

Lara Croft. With new beauty websites, are virtual beauty icons next?

Javier Vallhonrat expresses his futuristic vision of beauty. Makeup by Fred Farrugia, hair by Aldo Coppola (1999, L'Oréal Corporate).

Previous pages: **Extremes** photographed by Wolfgang Ludes. In contrast to the natural look, the 1990s upset all the taboos, finding inspiration in magazines and fashion shows.

While lips and breasts have deflated somewhat, stars have begun to acknowledge their cosmetic lifts and collagen injections more freely. Peeling, surface smoothing, and touch therapy have become almost regular beauty treatments. Social philosophers have focused on the phenomenon, calling it the "right to be young." Doctors claim that their patients simply want to look the same age they feel. This leaves us wondering if the third millennium will be the age of eternal youth.

MARIE-PIERRE LANNELONGUE

The New Beauty Queens

Having reigned over the world of fashion in the 1980s, top models turned to the movies. Cindy Crawford, Claudia Schiffer, Kate Moss, Shalom Harlow, and Carolyn Murphy appeared on screen. At the same time, prestigious cosmetics companies sought actresses to be their representatives. When Yves Saint Laurent introduced his Prélude à la beauté body-care line in 1993, he naturally turned to Catherine Deneuve. When Isabella Rossellini's contract with Lancôme expired, the company had many faces to choose from, including the actresses Cristiana Réali, Juliette Binoche, Marie Gillain, and the top French comedienne, Inès Sastre. The actress Elizabeth Hurley is the face of Estée Lauder. L'Oréal includes a number of screen stars in its dream team, including Dayle Haddon, Andie MacDowell, Nastassja Kinski, Milla Jovovich, Jennifer Aniston, Heather Locklear, Jennifer Lopez, the young French actress Virginie Ledoyen, and Gong Li, whose face is meant to seduce the millions of Chinese who have begun to discover the virtues of lipstick and pressed powder. The social analysts declare an end to the reign of top models. Actresses have won out because they are more closely identified with other women. In short, they are more "normal."

For Lancôme:
1. Isabella Rossellini. 2. Inès Sastre. 3. Marie Gillain.
5. Cristiana Reali.
For L'Oréal:
4. Claudia Schiffer. 6. Milla Jovovich. 7. Heather Locklear.

4

5

7

6

Beauty

Ethnic

Beauty | Oriental

At the beginning of the century, anthropological photographs some-
times appear with colonial settings—young shepherdesses, draped in
rough fabrics, exposing their budding breasts and thin waists as they
support the weight of an earthenware jar in their frail arms and gaze out
from eyes heavily rimmed with kohl. These portrayals were succeeded
by orientalist paintings usually depicting women as languid, naked, and
captive.

But, as Islam has spread, the sacred rituals of the East have become
much more elaborate than these fantasies. According to Islam, a woman
is associated with paradise, and the body with divine essence. Spirituality
and daily purification rites go hand in hand ("good hygiene is part of
faith," says the Prophet). Hammams and steam baths spread from Fez
to Constantinople and along the Silk Route. In the tenth century,
Cordoba had more than five thousand, and Baghdad almost twenty-
seven thousand. It was in these places that travelers discovered the
enchantment of marble basins, crystal pillars, and perforated incense
holders. Descending from the Roman thermal baths, the baths in the
Muslim countries developed their own features: three successively hotter
areas, domed roofs, and a resting room. Ottoman palaces of the nine-
teenth century sometimes contained a single marble covered room. In
the soft light, young boys are offered a glimpse of all that women have
to offer. These female visions have allowed them to develop a love for
the body unrestrained by Western standards. Their dreams are filled with
one thousand and one women glimpsed through the vapors, their bod-
ies revealed through their *sefsari*, the veil wrapped around their skin, like

Hair ornamentation.
Silver jewels signal
the wealth of the
young girl. Eyelids
are outlined with
harqus (makeup
made from nut galls,
barley, and ashes),
eyes rimmed with
kohl.

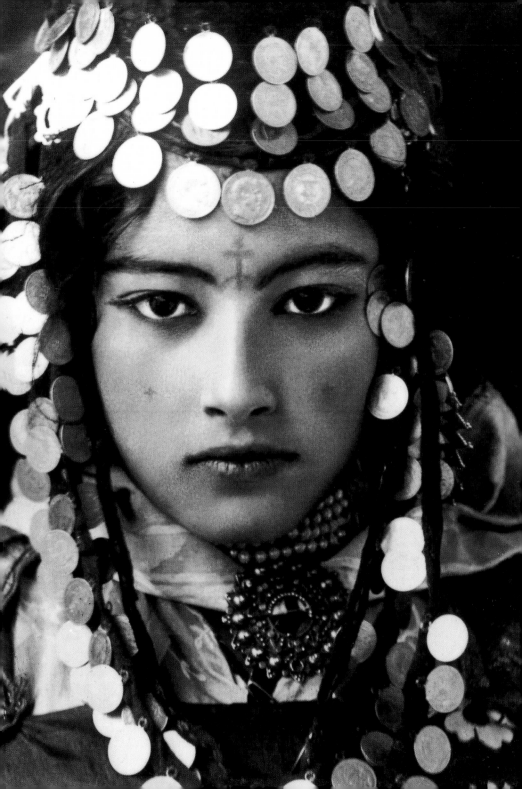

the nudes from the tales of Scheherazade, and their skin slathered in pomegranates, tiny waists, and bottoms "so large the owner must sit down again after she stands up and stand up again after she sits down." The selection also includes slender, lean, smooth, withered, swollen, and nimble bodies, not only of young girls, but also pregnant women, mothers, and old ladies. Young boys see the feminine body in every stage of the life cycle. Whether a nourishing mother or a prepubescent girl, whether pregnant or tired, the women are always learning or perfecting their ablutions. Women arrive at the baths, in their fluttering caftans, their scarves covering their heads, coated with henna masks. First they enter the relaxation room, where they undress amid much chatter. The richest and most traditional wear a cotton muslin veil, *izar*, or *sefsari*, wrapped around the body pareo-style to cover their breasts, and *qabqâb*, high clogs made of rosewood, ebony, or sandalwood and inlaid with mother-of-pearl, tortoiseshell, or silver studs to protect their feet from the heat of the marble and prevent slipping. Today, while thongs and plastic buckets usually replace the cedar wood or ebony *qabqâb*, the mannerisms and sounds remain the same. Naked or barely veiled, the women evaporate quickly into the misty depths of water that shoot out from large tubs or stream along the marble, amid the suffocating steam. Silhouettes of translucent contours, bodies gleaming with sweat. Next they are coated with black soap to dissolve the excretions from the skin's pores or covered with a layer of olive oil, egg white, and white henna for a bronzed look. Finally they are delivered to the *harzâ,* a woman who rubs the skin, scrubs it down, and then massages the body with a glove called a *kassa* that is made of abrasive wool or black crepe de chine, or a *mhakka*, a roller made from palm tree wood that is covered with a thick cotton cloth. The repetitive massaging action creates a layer of blackish grime that the women at first view with surprise but later with jubilation. In Iraq, seven days before her baby is due, the expectant mother is taken to the ritual hammam bath. Her mother coats her (except her breasts) with a special mixture of clay, thyme, mint, and

Bronzed lips. Fruity mouth. Voice from the delightful tale of Scheherazade in *Oum Kalthoum*. Photograph by Albert Watson, 1998.

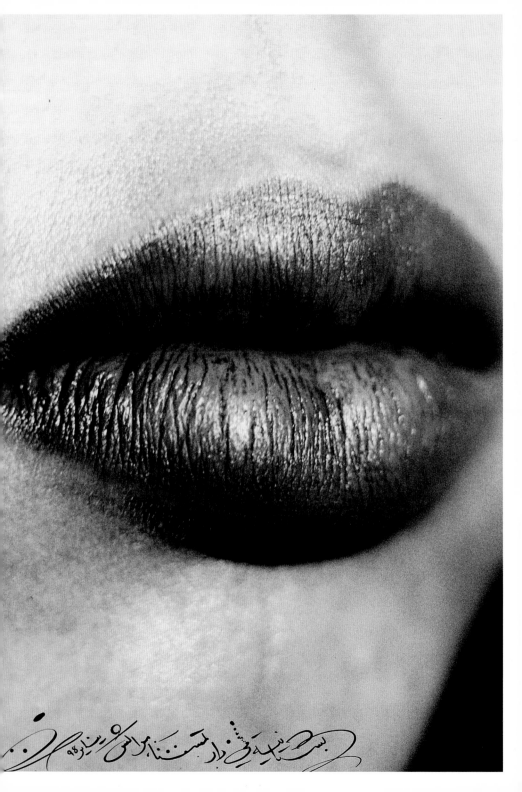

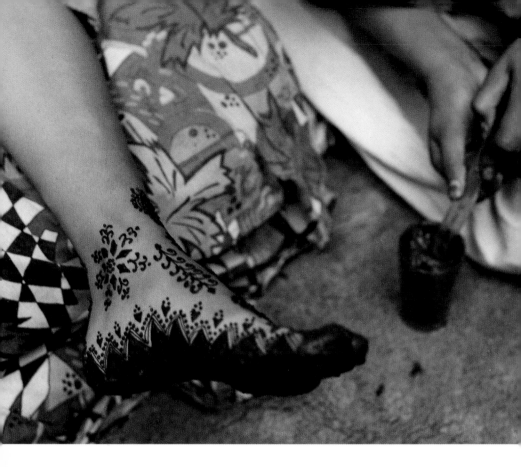

Henna ritual.
Seduction rituals for weddings where coquetry and talismanic motifs intermingle (1993).

two eggs, rubbing them vigorously on her body. The body and hair are then rinsed off and covered with a henna mask. After being rinsed with a *tassa*, a copper or silver cup (it can be iron or even plastic), full of warm water, the body takes on a glow. Next comes a lathering in *rassoul*, a soapy, lithium-derived clay found only in the Missoui region of Morocco. It acts as a detergent and removes any grease left on the body. Each woman has her secret ingredients for the *rassoul* and gathers lavender, cloves, carnations, rosebuds, pomegranate rind, citronella, cinnamon, wild grapes, and myrtle, which she filters and adds to the *rassoul*. The result is an exceptional paste that beautifies the hair and closes the pores of the skin. Returning to the resting room in the hammam, the relaxed beauties endure a strong swipe of wax or a mixture of sugar (or caramel) and lemon to remove their body hair. Finally, an invigorating mask of

white henna and rose water is placed on their faces for thirty minutes.

In southeastern Morocco the landscapes of places like Nourela and Er Rachidia are rugged and austere. Water there is scarce, though violent floods can occur. The oppressive heat of the day and coolness of the night induces the tri-annual flowering of the *Lawsonia inermis*, or henna tree. These trees are in great demand by the *hannaya*, the henna planters, who harvest the flower at the end of May or beginning of June, when its coloring power is at a peak. The henna flower is intoxicating, its perfume evokes jasmine, tea rose, and reseda. After the stems are cut, the henna is dried and the leaves are separated and wrapped in large jute sacks. They are sent to Marrakech, the largest storage center for medicinal plants in Morocco. The city is dry, and its climate perfect for storing plants. Thus it is not surprising that Marrakech is the traditional training center for practitioners of botanical medicine. In each family, these women explain how to use henna to care for the body, specifying the dosages required for healing, protecting, and enhancing beauty. Once the leaves have been ground into powder with a mortar, they know exactly how to prepare the henna. It is blended with clove, harmel, and dried rosebuds. Lemon is added as a perfume and antiseptic. Alternatively, cloves, myrtle, grilled oak apple, and henna leaves are crushed together and mixed with a decoction of pomegranate rind to produce a natural hair dye. Henna is also produced in Egypt, the best in Alexandria. The Zemmour Berbers offer henna as a wedding present. The henna night is a shared ritual. Once the young bride is rubbed down, washed, waxed, and prepared, she is ready for the henna treatment. The ladies of the family enthusiastically surround her, offering her mint tea amid glimmering candles. A beautiful green henna of the best quality (the deep green found on Persian miniatures) is set on a tray along with hot water, lemon, garlic, pepper, and sugar, together with eggs, a symbol of fertility. The modern-day *hannaya* paints the hands, the feet, and the ankles, using variously sized syringes to draw stylized flowers, arabesques recalling Arab calligraphy, or geometric forms embellished with good luck signs, based on her own inspiration and

motifs chosen by the bride. The finger- and toenails are often stained with henna as an added adornment. Then the *hannaya* dabs the henna with a cloth soaked in lemon, garlic, pepper, and sugar to avoid cracking. The feet and hands are wrapped in cotton and cloth to prevent the paste from falling off. The bride must keep the henna on for three, six, or twelve hours depending on whether she wants an orange or darker brown color. Black tones are obtained by first mixing the henna with oak apple (*takkaout*) or walnut stain. These mixtures can be used on the skin or to color hair. The henna paste is removed with olive oil, which softens the skin and accentuates the drawings. Ideally, the stain will last for two to three weeks. The young generation in Morocco today views the henna as a new way of keeping traditions while imitating the tattoo craze popular in Europe.

The teeth, celebrated metaphorically in *Thousand and One Nights* as two rows of pearl necklaces, are traditionally washed with *siwak*, the bark from walnut tree roots, which cleanses the mouth, prevents bad breath, gives a luster to the gums and the lips, and highlights the whiteness of the teeth. Red *akar*, derived from a tinctorial plant, is applied to the lips.

Wedding in Tangiers, 1989. Contemporary and sophisticated, this young bride submits to the adornment rituals for her wedding. Jewels are often rented for the ceremony from women who specialize in accoutrements and preparations for marriages.

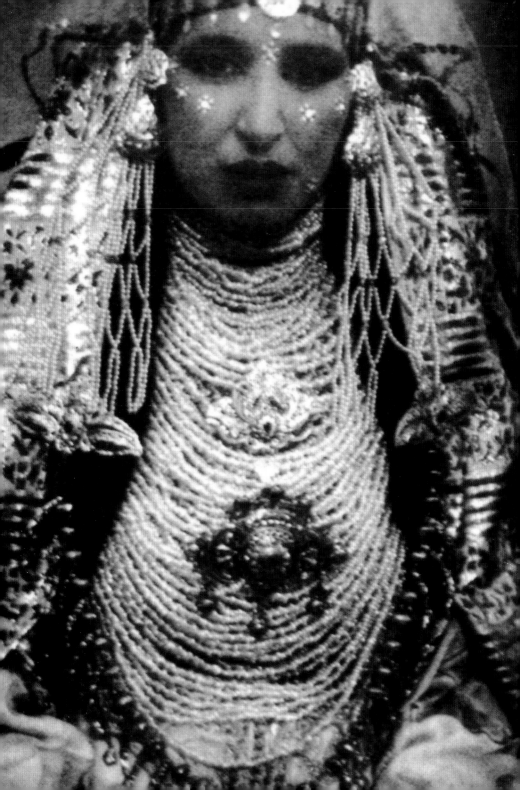

Top model Farida.
Azzedine Alaïa's
Eastern muse in the
1980s, Farida made
young North African
girls born in France
proud of their Arab
beauty. Photograph
by Peter Knapp.

The high point comes with the application of kohl makeup that
accentuates the eyes and overwhelms travelers to the East who see
nothing but a woman's veil and her expression. It is made from antimo-
ny, a metallic mineral found in Arabia and prepared by old women called
azouza. Each has her own secrets; some use date or olive pits, others
use iron sulfide. Over hot embers they heat a small piece of antimony
wrapped in a blue cloth, preferably soaked in olive oil, until an ash is
formed. The ash is then crushed with two cloves, several grains of
melegueta pepper, and a spot of musk. The mixture is sifted several
times through a sieve until it is as fine as talcum powder. It is stored in a
flask. In Algeria, dried and crushed jasmine is added, a blend that is
highly recommended for blondes. The young ladies of Imilchil in south-
ern Morocco, who come to look for a husband once a year in
September, make themselves up with an olive oil–diluted saffron paste,
which they paint in deep red circles on their cheeks. Argan oil is another

beneficial product from southern Morocco that is wonderful for nourishing and preserving the skin, rich in elements that activate cellular renewal. Oriental beauty is composed of a whole traditional pharmacopeia!

To round out the array of beauty offerings, the East boasts extraordinary resources for perfumes. Some flourish in the natural environment of the Maghreb, such as the orange blossom and the rose, which are transformed into refreshing sprays used in homes or at the hammam. Others are cultivated, such as *nard*, Indian cinnamon, Arabic incense and myrrh , musk, aloes, dill, arum lily, lotus flower, aromatic herbs, and gum resin. "All of Arabia exudes a divinely sweet odor," wrote Herodotus. Its riches intensify the flavor of the food, connect men to the gods, and perfume the linens of Ottoman princesses as well as the wives of Bedouin chiefs who gather aloe wood, gum arabic, ambergris, and white musk in their perfume burners.

In perfume burners, the incense burns slowly. The women of the East stand above the burners, pulling their clothes down over the smoke as it rises. They allow the smoke to rise until it reaches their lover, the secret of their foreplay. He is seduced by the perfumed rings from ambergris paste, a musk derived from the secretion of sperm whales mixed with rose water, while the Berber wives are exalted by necklaces of cloves.

Beauty |

Black

Several developments affected the perception of African beauty over the twentieth century. The Western world's impression of Africans and African Americans changed. Beauty rituals among ancestral tribes from the banks of the Senegal river to the desert of Namibia evolved. And new forms of African beauty were expressed in the city streets.

Paris, 1906. The natural beauty of Africa is recognized at the Universal Exposition. The same year, Matisse, Derain, and Picasso became impassioned with African sculpture. In 1925, the Revue Nègre exploded in a theater on the Champs-Élysées, and Paris fell in love with Josephine Baker. While Paul Poiret embellished her mixed-race skin with a siren's dress in silver lamé, and George Hoyningen-Huene immortalized her nudity, Baker sang, "I want to be white. How happy I would be if I could change the color of my breasts and my hips." She covered her body in lemon juice to lighten her skin. It was not until the 1960s that the phrase "black is beautiful" awakened awareness. In 1966, Paco Rabanne featured black models on the runway. Black pride emerged. In April 1967, the Black Panther Party was formed. Martin Luther King was assassinated one year later. Spearheading an anti-segregation and anti-sexist movement, Angela Davis made the Afro hairstyle extremely fashionable. Frizzy hair, grown naturally to acquire a bushy appearance, became one of the symbols of liberation. Black and mixed-race models became popular, inspiring fashion designers such as Yves Saint Laurent. They arrived in Paris from all over the world: Donyale Luna from Brazil, Katoucha from Senegal, Pat Cleveland and Naomi Sims from the United States, Mounia from the Antilles, Esther Kamatari from Burundi, and

Body painting in Ivory Coast for an initiation ceremony. On the continent, certain body painting rituals with chalk are used for adolescent girls who have undergone excision.

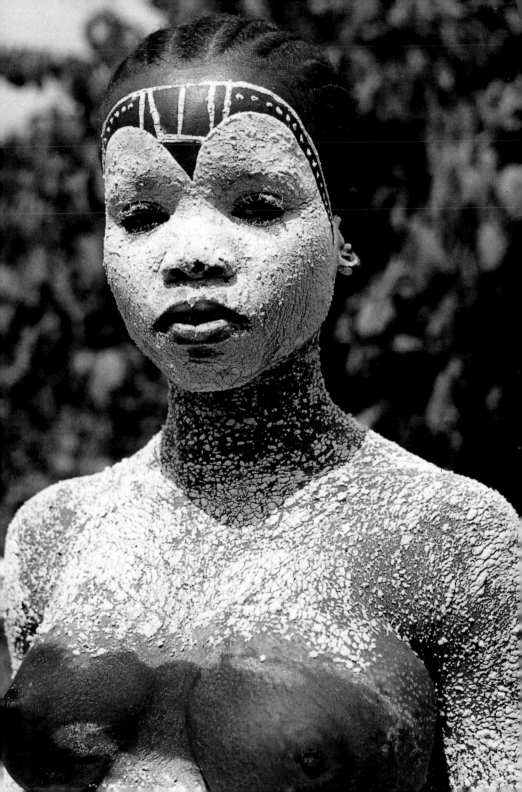

Iman from Somalia. Grace Jones became the emblem of the 1980s, while the last decade of the century witnessed the arrival on the scene of Naomi Campbell, Waris, Khadidja, Veronica Webb, and Roshumba. Anna Getaneh of Ethiopia and Alek Wek of Sudan were also consecrated beauty queens. After Naomi Campbell and Grace Jones, Alek Wek was the next phenomenon. Her cropped hair, free of any complicated braids, her baby face, her bluish-black skin that amazed even Africans, and her ideal features evoked images of pure and original beauty at a time when scientists had just discovered Lucy, the first female human. Alek's beauty is poles apart from the sophistication of Janet Jackson and the female singers on today's rap music videos. Over the last thirty years, African Americans have gained their rightful place on American screens and in the media. Since the 1980s, the filmmaker Spike Lee has played an important part in asserting this role.

The body and the hair are the raw materials of African statues. They reveal that beauty is not only intimately linked with seduction but also with the expression of social status and relations with the invisible, mystical world. A number of rituals that seem to be demonstrations of beauty are actually part of youth initiation and sacred rites.

Beauty customs change in Africa from west to east. The continent is not united as one entity. Though in *L'Afrique fantôme*, Michel Leiris's account of his voyage to Africa, he recounts how the naked people that he saw were distinctive for their consistently "upright bearing."

The practice known as body painting in the Western world finds its most beautiful expression in East Africa. In Sudan, the Nuba warriors cover their bodies with an ash and ocher glaze. On the Ethiopian border and on the frontiers of Sudan and Kenya, several Surma, Bumi, and Karo tribes share the body painting tradition. Both men and women use chalk mixed with water to draw geometric motifs. The Karo women paint motifs on their faces to complement their ocher-covered bodies. The passion for ocher crosses to the southwest of the continent, in

Josephine Baker, the Black Venus. Paris worshipped her in the Revue Nègre, and the rest of Europe soon followed. The United States did not recognize her as a star until her appearance in the Ziegfeld Follies in 1936. Pictured here in Berlin in the 1920s.

Black girl, 1930s.
Lacquered pin curls and Chinese doll makeup—the exotic look copied from Western fashions before black was recognized as beautiful.

Namibia, among the Himba tribes of Kaokoland. Living in harmony with their troops, the Himba attach great importance to beauty and spend a great deal of time perfecting the ocher that covers the body and hair. In the Indian Ocean, in Madagascar, Mayotte, and the Comoros, face painting is a beauty ritual. Masks of sandalwood and yellow turmeric are intended to protect the skin from the sun and to smooth the complexion.

European fans of body piercing could never rival the Sara tribes of Chad or the Surmas in Ethiopia, where girls' lips are pierced in childhood. Successively larger pieces of wood are placed in the hole until the girls reach the age of marriage. By that time the labrets or ornamental plates have deformed their mouths. Sometimes, a double labret is used. The "negresses with plates" described by colonials may have actually been girls that had been transformed to avoid being kidnapped during raids. While the foreigners were terrified by this practice, to the tribes the labrets are an ornament of beauty.

The Peul of Mali pierce their ears, adorning them with small silver hoops that cover the entire earlobe or immense gold earrings, open displays of seduction and riches.

Body scars. Scarification signifies wealth, beauty, tribal affiliation, and courage.

Shaved hair, a symbol of initiation or rite of passage into a new stage of life. Pictured here in Benin, Porto Novo.

Another form of body art is scarification, which results from bloody scars caused by a blade, knife, flint, quill, or fish bone. From Nigeria to Sudan, from Burkina Faso to the Congo, the scars take on different forms, including deep slashes along the lines of the face culminating in swollen tips that echo motifs on certain parts of the body. Scarification shared by both sexes may signify tribal affiliation as well as bodily beauty. In illiterate societies that do not record exact birth dates, age is indicated by the evolution of the body, from prepubescence to puberty. Ceremonies that initiate youths into the adult world include scarification sessions.

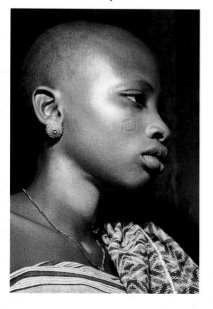

Beneath the naivete presumed by Western colonialists, Africa has its myths and its legendary beauty figures.

Among the cult deities of the Nigerian Orishas, Oxum is the goddess of seduction and elegance, beauty and charm. Her dance is sensual, an invitation to love. In Angola in the sixteenth century, Queen Nzinga appeared as a goddess who was perfumed with precious oil.

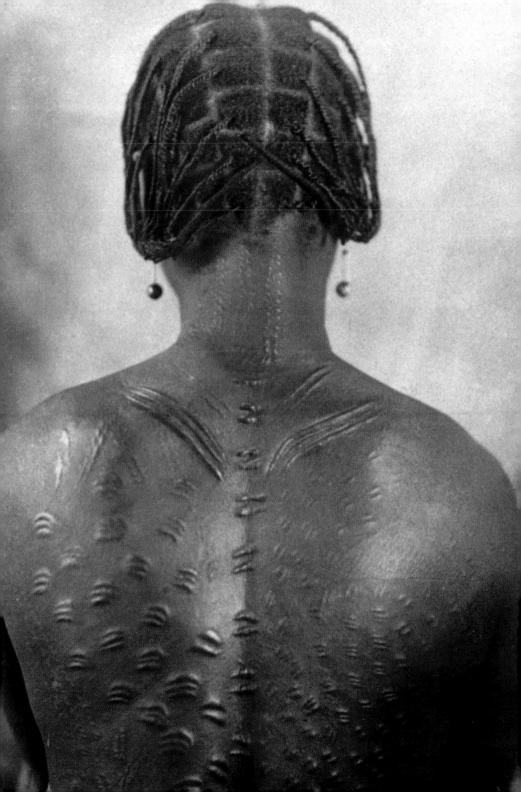

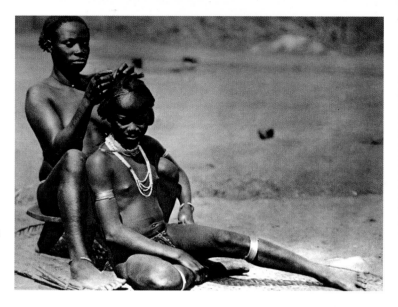

Braids, an art practiced all over the continent. Fine braids can require a full day's work by several braiders. This is a luxury today. Pictured here, a chief's daughter's hair is braided by her servant.

Black beauty rituals have always inspired the world, as proven by this photograph that was owned by Helena Rubinstein. She brought back beauty recipes from her travels.

Coquettish practices have always been common in tribal Africa. In Zaire, the Mangbetu file their upper middle incisors to form a dark triangle that heightens the smile. They also wrap babies' heads tightly to elongate their faces. Young girls braid their hair in fine strands, which they pin up in high buns topped with a small, rigid crown. This look appeared in the fall–winter 1996–97 Jean-Paul Gaultier collection that featured exclusively black models.

The West has taken a fascinated interest in the men of Niger. To celebrate the end of the rainy season in September every year, the male nomadic Peul shepherds, the Wodaabe, paint and adorn themselves. They dance for the young girls who choose the most beautiful dancers among them as their mates for the next season. Paying no heed to the sticky heat, they make up their faces with a pura paste, drawing a yellow line down the center. Their lips are painted black, their eyes rimmed with kohl, and rows of white spots are placed above their eyebrows. They coat their hair in butter, separating it into thick braids. They often shave the top of their head to make their foreheads appear bigger and to draw attention to their jewels and white turbans wrapped with fabric. Their feminine grace, fine features, and twinkling eyes are provocative.

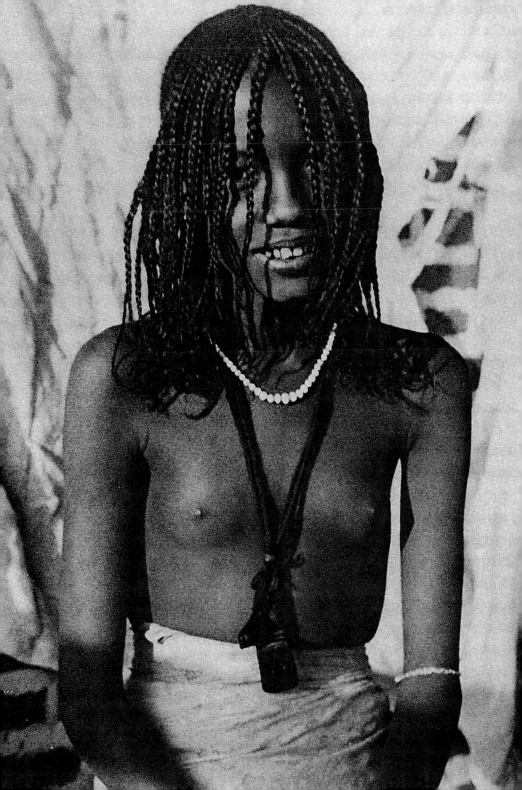

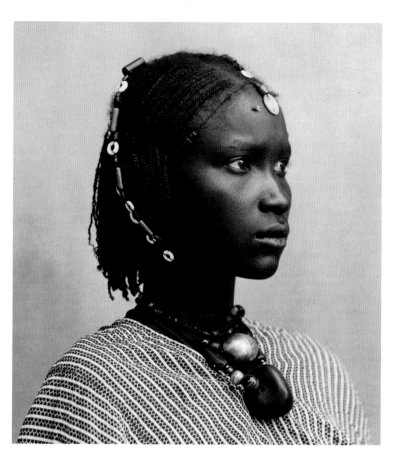

Ornamentation, a source of inspiration (here, a Lahobe woman in Senegal, circa 1900) for today's African couturiers from Alphadi to Oumou Sy.

During this celebration, which is called Geerewol, the men dance the *yakey* and roll their eyes in exaggerated expressions that accentuate their makeup.

Along the borders of central African countries and in the south among some pastoral societies, such as Burundi before the civil war that has plagued the country since 1993, certain natural attributes are considered signs of beauty. A beautiful woman is tall and thin, without being scrawny (she needs to be strong to work in the fields). Her silhouette is likened to the sky descending to earth. She is complemented for her "cow" eyes—an expression of innocence—her gleaming white corneas, the spaces between her teeth, and her purity comparable to clear water. She is appreciated for her simplicity and her rounded fore-

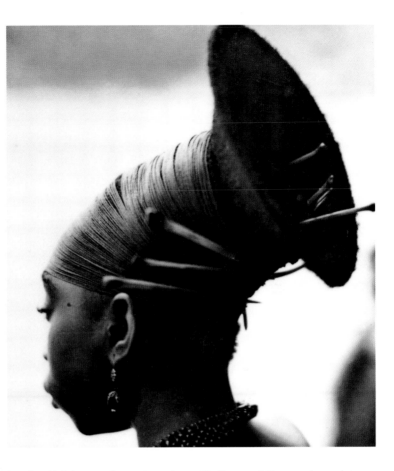

Mangbetu woman. In the very refined court of this kingdom in northeastern Zaire, discovered in the nineteenth century, heads were elongated and hair was adorned with hairpins of bone.

head, which is sometimes shaved as with the royal Ganwa clan, who wore a band of pearls around their shaved heads in the early twentieth century. To perfume her *invutano* (a traditional garment composed of a wraparound skirt and a second cloth draped toga-style over the shoulder) she burns fragrant wood called *umubavu* and to seduce she softens her skin with strong-smelling cow butter, which she mixes with *intake*, a flavored dried fruit that is ground into powder. *Agahama*, a type of ocher, is also added. With her hair pinned up, strands of pearls tinkling under her skirt, and the air perfumed with the sweet smell of freshly cut herbs and cow butter, which coats the sleeping mat that is placed atop the perfumed herbs, she invites lovemaking.

In Senegal, beauty and seduction are intimately associated. Pear-shaped breasts, willowy waists, and plump buttocks are celebrated. Skinny girls pad their skirts to make their behinds appear larger when walking along the streets of Saint-Louis. In Mauritania in 1972, on the site of Kumbi Saleh, archeologists discovered a female statue that was endowed with enormous buttocks, dating from somewhere between the eighth and tenth centuries. However, in Dakar today, the generation gap has blurred the standards of beauty to accommodate different age groups. While a slim young girl of sixteen—nicknamed "disquette"—may be an object of desire and will go out with her midriff exposed (*djambar* out), larger women called *diongoma* are still respected and appreciated. They also have their beauty contests where measurements (44–36–56 in.) are highly praised. The same applies in the Ivory Coast, where these women are called *awoulaba*. In fact, from Marrakech to Mauritania, the traditional medicine market sells preparations for fattening up girls of marrying age. While the ideal of the thin Western model has spread to urban societies, the *diongoma* still has her place. Whether a young disquette or a mature *dirianké*, the Senegalese women bewitch their men with *diali-diali*, belts of pearls worn under their hemstitched transparent skirts, intended for nights of lovemaking called *bethio*. To reinforce the aphrodisiac effects created by the rhythm of the pearls, the women store them in pots of *thiouraye*, or incense, that, according to each family's secret recipe, is a blend of aromatic resins from Yemen, sandalwood, and Western perfumes, reconstituted in Indian dispensaries or purchased in Parisian parfumeries. Thus a woman may smell of Versace or Dior's J'adore, altered to her whim. *Thiouraye* mixtures are also burned over a charcoal pan to emit an aromatic smoke. As in the East, women use perfume to arouse sensation. To soften their skin, they apply shea butter like their sisters in Mali and Burkina Faso. The shea butter is derived from a tree commonly called the "butter tree," which bears seeds that contain a greasy, edible substance. It is also used in Abidjan in the Ivory Coast, where it is mixed with coconut oil and called *karicoco*. Shea butter conditions the hair too.

Tiara of braids, Naomi Campbell. Interpretation of a popular style in Burkina Faso, the braids come to a point. Here, the top model, who was discovered in the 1980s, plays with this look for Paolo Roversi.

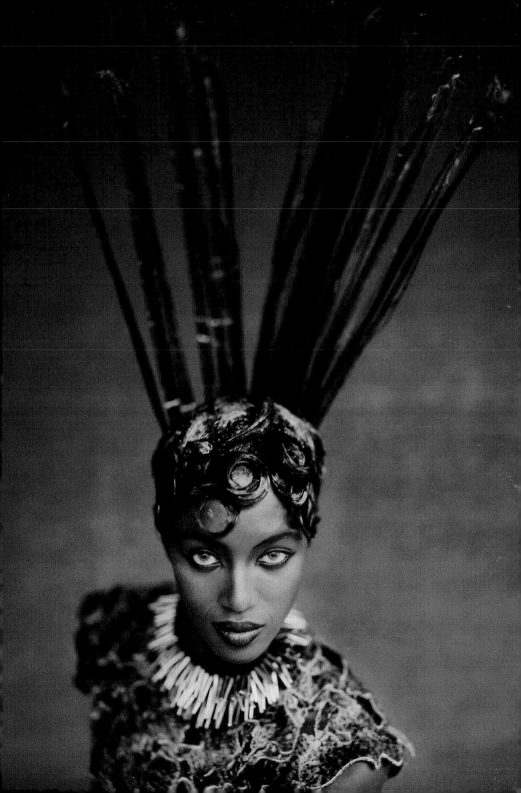

A number of semi-industrial products have found their way into salons in the African capitals. In modernized areas, as in the rural communities, a woman's hair is the focal point where she can best express her artistic talent. It is the part of her body that changes most with fashion. The historian Youssouf Tata Cissé talks about Bamako in the 1950s in a book on Seydou Keita, who photographed women at that time. They wore their braids up in styles called *portemanteau* (hall stand) or *cravache* (riding whip) or very extended with wool yarn in a style called Versailles, in an allusion to the luxury cabs that used to tour Bamako. Whether lacquered, plated, notched, braided, or ornamented with plaited or curled hairpieces, African women's hair is an alluring adornment. For a special occasion or a trip, a woman will go to a hair braider or have the braider come to her home. This process can keep several women busy all day. They tightly tie her hair into fine braids. In Burkina Faso, instead of braiding hair, it is separated into locks that are covered with a piece of black wire and worn in an intricate style. The actress Bo Derek made the finely braided look popular among whites in the 1970s. With the rasta movement, pale scalps were revealed as thin braids became a sign of a new association with an imaginative continent.

Perhaps following Michael Jackson's example, skin lightening became popular in the 1980s. The fad spread to Western Africa, where people used hazardous and destructive recipes to whiten their skin. Acids, detergents, cocktails based on Javel water, and photo developing fluid wreaked havoc from Dakar—where they were called *rhassel*—to Kinshasa, where they caused the skin to yellow. While the pages of a woman's magazine such as *Amina* are still filled with whitening products, the pride in black skin today should stifle this phenomenon.

Samburu braids. Adaptation of the Sambura warrior hairstyle from Kenya, north of Maasai country, used for John Galliano's Maasai-inspired pearl collection for Christian Dior Haute Couture in 1997. Photograph by Peter Lindbergh.

Following pages: **Africa-Asia.** Alek Wek, top model, and Karen Park Goude, stylist, as seen by François Nars, symbolizing two types of Western beauty for the twenty-first century.

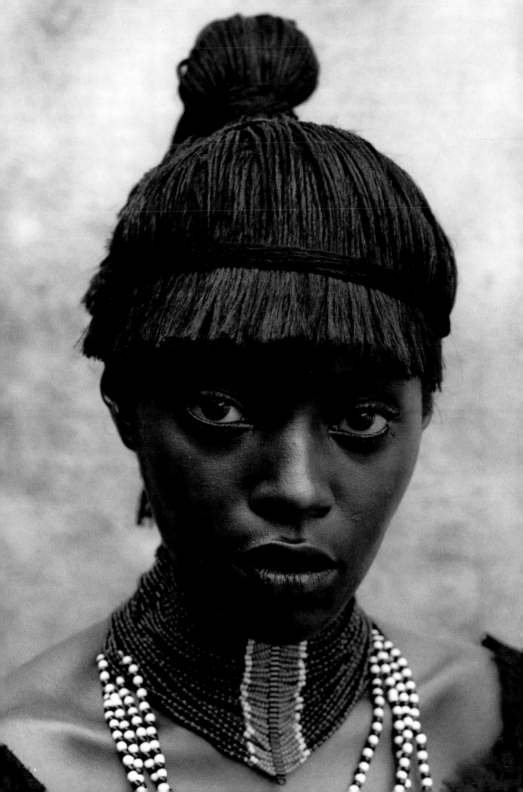

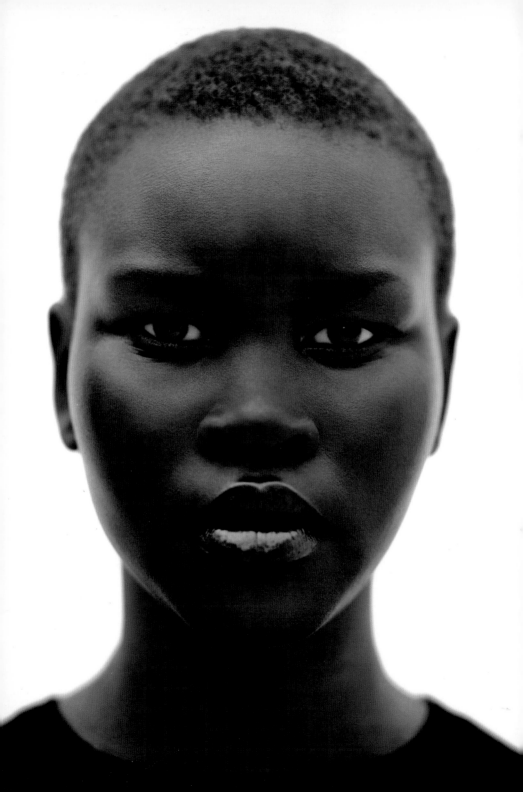

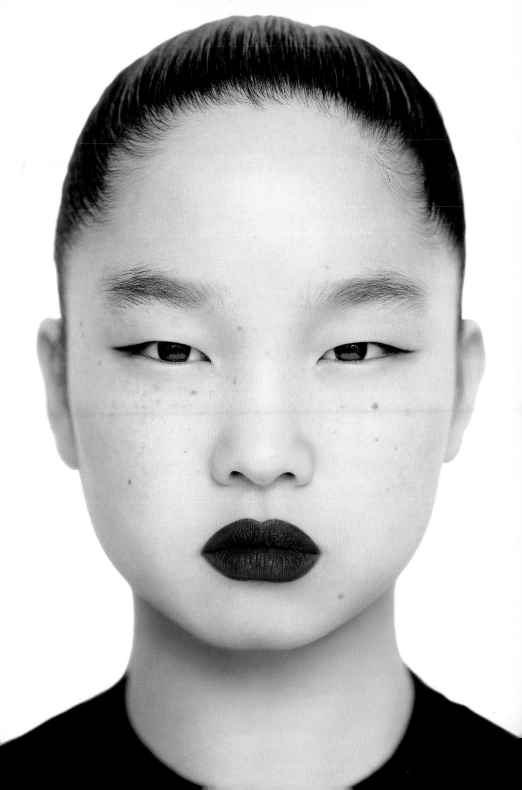

Beauty | Asian

Until the 1930s in Vietnam, Indonesia, Japan, and southern China, it was traditional to polish teeth with a preparation of iron sulfate until they gleamed like black diamonds. This accentuated fair skin, which has always been highly praised in Asia. (Hiding the teeth may also have been a way to avoid looking like Chinese invaders and dogs, both viewed as contemptible.) To avoid the sun, women always covered their bodies, particularly in Vietnam. In Burma, women coated themselves with an ocher paste called *thanaka*, extracted from the grated bark of the muraya exotica tree. In Bali, travelers were mesmerized by women who went about bare-breasted (missionaries had not yet established themselves on this particular island), while legs had to be hidden and feet were taboo.

In China, ideal beauty is defined by white skin, a round moonlike face, long, fine, wing-shaped eyebrows, large eyes shaped like peach stones, a mouth like a small cherry, very black hair, a narrow waist, rounded hips, and the tiniest possible feet. But to the Chinese, good health was paramount to improving outside appearances. Pharmacology and food were inseparably linked. It was said that beauty began on the plate; drinking a potion concocted from a base of finely ground pearls in sweet water diluted with vinegar softened the skin, and the proteins contained in the pearls smoothed the complexion. "It was once the prerogative of princesses to wear silk next to their skin to make it even smoother," recalled Madame Song, the director of Cardin in China. Shi-Kai, the first Asian top model, discovered by Pierre Cardin in the 1980s, remembered the practices of her grandmother Hui-Fang, a woman of exceptional refinement, who put special emphasis on the benefits of soups for skin care.

The geisha as interpreted by the make-up artist Topolino. The complexion is very white and the mouth is the color of rose petals. The West casts a poetic glance at a Japanese tradition.

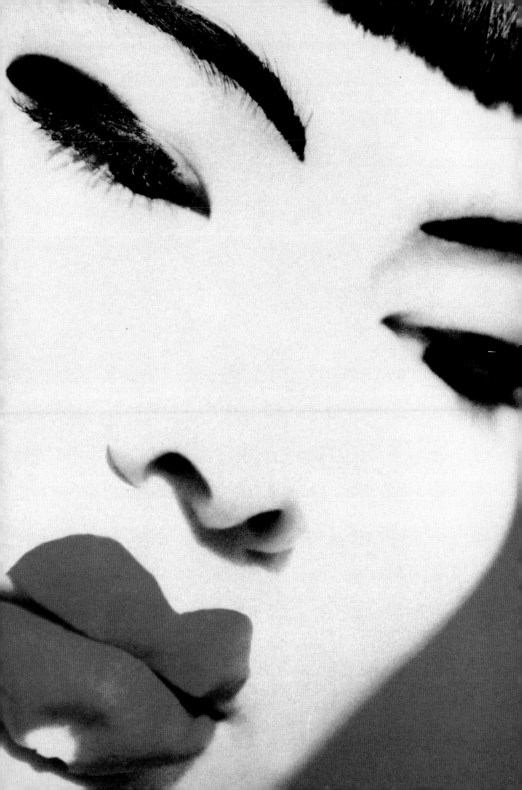

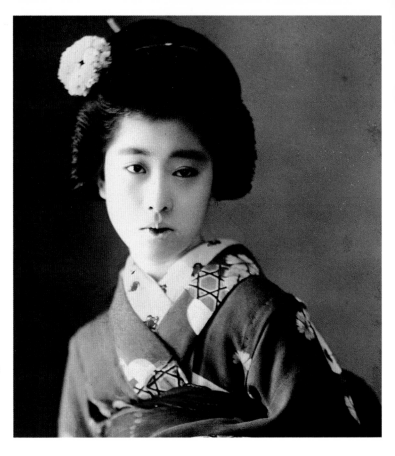

Hairstyle as sculpture. A geisha's coiffeur is a legacy from ancient China. Japan adopted this refined mannerism during the Edo period (1603–1868). This photograph dates from about 1900.

For a light complexion, she used a variety of radishes mixed with cane sugar. To fight wrinkles, she made a collagen-rich summer soup with lotus flowers, cane sugar, and sea mushrooms. A puree of white mushrooms with flowers and ice cubes served as an astringent toner. It was applied with a cosmetic glove, patted onto the face for a half-hour, then rinsed with water. Shi-Kai describes the lengths to which her grandmother would go:

My grandmother wore cloth slippers. The soles were stitched on with a heavy needle to make tiny holes. To perfume her steps, she put little cotton gauze packets of sweet-smelling talcum powder into the slippers. As she walked, tiny amounts of the powder escaped through the holes leaving a fragrant trace on the ground. What a delightful trail!

Hui-Fang placed little pockets at the waist of her hand-sewn garments, which she would fill with perfumed powder in the winter and fresh jasmine flowers in the summer. As summer drew to an end, she would dry flower petals and tuck them behind her ears or in the cupboard where she kept her undergarments. She wanted them to smell different from her outer clothes, without any strong, spicy or musk scents.

The changing concept of beauty reflects China's twentieth-century history. During the 1930s, when some concessions were made to foreigners in Shanghai, the Chinese-doll look appeared in the brothels. There, colonials' fantasies were satisfied by women in bangs with pin curls and Western-style makeup, wispy figures swathed in silk sheaths, with shoulders hidden and legs revealed up to the hips. Clouds of rice powder and curls of opium gave the final touch to this picture of exotic colonial eroticism. The victory of Mao's Communists in 1949 put an end to bound feet, the childhood mutilation that prevented normal growth and left women with minuscule feet. It had been part of the canon of imperial beauty and symbolized the isolation of women from real life. The Cultural Revolution in 1967 abolished anything bourgeois. Color was banned.

Tiny feet, circa 1900. Bound feet were atrophied from childhood on, and Chinese women remained dependent until the 1945 revolution.

Makeup and hairstyling became taboo. In the West, it was fashionable to wear psychedelic colors, but the pleasures of seduction were forbidden to Chinese women. No lipstick, no jewelry, no relationships, no bourgeois indulgences, no flowered jackets under penalty of forced labor at a re-education camp. In the first half of the 1980s, the dictatorship made a few concessions, and fashion and hairdressing salons made a cautious appearance. Women rushed to get their hair curled. The Chinese movement toward Westernization accelerated with the fall of the Berlin Wall. Thereafter, the market for cosmetic products began to develop, providing relief after many dreary years. By the beginning of the 1990s, workers and business managers had acquired a new worldliness. Beauty contests were organized all over the country. Major international brands established themselves. With the actress Gong Li as their spokesperson, L'Oréal led the pack, determined that every Chinese woman would carry a lipstick in her purse. The actress Gong Li was L'Oréal's spokeswoman. The new ladies of Shanghai were soon spending twenty percent of their salaries on cosmetics. Since 1994, sales in the market have increased fivefold, due to purchases by women twenty to thirty years old. L'Oréal acquired Maybelline and made the brand its

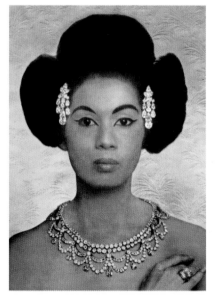

Korean hairstyle in the 1960s. A traditional Korean coiffure in an advertising campaign for the American jeweler Harry Winston. Here we have the look of a 1960s Asian star, decorated with "rocks."

flagship in the Chinese market. Stores carried perfumes such as L'Air du Temps, but also fragrances with altered names like Miss de Dior and Chinese perfumes including Chine de Chine and Polarplus. This new craze did not eradicate the classical standards of Chinese beauty, however. When Shi-Kai de Baecque was discovered by Pierre Cardin at the end of the 1980s, she did not fit in with local style. Her cheekbones were too high, her nose narrow, her mouth too big, her back too arched, her legs too long, and worst of all, she was too tall. She was more like a Manchurian than a woman of Beijing. Mocked during her school years in China, she only

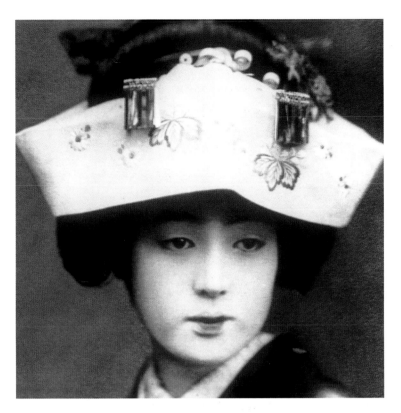

Light and shadow.
A Japanese bride's hairstyle rises above an immaculately made-up face and a doll's mouth.

Following pages:
Left: **The Cultural Revolution's natural look.** From 1967 to 1986, makeup and hairstyling were forbidden by Mao and his Red Guard.
Right: **Multiple beauties.**
1. A Korean woman from Jilin with high cheekbones.
2. A veil to block the sun in southern China's Guanxi province.
3. Hair rolled up into a silky headdress in Fujian.
4. Traditional headdress of the Miao minority in Guizhou, a Chinese province.

acquired confidence in herself after going to France.

As if emerging from the mists of time or the fogs that drift through the Yoshino Mountains, the Japanese woman adorns herself in white. She is so obsessed with the color that fashion magazines are drowning in it. When *Elle* France proclaimed the appearance of the "whitening" trend in 1997, it was already widespread in Japan. Products were offered by all the major brands, with Shiseido in the forefront.

In magazines and on runways, allusions to geishas followed one after another, each with its own look. Annie Liebowitz photographed seven models wearing Rei Kawakubo's dresses and made up with heavy white foundation for American *Vogue*.

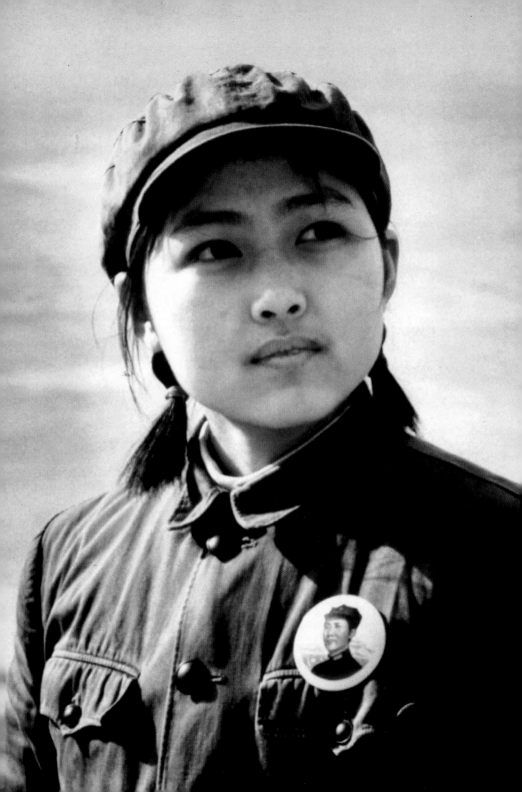

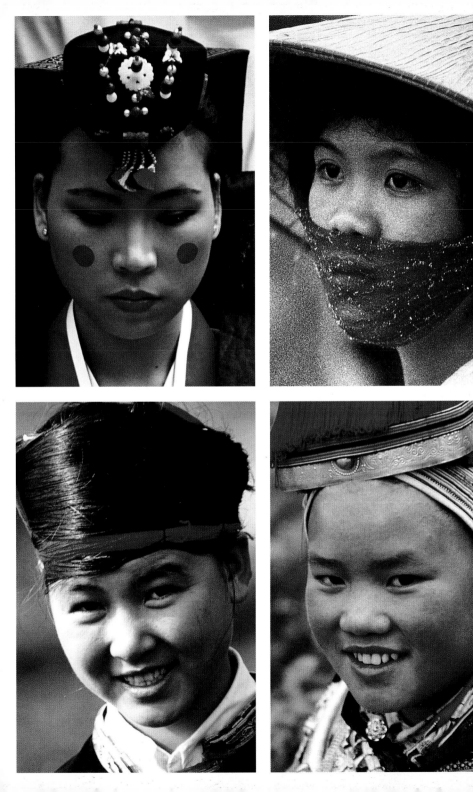

Large volume and dreamy smooth hair. A woman from a Chinese minority group.

Björk by Alexander McQueen and Nick Knight. There is a cross-cultural mix of influences on her record cover: Korean hairstyle, geisha mouth, a necklace from the giraffe-necked woman of northern Thailand, and a kimono.

Nick Knight celebrated the singer Björk. The couturier Alexander McQueen revisited the geisha style. The makeup of Amidala, the queen in the last episode of *Star Wars*, also drew its inspiration from the geishas. Seb Janiak re-created yet another snow-white, dreamy geisha in the July 1999 edition of *Harper's Bazaar*, an homage to the magazine's fashion director, Liz Tilberis, from her team and the entire world of fashion.

The source of this white phenomenon was "the person who lives for art." (In Japanese, *gei* means "art" and *sha* means "person.") Beginning at the end of the eighteenth century, the world of geishas followed precise rituals. Every visible part of a geisha's body was covered by a thick white foundation. Except when the body was exposed without any taboo in a public bath (*sento*) or spa (*onsen*), it was theatrically disguised, a practice evolved from the demands of an eroticism based on unattainability. A geisha wore her hair in a heavy sculpted chignon. (Today, it is a wig.) She wore no undergarments, but her silhouette was shaped by nine kimono belts constituting the binding obi that flattened the breasts. The nape of the neck, the focal point of Japanese seduction, was exposed, as was the beginning of the cleavage. A type of flexible adhesive was applied on all the upper parts of the body that the hand

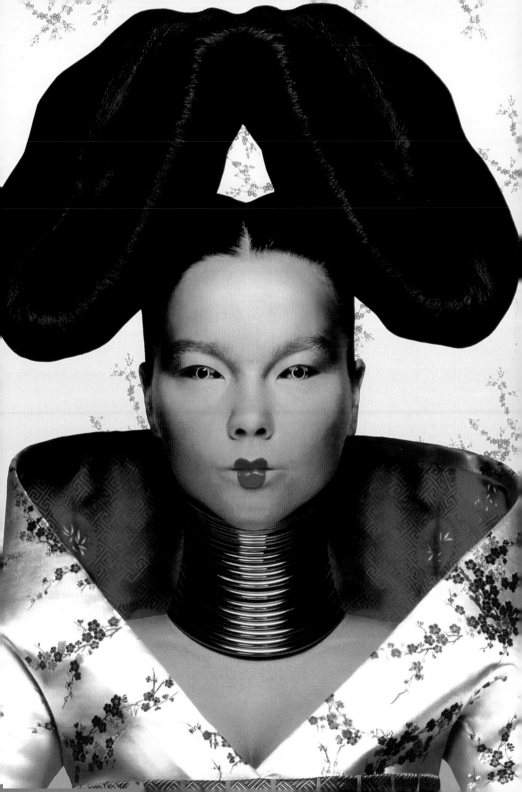

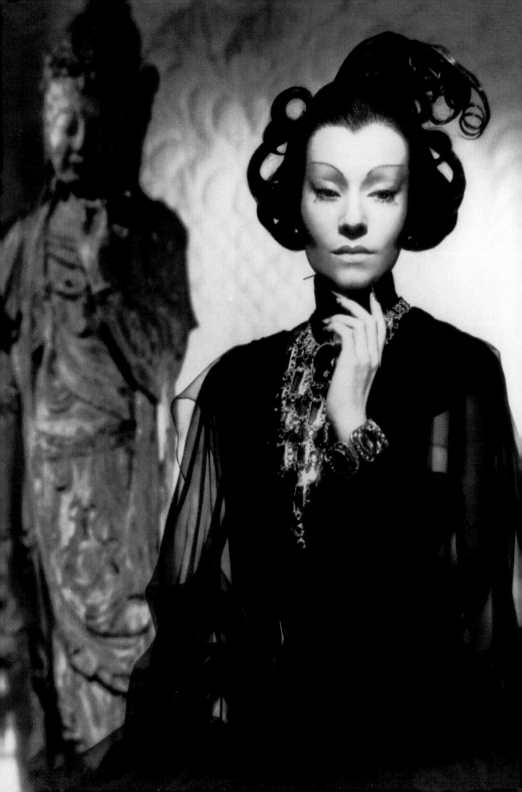

Gong Li. The great Chinese actress who starred in *Farewell My Concubine* and *The Emperor and the Assassin* embodies the new beauty of the post-Mao era. She is also the face of L'Oréal.

China made in Hollywood, 1942. For the role of Mother Ging Sling in the movie *Shanghai Express*, Josef von Sternberg brought polished nails, plucked and redrawn eyebrows, and a hieratic pose to the screen.

Following pages: **The nape of the neck,** the focal point of classical Japanese beauty. Asiatic grace photographed by Fabrizzio Ferri for Italian *Vogue*, August 1997.

could reach—face, neck, back, shoulders, and chest.

Then a white paste was applied, followed by a great deal of powder. A pink line marked the lower eyelid. Black eyeliner went on the upper lids, ending with a red dot at the outer corner. Next mascara. Lips were vermilion red strongly outlined with a brush at the top of the upper lip. The mouth was made to appear smaller. Natural polish went on the nails. There was no perfume except perhaps a hint of incense in the silk of the kimono. Voice, gestures, demeanor, and laughter all conformed to the criteria of the "charming woman." A geisha thus became an evocation of femininity in its entirety. This stylization of femininity was continued in contemporary times by two models. In 1962, Pierre Cardin introduced Hiroko to Paris, and she became the incarnation of the 1960s. During the 1970s, the Japanese designer Kansai Yamamoto made his own discovery in Sayyoko Yamaguchi. With the chiseled profile and distant nobility of a Garbo, she became the discreet idol of the runways in the late 1970s, introducing a series of gestures inspired by kabuki and no, two ancient schools of traditional Japanese theater. In 2000, a new form of social expression appeared in Tokyo: ultra-tanned young girls, with heavy makeup and brightly dyed hair.

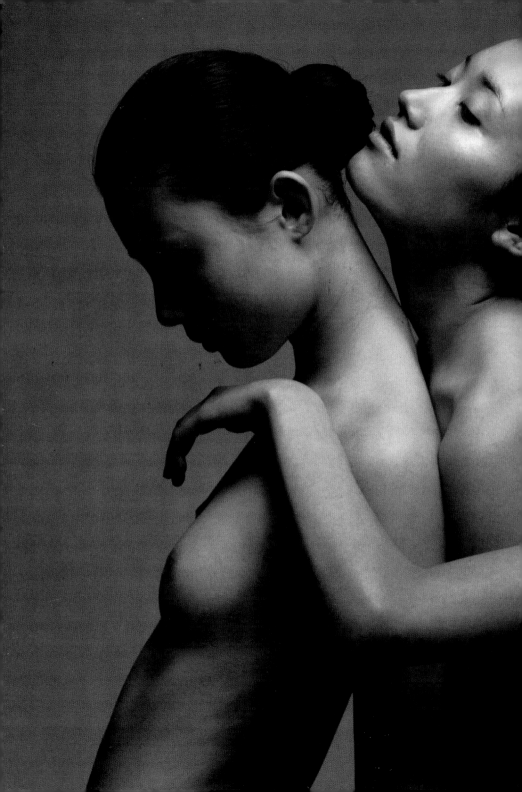

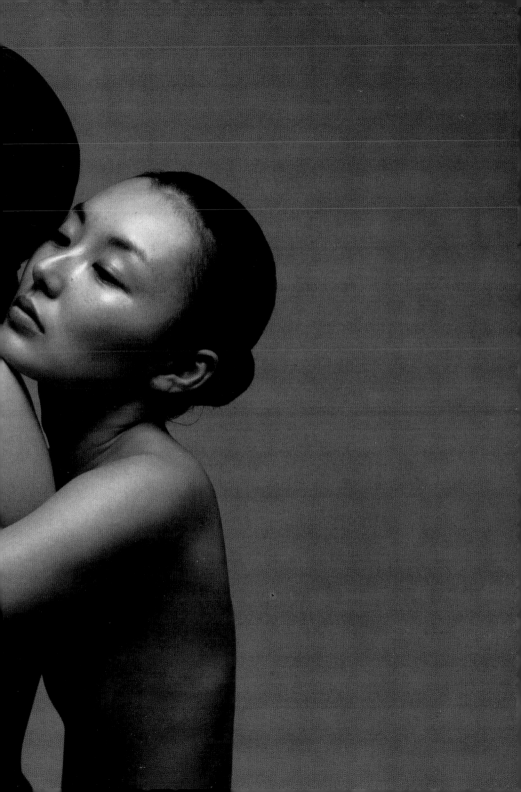

Beauty | **Indian**

The relief on the frescoed walls of the temples at Khajuraho and Ajanta pictures a goddess, a celestial woman posed in triple flexion, *tribhanga*, with high round breasts and swelling hips. Beside her, expressive male divinities display their muscled shoulders. She is also depicted in Mogul miniatures as the bride of Krishna, the god of love, shown adorning her feet with henna in a seventeenth-century painting. In miniatures, she has a wide-eyed delicacy. Goddess and maharani: these are the archetypes of beauty in India.

Consider the idealized fantasy of an Indian woman and her procession of images. Sometimes she is a sacred dancer, sometimes a venerated goddess, an ethereal, erotic, and opulent blend of the sacred combined with sultry sensuality. She is a temple statue, a bride or a dancer, always consumed by love. In Mogul miniatures, she is captured in profile. In this century, there have been movie heroines who embody all these roles, all these mythological destinies, all these traditions: Devi, Satyajit Ray's film goddess, or Leila Majnu, whose tragic destiny was similar to Juliet's as Pakeezah the courtesan. Westerners who do not understand Hinduism and are unfamiliar with Indian film cling to the clichés of maharanis, Mogul miniatures, and the Kamasutra. Colonials classified Indian women according to which of the five principal trading stations they came from. The West came to associate them with majestic serenity and an aura of mystery steeped in the science of love. More recently, the Indian woman has been perceived as the keeper of ancient botanical knowledge.

In Hindu tradition, feminine beauty is often celebrated by poets who extol the female body. The sixth-century poet Kalidasa wrote: "slim and

Classic beauty. Sleek, symmetrically styled hair and a graceful figure wrapped in a sari flowing like the sacred Ganges River.

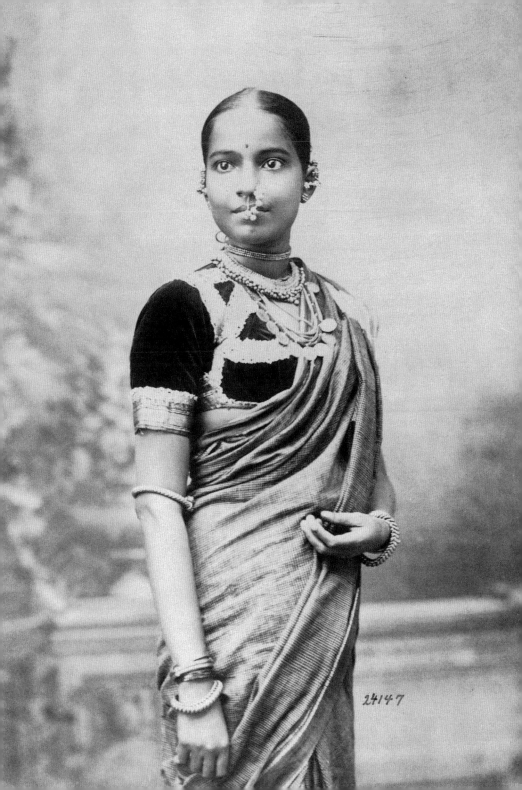

24147

brimming with youth, she has sharp teeth and lips as red as the bimba fruit. Her waist is slim and her eyes are like those of a timid doe. Her navel is deep. She moves with stately grace because of the fullness of her hips and her shoulders bend under the weight of her breasts." Coloring from a snapdragon plant brightened her lips, intensified with wild plum juice and wax for shine. To this day, Indian women are renowned for light complexions, slender yet rounded figures highlighted by the sari's drape, and long dark hair. Films have perpetuated this image. Actresses who lack natural curves wear padded bras to achieve the desired resemblance to a Hindu goddess. With the arrival of top models on the scene in the 1980s, thinness became acceptable, though the trend was confined to urban areas.

Praise for female beauty had always drawn on comparisons with nature: arms compared to lotus stems and torsos to banana trees. A lovely woman's gaze, according to the early-twentieth-century Bengali poet Rabindranath Tagore, had the serenity of a lotus petal, the inno-cent simplicity of a doe, the gaiety of the wagtail bird, and the darting movement of a goldfish. Beneath downcast lids reposed the tranquillity of water-lily eyes. The smooth chin resembled the stone of a mango, the neck was a shell, and the hands and feet were lotus flowers. In the time of the maharajahs flourishing natural motifs were used extensively to decorate enamel objects encrusted with precious stones—mirrors, fans, jewels, incense burners, ointment boxes, and vials of *attar* (essences and perfumes).

Musk, vetiver, patchouli, and sandalwood (beloved by the hippies) are blended today with pungent versions of French perfumes adding to their intoxicating allure. Perfume usage was much more sophisticated in ancient times, a legacy of ancient Greece. There was an art to placing and combining scents on different parts of the body. Silver vials con-tained perfumed water to sprinkle on garments. Aromatic musk and camphor powders, embers perfumed with incense, and resins were also used on clothing. Essences of musk, jasmine, and vetiver were distilled. Cardamom, cinnamon, and spice lozenges were used to sweeten the

breath. There were aromatic oils to dab on the earlobes and palms.
Sandalwood and turmeric rubs were used for massage. Camphor or saf-
fron creams smoothed the joints. Flowers were twined into hair. Fragrant
leaves were slipped between the breasts. Cheeks were perfumed with
musky rose petals. In southern India, fragrant oils such as coconut or
eucalyptus were commonplace, but their use was generally confined to
areas where they were produced.

As in the Middle East, China, and Africa, the concept of beauty in
India was linked to good health. Beauty remedies were sometimes remi-
niscent of a cookbook. Nurses of the Indian nobility were well versed in
herbal lore. It was an established tradition that the better part of the
morning in the *zenana,* the part of the house reserved for women,
would be spent performing one's toilette. Before independence, the
maharani of Travancore in the southern part of India would stay in her
bath for two hours. Instead of soap, she used three bowls of ointment
for the face, body, and hair, and four copper basins filled with water,
each perfumed with different freshly gathered herbs. Her body was
washed in coconut oil, dried with a fine cloth, then rinsed in water and
herbs and covered with a chickpea flour-based powder that was

removed with an *incha*, a kind of sponge made from a fibrous bark. Then the maharani was washed in reddish water colored with extracts from forty varieties of tree bark, after which the body and face were oiled and massaged. Special care was taken not to get any oil into the hair since it contained saffron, which was believed to impede hair growth. Finally the hair was gently dried over smoky embers strewn with many varieties of fragrant herbs. After the hair was dried and combed, the part was covered with crushed herbs to avoid exposure to the cold. On the eve of her wedding to the prince of Jaipur, the maharani Gayatri Devi, a dazzling beauty, was bathed in fragrant oil, massaged with turmeric to soften her skin, her feet decorated with henna.

Such care was the prerogative of maharanis, but the average woman has her own customs. She decorates her hair with fragrant jasmine garlands. A married woman paints a red line of kum kum powder along her part to indicate she is following the right path. A nose ring serves as a reminder not to spend more than her husband can afford. Some practices that appear sumptuously exotic to Western eyes are actually symbols and tributes to divinities. The *tilak*, the red dot marked on the forehead with sandalwood paste, signifies the new status of a married woman.

Marriage is an important moment in the life of an Indian woman, an occasion for elaborate celebrations and rites of pleasure. Long tresses are perfumed with sandalwood. All body hair is removed. A complete clay body mask is applied, followed by baths perfumed with herbs. Preparations of turmeric or chickpeas mixed with milk come next. Massages give skin a babylike softness. Eyes are made up with kohl, and the line of the eyebrows is raised with white dots. A two-day ritual fast ensues, followed by the mehndi night. On this occasion, hands and feet are decorated with arabesques of mehndi, the Indian word for henna. And finally the bride dons gold jewelry, a

Menhdi for marriage. The ceremony involves painting with henna, called *menhdi* in India. Red, gold, and pearls are propitious auguries for a Hindu marriage.

A princess in her splendor in the southern Indian state of Tamil Nadu. Her braid is decorated with golden jewelry and diamonds in enamel settings.

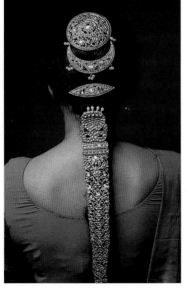

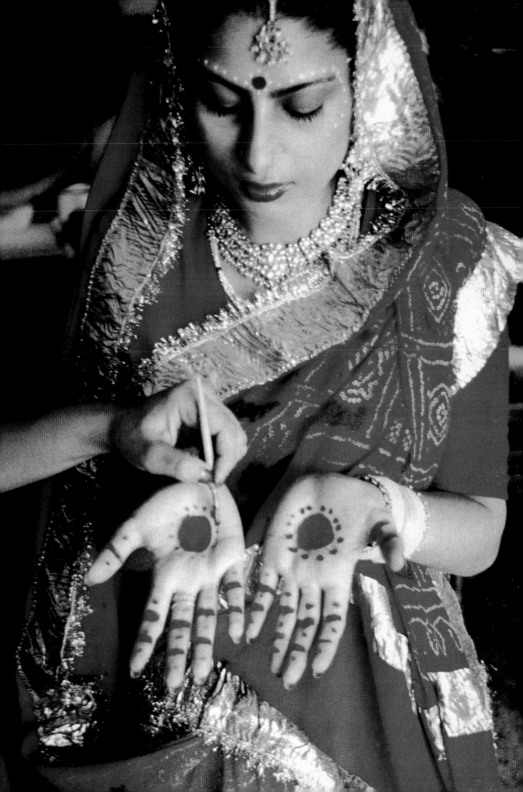

scarlet sari bordered with gold, and garlands of soft flowers. Her eyes are lowered beneath a red veil.

Inheriting traditions from the Mogul Empire, India shares certain beauty practices with other parts of the Orient. Henna is much more commonly used to decorate the hands and feet than to strengthen the hair. India is currently the world's largest producer of henna. In the Punjab, *suak* (known as *siwak* in Morocco) is used both to color the lips and gums and to whiten the teeth. *Kajal* (kohl in the Orient) is a form of antimony used for making up the eyes.

The twentieth century represented three distinct stages for Indian women: the end of *purdah* (seclusion), independence after August 15, 1947, and access to international markets in the 1990s. Before independence, women from India's noble families often traveled in Europe, adding spice to fashionable society between the wars with their unique beauty and dashing allure. Young Indian princesses experienced all the euphoria of a free life, dressing in Western fashions and relishing European makeup in London, Paris, or Switzerland, before marrying according to traditional rites and re-entering their lives of seclusion. War and Indian independence propelled them into a more active life. In the new India, liberated from the British Empire, politics assumed a nationalist, authoritarian tone, and rapprochement with the Soviet Union closed economic borders. India developed its own brands, and Lakme and Shannaz dominated this lucrative market without external competition until the collapse of the Berlin Wall. Today, all the major labels are sold in India, and in urban areas stylish young women readily buy Estée Lauder, L'Oréal, and French perfumes. Far from discouraged, new Indian products have emerged, stimulated by competition. They boast an expertise based on an aesthetic tradition of great cultural richness and knowledge of the cosmetic value of plants, a legacy of ayurvedic medicine.

Profile of young Indian dancer(David Hanson/Stone)

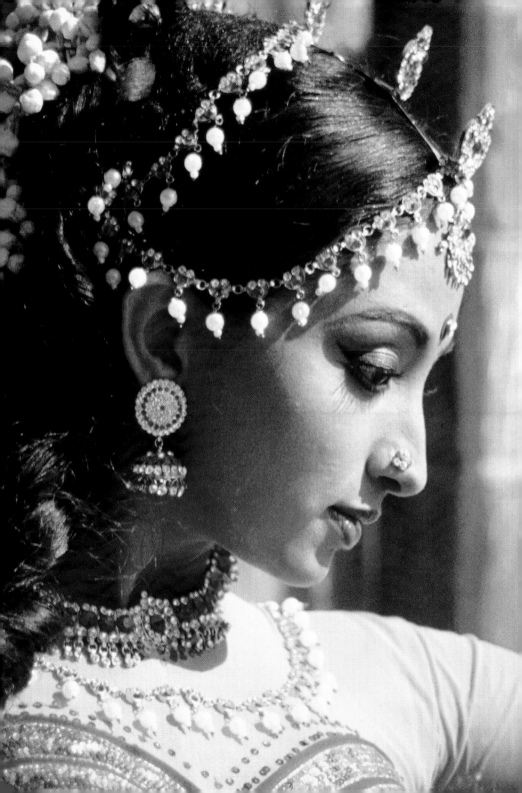

Beauty
Pacific Island and Latin American

The people who live in the islands and lands around the Pacific Ocean share various traditions. Over the centuries monsoons and fishing expeditions led islanders to distant destinations. During encounters with other ships and exploration voyages their rituals gradually spread. While they were reinterpreted and assimilated, the adapted rituals retained the strong sense of pride in self-adornment and in the poetry of their myths. Tattooing is found in New Guinea, Japan, New Zealand, Polynesia, and the Amazon. The Maori stylized the great flowery designs of Japan's tattoos with slate-gray shading. Amazonian Indians extracted the dyes for their tattoos from the genipap tree. In 1935 the anthropologist Claude Levi-Strauss counted four hundred distinct designs for facial tattoos among the Caduevo, and took note of their artful asymmetrical compositions with arcs, spirals, and crosses. Beginning at the hairline, women flawlessly executed the tattoos using a fine bamboo spatula dipped in genipap sap, which turned blue-black with oxidation. The markings seemed to Levi-Strauss like "pictorial surgery, the mark of art on the human body." In his *Tristes Tropiques*, he tells of the magnificent diversity of the Pacific islands. The Bororo people colored themselves vermilion from head to toe using urucu seeds crushed in oil; their hair was cut in a bowl shape and covered with the same paste. There were other forms of body painting: "gleaming powder coated the shoulders and chest with crushed mother-of-pearl." Men adorned themselves as well. "With

Captivating and voluptuous. This is the incarnation of sophistication. An idol of Latin sensuality, Maria Felix in Yves Ciampi's *Heroes and Sinners* (*Les heroes sont fatigués*), 1955. Photograph by Roger Corbeau.

Pre-Hispanic beauty. An Indian woman in the Andes with jet-black braids. Mexico, 1988.

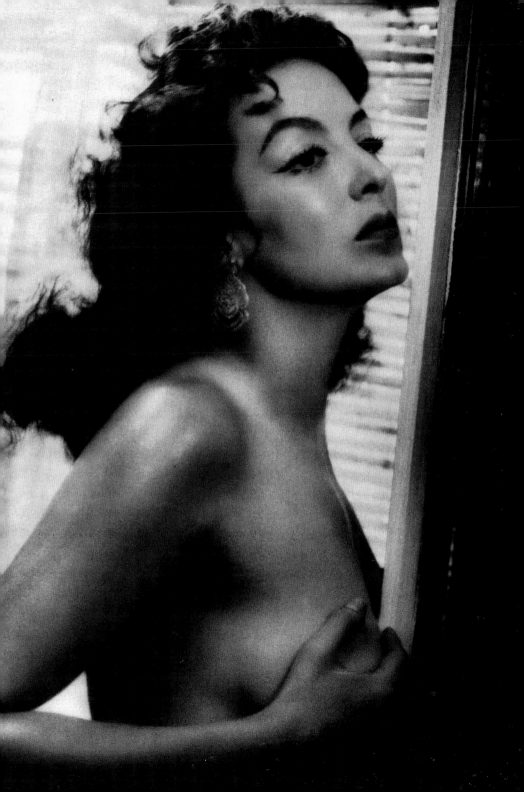

shoulders the breadth of longshoremen, they transformed each other into baby chicks, gluing soft down to their skin." In central Brazil, southwest of Belem, Kaiapo Indians also use roucou red to color their faces and genipap black for painting lines; these are most graceful when they are drawn by women on each other or on their children with a spatula fashioned from palm fronds. Depending on ethnic background, social status, age, and the ritual calendar, the body is covered with lines, asymmetrical shapes, and drawings outlined with red and black.

"The tattoo artist uses a little hammer to pound into the skin the sharp points of a comb, which are soaked from time to time in dye." Thus Captain Cook described a tattooing session in the Marquesas Islands in 1776. Women in the Society Islands were tattooed only on the buttocks or hips with a few designs on their hands and ankles, while men covered their entire bodies.

The hair of Amerindians is similar to that of Asians, smooth and black. Kaiapo children wear it short, while the Yanamami tribe favors a bowl cut. Women from the coasts of Mexico to the high plateaus of the Andes wear braids. We might suppose peoples had ventured across the ocean and woven ties long before our time and our arrogant missions of

A Central American muse. Nieve was the model for the Mexican painter Diego Rivera. Mexico, 1949.

conquest. However, there is also diversity among the regions. While the eyebrows of Central American Indians are prominent, the Amazonian Indians use every artifice to eliminate all hair from the face, including eyebrows.

Tahitian women have been the stuff of dreams for generations. They are famed for their splendid manes of hair, which they care for with *monoi*.

Although we have become a bit jaded by advertising images for shower gels and vacation clubs, with sun-drenched coconut palms waving in the background, *monoi* (which means "perfumed oil"), still plays a respected role in

Frida Kahlo, a painter, was Diego Rivera's wife. She overcame her sufferings from polio in this scene set in pre-Hispanic Mexico, where ribbons, flowers, and jewels frame her features (circa 1939).

Polynesian beauty care. It is composed of coprah oil (from sun-dried coconut pulp), in which buds from the tiare flower are soaked for ten days, giving it a unique fragrance. Another natural product on the islands of Oceania is Morinda citrifolia, a tree known as *nono* in Tahiti and Tuamotu, *noni* in the Marquesas Islands and Hawaii, and *kura* in Fiji. Nono is a virtual panacea. Nono paste, which is obtained by fermenting a fruit that resembles a little green pinecone, is a base for medicines and cosmetic products.

The peoples of the world share countless natural remedies and practices that should be recognized for their efficacy and ecological awareness. While some lands may not have petroleum, mineral deposits,diamonds, or any other of the resources on which empires are built, their inhabitants nevertheless have the understanding and expertise to make themselves attractive and healthy.

For example, long before the advent of sunblock creams, women made protective ointments similarly produced by the major cosmetics companies today.

Through womankind's inexhaustible wisdom we are sure to uncover many other secrets of good health. The challenge for the future is not to steal this knowledge, but to improve the lives of the women who harbor it in an evenhanded exchange. Such commerce, or fair trade, preserves ethnic societies and protects their environments. One example is the company Body Shop, which has developed product lines based on fruit and nuts from Brazil, helping women in the Amazon to live with dignity.

"The people of Guinea are neither black nor white," noted Christopher Columbus in writing about the Indians. Once the Spanish conquistadors had overrun the Aztec Empire, Mexico soon became a mestizo, a cross-cultural breeding ground that spread throughout Latin America. (There were twenty-five thousand mestizos in Mexico by the end of the sixteenth century.) This trend continued, following the whims of history. African-Cuban tawniness mingled with Venetian fairness, Argentinians bred children far from the Andalusian Jewish community of their ancestors, and the blood of Indians mixed with that of European, African, and Asian arrivals.

Tahitian flirtatiousness. Models with hair oiled with *monoi* and decorated with flowers illuminate Paul Gauguin's paintings.

The Yanomami cut. The highly styled Jet-black hair of an Indian in the Venezuelan Amazon.

Latin style exploded in the 1980s and 1990s. The salsa and the

tango became all the rage. Cuban music was made even more popular by Wim Wender's film *The Buena Vista Social Club*. From the bars of Havana to the studios of Hollywood, from Maria Felix to Jennifer Lopez, Latin beauty learned to enhance its distinctive features. Heiress to these blends of Indian, Italian, Spanish, Portuguese, African, and Creole blood, the ideal Latin beauty evokes sensuous fantasies of wavy jet-black hair, bare shoulders, and skin tones that range from amber to coppery to café au lait, blended in a spicy dream where all is luxury, excess, and pleasure.

FRANCINE VORMESE

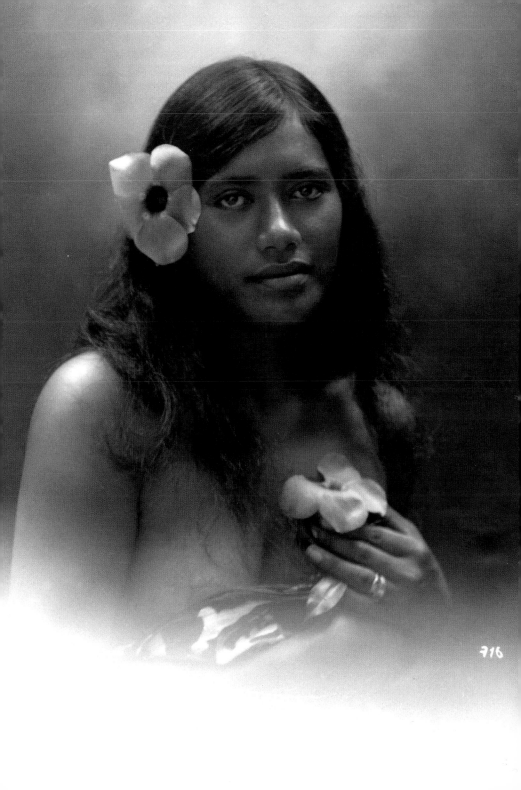

Beauty | Cosmetics

Beauty | Cosmetics

"The twentieth century has been the century of technological and scientific evolution in beauty. It has been an era marked by important cosmetic discoveries and it culminates with a glimpse of new promise for the future. Women will be thriving and beautiful with energy like the sun," announced Akira Gena in a recent international scientific symposium. In these brief words the chairman of the Shiseido Corporation perfectly summed up the often extraordinary history of cosmetics.

The industry was born at the beginning of the century. From the outset, cosmetics were a mix of the completely practical and the wildly inventive. The products were first developed in pharmacies and were already seen as tools in the quest for eternal youth. Though many of these creams lasted only a few years, some were handed down to posterity and are at the origin of economic empires.

Two chemists introduced Pond's, which is still a favorite in the English-speaking world. Crème Simon is another example. Developed by Joseph Simon in 1860, its popularity as a remedy for cold-stressed skin grew consistently until World War II.

Mr. Mirault, another pharmacist, whose Parisian shop was on the boulevard Malesherbes, made powders and ointments using recipes handed down from father to son. One of his clients, a lovely American woman, was none other than Harriet Ayer. In 1887, she purchased the formula for Baume de Beauté de Madame Recamier and returned to America, where she introduced the cream that marked her debut in the cosmetics business.

The aesthetic of the 1990s photographed by Torkil Gudnason in *Madame Figaro*.

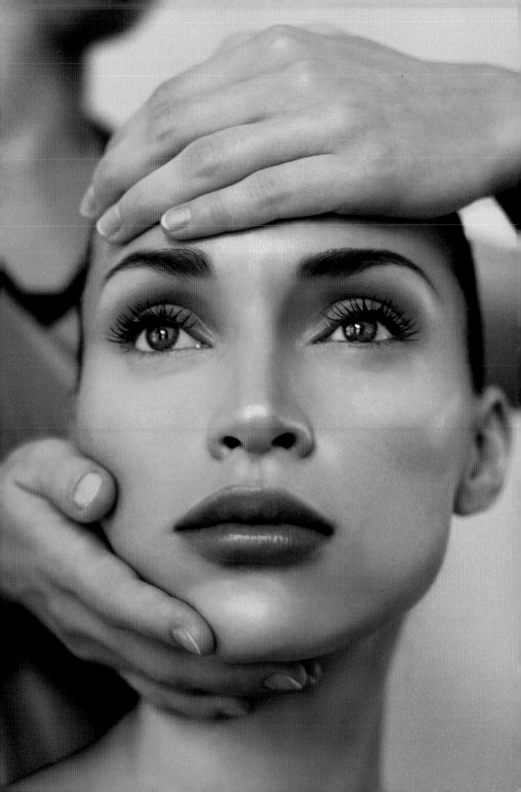

After Eau de Perles to whiten hands, Sels Poignants Aromatises contre le Mauvais Air and Crème de Rose aux Limacons pour le Teint, Guerlain offered Secret de Bonne Femme to Parisians in 1904. This cream contained no active ingredients and owed its success to its texture alone. It was beaten by hand like whipped cream, and put in containers with little spoons to protect its fluffy, pearly consistency. It is still sold, but only in Europe, since this fragile emulsion would not survive an airplane journey.

In 1902, two Italians, Giambattista and Cornelio Bonetti, bought the patent for a base used by pharmacists to make pomades. Diadermine cream, which quickly became a popular family choice, was used to soften housekeepers' hands and to heal children's frostbite and chapping.

Around 1911, Paul Beiersdorff, a German pharmacist, invented a cream that was a minor revolution—the first water-in-oil emulsion cream. He hoped to make a cream for wealthy, sophisticated women, and he succeeded beyond his wildest dreams. Women came from all over Germany to buy this rich cream, whose recipe remained a well-kept secret for a very long time. It did not come to France until 1931, when the legendary name Nivea was bought back from Guerlain, who had purchased it in 1875.

Yet another pharmacist caused a stir when he opened the Fukuhara Pharmacy in the Ginza district of Tokyo. In this first Western-style pharmacy, Yushin Fukuhara offered customized products made from commodities imported from the West. In 1897, he introduced the skin lotion Eudermine, an energizing, soothing tonic, the first Japanese cosmetic product made according to a scientific formula. The label on the red bottle was written in French with a graphic design inspired by the painter Seurat. A hundred years later Eudermine is still on the market and admired all over the world, now packaged in a newly designed bottle by Serge Lutens.

A massage session. There were many attempts to find beauty applications for the magical force of electricity. After numerous experiments, ionization and electropolishing were successes.

Nourishing cream. For fifty years, cosmetics nourished the skin with rich creams, rather than hydrating it or treating its wrinkles.

nourrir, vivre belle...
crème supernourrissante
GUERLAIN

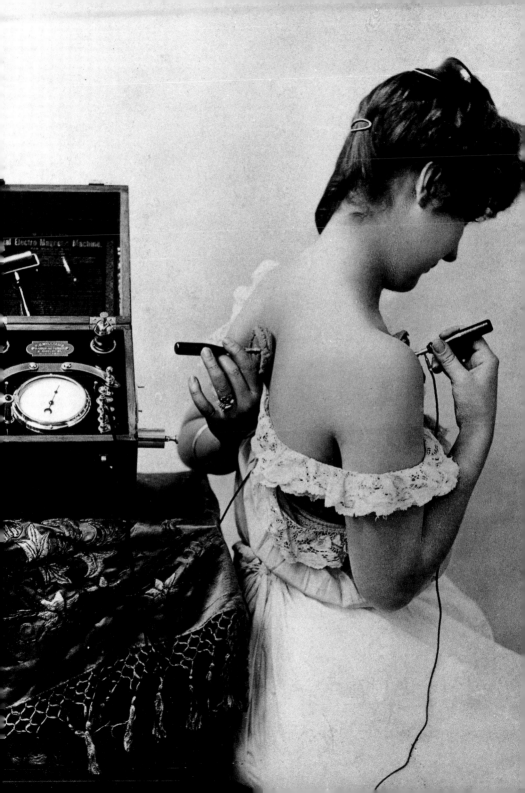

After World War I, women longed to be more and more beautiful, and they were ready to spend time and money to achieve this goal. Helena Rubinstein and Elizabeth Arden appeared at the same moment to fulfill these longings. Both women had terrific intuition combined with an extraordinary business sense. Helena Rubinstein opened her salon in Paris in 1912, having made a fortune in Australia and England with her famous Valeze cream. She was in the habit of receiving her clients in her small three-room apartment in Melbourne, listening to them and offering her advice. She was the first to sell made-to-order commercial cosmetics, and she maintained an inventory of products for different skin types. She opened the first beauty institute in London, which was frequented by the entire British aristocracy. Before long, Helena Rubinstein was no longer content to limit herself to facial care. She turned her attention to the body, developing firming rubs, advising on eating habits, and putting women on diets. She was completely in synch with the physical cultural movement emerging in Europe. Gymnastics were viewed as a source of good health. Homeopathy and natural medicine were flourishing. Vodder perfected lymphatic drainage, and Moshe Feldenkrais was working out his theories on energy.

Helena Rubinstein in her Paris laboratory in 1932. "Nothing gives me more pleasure than working in my kitchen."

This premiere emulsion quickly set the standard for creams as it was intended not only for women but also for men. (Allemagne, 1922)

Miss Arden, whose real name was Florence Nightingale Graham, opened her own extremely luxurious salon in New York in 1909. The ambitious daughter of a Canadian truck driver, she studied nursing, but quickly realized she preferred people who were in perfect health to those who were ailing. She began as an associate of Harriet Hubbard Ayer, but soon set off on her own. Always independent, she developed the concept of total beauty, which included not just beauty care products, but also hairstyling, makeup, and lessons on upkeep and etiquette.

She even announced: "I judge a woman and a horse by the same criteria: legs, head, and rear end." Just after introducing her famous 8-Hour Cream in

1934, she opened Main Chance in Arizona, the world's first spa, where she collaborated with the Hollywood nutritionist Gaylord Hauser. Before that, 1920 had been her year in Paris. After training two aestheticians, she welcomed her first clients at 244 rue Saint-Honore (Helena herself lived at 216), in a beauty institute identical to its famous predecessor on Fifth Avenue, right down to its red door.

Nadia Gregoria Payot is another woman to remember from this era. Born in Odessa in 1886, she was one of the first female dermatologists. She emigrated to New York, and it was while treating one of her most famous patients, Anna Pavlova, that she developed a system of exercises for the face and neck. At the age of forty, Pavlova had a perfect figure and body, but her face betrayed her age. Nadia Payot worked out a whole series of movements that, when practiced daily, preserved the firmness of the dancer's face. She had a very aesthetic approach to cosmetology.

Plastic surgery now appeared everywhere as a recognized medical specialty with its own professional associations, journals, and conferences. Joseph invented rhinoplasty in Berlin. Von Steinach did the first facelift in Vienna. In Germany, doctors were operating on eyelids and performing breast lifts. However, it took a great deal of courage to undergo surgery under shaky anesthesia when infection was a routine surgical complication. Who dared? Actresses and dancers.

Returning to Paris, Nadia Payot also opened a beauty institute located in the private home of the Countess of Castiglione. She made the beautiful courtesan's bedroom her office, where she received famous patients and introduced products that made history: Lotion Bleu and Pate Grise. Their formulas remained unaltered until the 1980s, when they were regrettably withdrawn from the market because they contained active ingredients that are now restricted to medical use: camphor and zinc oxide.

Cosmetic surgery. Faces shattered on the battlefields of World War I gave rise to plastic surgery, but it only became a recognized specialty in the 1930s.

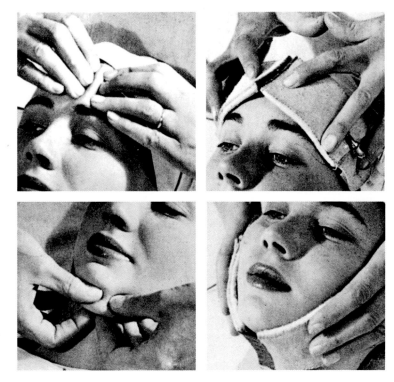

Aestheticians were the first to treat wrinkles and bagginess in the skin. Their methods are still in use today.

Beauty institutes gradually came to play a more important role in women's lives. Now they were numerous and democratized. No longer reserved for the elite, these were places open to working women like secretaries. Small facial imperfections were taken care of, and so were life's little heartaches. Beauticians were also confidantes, as they still are today.

Jeanne Gatineau, a podiatrist and therapeutic massage expert, opened her Paris establishment on boulevard Haussmann in 1945. Women came because she was said to have extraordinarily skillful hands. She surrounded herself with dermatologists and scientists. She studied the works of Alexis Carrel, who had just demonstrated that skin is a living organ, and began to perfect products such as the cleansing milk and nasturtium and jonquils lotions that are still on the market today. She refined her massage techniques with specific sculpting movements for the body.

Focusing her research on slimming, she discovered the properties of the iode. Crème iodocellite was a sensation in 1947. In 1949 she introduced a breast treatment. Her products, which were applied in the institute's little rooms, were immediately successful with clients. Jeanne Gatineau retailed them in her institute, developed a distribution system for the provinces, and opened a school to teach her methods.

Jacques Courtin opened the Clarins center for physical improvement on rue Tronchet in 1954. This institute was designed to answer a woman's every need. Did she have wrinkles? He created the first anti-wrinkle cream. Did she have swelling? Courtin introduced Huile Anti-eau, followed by Huile Tonic. Clarins is now known internationally, quoted on the stock exchange and still under family management. The company remains the uncontested leader in slimming products.

A medical approach to beauty care became more pervasive with skin peels and injections of paraffin in the cheeks. The terminology used in discussing beauty became more sophisticated. Once again Helena Rubinstein was an innovator in introducing scientific language. Calling a firming mask Contour Lift Film in 1953 was daring, though now such names are commonplace. In 1956, she was able to demonstrate the efficacy of Skin Dew with scientific studies. A year later, she came up with another innovation, Skin Life, which offered a biologically active regenerator, GAM, whose effects on tissue preservation are remarkable. Helena marketed her product in person and traveled all over the world with a piece of living tissue, immersed in a GAM bath, stashed in her luggage.

Rich, heavy creams made from petroleum jelly and glycerin were replaced by others based upon the principle of cellular regeneration.

Advertisement for Nutrix cream, 1949. This cream, which Lancôme introduced in salons, is still sold today all over the world.

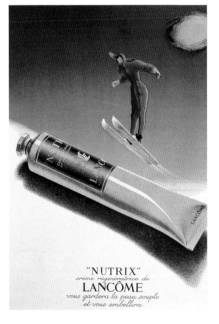

"NUTRIX"
crème régénératrice de
LANCÔME
*vous gardera la peau souple
et vous embellira.*

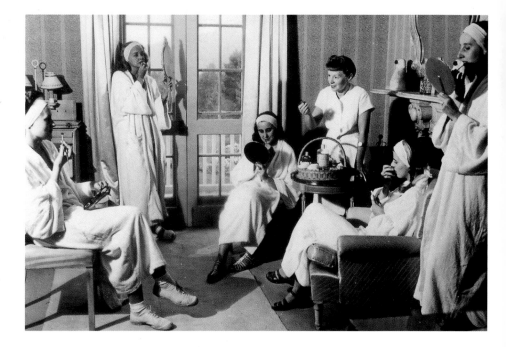

The fashion now was for biological extracts from placentas and embryos, products that drew inspiration from the live cells used in the Valmont and La Prairie clinics in Montreux, Switzerland, which were favored by the international jet set. This research yielded Payot's Crème Embryonnaire, Lancaster's Crème Vivante, Guerlain's Crème Nourrissante #2, and Orlane's Placenta line.

Eugène Schueller, the inventor of modern haircoloring and the mastermind at L'Oréal, died in 1957. He was succeeded by François Dalle, who acquired numerous other companies including Lancôme, Vichy, and Biotherm, all of which contributed to the growing presence of French cosmetics on the international market. This company's ambitious strategy for diversification and internationalization remains in force.

Meanwhile, the 1960s were still dominated by two great, implacable Americans. In their twilight years at the head of international empires, the two grandes dames were locked in a death struggle. When Elizabeth Arden introduced her Invisible cream, Helena Rubinstein decided that she would no longer classify her products by function (nourishing or hydrat-

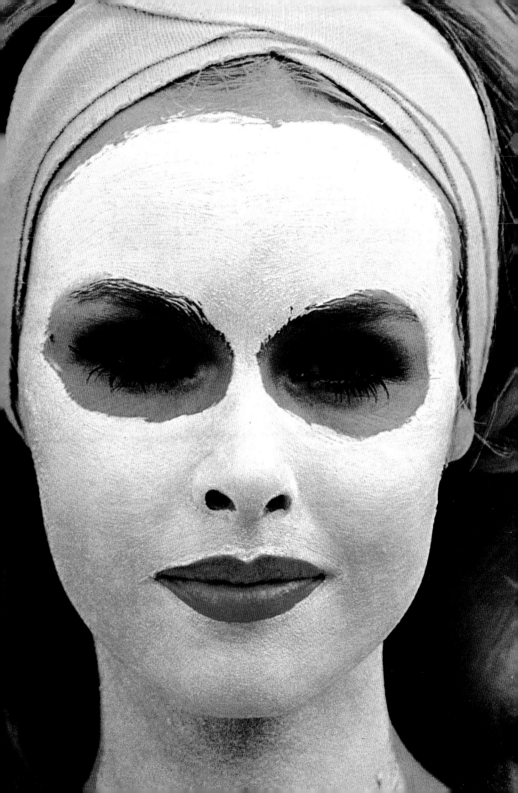

ing, for example). Instead, she would offer complete lines of products.

Women had great brand loyalty at this time, a frame of mind that encouraged them to buy all the offerings in a product line. This approach to classification was copied by competitors, including Revlon, which introduced its Eterna 27 in 1961; this was the first treatment targeted at women over thirty-five. Helena Rubinstein died in 1965 at the age of ninety-three, and Elizabeth Arden shortly thereafter. Another woman was becoming an increasingly powerful presence on the international scene: Estée Lauder.

Having unsuccessfully attempted a theatrical career, Estée Lauder opened the "House of Ash Blondes" in Miami's Florence Morris Beauty Salon in 1946. Here she sold her Crème Tous Soins, which her uncle, a chemist, had developed. She had a great gift for public relations and employed the "talk and touch" approach to selling. It was the first time a saleswoman ventured to apply a dab of cream to a client's face, or give a touch of blush to demonstrate how the color brought out the eyes. Success was instantaneous. She gave her own name to this cream, and added a lotion, the first makeup-removing oil, and a powder to the line. The Estée Lauder brand was launched. A bevy of sales representatives, the "Lauder girls," traveled all over the United States. Two years later, the prestigious Saks department stores admitted her to their selling floors. Success was assured, because Estée Lauder was the first to develop what we today call marketing. With every product purchased, she offered a free sample. However, the greatest pride of this woman, who was known as the Garbo of business—she lived a secluded life in Palm Beach and her last official photo dates back to 1982—was her family. Her business, which is now worth two billion dollars, is still in family hands and managed by her sons, Leonard and Ronald, and her grandchildren, William, Jane, and Aerin.

When Estée Lauder products came to France in 1969, thriving French brands were doing little export business. Examples include Orlane, which then introduced its famous Crème Force C; Lancaster, whose sun products epitomized the Monaco tan; Roc, which specialized

Cosmetics take on the body. It was May 1968, but despite twenty years of struggle, slimming creams did not successfully penetrate the market. Page from *Votre Beauté*.

in hypoallergenic products; Clarins; and Yves Rocher in Brittany, who inaugurated the concepts of "eco-beauty" and selling cosmetics through catalogues.

Confronting fierce competition, these companies had to defend their own territory. They embarked upon scientific research that produced numerous discoveries.

The first anti-wrinkle and collagen creams made their appearance. Collagen was discovered to help preserve the resilience and firmness of the epidermis; it is a protein that tends to naturally diminish in the tissues with age, resulting in one of the first visible signs of aging skin. The introduction of collagen into beauty creams thus represented remarkable progress in the struggle against visible aging. Ultima was the first to sell a soluble and stabilized one hundred percent collagen product in 1965, as part of a line of anti-aging products especially targeted at dry skin. Twenty years later, Ultima innovated again when it successfully isolated the pro-collagen molecule, which provides collagen to young skin, and incorporated it into its Pro-Collagen Anti-Aging Complex for the Face and Neck.

In 1975, Vichy introduced Equalia. It was a scientific breakthrough, a completely novel formula with a light, fluid texture. In a marketing first, Vichy flooded magazines with editorial infomercials that appealed to women's scientific curiosity with densely worded technical arguments.

There were other major innovations. Exfoliation, a new beauty technique, began in New York in 1970, thanks to a *Vogue* reporter, Carol Phillips. On August 15, 1967, she published an article "How to Regain Gorgeous Skin," in which the dermatologist Orentreich discussed his theories on cleansing and exfoliation and described the results he had achieved. *Vogue*'s phones were soon ringing off the hooks. For the next year, under the sponsorship of Estée Lauder, Carol Phillips and Dr. Orentreich worked together to perfect a complete range of products. In September 1968, the first Clinique counter opened at Saks Fifth Avenue. Today, Clinique is the world's best-selling brand.

Facelifts were performed on younger and younger women (about forty-eight was the average age) by increasingly skilled hands. It was no longer a very risky operation. Photographs by Torkil Gudnason in German *Vogue*.

Cosmetics were increasingly targeted. As understanding of the skin's structure became more profound, cosmetics targeted the nucleus at the heart of the cell.

Aesthetic medicine is no longer reserved for an elite: it became widely available and posed serious competition to skin care products.

Following pages: **What will tomorrow's cosmetics be like?** Employing more than two thousand people in research, L'Oréal attempts to picture the concepts and the textures of the future. Every new product takes five years of research.

Couture houses now entered the fray. Christian Dior started things off with his makeup line l'Explosion des Couleurs in 1969, followed by his first skin care products in 1973, including Hydra Dior. In 1975, Chanel introduced her Collection de Beauté, which consisted of makeup and several specialized care products, including the regenerative Crème no. 1 FRE, which is marketed using highly technical language.

Brands invested colossal sums in their research laboratories and made their researchers media stars who were supposed to convince others of the high performance of their formulas. Lionel de Benetti for Clarins, Joseph Gubernieck and Daniel Maes for Estée Lauder, Pierre Perrier for Christian Dior, Jean Claude Le Joliffe for Chanel, and Edith Clar at Lancôme were the best known of these scientific spokesmen.

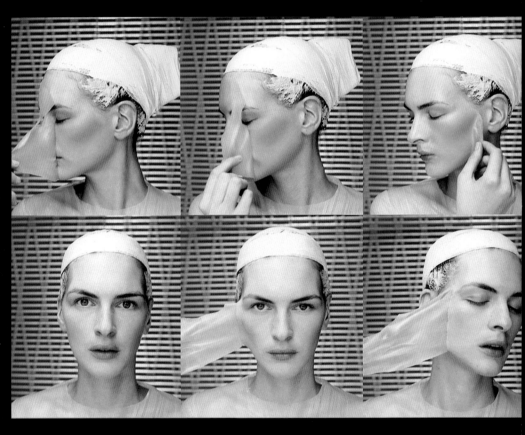

Relentless rivalry kept research constantly moving forward. In 1983, two care products laid claim to the same innovation: Lancôme's Niosôme and Dior's Capture. Both contained liposomes, those famous microcapsules that penetrate deeply into the skin to distribute their active anti-aging ingredients. Then came Orlane's Anagenese, Rubinstein's Intercell, La Prairie's Hydra Suisse, Shiseido's BioPerformance (which established the brand in the French market), Roc's Myosphere, Clarins's Crème Multiactive—just a few examples from more than two hundred.

People seemed to talk about nothing but aging in all its manifestations. Facelifts were available to everyone, and the first skin-smoothing injections began in America. Estée Lauder's Night Repair took cosmetic technology to new heights. This product, in a pump bottle, was the first lotion to use hyaluronic acid. In 1991, Estée Lauder further improved her product, replacing it with Advanced Night Repair. These days, every five minutes a woman buys a container somewhere in the world.

The last major innovations before a shift in the market were emulsions that created an illusion. Lauder's Eyzone had fine opalescent filaments in a beautiful spiral, visible through its little transparent container. Jeanne Gatineau offered Diffusance beads.

After science had its day, marketing took over the show. Trends in cosmetics shift constantly. By the beginning of the 1990s, a cream's life cycle was just two years.

In 1991, Jacques Courtin introduced the anti-pollution concept. The purpose was straightforward: to protect the skin from harmful elements in the environment. The profession at first mocked the notion, but competitors very quickly entered the field, and creams for city dwellers became numerous. Women fought the effects of pollution, and clarified their skin.

Avon, swiftly followed by La Prairie, introduced fruit acids, an alternative to the skin peels that Americans practiced to excess. All the scouring caused new tracks and lines. Women with delicate skin or skin made sensitive by overaggressive treatments still had an undiminished desire for radiance. The quest for luminosity would soon outstrip the battle against wrinkles with vitamin C and retinol.

Texture is now just as important in skin care products as their active ingredients. Creams must stimulate sensory appetites.

But too much marketing is just hype. Searching for authenticity, people turned to "eco-sensitivity."

Aromotherapy products, which featured essential oils, overtook products based on chemistry. Scientists fought back, drawing inspiration from textiles. The new millennium opens with stretch and microfiber textures, which boast of their many sensual appeals. Consider Dior's Model Lift or Lancôme's Hydra Zen.

In beauty circles, the word was that pleasure now prevailed over efficacy. Eighties consumers were real wrinkle technicians; now cosmetics target the thirty-plus women who emphasize the harmony and regularity of the face over mere signs of aging. A new generation of products has appeared, including Clarins's Lift Minceur Visage, Biotherm's Re Pulp, and Shiseido's Skin Care, the first product to be simultaneously launched on a global basis, and most importantly, Dermalive. This synthetic product, developed in Germany, reshapes the face with injections. It has unseated all skin-plumping competitors, such as silicone and collagen. Within a year and a half, it became the injection therapy most often prescribed by dermatologists and surgeons. Will face and body sculpting now overtake cosmetics?

CATHERINE JAZDZEWSKI

Beauty | Magazines

Beauty | Magazines

From 1780 when Le Cabinet des Modes, the first woman's magazine, was published, until 1933, with the publication of Votre Beauté, beauty topics in weekly and monthly magazines were limited to cosmetics "promotions." Since truth-in-advertising laws did not yet exist, this type of advertisement was loaded with promises, and certain products proudly trumpeted miraculous results. For example, a copy of L'Illustration in 1910 boasted the merits of its Moulin pomade that "cures sores, pimples, red spots, itching, eczema, and hemorrhoids. And it makes your hair and eyelashes grow!" As early as 1902, Helena Rubinstein understood that she needed to use promotional advertising to build her reputation. Her first husband, the journalist Edward Titus, wrote her first catchphrases. From 1910 through the 1920s, the practice became widespread, and brands used publicity to advertise their latest innovations and extol the virtues of their products to women of the world, aristocrats, and divas. Crowned royalty lent their names and faces to Pond's Cold Cream publicity campaign in 1924, making history in the advertising world. To promote its Pastel Rouge, Bourjois invented the character Babette, a resourceful urchin with irresistible charm whose adventures were followed in serial form in Le Jardin des Modes. While the magazine did not run a beauty column, Le Jardin des Modes featured a column called "De tout un petit," which contained a hodge-podge of all-purpose hygiene and beauty advice. Since brand names were specifically cited, the roots of editorial advertising can be traced to this time. In 1933, the first magazine devoted to beauty appeared in France: Votre Beauté.

Votre Beauté
cover, 1946.

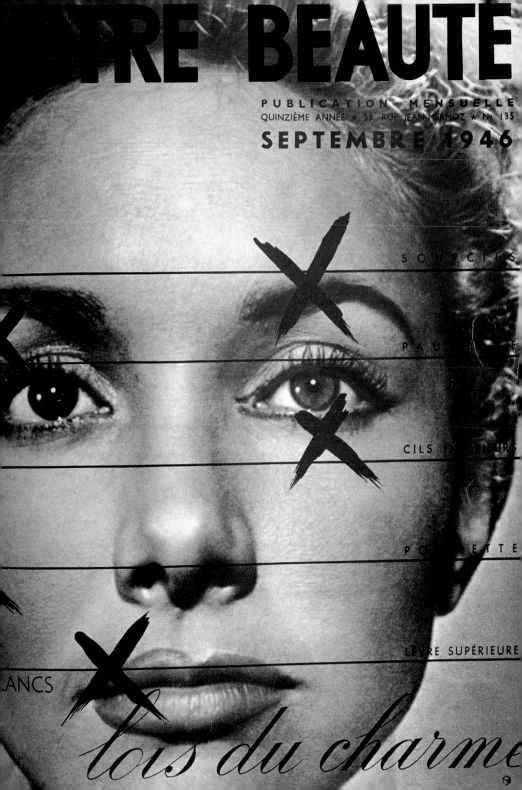

The publisher was Eugène Schueller, the founder of L'Oréal, who became a press baron to help promote his hair products. Votre Beauté introduced women to the permanent, the use of curlers, and haircoloring, while dedicating much attention to body care. This monthly magazine focused on exercises, beauty institutes, and cosmetic surgery. Its editor in chief from 1945 to 1947 was François Mitterrand. In his detailed editorials he encouraged women to make themselves beautiful in order to help their husbands rebuild France. Sold by L'Oréal in the middle of the 1990s, Votre Beauté remains the only major mass-market French magazine solely devoted to beauty.

In the 1940s, promotional ads continued to sell beauty products. After featuring princesses and divas, the major brands turned to actresses for endorsement. The beauty press completely fell under the spell of the cinema, and Hollywood in particular. "The enchanting charm of Hollywood is within every woman's reach. Whether you want to be a blonde like Ginger Rogers, a brunette like Sylvia Sydney or auburn like Barbara Stanwyck, you can find the perfect Max Factor powder, foundation and lipstick to harmonize with your individual coloring." Millions of readers learned the latest makeup and hairstyle secrets in beauty recipes revealed to the magazines by their favorite stars.

Vogue **cover** by Erwin Blumenfeld, January 1950.

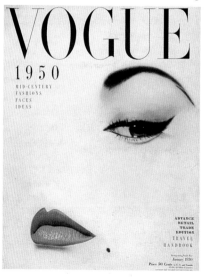

In the 1940s and 1950s in the United States, with Harper's Bazaar and then American Vogue, an extremely sophisticated press emerged, in which photographic creativity reached the height of perfection and invention. Under the leadership of artistic directors and editors in chief such as Alexey Brodovitch, Alexander Liberman, Carmel Snow, and Diana Vreeland, these magazines called upon the talents of the great photographers to symbolize and interpret beauty. Man Ray, Blumenfeld, Horst, and later Richard Avedon, Irving Penn, Norman Parkinson, Henry Clarke, and Terence Donovan presented faces

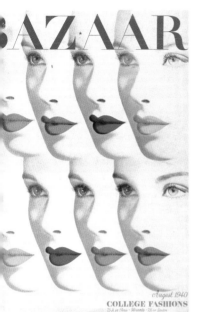

COLLEGE FASHIONS

Harper's Bazaar **cover,** August 1940. Photograph by Herbert Bayer, layout by Alexey Brodovitch.

and bodies in pictures that are still considered some of the most wonderful images of beauty ever created. It was the fashion editors, with their focus on haute couture, who encouraged these images, and the models, such as Suzy Parker, Dovima, and Lisa Fonssagrives, created the personalities, often working on their own makeup.

In the United States, Glamour was the magazine of the 1960s. While Vogue and Harper's Bazaar dominated the mass market in Europe as reference magazines, people in the fashion and beauty industry—helped by the trend-tracking agencies that were beginning to emerge—dissected and cut out articles from Glamour. Published by Condé Nast, it targeted young American girls. Since they had less money to spend, the magazine featured lower priced items. During more than thirty years with Ruth Withney as its editor in chief, Glamour never departed from this approach. Defining itself as a "service magazine," it gave advice and plenty of ideas, and always showed the results gained from problem solving and imaginative thinking. Amy Greene managed the beauty pages from 1961 to 1969 and she added a journalistic tone. She invented the makeover (with before and after shots), employing the young generation of makeup artists, hair stylists, and photographers. Kenneth Battelle, the famous New York stylist who originated Jacqueline Kennedy's bouffant hairdo, created more than three thousand makeovers for the Beauty pages. The work of Vidal Sassoon, Jon Peters, Carrie White, Marc Sinclair, Monsieur Marc, and George Maters all appeared in Glamour. At that time the fee for a hairstyling editorial photo session was $125. Amy Greene chose healthy and energetic young country girls who were photographed at home or in the street. She displayed their metamorphosis while promoting the "natural" look. The magazine would receive more than five hundred letters a day from girls asking to participate.

Working closely with the major cosmetics producers such as Charles Revson, Leonard Lauder, Helena Rubinstein, Elizabeth Arden, Richard Salomon (Charles of the Ritz), and Max Factor, Amy Greene developed an extensive exchange of ideas with them and was even able to make recommendations regarding the development of new products. Glamour's public followed her lead immediately, as in the case of Revlon's Blush-On, which sold 350,000 at five dollars each in one month, a record for the time.

In France, it was Elle that revolutionized the beauty pages. The weekly magazine created by Hélène Gordon-Lazareff was able to elevate beauty and fashion writing from the conformist tone of good taste in which it was steeped. She began making freer use of language. Peter Knapp remembers that "Hélène Lazareff refused to meet with any advertisers. One day, Charles Revson asked to meet her. He was very unhappy with an article by Alice Chavane, which said that his product did not diminish wrinkles. As the magazine refused to offer a retraction, he slammed the door behind him and withdrew his ads. A year later he passed through Paris again. Returning to the magazine's office, he admitted that he could not manage without Elle."

Caroline van de Velde recalls that "it was in 1965 that in-depth articles on subjects written specifically about beauty topics began to appear." The tone of the articles was light, optimistic, and peppered with humor. "The magazine tried to be original by discussing the latest makeup or hairstyle trends such as bangs or eyeliner." Elle adapted the before-and-after idea for the model Nicole de Lamargé, who, by accepting the rules of the game under the skillful direction of Peter Knapp, the artistic director of the magazine, was able to undergo one of the most incredible metamorphoses in beauty journalism. Fouli Elia, Mike Reinhardt, and of course Peter Knapp created Elle's style, and its popularity exploded in the 1970s. With the special accent and tone set by its young, healthy,

Glamour **cover** by Milton Greene, July 1962.

American Vogue, 1967. Alexander Liberman discovered or attracted the greatest talents of the 1960s.

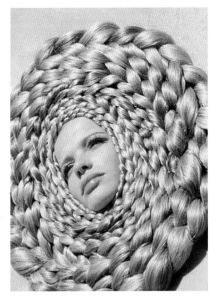

GLAMOUR

July 50c

ial Beauty Issue:

e world's
eatest
irdresser,
nneth
eates for
u:

O NEW
AIRDO'S
m 4
sic sets...

ou or your
dresser
uctions inside

TRA
d-life hairdo
outs

fashion forecast

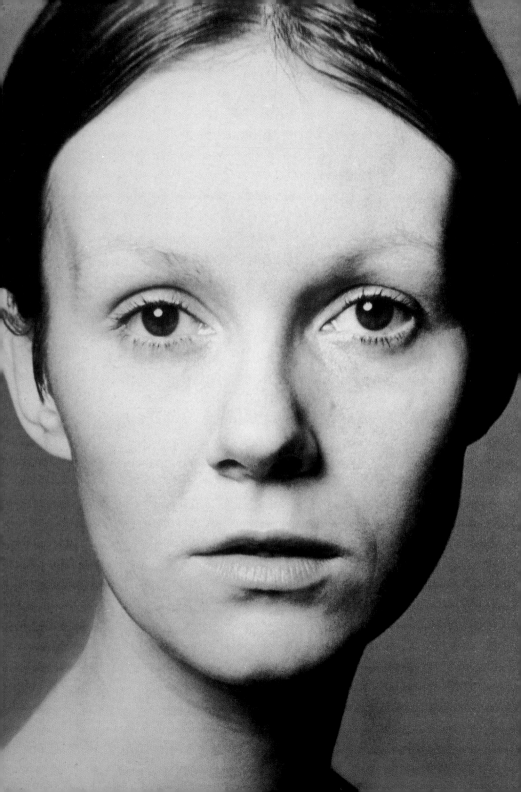

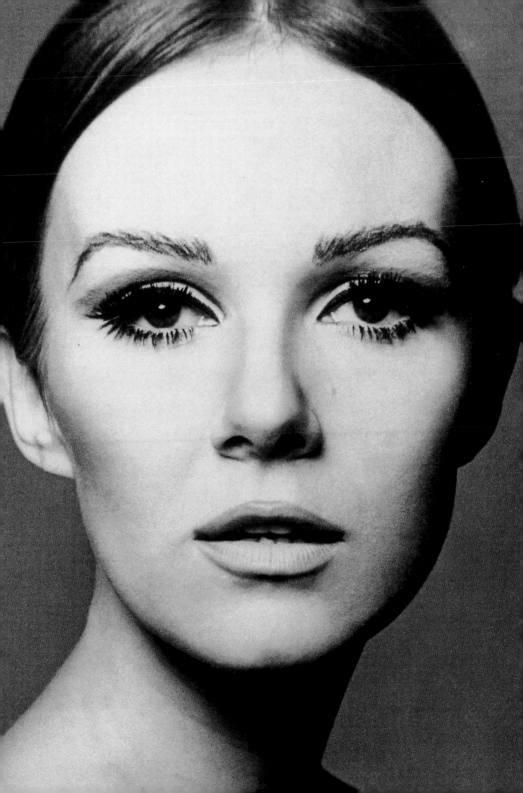

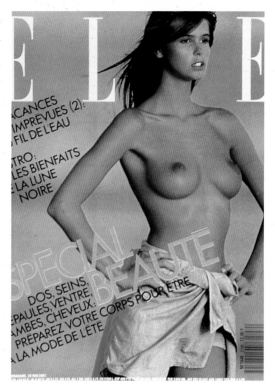

and attractive covergirls, Elle became the launching pad for several generations of rising beauty stars from Brigitte Bardot to Laetitia Casta, including such models as Claudia Schiffer, Estelle Hallyday, and Elle MacPherson, who under the skillful eye of Gilles Bensimon was the subject of one of the most famous beauty magazine covers of today.

The first beauty care articles appeared in the beginning of the 1970s. They coincided with an explosion in the cosmetics market, where brands were multiplying rapidly. From that time on, writers could no longer organize photo sessions, since they were now required to devote them-

Elle cover, May 1987, by Gilles Bensimon. One of the most popular editions of this magazine, with more than 600,000 copies sold.

Marie Claire, February 1996. The duo of François Deconinck, photographer, and Laure Deren, beauty image designer, created some of the most beautiful style images for Marie Claire. Previous pages: "Before-After." Nicole de Lamargé, at left, without makeup, at right, after applying her own makeup. Photograph by Peter Knapp for Elle, March 1966.

selves entirely to writing. A new generation of women entered the scene to manage these pages and they succeeded at enriching the issues. Meanwhile, the major cosmetics and perfume companies became bigger suppliers of magazine advertising. When the French edition of the monthly U.S. magazine Cosmopolitan appeared in 1973, Rosine Vidart, formerly a journalist at Paris Match and RTL, was named head of the beauty and fashion pages alongside editor in chief Juliette Boisriveaud. They turned the magazine into an immediate success, with their direct and personal tone, addressing the readers as friends. Women devoured Rosine Vidart's articles, and the magazines flew off the shelves. Vidart was nicknamed Miss "Out of Stock."

A new generation of journalists had emerged with a whole new approach to handling matters of beauty. In France, Vogue illustrated its features with the magnificent still lifes of Daniel Jouanneau and the modern talents of Guy Bourdin, Helmut Newton, Serge Lutens, Jean-

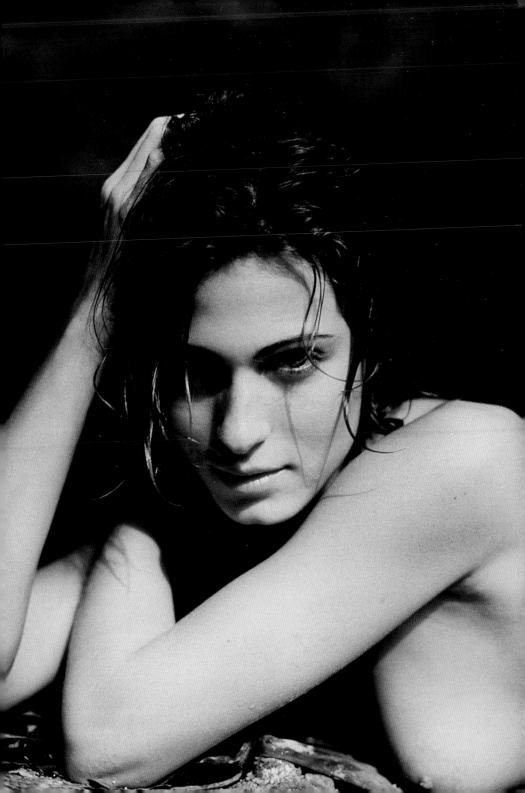

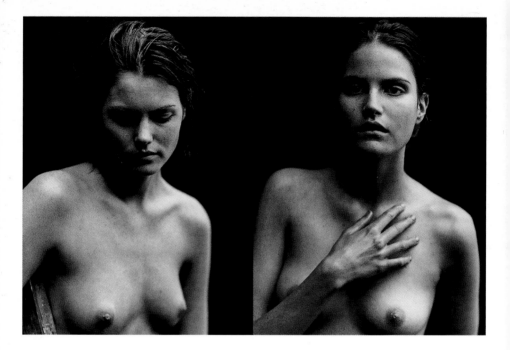

Pages from Vogue **Italy,** August 1997. The press was responsible for initiating a sense of beauty that was more emotional than practical. Photographs by Peter Lindbergh, The Now Beauty series.

Makeup breaks with convention. Stella Tennant photographed by Paolo Roversi for the "Special Makeup" issue of Vogue Italy in 1999.

Following pages: **Pages from** Vogue **Italy,** October 1999. To suggest, to imagine: a creative approach as opposed to the American consumer approach. Stephanie Seymour photographed by Ellen von Unwerth.

Baptiste Mondino, and Mario Testino, who all exhibited a spirit of elitist beauty. Under the leadership of Thérèse Hamel, Marie Claire developed a beauty column for its increasingly sophisticated readers, creating an annual prize in 1985 for cosmetics—the Prix d'Excellence de la Beauté—and produced Marie Claire Beauté from 1986 to 1989 in response to major demand from the French market. Under the competent leadership of Evelyne Vermorel, the beauty pages of Madame Figaro combined well-written text with professional beauty images created by Pierre Berdoy and Tyen, who perfected the quality of close-up shots to best display makeup and other products. In Italy, Vogue was managed by the talented Franca Sozzani, who further modernized beauty. She published images from the great fashion photographers such as Paolo Roversi, Peter Lindbergh, and Steven Meisel. The free spirit of this laboratory of images generated some of the most stunning beauty photographs ever.

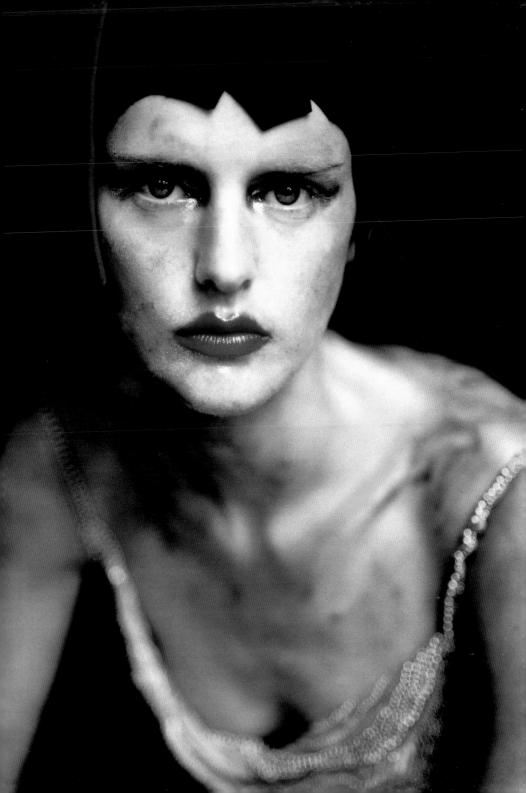

Opporsi alla discesa libera dei tessuti epidermici? Invertire la freccia che segnala lineamenti in ribasso? Le vie del lifting sono infinite: oltre a quello chirurgico c'è il lifting elettronico, quello cosmetico...

lift up

N iente capelli spioventi ai lati del viso: dopo i quaranta, ogni centimetro all'insù è un anno di meno». Lo diceva un celebre parrucchiere degli anni '60, Alexandre, grande consolatore la donna e amico delle regine del jet set, da Grace Kelly alla duchessa di Windsor, leggenda vit le sue accconciature raccolte, ufficialmente per esaltare diademi e nimbi di fiori, in realtà per lasciare libero il viso delle auguste clienti, non sempre giovanissime. Sapeva il fatto suo, il divino coiffeur. La tensione dei capelli su tempie e nuca, sottilmente dissimulata dalle acconciature, produceva sul viso l'effetto esteso tipico del lifting, dicono i maggiori di un lifting. Insomma, qualcosa di simile a quanto che in teoria si usano sono le parrucche di, senza per non farsi annunziare la faccia dai toni di luce.

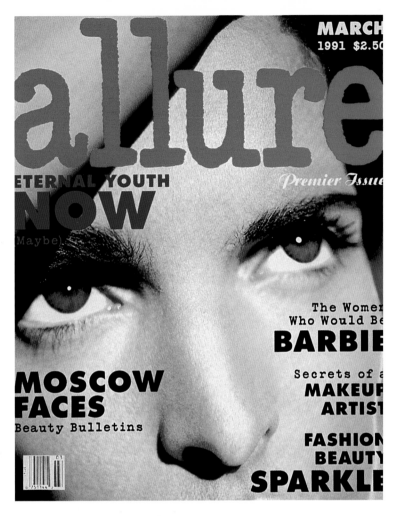

MARCH
1991 $2.50

allure

ETERNAL YOUTH
NOW

Maybe

Premier Issue

The Women
Who Would Be
BARBIE

Secrets of a
MAKEUP
ARTIST

MOSCOW
FACES
Beauty Bulletins

FASHION
BEAUTY
SPARKLE

First cover of Allure, March 1991. From the outset, the tone was direct and incisive. Photograph by Sante D'Orazio.

In England, the magazine The Face, beginning in the 1980s, revolutionized the image of beauty by replacing the archetype beauty with shocking images of young people that did not fit in with the more conventional ideal aesthetic. The Face removed itself from the majority of "hype" magazines, with an approach that blended street subculture with a more media-orientated culture, along with a self-questioning style. The beauty and fashion images were provided by the big names, including Jean-Baptiste Mondino, Mario Testino, and Mario Sorrenti, and newcomers including Marcus Piggot, Vincent Peters, and Jonathan

West. They struck the tone of the new generation and contributed to the evolution of taste by presenting new beauty criteria.

Throughout Europe and the United States, these journalists and beauty editors offered a new orientation to the beauty pages, proposing new approaches and more personal styles, adapted specifically to each publication. While beauty had become more scientific, writers were more accurate about the products they discussed, driven by the demands of increasingly savvy readers. Their articles delved deeper and were more technical. They provided precise information, advocating objectivity. The writing culture evolved in line with greater product specialization, with beauty pages shifting toward scientific journalism.

Readership rose, and in the face of success, the links between writers and advertisers strengthened. Nothing was spared in trying to seduce and convince journalists of a product's effectiveness. Trips and gifts accompanied the presentation of each new product, and reprisals were fierce if the product was not featured according to the advertiser's expectations. As a result of this relationship, trust in the press was tarnished and it lost some of its credibility. At the same time, the number of magazine titles multiplied. At the end of the 1980s, more than twenty magazines—including two for the industry, Women's Wear Daily in the United States and Cosmetic News in Europe—included articles on beauty that were often no more than long, boring lists of products. How could the industry be revived?

Allure originated a shock wave in the United States. The first American magazine dedicated exclusively to beauty was launched in 1991 by Condé Nast. Its editor in chief, Linda Wells, changed the course of the industry. From its first issue, the magazine set a new tone: shocking, seductive, provocative. Both impertinent and practical, blunt and glamorous, it boldly stated and demonstrated that pink is awful on redheads, that foundation emphasizes wrinkles, and it did not hesitate to highlight any displays of bad taste by minor or major actresses. Every article exhibited journalistic inquiry with illustrations covering the story. It created a "people" column, a trend popular at the end of the twentieth cen-

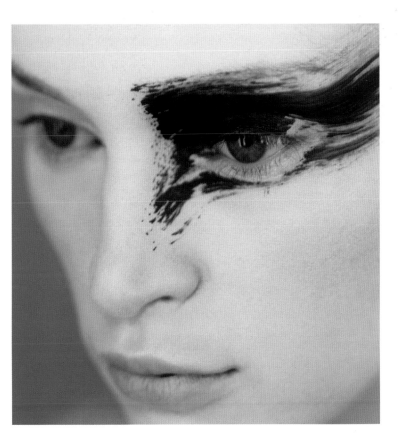

The graphic eye for Vogue France, 1997. Seeking originality, looking for new language, halfway between experimental and ethnic. Makeup by Topolino, photographed by Éric Traoré.

Surface **magazine**. In the studio, one turns from materials and products and the market follows. Photograph by Torkil Gudnason.

tury. Ten years after it was created, Allure has become more subdued, but its witty eloquence remains intact and it has influenced the French press in its quest for realism.

During a slump in the 1990s, the beauty press went through an identity crisis, as profitability became more important than imagination. Beauty was no longer for dreaming, it had become consumer-oriented. Newcomers such as Dutch, I.D., Wallpaper, and Frank have tried to reinvent the language of beauty while claiming responsibility for a marginality that is already conventional.

CATHERINE JAZDZEWSKI

Beauty | Perfume

Beauty | **Perfume**

The art of perfumery originated at the end of France's Second Empire. New technological advances and chemical discoveries made it easier to extract essences, isolate and synthetically reproduce olfactory molecules, and create artificial aromatic essences. Several factories were built, notably in Switzerland, but Grasse, which produced most of the agricultural raw materials, remained the world center of the industry. It was there in 1898 that Antoine Chris built the first large factory, which used new extraction techniques. The great producers who supplied perfumes to the rich and famous included: Germany's Eau de Cologne, France's Houbigant, L. T. Piver, Lubin, Roger and Gallet, and Guerlain, England's Floris, Penhaligon's, and Geo. F. Trumper, and from 1886, America's Avon. At first there were six basic fragrances: rose, jasmine, orange flower, violet, tuberose and black currant. The moral and hygienic codes of this rather puritanical era frowned upon the ambergris and musk so dear to the eighteenth century, finding only light floral perfume waters acceptable. The fragrances were often mingled like bouquets. They were not applied directly to the skin, but were instead sprinkled on handkerchiefs, shawls, gloves, or writing paper. Guerlain's L'Eau Imperiale was created in 1853 for the Empress Eugenie, and Penhaligon's various blends are some of the last of this type still on the market.

Chemistry paved the way to almost infinite creative possibilities. Previously limited to combining natural essences, complex fragrances could now complement and enhance each other, blending imperceptibly together in a clearly defined sequence. New scents were created, olfactory harmonies born from the imagination, totally unlike any of the scents found in nature.

Eau Impériale, Guerlain, 1853. Decorated with imperial bees, the upper portion of this flacon created for Eugénie recalls the column in the place Vendôme in Paris.

Hammam Bouquet, Penhaligon's, 1872. At the height of the colonial period, the late nineteenth century was smitten with exoticism.

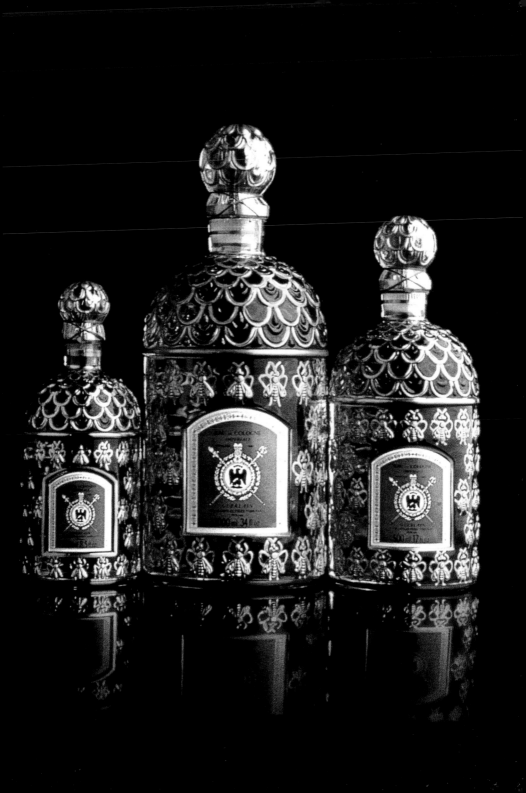

Formerly a mere craftsman, the perfumer became an artist. He was sometimes portrayed by the troubling image of Huysmans's Jean Floressas des Esseintes, a demiurge in the world of emotions, all the more intriguing because of his impalpable, fugitive presence.

Paul Morand wrote: "In 1900, people believed in science, machines, progress, socialism, color photography and the inexhaustible riches of this planet." The year 1905 marked the real beginning of the twentieth century, the advent of the modern world. Symbolically, it was the year that Colette cut her long braids and the Austrian Berta von Suttner became the first woman to win a Nobel Prize (for peace). Gradually, "the right to dare anything" espoused by Gauguin penetrated into the contemporary mind-set. Considered "wild beasts" by conventional disapproving critics, Matisse, Derain, Vlaminck, and von Dongen scandalized the Autumn Salon.

In the realm of perfume, one character stood in the forefront: François Coty, who stylishly carried on the major innovations of Houbigant and Guerlain when he introduced L'Origan, also in 1905. Coty was a self-taught genius, visionary and ambitious. He was introduced to perfumery by Antoine Chris's son, Leon, who headed the largest factory in Grasse. Coty was more than just a talented perfumer. As printed on his calling cards, he was "an artist, industrialist, technician, economist, financier and sociologist," a true orchestra of a man. With L'Origan, he boldly took a new path and gave perfumery the structure and impetus it had formerly lacked. Presented in a simple bottle crafted of fine crystal by Baccarat, L'Origan was both flowery and spicy, with a harmony of intensely scented flowers, dominated by a carnation-green accord. In the words of Edmond Roudnitska, "L'Origan is the first violent perfume of the century," marking the beginning of an era of great perfumes that did not attempt to reproduce nature, but succeeded in creating an abstract and entirely novel fragrance from many elements.

Its success was instantaneous. Roudnitska tells how he went to an opera premiere as a young man the week after L'Origan's introduction and entered a hall completely engulfed in its scent.

L'Origan, François Coty, 1905. Like the Fauvist paintings, L'Origan created a sensation with its strength and novelty before it was widely imitated.

Coty had an exceptional business sense and tremendous flair. He quickly realized that the perfume industry had to penetrate outside the circles of the idle rich to the growing middle and upper middle classes. To reach this broader market, he had to diversify his products and devise new methods of manufacturing, presentation, advertising, sales, and distribution. But, Coty remained committed to the aesthetic side and strove to provide the best quality at the best price. In the spirit of his time, he made use of all the possibilities offered by the flourishing growth of the decorative arts.

The bottles of other perfumers were still very conventional and uniform, bearing a strong resemblance to pharmaceutical vials. Coty was the first to dramatize the connection between the design of the flacon and a sense of intoxication.

"A perfume should attract the eye as much as the nose, because it has an appearance as much as a scent." In 1908, Coty persuaded the jeweler René Lalique to design his bottles. Lalique was famed for his extraordinary enameled jewelry, worn by all of Europe's royalty and high society, including Sarah Bernhardt, who flaunted his creations on stage. He was fascinated by the challenge of working in glass. Intrigued by Coty's request, this goldsmith, whose specialty was one-of-a-kind, intricately worked pieces, quickly perfected semi-crystal glass, which was lighter and easier to handle than heavy Baccarat crystal. He also developed new methods of molding, pressing, and blowing glass. For the first time, his pieces were quasi–mass produced, but a craftsman's finishing touches assured that each had the value and personality of a work of art.

Lalique. This glass vignette inaugurated a collaboration between Lalique and Coty in 1908 that was stormy at times but always fruitful (L'Effleurt).

François Coty: to everyone who knew him he was a genius.

Created in 1909 for the perfume Cyclamen, a bottle decorated with dragonflies launched a lasting, fruitful collaboration. From labels to signs, from powder boxes to display shelves, the partnership culminated in Lalique's first architectural work, for the Coty building in New York. He designed windows and pressed glass panels with poppy designs, still

visible today on the facade of Bendel's department store. Engraved and printed by Draeger, the foremost art printer, Coty's packaging was also sumptuous. Embossed paper imitated sharkskin, embroidery, and Dresden china; it was highlighted with fine gold and padded with silk and satin, conveying every emotion in skin tones that ranged from carmine to soft pink.

The same attention was lavished on derivative products and cosmetics, which were far less expensive and more widely sold. Echoing that famous powder in its round gilt box decorated with white and gold powder puffs, colognes, talcum powder, soaps, bath salts, hair cream, lotions, powders, lipsticks,

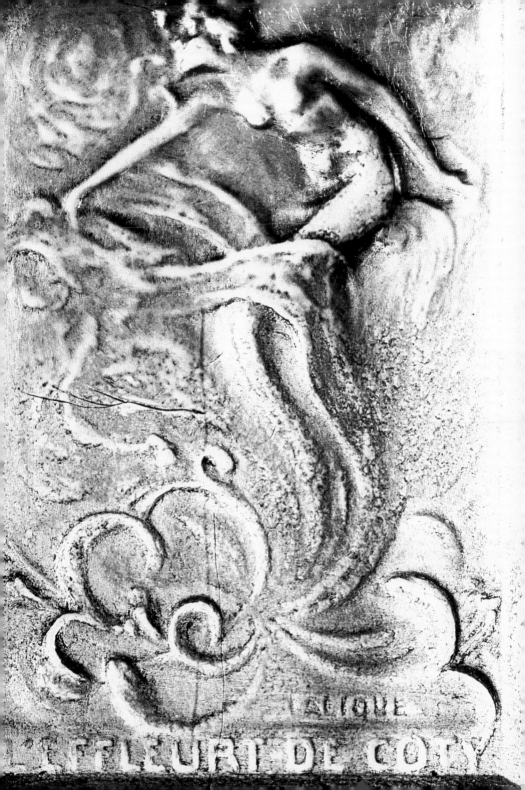

LALIQUE

L'EFFLEURT DE COTY

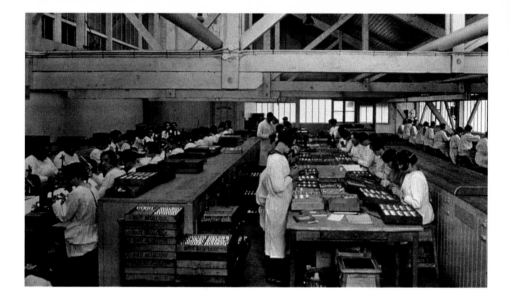

Coty factories. From La Cité des Parfums in Suresnes, Coty's empire spread throughout the world.

and rouge were all presented luxuriously. These products were scented with Coty's fragrances, making his perfumes, and the dreams they inspired, available to every woman.

A visionary with a sure tactical sense, Coty systematically worked on new selling strategies. Samples, gift boxes, varied and ever-changing packaging, unique window arrangements, and elegant display cases attracted clients. Meanwhile, advice and strict instructions were issued to train and direct representatives and retailers. Advertising copy spoke to the imagination, stimulating a woman's desire to buy by identifying her with the product offered. Coty immediately laid siege to the international market, opening a branch in Moscow in 1910. He set up Coty Incorporated in New York in 1913, which in turn established distribution companies in Europe and Latin America. Nothing was left to chance, and in fifteen extraordinarily successful years, Coty managed to capture the still new mass market and create the first perfume empire. Coty had streaked across the history of perfume like a brilliant meteor, but his fragrances no longer perfume the air.

Of the fragrances of that era, only Caron's Narcisse Noir and N'Aimez que Moi and Guerlain's L'Heure Bleu and Mitsouko remain.

Ernest Daltroff opened the little Caron perfume shop in 1904. Daltroff, who came from a wealthy, cultivated background, did not have a chemist's training. Perfume was a calling for him; since childhood his sense of smell was so powerful that his mind registered scents before any other impressions. He loved to travel, and returned home with a vast range of aromas, linked in his mind to all manner of discoveries and emotions. In his small laboratory in Asnières, which was soon to become a completely separate factory, dressed in a big blue gardener's smock and wearing an old cap, he worked like an artist, composing many of the most marvelous creations of our century.

L'Aimant bath salts, François Coty. He was the first to think of deriving other products from perfume.

Following pages: **Flacons created by Baccarat.** Between 1897 and 1907, daily production increased from 150 to 4,000. Both perfumers and couturiers called upon Baccarat to create crystal containers for their precious fragrances.

Patou, *Amour Amour,* 1925.

Alphonse Gravier, *L'Envoûtement,* 1925.

Houbigant, *Subtilité,* 1919.

Coty, *Adopté par la reine douairière d'Italie,* 1909.

Guerlain, *Jicky,* 1947.

Coty, *Muguet,* 1916.

Gellée Frères, *Pour être aimée*, 1911.

Caron, *L'Infini*, 1925.

Parfise, 1925.

Molyneux, *Rue Royale*, 1940.

L. T. Piver, *Gao*, 1925-1927.

Schiaparelli, *Le Roy Soleil*, 1945.

Daltroff was certainly the most subtle perfumer of his time, whose work most closely imitated that of a painter or musician. After several fruitless attempts, in 1911 he developed Narcisse Noir, a sumptuous floral bouquet with a dominant note of orange flowers. Warmly sensuous, this perfume conquered the American market, where Daltroff, assisted by his wife and colleague, Félicie Vanpouille, focused his selling efforts. Like Coty, he immediately became an enduring symbol of French perfumery in the United States. Hollywood paid him living homage in 1950 when Gloria Swanson, holding the round Baccarat bottle topped with its shadowy black flower, languidly enunciated the name of the fragrance in Billy Wilder's *Sunset Boulevard*. Narcisse Noir was followed in 1912 by L'Infini, a spicy fragrance that was more novel than pleasing. N'Aimez que Moi was introduced in 1916 in the midst of the war. This tender bouquet, blending childlike violet candy notes with feminine lilac, iris, and ambergris, was the perfume young soldiers on leave gave to their sweethearts as a token of their faithfulness. One perfume followed another, each composed like a concerto or a novel, telling a story based on reminiscences as much as evocations. The scents spoke to the soul more than to the body; they were almost tangible, brimming with their own life, to be inhaled with eyes closed as if envisioning a mental book of images.

Gloria Swanson in Billy Wilder's masterpiece *Sunset Boulevard*.

Narcisse Noir, Caron, 1912. Sensuous and floral, this perfume was introduced in the United States by one of the master French perfumers, Ernest Daltroff, the founder of Caron.

Jacques Guerlain worked like a professional. Marrying instinct and reflection, he allowed his plans to ripen over time. Après l'Ondée, introduced in 1906, remains an ideal example. It so powerfully and delicately evoked the scent of fresh rain on soaked grass that seventy-seven years later, it guided Saint Laurent in the composition of Paris, his bouquet of roses.

Challenged by the novelty of L'Origan, Jacques Guerlain turned to oriental and floral notes, which he refined and refreshed. In 1912, he introduced a creation that was not just a variation. The majestic L'Heure Bleu was an entirely new phenomenon.

Guerlain recounted how he was captivated by the serenity emanating from the twilight's blue glow while strolling

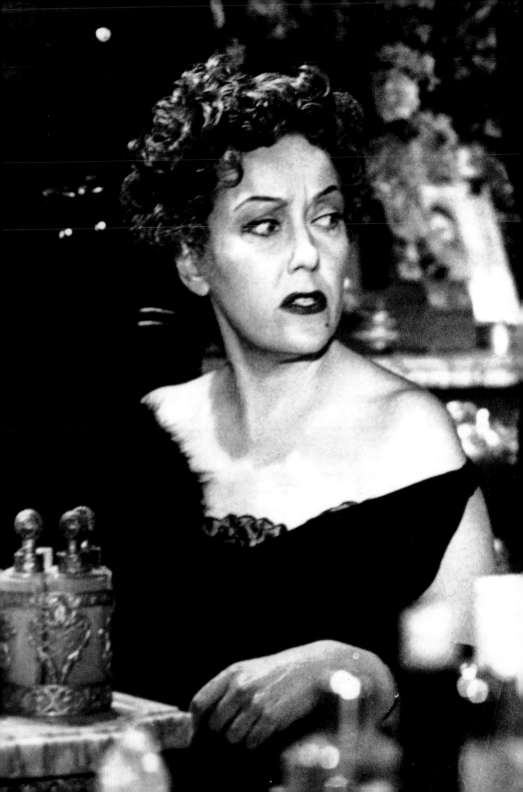

Jacques Guerlain, the creator of the house's greatest perfumes.

along the banks of the Seine at the end of the day during the summer of 1911. It was a beauty so pure that it conveyed what Nerval called "the black sun of melancholy," a looming nostalgia for the fleeting sweetness of the close of an era. "I felt something so intense that I could only express it in a perfume," said Guerlain, who described the magic of L'Heure Bleu in his notes: "The sun was setting, but night had not yet fallen. It was that uncertain hour. In the deep blue light, every-thing—the shivering leaves, the lapping water—seemed concentrated on expressing a love, a friendship, an infinite tenderness. Suddenly, mankind was at one with things, for a moment in time, the time of a perfume." Powdery, velvety, both restrained and sensuous, the timeless L'Heure Bleu exhales, touch after touch, the impressionist charms of Monet's paintings.

L'Heure Bleue, Guerlain. A delicately fashioned poem in a Baccarat bottle, it was one of the first fragrances designed in 1912 by Raymond Guerlain, Jacques's nephew.

Meanwhile, the impetuous Coty was launching one new product after another at dizzying speed, earning the attention and admiration of even his fiercest competitors. He created twenty perfumes after 1904, including L'Or, in 1912, a harmony of blond tobacco scents. Chypre, introduced in 1917, was another sensation. Its woody-powdery fragrance created such a perfect accord that its name became a generic term for a new and prolific fragrance family based on oak moss. The Belle Époque was over; flowers seemed too mawkish, oriental notes too languid. Chypre had the power and character necessary to attract women during the inter-war period.

Two years later, Jacques Guerlain, always receptive to new trends, expanded the potential of Chypre by blending it with an aldehyde with a peachy odor, and a few pinches of pepper and cinnamon. The new master had created the mysterious Mitsouko perfume that enchanted men as much as women. Chaplin drowned himself in it and Diaghilev had it sprayed on curtains and hangings wherever he went so that every place would smell like home. The perfume was named after the heroine of Claude Farrère's melodrama, which pitched love against honor, with the Russo-Japanese war as a backdrop. Like Madame Butterfly, she entranced the West with her exoticism and passion.

It was also in 1919 that Caron introduced Tabac Blond, an avant-garde perfume with a dominant leather note, a pioneering salute to those shockingly tomboyish girls who had vacated the boudoir for the smoking room. From their long cigarette holders drifted the disturbing swirls of their androgynous charms.

The aftermath of the Great War gave way to a heady zest for life. While American and France were victors, the conformist, bourgeois society of the Belle Époque was irrevocably vanquished.

Mitsouko, Guerlain. With its peachy and oak mousse accord, this innovative perfume of 1919 has survived the years.

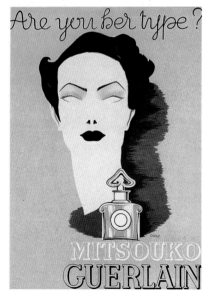

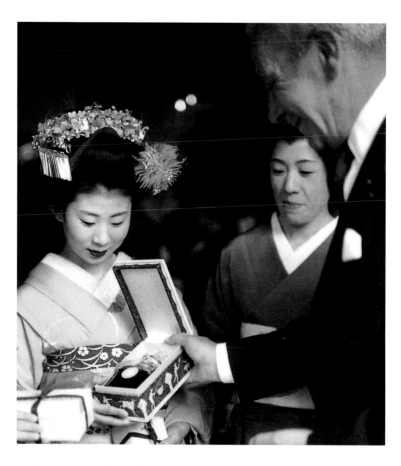

Raymond Guerlain, in Tokyo in 1962. From L'Heure Bleue to Chamade, Raymond Guerlain designed the most beautiful flacons of this illustrious house.

Freedom in all its guises and expressions marked the day. Insolent, virulent, and grating, the period between the wars was exemplified by the Dada manifesto of 1918, which raged "against all systems" and set the tone. The world was in the midst of a political, technological, cultural, and social revolution. Nothing would ever again be as it was "before." In the midst of this tumult, the irreversible emancipation of women lent a fresh and singular dynamism to all these trends. This movement called for a radical break with the past, and women joyfully started over with a clean slate. The new code was in evidence everywhere, exemplified by a new perfume with a lapidary name: No. 5. An austere, cubelike bottle, a label as simple as an office stamp, a box as stripped down as industrial packaging, a number instead of a name—

there was nothing about it that invited a woman to call attention to herself or project herself over another. It was a fragrance that offered each and every woman a different idea of who she really was.

The perfume, created by Ernest Beaux, one of the era's greatest "noses," had over eighty ingredients and was unusual in its high level of aldehydes, which gave it the greatest penetrating power of any fragrance to date. "There's never been a perfume like this before," said Chanel when she discovered it in the laboratory. "It's a woman's perfume that smells like a woman." Switching perfumes when changing clothes, according to the time of day and social obligations, was a thing of the past.

Reaching out beyond her privileged clientele, Chanel gave a voice to the situation of the contemporary woman, whose duties were professional and civic, not just social. The notion of the ornamental, flowery, or childlike woman, the ingenue or the temptress, sequestered in a world of flounces and insipidity, was banished. It was replaced by what Chanel herself embodied: a woman who works, thinks, and makes decisions without yielding her rightful claim to be beautiful and attractive "while doing her job." Just as a Chanel suit can be worn from morning till night, her perfume was presented as a permanent statement of a chosen way of life. The number 5 was Chanel's "magic number," and it

Marilyn Monroe. At night, all she wore was five drops of No. 5.

No. 5, Chanel. Launched in 1921, it created the same revolution in perfumery that the little black dress created in fashion.

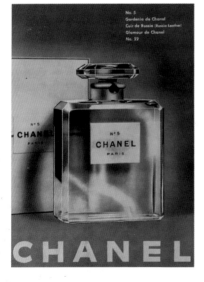

sealed a pact between couture and fragrance, style and scent, that has never been broken. In the years that followed, Ernest Beaux, working systematically with Chanel's beloved ylang-ylang, concocted several superb fragrances, each very personal and very distinct. No. 22 was less powerful and more citrusy than No. 5; Cuir de Russie in 1924 was wild and dark, almost masculine; Gardenia in 1925 was the only perfume to actually reproduce the rich, sweet natural fragrance of its namesake. These remarkable creations were ahead of their time, making no concession to fashion. They disappeared from the market for a while, but were happily restored in 1983.

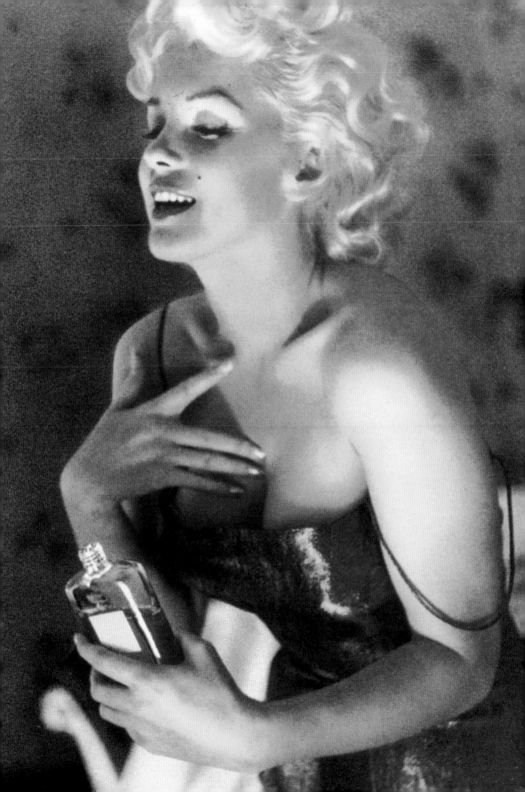

Le Mouchoir de Rosine, Poiret. Paul Poiret was the first couturier-perfumer.

Jacques Polge, Chanel's current "nose," has decided to protect their unique character by limiting their sale to Chanel boutiques.

The press never really questioned whether the couturier was "qualified to produce perfumes" (*L'Excelsior*, 1927). What had once seemed audacious became a routine practice among women. Chanel many have been the most assertive, but she was not alone. In the buoyant atmosphere of the Années Folles, other famous couturiers were close on the heels of established perfume houses. Like Chanel, Lanvin, Patou, and Worth created their own perfume companies, integrating autonomous laboratories and attracting the most creative "noses." They called upon the industry's independents, such as Bertrand Roure in Grasse, Firmenich and Givaudan in Switzerland, Naarden in Holland, and Haarmann and Reimer in Germany, companies that to this day have an almost complete oligopoly in world production. The high quality of these products swept away the doubts of traditionalists. Colette, who adored perfumes and fashion, summed up the consensus: "The couturier is better that almost anyone else at knowing what women need. . . . Couturiers were becom-

ing more and more like artists every day. . . .

With the couturier-perfumer, fragrance can become more than an orchestration of elegance; it can, and it should, render the melodic theme, the clear, direct expression of the trends and tastes of our era." Or, as Maurice Sachs put it: "It's just another movement"—like the one Chanel launched with her "little black dress."

Musicians, dancers, painters, writers, movie makers, directors, actors, athletes, and designers all participated in a whirlwind of activity, set into motion on all fronts by leaders, all under forty years old. Paris stood at the center of an international movement that attracted all the creative young minds of the day, whether well-off or impoverished. The nouveaux riche arrived from the booming shores of America alongside exiles from Stalin's Russia. Following Picabia's injunction, the generation of the 1920s lived for pleasure, reinventing its own hierarchy of values from moment to moment. Among these was the discovery of sports, the love of the open air, sun, and sea, splendidly embodied in the tennis champion Suzanne Lenglen, Jean Patou's muse, whose star was at its zenith in 1925. Patou drew inspiration from men's sporting gear for his first "sportswear" collection, embroidered with his initials. His designs attracted women, usually American and English, who, like the characters in *The Great Gatsby*, wore all their clothes, "whether suits or evening gowns, as if they were sportswear." Just as Patou's geometric, relaxed styles reflected the era so eloquently described by Fitzgerald, the names of his perfumes struck the same note. "Amour, Amour, Que Sais-Je, Adieu Sagesse: in three names, at three moments, Jean Patou explained the shift in mentalities and summed up an entire era," said Maurice Sachs. During the high season, Paris and New York's fashionable society gathered in Deauville, Biarritz, and Monte Carlo. Patou opened boutiques in these locales and followed his rich, self-indulgent clients, who were greedy for festivities and passionate emotions, like Louis Aragon's young, eccentric mistress Nancy Cunard, or the sublime Louise Brooks, whom he dressed both for the streets and the stage.

Patou was the flamboyant grand seigneur, overflowing with spirit, wit, and ideas. He made the sun shine and the rain fall on fashionable society, like the two Hispano-Suizas that escorted him each season: a white one with a black chauffeur for sunny days and a black one with a white chauffeur for overcast days. Patou hired Henri Almeras, formerly with Paul Poiret, to develop his perfumes. Patou was an admirer of Poiret, fashion's genial lord of the manor before 1914; he was the first couturier to think of subtly linking haute couture and perfume, without any overt, immediately obvious connections. Christened Les Parfums de Rosine in honor of his daughter, this line of fragrances in their enchanting bottles was reserved for an exclusive clientele.

In 1927, Patou introduced Huile de Chaldée, the first tanning oil, coupled with a perfume by the same name. In 1929, he brought out Le Sien, the earliest unisex fragrance, for which Patou himself wrote the advertising copy: "In sports, men and women are equal. In sport fashions, an overly feminine perfume rings false . . . Le Sien is appropriate for a man, but goes equally well with the personality of the modern woman who plays golf, smokes, and drives her car at 80 miles an hour."

Joy, Jean Patou. His magical formula has not changed since 1930.

Huile de Chaldée, Jean Patou, 1927. The first tanning oil is still one of the most popular today.

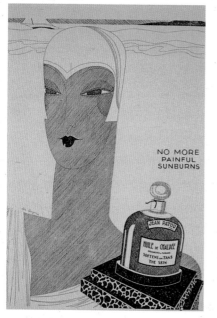

NO MORE PAINFUL SUNBURNS

That same year, Patou commissioned the architects Süe and Mare to design a perfume bar for his boutique on rue Saint-Florentin, where clients could have their very own fragrances blended, just as they could order a cocktail in ultra-fashionable watering holes. Patou's greatest success came in 1930 with Joy. In the midst of the Depression, when his regular American customers were canceling orders, Patou decided to send a present created especially for them. The gift was Joy, a glimpse of hope and a marvelous kick in the teeth to low spirits. More than ten thousand jasmine flowers and 350 roses were required to produce one ounce of Joy, which was perfected by Henri Almera, still the firm's reign-

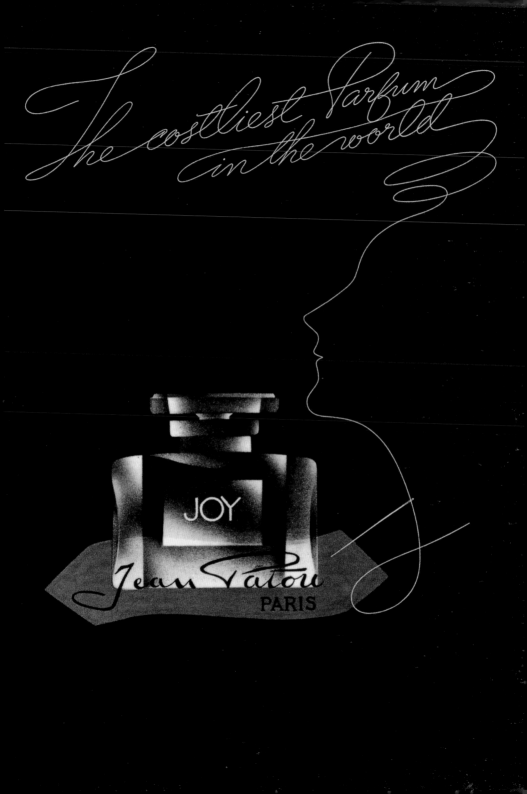

ing perfumer.

The sultry Elsa Maxwell, the master's friend and advisor and the high priestess of fashion and festivities, turned what might have been a drawback into an advantage, by engraving a provocative slogan. In its crystal bottle designed by Louis Süe, who took an architectural approach that paid homage to the golden number, Joy became, and remains today, "The world's most expensive perfume."

Jeanne Lanvin was the third great name of this epoch. She was older and more traditional, and her clients included the elegant, refined upper middle class. After several attempts, including My Sin in 1924, a success in the United States, she created a masterpiece in 1927 with Arpège. Lanvin, who adored her daughter Marie-Blanche, could think of no better present for her thirtieth birthday than a new perfume with a lasting, sumptuous bouquet of scents. When she discovered it in the laboratory of its creator, André Fraysse, Marie-Blanche, a musician, compared it to an arpeggio, that chord whose notes ripple out one by one. The designer Armand-Albert Rateau, who was in charge of Lanvin's decor, designed the famous ball-shaped bottle. It was fashioned by Lalique in black glass and decorated in gold by Paul Iribe with a design showing Jeanne and the infant Marie-Blanche. A faithful follower of Lanvin, Louise de Vilmorin, composed this poem in the shape of the Arpège bottle: "Arpège, musical perfume, with a bouquet of notes rippling from cool to warm, Fabulous success, it smells all at once of flowers, fruits, fur and foliage. It murmurs a happy song . . . Good fairies would advise you, 'Keep Arpège at your fingertips.'" Although Joy still retains its jasmine note, the original fragrance of Arpège disappeared in 1993, when marketing dictated the modification of the formula to appeal to the olfactory expectations of our own fin de siècle.

Although the Années Folles saw the advent of the couturiers-perfumers, the scent of Shalimar still clings to 1925, the turning point and symbol of the era. Like all of Guerlain's perfumes, Shalimar (which is a translation of the Sanskrit "dwelling place of love") recounts a story. It tells of the wondrous Mogul gardens where Shah Jahan and his beloved

Arpège, Lanvin, 1927. A tale of everlasting love between Jeanne Lanvin and her daughter.

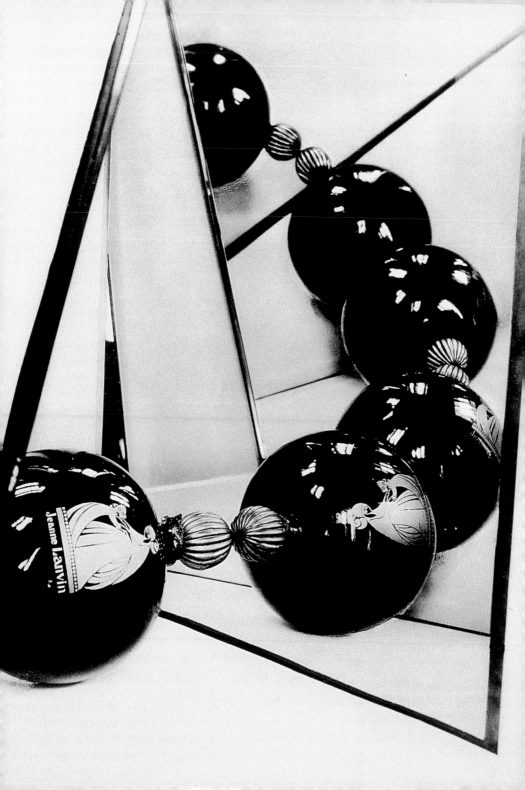

Mumtaz Mahal spent divine interludes until her untimely death. "Like a solitary tear suspended on the cheek of time," according to the verse of the great Rabindranath Tagore, the Shah immortalized his beloved by building the most magnificent of all mausoleums, the Taj Mahal, on the banks of Lake Shalimar.

Moved by this tale, which was told to him by a maharajah visiting Paris, Jacques Guerlain conceived a perfume as an homage to this love. Sensuous, powdery, and deep, but livened with the lemony tang of bergamot, Shalimar was the offspring of Jicky, to which Guerlain had added a touch of chemistry's newly created ethylvanilline, one of a growing range of vanillalike essences. After an essential rebalancing, Shalimar was ready in 1921, but was kept under wraps awaiting the major event of 1925, the International Exposition of Decorative Arts.

Jeanne Lanvin's bathroom. Armand-Albert Rateau was Lanvin's anointed decorator, for her apartments as well as her boutiques and flacons.

Designed by Raymond Guerlain, the bottle of draped crystal in an oriental style was in marked contrast to the pure cubist forms that prevailed in the exhibition; the perfume nevertheless carried off the first prize. It was as voluptuous as a silk gown with an outrageous décolletage, to use the words of Jacques's grandson, Jean-Paul Guerlain. Worn by Raymond's wife during a Paris–New York crossing on the Normandy, Shalimar devastated the passengers. It took off like a rocket in the United States before succeeding in France. Along with Jicky, it remains Guerlain's best seller.

The Daltroff-Vampouille duo practiced an elitist business policy, based more on confidentiality than

Or et Noir, Caron, 1949. Issued in limited quantities, this Baccarat bottle was completely covered with gold leaf.

publicity. Instead, Daltroff went in person to present his products to department store buyers and delivered them in droppers. He had an assured success in 1922 with Nuit de Noël, which chased away winter's chills with a fragrance of untamed, oriental luxury. The perfume was in sharp contrast to Baccarat's black bottle circled with a gilt band, which the fashion of that time demanded.

Its rich, complex harmony influenced numerous later creations that reinterpreted Nuit de Noël by emphasizing one note over another. Perfumes as different as Bois des Îles (Chanel, 1926), Shocking (Schiaparelli, 1937), Madame Rochas (1960), and Calèche (Hermès, 1971)—the latter two created by Guy Robert, who was their ardent admirer—descended from Nuit de Noël. In 1927, as a souvenir of a happy vacation, Caron named Bellodjia after the village of Belladgio on the banks of Lake Como; its scent was unique, with a dose of carnations over a vetiver base.

In 1921, the venerable house of Molinard, established in Grasse in the middle of the nineteenth century, brought itself up-to-date with Habanita, so named because it was originally intended and used for scenting cigarette paper to moderate the odor of tobacco. The provocative Habanita, with its vanilla, musky, spicy notes, was promoted by advertisements claiming that it was the world's longest-lasting perfume. It spoke to the 1920s vogue for exoticism. It was a period attracted by the Orient of legends and the South America of postcards (best known for its rhythms and billionaires). Lalique designed numerous bottles for Molinard, including Îles d'Or for Habanita in 1929; this Art Deco masterpiece in unpolished crystal with a frieze of kneeling nude dancers waving veils is now produced in black, but the perfume itself is unchanged.

Chanel responded in 1926 with the euphoric Bois des Îles, which conveyed the same desire for far-off lands and swirling opium smoke. It was more sophisticated, less "girlish" than its predecessors, blending sandalwood and vetiver with ylang-ylang. This fragrance was more invigorating

and modern because it bore the timeless mark of the Ernest Beaux–Chanel collaboration, whose credo was "fashion is what goes out of fashion."

While couturiers and perfumers were rivaling each other in feats of imagination, outdoing themselves in the quality of their raw materials, the luxury of their packaging, and the lavish social events that accompanied new introductions, the more affordable brands followed in Coty's footsteps. Coty introduced L'Aimant in 1927 as "the most alluring perfume in the world," accompanied as always by a cologne and a complete companion line. These companies took up mass production, satisfying the expectations of the growing number of women who, although not wealthy, had achieved financial independence and wished to keep up with current styles. In 1928, the same year the company La Redoute invented catalogue sales, distributing 600,000 free catalogues, Coryse Salomé launched a franchise distribution system, offering colognes and eaux de toilettes sold throughout France. In 1929, Ernest Beaux put the dream at the threshold of the middle class: it was a powdery carnation scent in a simple midnight-blue bottle with a silver label. Soir de Paris, introduced by Bourjois ("It's spelled with a 'j' for joy"), was the first perfume sold in department stores, an enduring source of delight to the modestly well off. Ten years later, this was the fragrance that immortalized the love between Jean Gabin and Michèle Morgan in the film *Port of Shadows* (*Quai des brumes*).

Blue Grass, Elizabeth Arden, 1935. The first truly American perfume.

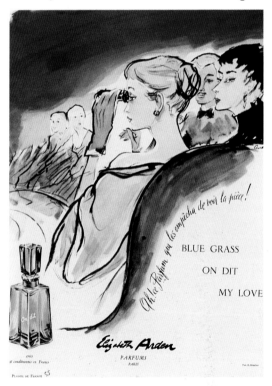

While the crash of 1929 affected everyone, Parisians still improvised new celebrations every evening. Before reaching the darkest pages of its history, the financial crisis, which was all too evident, revived a thirst

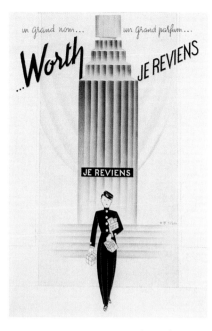

un grand nom... un grand parfum...

Worth JE REVIENS

JE REVIENS

Je Reviens, Worth, 1932. Sold today in Lalique's spherical, star-studded bottle, Je Reviens originally conquered America in a very architectural skyscraper container.

for creativity and a mania for consumption. There were twenty-five new creations from Patou between 1925 and 1938, eleven from Guerlain, thirteen from Lanvin, and sixteen from Coty (five in 1935 alone).

The figures speak for themselves. A study carried out in 1931 showed that 78 percent of women used perfume daily, changing their perfumes like dresses. Those who could changed several times a day, depending on the season, the time of day or night, and the social occasion involved, as recommended by *Figaro Illustré*. This magazine distributed its review of Coty to retailers, giving a prodigious boost to their marketing efforts.

Perfume kept pace with current trends, including the passion for long-distance travel and speed, now facilitated by progress in railroads and the expansion of shipping companies. Lindbergh crossed the Atlantic in 1927, and Hélène Boucher and Maryse Bastié followed in turn. In 1930, the French Lena Bernstein surpassed the record for time in the air by a woman, and Caron saluted this exploit with a spicy oriental fragrance with a Far Eastern accent, called En Avion. Guerlain, on the other hand, chose Vol de Nuit, with its green, woody energy, reinforced with hints of iris and vanilla, to pay homage to the greatest event of the twentieth century; it was symbolized by Saint-Exupery's novel of the same name, which was also published 1933. Fleurs de Rocaille, which is still Caron's best-selling perfume, was introduced at the same time. The fragrance had a dry Provençal bouquet with earthy notes and a base of oak and cedar. It was one of the first lighter floral perfumes, which, with Patou's Normandie (1935) and Vacances (1936), sprang from the growing popularity of sports, which had begun in the 1920s. Athletic activities were becoming increasingly important as sports became more democratized, thanks to the paid vacations provided by the Front

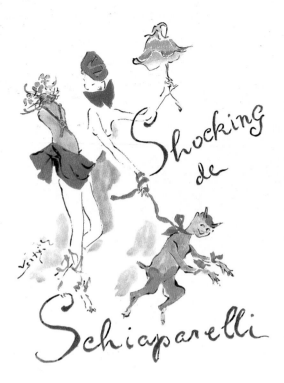

Shocking, Elsa Schiaparelli, 1937. Illustration by Christian Bérard, the couturière's close friend and collaborator.

Mae West. From Rochas to Gaultier, the abundant curves of this actress inspired numerous designers.

Populaire. The same trends encouraged women in the 1930s to turn to refreshing perfume waters, based on recipes both old and new.

Examples included Eau de Lanvin, which was also launched in 1933, Elizabeth Arden's Blue Grass (1935), the first American fragrance to conquer Europe, Guerlain's Eau de Fleurs de Cédrat (dating back to 1920), and Eau de Verveine (1890). The many varieties of lavender colognes should not be forgotten. They include Caron's immortal Pour un Homme, which, from the moment of its introduction in 1934, was given to husbands by women who fully intended to steal it back.

Dans la Nuit, Vers le Jour, Sans Adieu, Je Reviens, Vers Toi—Worth's five perfumes sketched out a mysterious message of love. In the endless history of perfume, Worth has his own unique place. The English design dynasty was established in Paris in the middle of the nineteenth century by Charles Frederick Worth, who became couturier to the French court. The very word was invented for him: a masculine form of a noun that

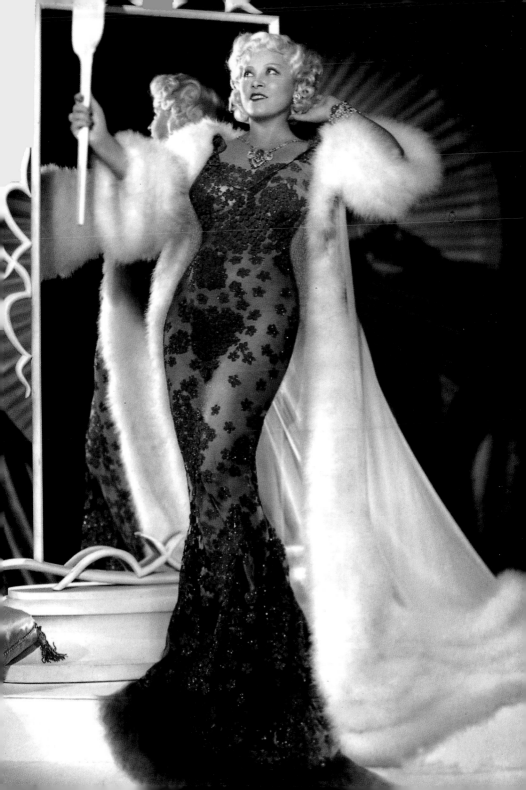

had previously applied only to women. In 1922, Worth asked the perfumer Maurice Blanchet, owner of Coryse Salomé, to create a fragrance; he also commissioned René Lalique to design bottles, which are considered among the great glassmaker's purest and most modern works, still sought-after by collectors today.

For Dans la Nuit, Lalique first used the cobalt-blue glass that became the instantly recognizable hallmark of Worth perfumes, and that inspired Bourjois in 1929. Introduced in 1932 in a very avant-garde skyscraper bottle, Je Reviens met with phenomenal success ten years later. Thanks to its name, which the American label translated into the future tense, it became the perfume given by soldiers and officers to mothers and wives before they embarked for Europe. But the fragrance was almost abandoned after the war. Only five examples survived. Presented today in a spherical bottle strewn with stars, Je Reviens has a floral fragrance intensified with a smoky aroma of narcissus and a distinctly woody—almost earthy—lower note. It was, according to most industry experts, the perfume that set the style for fragrances in the 1950s.

Femme, Rochas, 1944. Roudnitska's second creation and his first masterpiece for Rochas.

The stormy, eccentric Elsa Schiaparelli bucked all trends. Her first triumphs dated back to 1929, and her first perfumes in 1934—Salut, Souci, and Schiap—adapted to current tastes the baroque sophistication embraced by surrealism; the movement was then in its ascendancy, and she subscribed to its credo with the full force of her imagination. Shocking, created in 1938, was a floral, animal blend inspired by Nuit de Noël that expressed the biting, inventive humor of surrealism. At the suggestion of Patou, Schiaparelli drew inspiration from the figure of Mae West, who became her client along with many other Hollywood stars. Leonor Fini made West into a couturier's model, circling her waist with a measuring tape and coifing her with a brooch made of glass flowers. In search of a color for the container as well as a name for her perfume, "La Schiap" happened upon the most violent, piercing pink imaginable, and named it "Shocking." The name and the color were forever identified with Schiaparelli, whose bold imaginings long influenced the

world of fashion.

The Liberation set Paris's Saint-Germain-des-Prés swinging into motion. By day, the fashionable passed the time tanning themselves on the Café Flore's terrace while chewing over murky existentialist ideas; by night, they lurked in Tabou's caves chewing gum from GIs, who were not far from the Ritz that Hemingway had "liberated," lined up along the rue Cambon and Place Vendôme for a few drops of No. 5, Shalimar, or Vol de Nuit.

Nylon stockings stood up even to the rigors of be-bop, accompanied by Boris Vian's wicked trumpet. In France, elected officials could no longer stand up against the French vote. With Bogart and Bacall's Lucky Strikes, everyone rediscovered the pleasure of a good smoke. With Rochas, Carven, Dior, and Ricci, the French inhaled the perfume of liberty; it seemed to resonate with de Gaulle's voice and a touch of an American accent.

"One should smell a woman before even seeing her," said Marcel Rochas. Though the designer had been well known since 1925, he hit his stride as a perfumer in 1944 with Femme, composed by the young "nose" of the future, Edmond Roudnitska. A fruity chypre note blending peach and plum with tuberose, it was a heady, enveloping, almost maddening perfume whose powerful scent radiated a voluptuous aura. Femme asserted an insolently heightened femininity, emphasized by its strong, simple name, which proclaimed the obvious.

Rochas was an aficionado of film, and recognized its influence over developments in fashion very early. He opened a second office in Hollywood in the mid-1930s, where he became the anointed couturier for a battalion of stars on the screen and about town. Foremost among them was the lavishly endowed Mae West, with whom he had a long friendship. It was for her that he created the name and design of the lingerie worn by all the dreamboats of the era: the "Mae West" black lace corset. Carole Lombard, Katharine Hepburn, Joan Crawford, Jean Harlow, and Loretta Young were soon joined in Paris by Arletty, Madeleine Renaud, Michèle Morgan, Danielle Darrieux, Edwige Feuillère, Gaby Sylvia, Madeleine Sologne, and Micheline Presle. Rochas sent to these followers, and to a few other faithful clients including the Duchess of Windsor and the Vicomtess de Noailles, a unique marketing letter. He offered them the opportunity to purchase by subscription an exclusive edition of his new perfume, numbered and restricted to a few hundred samples. It came in a bottle designed and signed by Lalique and was presented in a white satin box covered with black chantilly lace over gold tulle. This original bottle with a relief of roses is little known today; it was intended for the perfume's initial launch, and was deliberately elitist. In 1945, the current bottle made its appearance, again signed by Lalique, with its rounded form inspired by Mae West's generous curves. The time was ripe to reveal Femme to the mass market, and Rochas had the idea of organizing a retrospective exhibition, tracing the history of perfume all over the world from 1765. He dedicated the show to Paul Poiret and commissioned the decorators Christian Bérard and Annie Baumel to do

the layout. All the great antique dealers lent their support for this major show. Following on the heels of international Parisian socialites, middle-class Parisians trooped through the month-long show.

The Liberation was accompanied by an explosion of young people who wanted to enjoy their youth. In contrast to the Années Folles, when the young rejuvenated the world of adults more than distancing themselves in their own world, this new generation tried to set themselves apart by establishing their own identity. This rebellious young crowd chose Ma Griffe as their hallmark. Carven was thirty-six when she opened her couture house. Delicate, petite, and athletic, she had retained the figure of a young girl.

Her styles featured bright colors and simple forms, whose freshness attracted the youngest clients, like the green-and-white-striped ensemble entitled Ma Griffe. It was the perfect name for a lively, piquant fragrance that surprised with an acid, almost metallic, note derived from the newly discovered synthetics. Paris discovered it one morning in the spring of 1946, when an airplane dropped thousands of little green and white parachutes over the Trocadero bearing geometric bottles. It was an homage to the French Resistance in which Carven's husband had been a hero. The idea belonged to André-Pierre Tarbes, who was in charge of marketing. He continued to conjure up many totally new promotional innovations. Carven was the first perfumer to sponsor a sports event, the Coupe Carven, the first to create a literary prize for young writers, and the first to sell perfume duty free on major airlines. Carven also financed a ballet with a green and white theme, danced by Ludmilla Tcherina.

It was 1947. While the younger generation let off steam, Europe, its euphoria past, found itself confronted by the grim reality of rationing and interminable strikes, and a shortage of coal in a freezing winter. Christian Dior, formerly a stylist for the designer Lucien Lelong, chose a bad moment to present his first collection and create his first perfume. In a very luxurious bottle of cut crystal, Miss Dior was the quintessence of the spirit of the "New Look." It was a very haute couture, complex perfume. Developed by Jean Carles and Bertrand Vacher, it successfully created a synthesis among

the three periods that preceded it, blending floral and chypre notes with all the latest green harmonies revealed in Balmain's Vent Vert, which had come out several months before. Miss Dior was initially quite elitist, but later became more available. It was given a new glass bottle in 1950, engraved with the hounds' tooth motif beloved of the great designer, cut like a severe suit, and softened with a white or black silk ribbon knotted around its squared-off top.

Vent Vert, Balmain's second offering created by Germaine Cellier, the first female "nose" in the French perfume industry, paved the way to a new family of fragrances called the "green florals." Saturated with galbanum, used for the first time in such a large quantity, it has the strong scent of freshly mown grass and new foliage that Colette described as having: "the pungent character of plants crushed in the hand," adding her canny assessment: "It will certainly please today's devilish women." Caron's Alpona revisited the association of fresh flowers with citrus fruits in 1939. The timing was wrong—both too early and too late—but the fragrance inspired postwar creations.

One year later, L'Air du Temps reverted to the floral model, dramatizing it with musk and spices, the image of a woman who was both ingenuous and wanton, sensitive and sensual. There was no green note in this delicate scent, which was unabashedly romantic, but it was clarified by a graceful vivacity and a new-found insouciance. Robert Ricci, Nina's adored son, a devotee of perfume, perfected that absolute harmony with the assistance of the "nose" Franci Fabron. Ricci also created the doves with outspread wings that seem to pause a moment in their flight to be suspended around a bottle that twists like a flame.

Marc Lalique, the son and successor of his father René, was a close friend of Robert Ricci, to whom he often offered exclusive designs. He

L'Air du Temps, Nina Ricci, 1947. All carrying Lalique's signature, these are the varying presentations of one of history's cult perfumes from 1948 until 1998.

sculpted one of the most splendid bottles in the history of perfumery. It was the ultimate alliance of a fragrance and its presentation, of a name and an image. L'Air du Temps traversed time and space to become a legendary perfume, one that every woman longed to wear at least once in her life. Just as Robert Ricci had dreamed, it held the very essence of happiness.

The 1950s saw the revival of the slender, courteous, well-groomed, distinguished wife, in the image of Grace Kelly or Princess Margaret, whose fairytale experiences were closely followed. These paradigms maintained their impeccable households thanks to the miraculous domestic appliances to be found in the Exhibition of Household Arts. During these tranquil and cheerful years, people recovered a sense of life's joys despite the nuclear threat. They were able to distance themselves sufficiently to raise a new generation so vigorous and happy that everyone seemed to be rejoicing in their first youth.

Balmain-Cellier's third perfume, Jolie Madame, was introduced in 1949. It was a mingling of floral, citrus, and leather notes. Its fragrance and its name (suggested by Gertrude Stein) conveyed the essence of a period that was torn between practicality and glamour, so tenderly depicted by Jacques Tati.

The same is true of the two great perfumes created especially for the modern man. Germaine Cellier's Monsieur Balmain and Roudnitska's Moustache, made for Rochas, have offered deliciously acidulated refreshment for the cheeks of fathers and sons since 1949.

There were classic bouquets that were both attractive and reassuring to elegant women. Madame Rochas and Hermès's Calèche, both by Guy Robert, the Catalan designer Balenciaga's Dix, Guerlain's Chant d'Arômes, Grès's Cabochard, and Givenchy's Interdit are just as irresistible today.

Cabochard, Grès, 1959. A perfume as unique as its creator.

A young dancer who had recently turned to acting, Audrey Hepburn had just finished filming *Roman Holiday* with Billy Wilder when she met Hubert de Givenchy in 1954. She was the archetypal young woman of the period, and soon became the enduring close friend of the brilliant twenty-seven-year-old couturier. Three years later, after designing the costumes for *Funny Face*, he presented his muse with a perfume in her image, both floral and piquant, chic and peppery. It was initially reserved for her exclusive use, but this splendid gift was

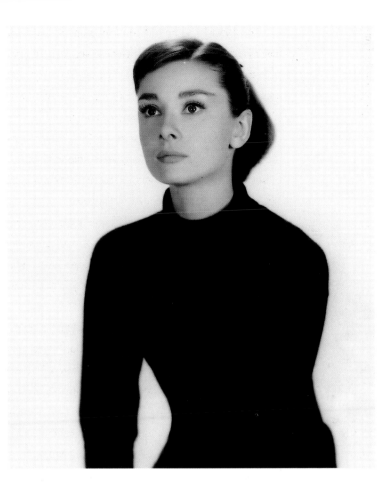

Audrey Hepburn, Hubert de Givenchy's muse, personified the couturier's first perfume, Interdit.

soon on the market; when she heard this news, Audrey Hepburn exclaimed that it was "forbidden." The French translation, *interdit*, remains the name of this fragrance, which is presented in a four-sided bottle, topped with a round stopper resembling a tiny, pert hat. Like the little black dress in *Breakfast at Tiffany's* (1961), it was a masterpiece of timeless simplicity.

Another success of 1959 was Madame Grès's Cabochard, by Bernard Chant. The little brother of Tabac Blond and Piguet's Bandit (1944), Cabochard blended notes of leather and chypre and made an impression on the era with its distinctive personality, which still attracts dedicated devotees and the admiration of perfumers.

The 1950s were the time for the perfume of another young American whose talent and professionalism were matched only by her ambition.

Estée Lauder caught the eye of French women. She was an admirer of Chanel, she dressed in Dior, and she quickly became a follower of Givenchy. She wanted her own No. 5: this was Youth Dew, released in the United States in 1952 and in France two years later. The perfume's luxurious bottle could have been designed by Zsa Zsa Gabor and it remains today, fifty years later, a piece worthy of Hollywood's archives. It was a triumph. Estée Lauder adopted and adapted Coty's ideas, marketing her products through what she called "layering," using her fragrance in lines of bath and body care products. Oriental and sweet, Youth Dew made a beautiful bath oil presented in cheerful little bubbles; it also appeared in a moisturizing lotion and even little sachets to perfume drawers or handbags.

It was a clever idea that inspired new ways to use perfume, and it uncovered a formerly unexplored niche in the market.

There was a return to fragrances dominated by a single flower and to classic bouquets. Roudnitska's Eau Fraîche made quite a splash. Roudnitska, was unquestionably a leader in the revival of perfumery, transforming the conception and structure of its products in ways that influence us today. His collaboration with Dior led the way in the 1970s. With the exception of a few isolated but remarkable creations, this was a decade during which the perfume industry seems to have been marking time, in the calm before the storm.

Among the single-flower fragrances, three left a lasting legacy. Fracas, the unforgettable tuberose perfume, created by Germaine Cellier for Piguet in 1948, is a continuing success, currently experiencing new popularity in the United States. Roudnitska's magic laboratory produced Rochas's La Rose (also introduced in 1948 but not so long lived), and Diorissimo's lily of the valley fragrance (1956).

La Rose was Marcel Rochas's favorite perfume. It was one of the few tinted fragrances (pink, of course). Rochas invited Paris society and the women's press, which carried increasing weight, to a celebration

Youth Dew, Estée Lauder, 1952. The first great perfume of a brilliant woman whose spectacular success symbolized the American dream.

Diorama and Miss Dior, Christian Dior. A lavish limited edition in crystal and gilded bronze by Baccarat (1949).

where everything was rose-colored, champagne and food included.

Inspired by Christian Dior's favorite flower, the sparkling lily of the valley, Roudnitska's Diorissimo has happily survived, no doubt because, according to its very modest creator, it is "a perfume with a new architecture." He reacted against the growing complexity that weighed down perfume products; these scents seemed to him increasingly confused, and closer to confectionery than fragrance. Roudnitska decided to pursue simplicity; in perfumery, this is not necessarily the same thing as simplification, and still less is it taking the easy way out. In contrast to inexpensive, mass-market fragrances that artificially copy the smell of a single flower, only conveying an approximation of its true scent, Diorissimo stylized lily of the valley to convey all its facets, including "the odor of freshly cut wood," according to Roudnitska. After three years of work he arrived at this unique perfume, which, in his own description, was "as fresh as spring rain on a white garden" and which for Christian Dior was more than a perfume, it was his olfactory hallmark.

L'Eau Fraîche, which made its debut in 1952, was a new face in the

Eau Sauvage, Christian Dior, 1966. The first of the deliberately blended waters. Illustration by René Gruau.

perfume world, more powerful than cologne and lighter than eau de toilette. To the lemony, citrus, or hesperidic base notes used in all colognes, Roudnitska added jasmine's floral notes and chypre's oak moss, and doubled the usual concentration of cologne.

Roudnitska's adaptation made the scent more contemporary, with a balance that allowed freshness to emerge from sources other than hesperidic or green notes. With the intuition of a fortune-teller, Rochas created a completely new balance, which became the prototype for one of the principal types of modern perfumes.

L'Eau Fraîche, Diorling, Diorella, Eau Sauvage—throughout the 1960s, the Roudnitska-Dior-Gruau troika set the pace for the introduction of new perfumes. They brought out one winner after another. Eau Sauvage, which was ready for release in 1962, was held back for Diorling's introduction in 1963, and finally came to market in 1966. Following a policy

Edmond Roudnitska. He reigned for thirty years as the uncontested master of the world of perfume.

that Roudnitska himself called "purifying rigor," and drawing inspiration from Coty's Chypre, he excluded powdery, sweet notes to concentrate the accord on two notes, one citrus and the other jasmine, making a fragrance whose lightness did not detract in the least from its power.

A new fragrance designed for men was a triumph. According to its creator, it was "a radical antithesis to everything that has gone before in the history of perfume," the first great modern blend.

page 367Although Pschitt Orange ("for you, my angel") and Pschitt Citron ("for my boy") continued to accentuate the differences between the sexes, Eau Sauvage intoxicated both sexes in the joyous crowds of the swinging 1960s. Women with a thirst for light sparkling scents stole it from their men. There were numerous feminine antecedents, including Lancôme's (1969) and Laroche's Eau Folle (1970). Rochas reintroduced Eau de Rochas, which had the same formula as Eau de Roche, originally

created in 1948, but had been out of production since 1956. Credit for this refreshing scent goes to Nicolas Mamounas, Rochas's "nose"; with its floral, citrus, and wild narcissus notes, Eau de Rochas remains the company's bestselling perfume. Roudnitska avoided any heaviness with Diorella in 1972, and achieved a completely novel marriage of contrasts... floral, ripe fruit and woody vetiver notes carried by the striking acidulated notes of Eau Sauvage. "It's chamber music," asserted the perfumer Jean-Claude Elléna, who created First four years later for Van Cleef & Arpel.

Also introduced in 1966 as a transitional perfume, Fidji contrasted sharply with the products from Dior and Roudnitska, marking a new concept in perfume marketing. Lancôme, a small company at that time, had just acquired the Prestige division of L'Oréal, with Robert Salmon as the head of marketing for the perfume department. Laroche was a young couturier whose image and style were not particularly well defined in the public's mind. International Flavors and Fragrances (IFF), an American organization, had just established its finished perfume center and hired a group of "noses."

With the rising popularity of traveling to distant destinations, the middle classes in the Western world discovered the attraction of the Pacific beaches. While on a trip with Guy Laroche at the Club Méditerranée in Agadir, Salmon decided on the name Fidji, a symbol of eroticism that evoked general images of faraway places, not specifically identifiable. He also thought up the slogan: "Woman is an island, Fidji is her perfume." For the flacon, Salmon was inspired by one of Lancôme's first perfumes, Tropiques, created in 1935 by Armand Petitjean; as for the scent, it was "a modern version of L'Air du Temps." Josephine Catapano, one of the IFF "noses" who had never been in contact with Salmon and who was not aware of the name of the perfume until the last minute, said: "They simply told me that he wanted something very feminine and easy to wear, light, fresh and very floral." She worked from the woody-floral format of L'Air du Temps and found, from

Fidji, Guy Laroche, 1966. A short, sweet word that sounds perfect in any language.

Ô de Lancôme designed by Serge Mansau in 1969: a column sculpted to look like a petrified fountain.

Guy Laroche

Paris

fidji

La femme est une île
Fidji est son parfum.

among the new generation of aromatic chemical products developed by IFF, a scent that carried the strong impression of "a breeze that had just passed over a bouquet of flowers." This new floral-green blend would later inspire Revlon's Charlie, Gucci's No. 1, and dozens of other perfumes, but the secret and exclusive formula of Fidji, "the happy island," has never been duplicated.

Three years later, in 1969, Louis Amic, the head of Roure-Betrand-Dupon, the largest French perfume manufacturing company, now Givaudan-Roure, approached Paco Rabanne, the "metallurgist," as Chanel spitefully called him. For Amic, as for Salmon, perfume was a commercial product, born of five elements: name, perfume, bottle, distribution, and financial backing. He was in the habit of saying, "If you line up the five cherries you will be successful, but with four cherries and a banana you will have a failure on your hands!" The fragrance was to be chosen from among a series of finished products prepared by Michel Hy, one of the house "noses." Descending directly from Madame Rochas and Calèche, created by Guy Robert, Calandre's uniqueness was due to two synthetic products: rose oxide with a quasi-metallic freshness, and Evernyl, a molecule that amplifies the woody notes that had been discovered in 1898 but not produced as a synthetic until 1968. Roure was the first to use this new chemical before it reached the general market. Pierre Dinand used ABS, a plastic material imitating metal, to encase the strict rectangular shape of the glass, which was designed to look like a Rolls Royce radiator grille. "Calandre" means car radiator grille in French.

Calandre, Paco Rabanne, 1969. A very intricately designed bottle that has withstood the test of time.

In the same year, Guerlain introduced a different approach with Chamade, which Jean-Paul Guerlain, Jacques's grandson, had been working on for seven years. An innovation, Chamade, was the product of an accord between very high quality natural raw materials and the latest developments in chemistry. The newly arrived Hedione had the power to reproduce the freshness of jasmine flowers and gave Chamade a powerful élan. The use of essence of black currant buds contributed the fruity

Catherine Deneuve. She is the unforgettable heroine of the film *Chamade*, based on François Sagan's book. Her image, the film, and this perfume symbolize the 1960s. In 1986, the actress created her own perfume called Catherine Deneuve.

heart.

Hedione was also used in No. 19, which was released in 1971. The fragrance was a farewell salute to the flamboyance of the great Chanel, who died a few weeks later. Prepared by Henri Robert under the watchful eye of Coco, who despite her eighty-odd years was still a tough taskmaster, No. 19 celebrated Coco's August 19 birthday. Fifty years after the creation of No. 5, it had a perfectly blended floral-green accord that influenced Balmain's Ivoire (1979), Lauder's Beautiful (1985), Ralph Lauren's Safari (1990), and Cartier's So Pretty (1995).

Saint Laurent was known to say that intoxication mattered little provided one had a stylish image. This certainly applied when the ready-to-wear market brought haute couture to the streets. With the sensational

global launch of Charlie in 1973, the same revolution was instigated in fine fragrances, hailing a new era of mass-marketed perfumes. As Charles Revson, Revlon's owner, said of his creation: more than a woman's perfume with a man's name, Charlie was a social artifact, an image "of the ideal liberated woman who proudly projects that image." In the open battle for equality of the sexes, an explosive ad campaign relayed by an enthusiastic press portrayed Charlie as a model fighter. Clad in a pants suit and high heels, a man's shirt, long hair and striding along on her own, she exudes feminine independence. She is "sexy and unisexy," as demonstrated by the fact that she has her own perfume and she does not have to wait for a man to choose it for her or pay for it. Perfecting the formula for Charlie was a long process; the goal was to offer "a sporty, everyday perfume." The long-lasting fragrance is derived from L'Air du Temps, via Fidji, with a more spicy green and toniclike floral note. Sold at substantially lower prices than most other perfumes and surrounded by a plethora of advertising accessories that reinforced the idea that the wearer had chosen a special lifestyle, Charlie, the first mass-marketed product launched with glamorous flair, surpassed all expectations of international success.

A year earlier, the famous marketing consultant Susanne Grayson said in an article entitled "The Myth of the Refined Perfume": "Any mystique surrounding a high quality perfume is in the eye of its creator. . . . It is the marketing that determines whether a perfume will become a classic or disappear quickly from the market. The role of marketing is to give a perfume a specific significance."

"We start by making beautiful things, we think about selling them later," said Roudnitska. The terms of this doctrine were soon completely reversed. Gone were the days of the inspired couturier, of the perfumer who slowly composed a unique scent like a musician constructing a symphony, of the glass master who sculpted a flacon that would last forever, of craftsmen like Christian Bérard or Gruau who could envelop the whole product in a cloud of dreams. Perfume was no longer a work of art molded by several hands who all contributed to its harmony. It

Charlie, Revlon, 1973. Women were liberated and this perfume hit the streets.

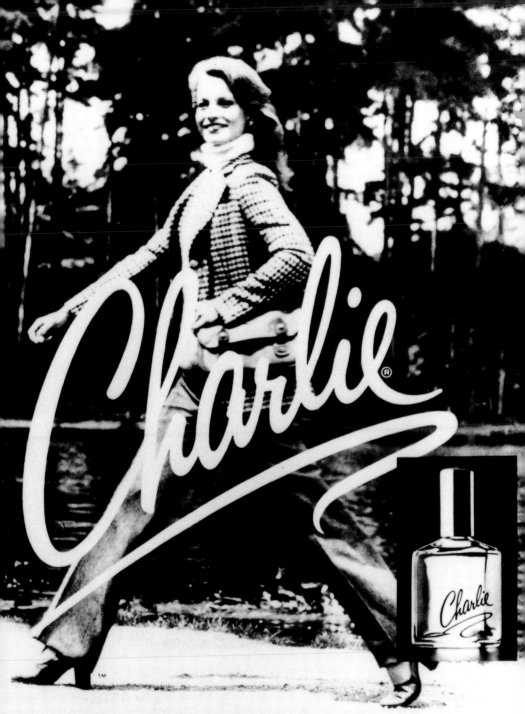

The gorgeous, sexy-young fragrance. By Revlon

Concentrated Cologne, Perfume, Perfumed Dusting Powder and Body Silk.

had become a luxury commodity, a source and vehicle of immediate profit.

Perfume companies were becoming divisions of larger integrated units as they continued to merge into major international chemical and pharmaceutical industrial groups, supported by banks and other financial and stock market institutions, who sought a role in their management. In Edmond Roudnitska's opinion, it was at this time in the middle of the 1970s that a perfume's development came to depend on the training, background, and determination of the people involved at the different planning stages who, in general, were not perfume professionals. Furthermore, internationalization required that the product be accepted by a clientele with multiple cultural references that were often incompatible, reducing opportunities for originality.

With all this mixing together of contradictory fears and reservations, it took the power of a personality like Yves Saint Laurent, who threatened to withdraw from the project, and the support of two professionals with greater experience than the rest, to allow the master to maintain authority over his plans for Opium and ensure its coherence. The name chosen by Saint Laurent was not accepted at first by the people at Squibb, the pharmaceutical conglomerate that held a major stake in Charles of the Ritz, which in turn owned Saint Laurent perfumes, as they feared an outcry from the more puritanical public in the United States. The bottle was designed by Pierre Dinand, based on an idea from the couturier. It also underwent numerous and costly modifications. In order to please everyone, a number of laboratories were asked to compete in creating the fragrance with the sole requirement that it should be "an oriental perfume capable of competing with Shalimar and Youth Dew." In the United States, three scents from the perfumeries of Raymond Chaillan and Jean-Louis Sieuzac of Givaudan-

Chloé, Karl Lagerfeld, 1975. A tuberose-based perfume whose theme was highlighted by the lily-adorned flacon. Illustration by Pierre Le Tan.

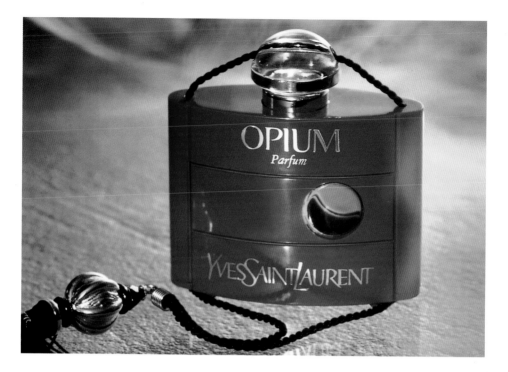

Opium, Yves Saint Laurent, 1977.
Despite discouragement (and the fear of a scandal in the United States), Yves Saint Laurent managed to maintain the upper hand over Opium's design and image.

Roure were tested against Chloé, Karl Lagerfeld's first perfume, one of the bestsellers at that time. Once again, Saint Laurent was given the final say. Instead of the chypre note that came out ahead in the tests, he chose the perfume we know today, announcing a return to heavier fragrances that originated with such famous perfumes as Coty's Origan, via Shocking and Tabu, which was created by Dana in 1932.

Ever prudent, Squibb launched the perfume in stages, first in France, then throughout Europe in 1977. It was so successful that by 1978 a lavish celebration enthroned Opium in the United States, and the anti-drug protests that ensued only succeeded in increasing sales. Opium, which almost did not see the light of day, remains, twenty-three years later, one of the ten bestselling perfumes in the world.

The explosion of ready-to-wear in England, the United States, France, Italy, and eventually Japan, naturally attracted the attention of major cosmetic firms. They hoped to exploit this massive expansion in the fashion market. L'Oréal approached Cacharel, one of the most commercially promi-

nent fashion brands in 1975. Following in Revlon's path, Anaïs Anaïs came out in 1978, the first French perfume to project an ideal feminine type and to associate symbols of luxury with a mass-marketed product.

Represented by the image of flowerlike young women created by the photographer Sarah Moon, Anaïs Anaïs was the anti-Charlie, conveying the hippie-bucolic-pre-Raphaelite look favored by the younger generation over the businesswoman style. Instead of traditional perfumes, young girls preferred fragrances popular with hippies such as incense, musk, and patchouli, brought back from India or produced by small companies concentrated in the San Francisco area. Here again was an instance in which fashions were set by the woman in the street and not by professionals. Using the inevitable L'Air du Temps–Fidji reference, the smell was created by four "noses" from the house of Firmenich, and was thus floral and sweet, but spiced with musk and incense. It passed all the rigorous tests recently introduced in France. Not expensive, the simple white opaline bottle, designed by Annegret Beier, stood out clearly from other luxury flacons, which were usually transparent and ornate; the label was adorned with imaginary flowers that clearly identified the product. Sold at a price 30 percent below other perfumes, it could be distributed through new noncompetitive and more accessible means. Besides being sold in cosmetics shops and large stores, Anaïs Anaïs was the first perfume brand to be offered in self-service stores.

Anaïs Anaïs, Cacharel, 1979. Country freshness and simple flowers targeted at the young hipsters of the 1970s. It was an immediate success.

The 1980s was an era dominated by a thirst for opulence, with overtones of arrogance and narcissism. Ruthless, domineering yuppies and aerobics fans seemed to hold sway. Appearance, and therefore fashion, was driven by a semi-annual routine of couture collections, which became emblematic of a quest for identity and social recognition for certain women. Marketing, management, design, packaging, diversification, communication, advertising, and profitability were all the rage, setting the trend or following it—no one was sure anymore, since the threat of being "out"

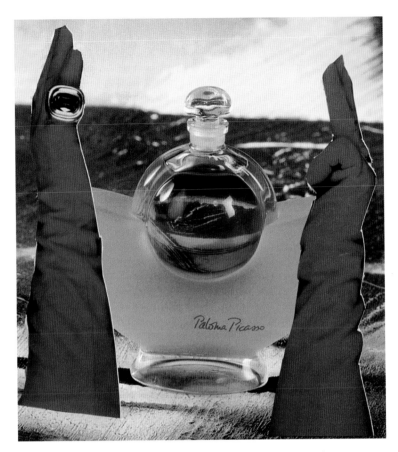

Mon Parfum, Paloma Picasso, 1984. One of the most beautiful contemporary flacons offered in superb limited editions.

was so great. The trends changed at such a constant pace that images were quickly broken down and renewed again. The vast global market was more accessible to perfumes than to fashion, as the perfumed object was a symbol that could penetrate countries where morals or purchasing power restricted participation in fashion's whims. Sixty percent of the world perfume market was controlled by ten groups representing twenty-four labels: Valentino, Armani, Gianfranco Ferré, and Versace, then Gucci, Fendi, Cerruti, Trussardi, Missoni, and Dolce et Gabbana. The greatest Italian couturiers and stylists had joined the crowd, creating compositions that were accompanied by perfect introductions to the international markets. In France, new perfumes regularly appeared, including Saint Laurent's Paris, which, in 1983, superbly captured the

effect of a vase of rosebuds, Givenchy's L'Ysatis in 1984, personifying the woman who is active by day and romantic by night, and Byzance, launched in 1986 by the new Rochas trio (Hélène Rochas, Nicolas Mamounas, and Claude Buchet) with support from the German Wella group, which had entered the perfume world. Outside the fashion world, Hermès introduced Parfum d'Hermès in 1984. Other major luxury names followed the example of Hermès, choosing perfume as a means to expand their reputation to a wider audience and to tap greater profits. Jewelers entered the market, with Van Cleef and Arpels's First setting the trend in 1976, followed by Must from Cartier in 1981, and subsequent releases from Boucheron, Bulgari, and Tiffany. In 1981, the milliner Jean-Charles Brousseau offered Ombre Rose, the shoe designer Jordan created Un Jour, his second perfume, and Revillon, the fur company, made its debut with Turbulence. As soon as a couturier showed a successful collection, a perfume bearing his name entered the fray. This was the case with Emanuel Ungaro's Diva in 1983, whose bottle suggested the folds of a woman's dress and a very haute couture image that was a magnificent reflection of Parisian elegance. In the United

Annick Goutal, who suffered a premature death, formulated her perfumes with artistic mastery.

States, Giorgio of Beverly Hills and Oscar de la Renta joined the ranks alongside Estée Lauder, the reigning queen of floral essences, whose White Linen (1978) and Beautiful (1985) remain among the ten top sellers in the United States.

From 1972 to 1990, more than fifteen hundred perfumes were offered in France, or nearly two new products every week. This surge inspired American perfume companies to attack the French market, even threatening France's supremacy on the world market, which had become increasingly difficult to dominate.

Lavish launch parties for members of the international press and major buyers rivaled each other in extravagance. Publicity films were made

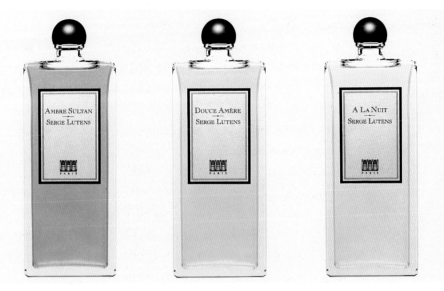

Ambre Sultan, Douce Amère, and À La Nuit, 1993–2000. While the design of Serge Lutens's bottles is simple, the names of his perfumes invite reverie.

Following pages: **Salons du Palais-Royal-Shiseido.** Dedicated entirely to Serge Lutens's fragrances and decorated by him, this jewelbox boutique is mysterious and entrancing.

by directors known for their work as auteurs, such as François Reichenbach, who put his signature to the film for Lancôme's Magic Noire in 1978. In 1985, in the most expensive introduction ever, $40 million was invested in Poison, the powerful new Dior perfume, with a sumptuous celebration at Versailles. Also in 1985, Lancôme spent $26 million on the unveiling of Trésor—which earned profits of $130 million the same year—with a concert given by Jessye Norman at the Beaux-Arts theater, in a production directed by David Lynch. Differentiating oneself from the competition by every conceivable means was imperative. Fabulous contracts were offered to actresses, such as Isabella Rossellini for Trésor, Juliette Binoche for Poême, and Vanessa Paradis for the very baroque Coco. Consultants were hired to identify specific types of females for the new perfumes to target. In turn, actresses were chosen who personified the publicity image associated with this market sector.

Jacques Polge, Chanel's "nose," and Jacques Hellue, Chanel's artistic director, created Coco's name and classic bottle, updating Miss Chanel's tradition without betraying the legendary taste of the Grande Mademoiselle. They repeated this feat several years later with Allure. The remarkable ability of Chanel's perfumes to transcend time while

continuing to set the fashion is due to the personality of Jacques Hellue, who succeeded his father Jean as artistic director. Having worked at Chanel for more than thirty years, he is intimately involved with the spirit of the house and maintains strong control over the design and image of the Chanel perfumes.

A surprising outsider, Paloma Picasso, defined her own contrasting approach to marketing. A well-known stylist, she made superb jewelry for Tiffany, among others. Her maternal grandfather was the perfumer Émile Gillot, and she had always been fascinated by the world of scents. The fact that she was known to the public only as the daughter of her famous father and that she was not connected with a specific brand paradoxically gave her the liberty to enter the world of luxury perfumes free of the constraints generally imposed by the demands of marketing. She was able to redefine the rules of the game and focus her energies on a unique and high-quality perfume and a flacon that attracted considerable attention. After she approached several skeptical companies, her determination won over Georges Friedman, the director of Warner Cosmetics, producers of Ralph Lauren perfumes. Working very closely and patiently on the formula with Francis Bocris from Créations Aromatiques and Ben Kotyuk, who created models for the bottle and packaging from her designs, she directed every aspect of the project including the publicity photographs taken by Richard Avedon, which were reserved for supportive members of the press. Her unique voluptuous perfume made its debut without a sumptuous introduction or film or publicity poster. It was a winning bet based on Paloma's personality and the professionalism that guided her every step.

Serge Lutens made similar, though more subdued, strides into the world of perfume. An artist with multiple talents, an absolute perfectionist, Lutens accepted nothing less than authenticity. He firmly refused to accept a world in which know-how replaced savoir-faire. From makeup to photography to film advertisements, Lutens invented his own style, which seduced the refined avant-garde from Paris to Tokyo. His alliance

L'Eau d'Issey, Issey Miyaki, 1992. Purity and transparency characterize one of the first new age perfumes.

Kenzo de Kenzo, 1988. Flowers and fruit for the ikebana of the Japanese stylist.

with Shiseido occurred naturally. In 1982, Nombre Noir, his first perfume, revealed his abilities as both a true composer of scents and a reliable director; he orchestrated the entire project from flacon to publicity, with Shiseido's full support. Over the course of the next ten years, Lutens nurtured his ideas and perfected his scents, culminating in the opening of the Salons-du-Palais-Royal-Shiseido, a magical house of perfumes harking back to the nineteenth century. Despite a minimal publicity budget with little allocated to marketing, and sales restricted to the boutique, mail-order, and the Internet, he created a true universe of scents.

Another independent perfumer, Annick Goutal, opened her first boutique on rue de Bellechasse in Paris in 1981, with L'Eau d'Hadrien, composed as an homage to Marguerite Yourcenar's Mémoires d'Hadrien. A musician by training, she also had a natural "nose" that she turned into a profession after studying in Grasse. She worked from home on her "organ" of scents, perfecting her endeavors with consummate artistry, pas-

sion, and sensitivity. Before her premature death she had prepared sixteen delicate perfume waters, each with a sweet-floral note. The secret composition of her last perfume, Ce Soir ou Jamais, combines 160 natural ingredients. Although the perfume house was purchased in 1985 by the Taittinger group, which has brought sales all over the world, Annick Goutal never compromised on her line of products or the quality of her creations.

At the beginning of this century, L'Artisan Parfumeur, Diptyque, and Jean-François Laporte, a master glovemaker and perfumer in eighteenth-century parlance, stand out as examples of a trend toward independence combined with a return to the simple and fresh floral perfume waters so popular in the nineteenth century. Sheltered from the dictates of international commerce, each of these independent houses and individuals followed their own back roads, more challenging, but more rewarding than the main highway, where the tolls mount along the way. While such highways may be intended to turn the entire planet into one easily accessible global village, at times they are so congested that they threaten to collapse under their own weight. Laboratories of ideas and creativity, the independents are the olfactory leaders. Alongside the great classics, their fragrances have become new points of reference in an overabundant

Eau de toilette Jean Paul Gaultier, 1993. Encased in an aluminum can, Gaultier's first perfume conveyed the bubbly and provocative image of its creator.

market, where the pace of new introductions has increased threefold, or one every two days. It is rare to identify a stand-alone perfume, since the tendency is to form into groups and follow trends. Working in teams on several lines for different potential clients, perfume manufacturers hold fully prepared formulas in reserve to launch into the system at appropriate times in response to competition. As Serge Lutens states: "In trying to reproduce perfumes which are copied out of market necessity, you end up with an incestuous family that breeds monstrosities."

Accordingly, at the beginning of this decade, the market has become saturated with fresh floral perfume waters, encouraged by the well-earned success

Angel, Thierry Mugler, 1992. Extremely glamorous, Angel's stellar sales escalated rapidly. Thierry Mugler photograph for the 1995 campaign.

of the new market leader, L'Eau d'Issey. Meant to capture a zenlike simplicity, the demand for lighter perfume waters will evolve into mixtures of higher concentration.

Calvin Klein's breakthrough had a huge impact on the market. Based on a global concept, his style and sales pitch targeted men as well as women. Featuring a chic minimalist look, he appealed to the new urban generation. This novel approach has changed the public's perception, as well as design and sales methods, so that perfumes have become identified with an attitude, a lifestyle.

In CK One's wake, a wave of neutral scents emerged, meant to be shared. Based on aquatic, woody, and marine formats, equally appealing to both sexes, their ecologically correct recyclable bottles and affordable prices are aimed at young people. Alongside mixed eaux, 35 percent of perfumes on sale in 1997 were classified as jumeaux.

After his first perfume for women, Obsession (1985), Calvin Klein

launched Obsession for Men, then Eternity and Escape, with their own versions "for men," which were produced with slightly different notes though with the same central accord, and sold in an identical or almost identical bottle. From a woody base, his perfumes moved toward a more fruity format. A wave of "gourmand" fragrances appeared, sweet, slightly acid, or chocolatey, invading perfume stores with whiffs of stolen candy and other kitchen aromas.

Among these many "olfactory desserts," an expression coined by the psychologist J. Mensing, several were successful, leaving their imprint with a publicity image as strong as their perfume. Examples include Nina Ricci's Deci-Delà, Cacharel's Loulou, and Kenzo's Jungle, launched by Pierre Broc, who had previously created Kenzo's first perfume, Kenzo de Kenzo.

Thierry Mugler's first perfume, Angel, debuted in 1992, distinguishing itself by its authenticity and the rare longevity of its success. Unlike his colleagues, Thierry Mugler waited a long time before he created his first fragrance, a true original, reverting to the tradition of the couturier perfumers. Angel was based on smells that Mugler remembered from his childhood of fairgrounds, where caramel and chocolate odors filled the air, to which he added a sophisticated patchouli-vanilla accord that echoed the feminine theatricality of his collections. The bottle was shaped like a star, one of Mugler's recurring themes, which enhanced the novel blue color of the liquid; the Brosse glassmakers perfected a special machine and invented a "high brilliance" glass endowed with the same qualities as crystal, but without the ecologically incorrect lead that would restrict sales. Even the direct marketing was innovative. It took the form of questionnaires inserted in the packaging, initiating a dialogue with clients. Their suggestions led to the creation of a number of perfumed beauty products overseen by Clarins. Such excellence was well rewarded, for despite its expensive price Angel slowly but surely rose to become one of the five top-selling perfumes in the world.

The story was similar for Jean-Paul Gaultier's first perfume, in 1993, named after him. With a wink to Schiaparelli, his bottle showing a corseted female is humor-

Paris, Yves Saint Laurent, 1983. A bouquet of romantic roses that gave birth to the mischievous Baby Doll in 1999.

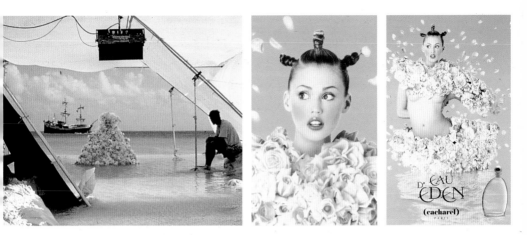

ous, sexy, and out of line. The fragrance is floral but spiced with anise and ginger. This image of eternal femininity, updated with the bold style of the most iconoclastic of the French couturiers, quickly became a smashing success. The tuberose-based Fragile followed in 1999. It was presented in a masterpiece of kitsch and humor, a snowball souvenir with sequins replacing snowflakes.

Lolita Lempicka also won personal success with the perfume she launched in 1996. It has a licorice fragrance that boldly exudes a romantic femininity; its baroque flacon suggests the forbidden fruit. Without drumrolls or trumpet blares, this fragrance reached the bestseller ranks at the end of the century.

In 1994, Rei Kawakubo, the Japanese designer for Comme des Garçons, also launched her own concept with an eau de parfum bearing her name. Her perfume is presented in five variations all housed in the same minimalist, flat, and horizontal bottle. In keeping with the creator's very avant-garde image, the perfume is offered very selectively to an elite clientele and the editions are limited along the lines of a new collection, with fresh releases each Christmas. In February 2000, five special perfumes were introduced and sold in her first perfume boutique, recently opened in Paris.

Having tired of the pastoral themes, Mugler and Gaultier announced a swing in the pendulum. Too much purity provoked a return after 1994

to the oriental-sensual-spicy-musky notes popular in the 1980s. Samsara was the mainspring in 1989, followed by Cacharel's Eden, Givenchy's Organza, Céline's Magic, Balenciaga's Cristobal, Bourjois's Mirage d'Orient, Rochas's Alchimie, and finally the heavier version offered by Vivienne Westwood's Boudoir. A new interest in milky fragrances deposed the candy notes; the Orient became a mystical place, replete with the serene and reassuring vapors of the new age. Issey Miyake's Feu, the first combination of amber and lactone, rubbed shoulders with Cacharel's Noa and the primitive rounded, egg-shaped flacons of Kenzo's Time for Peace Pour Elle. This crowd also included Tan Giudicelli's new Hannam and J'Adore by Dior, who thus provided the anti-dote that had been missing for his earlier Hypnotic Poison.

With the proliferation of offerings, many perfume houses decided to introduce limited-edition "products" or numbered collectible flacons, as well as special-occasion packaging. In addition, the houses have been forced to resort to expensive and pervasive ad campaigns affiliated with the most prestigious fashion photographers and film directors. These image makers include Jean-Paul Goude, Mondino, and Peter Lindbergh, all of whom have contributed to the cultural globalization that characterizes the beginning of this millennium.

In less than a hundred years, perfume has become a consumer product like any other, and the market for men and young people continues to expand.

Sonia Rykiel is the only perfumer who has resisted internationalization: like her ready-to-wear house, her perfume, introduced in 1977 in its little orange flacon shaped like one of her sequined sweaters, accompanied by a male version clothed in purple, is entirely financed and distributed by her own company. Rykiel refuses to risk this independence, since the company licensed to produce

CDG Eau de parfum, **Comme des Garçons,** 1994. Délibérément minimaliste, un flacon unique qui abritera différentes fragrances.

CK One, Calvin Klein, 1995.
Equality of the sexes for the 1990s where everything is shared—even perfume.

her perfume 7e Sens, launched in 1979, withdrew its support and took 7e Sens off the market several years later. Numerous letters pleaded for the return of this atypical perfume, with its bold fruity nose reminiscent of peaches and prunes, and its unusual flacon designed by Serge Mansau to look like a heavy glass inkwell topped by a silver-plated stopper.

Sportswear designers soon joined the crowd of couturiers and ready-to-wear houses: Benetton, Chevignon, the Gap, Adidas, Kookaï, Naf Naf. There is no longer any value to logo perfumes, and originality now lies with those who resist the temptation to have their own perfumes, such as Azzedine Alaïa, who has been solicited by the major groups numerous times. For the luxury houses, it is tempting to exploit the resources offered by brands or names whose celebrity spans the globe but who have no association with perfume, such as Dupont, Davidoff, Lacoste, La Perla, Harley Davidson, Pavarotti, Salvador Dalí, and Andy Warhol. In addition, the two great flacon makers, Lalique and Baccarat, have also entered the competition.

While the purists may have become discouraged with this abundance of fragrances, proclaiming that such great numbers inevitably erode originality, Edmond Roudnitska's recommendation regarding intelligent marketing may prove to be the remedy for the unrestrained competition that has led to the incessant zap of fast perfume sales. Witness the development of Mugler or of Séphora, the pioneer of beauty chain stores with shops in Europe, the United States, and Japan. Maintaining France's upper hand in the perfume domain, Séphora has chosen to inform and educate its clients, installing a library of scents in each store, rather than attacking them with advertising jargon. Alongside vast discount stores, the elitist perfume boutiques such as the Salons du Palais-Royal-Shiseido or Caron on avenue Montaigne in Paris, with its perfume fountains, seem to have broadened in scope as well. The major companies have also come to understand the need to offer plenty of free space

to the perfume makers or risk killing the goose that laid the golden egg. As an example, Estée Lauder has financed the English Jo Malone, who since 1994 has been working on very original binary accords that can be combined in infinite compositions.

The Patrick Alès group operates in a similar fashion. Having acquired Caron perfumes, it has chosen to preserve its heritage of rare and complex scents and to maintain the quality and wide diversity of labels for which the Caron name is famous. Similarly, Shiseido is encouraging Serge Lutens to create a new line of five perfumes distributed under his name. The product of in-depth research, this coherent series will revive the tradition of perfume-odors that envelop the skin, moving with a woman like her shadow; it confirms Lutens's talent and places him among the most discerning "noses" of our time.

Will the beginning of the twenty-first century rediscover the joys of fine perfumery? With creative freedom, the wisdom of experience, the collaboration of true artists in marrying the contents and the container, inventive derivations rather than copies, and a love and understanding of what is fine and beautiful, perhaps we can be optimistic. After all, if we used current criteria, we'd be without Jicky, which took thirteen years to achieve profitability, or Diorissimo and Fleurs de Rocaille, which were jealously and painstakingly concocted in secret. Shalimar, L'Air du Temps, and Chanel No. 5, which so many years later still lead the others in sales, would never have seen the light of day.

Progress in science, together with a crossbreeding of cultures, has led westerners to rediscover the therapeutic role of plants and the influence that scents can have on their health and their physiological well-being. The popularity of aromachology, anticipated by Clarins with its Eau Dynamisante, is represented today by Decléor, Crabtree and Evelyn, Aesop, Healing Gardens, Shiseido, and Kanebo, and seems to reflect the trend of the future. Henceforth, perfumes will not only work to please the senses, but will also offer the serenity of an uplifted spirit within a sweet-scented body.

FABIENNE ROUSSO

Allure, Chanel, 2000. A contemporary interpretation, faithful to the specifications of the house.

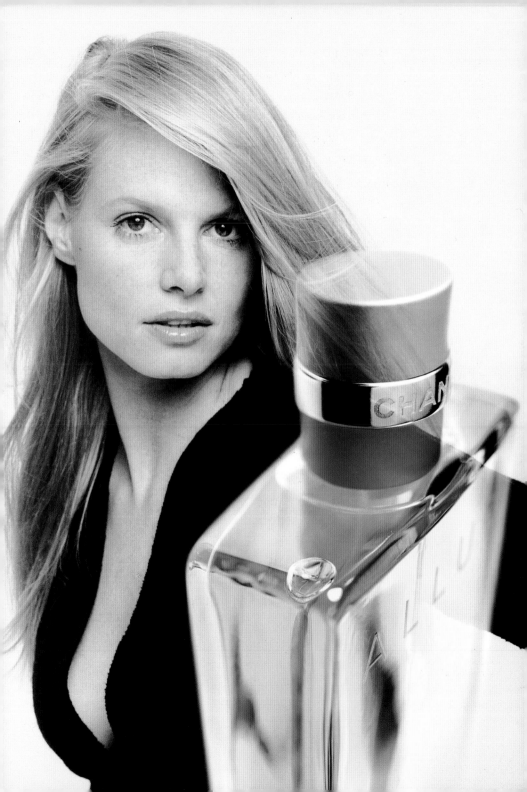

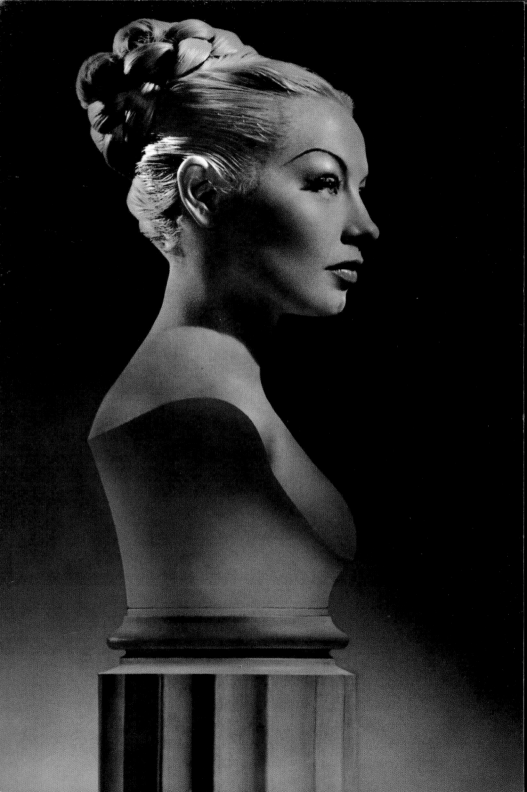

Beauty | Appendices

Beauty

Bibliography

Beauty–A Historical Review

Auteurs grecs et latins, Paris, librairie Guillaume Budé.

Les Blasons du corps féminin, in Poètes du xvi^e siècle, Paris, "Bibliothèque de la Pléiade", Gallimard, 1970.

Histoire universelle, Paris, "Encyclopédie de la Pléiade", Gallimard, 3 tomes, 1956-1958.

Histoire de l'art, Paris, "Encyclopédie de la Pléiade", Gallimard, 4 tomes, 1961-1969.

Barbey d'Aurevilly, Jules Amédée, Les Diaboliques, Paris, Le Livre de poche, 1999.

Baudelaire, Charles, Le Peintre de la vie moderne, in Œuvres complètes, Paris, "Bibliothèque de la Pléiade", Gallimard, tome II, 1976.

Chaponnière, Corinne, Le Mystère féminin, Paris, Olivier Orban, 1989.

Dayot, Armand, L'Image de la femme, Paris, Hachette, 1899.

Duby, Georges, et Perrot, Michelle, Images de femmes, Paris, Plon, 1992.

Faure, Élie, Histoire de l'art, Paris, Le Livre de poche, 1964.

Fouquet, Catherine, La Beauté, pour quoi faire?, Paris, Temps actuels, 1982.

Garland, M., The Changing Faces of Beauty, Northampton, Clarke and Sherwell, 1957.

Gautier, Théophile, De la mode, Arles, Actes Sud, 1993.

Grillet, B., Les Femmes et les fards dans l'Antiquité grecque, Paris, éditions du CNRS, 1976.

Houdoy, Jules, La Beauté des femmes dans la littérature et dans l'art du xii^e au xvi^e siècle, Paris, Aubry et Détaille, 1876.

Maigron, Louis, Le Romantisme et les mœurs, Paris, Honoré Champion, 1911.

Tertullien, Livre de l'ornement des femmes, in Jean Delumeau, La Peur en Occident, Paris, Le Livre de poche, 1978.

Truc, Gonzague, Histoire illustrée de la femme, Paris, Plon, tomes I et II, 1940.

The Decades

Barillé, Élisabeth, Guerlain, Paris, "Mémoire de la beauté", Éditions Assouline, 1999.

Castelbajac, Kate de, The Face of the Century, 100 Years of Make-Up and Style, New York, Rizzoli, 1995.

Chahine, Nathalie, Foufelle, Dominique, Deprund, Christine et Forest, Françoise de la, 100 ans de beauté, Paris, Atlas, 1996.

Cohen, Meg, et Kowlowski, Karen, Read my Lips, a Cultural History of Lipstick, San Francisco, Chronicle Books, 1998.

Corson, Richard, Fashions in Make-Up, Londres, Peter Owen, 1972.

Czekowski, Nicole (sous la dir. de), Fatale beauté, une évidence, une énigme, Paris, Autrement, n° 91, 1987.

Demornex, Jacqueline, Lancôme, Paris, "Mémoire de la beauté", Éditions Assouline, 1998.

Foufelle, Dominique, 100 ans de vie de femme, Paris, Atlas, 1997.

Jazdzewski, Catherine, Helena Rubinstein, Paris, "Mémoire de la beauté", Éditions Assouline, 1998.

Leroy, Geneviève et Vivien, Muguette, Histoire de la beauté féminine à travers les âges, Paris, Acropole, 1989.

Schefer Faux, Dorothy, What is Beauty?, Paris, Éditions Assouline, 1997.

Ethnic Beauty

Allen, Charles et Dwivedi, Sharada, Lives of the Indian Princes, Londres, Century Publishing London, 1984.

Al Moukhtarat, n°36 , Paris, Institut du monde arabe, 1997.

Baker, Joséphine, et Bouillon, Jo, Joséphine, Paris, "Vécu", Robert Laffont, 1976.

Barbieri, Gianpaolo, Tahiti Tattoos, Cologne, Taschen, 1998.

Barthes, Roland, L'Empire des signes, Paris, "Champs-Flammarion", Flammarion, 1980.

Beckwith, Carol, et Fisher, Angela, La Corne d'Afrique, Paris, Chêne, 1990.

Benchaâbane, Abderrazzak, et Abbad, Abdelaziz, Les plantes médicinales commercialisées à Marrakech, Marrakech, "La Main verte", Traces du présent, 1997.

Blauer, Ettagale, *African Elegance*, Londres, New Holland Publishers-Nedbank, 1999.

Corps tabou, Le, "Internationale de l'imaginaire" tome VIII, Arles, "Babel", Actes Sud, 1997.

Devi, Gayatri, *Une princesse se souvient*, Paris, Kailash, 1992.

Falgayrettes-Leveau, Christiane, *Corps sublimes*, Paris, Musée Dapper, 1994.

Fisher, Angela, *Fastueuse Afrique*, Paris, Chêne, 1984.

Guillain, Robert, *Les Geishas*, Paris, Arléa, 1997.

Huet, Michel, et Savary, Claude, *Danses d'Afrique*, Paris, Chêne, 1994.

Jain, Jyotindra, et Neubauer, Jutte Jain, *L'Idéal féminin dans l'art indien*, Paris, cat. exp. Galeries Lafayette, 1995.

Laoust, Emile, *Noces berbères*, Aix-en-Provence, Edisud, 1992.

Leiris, Michel, *L'Afrique fantôme*, Paris, Gallimard, 1934.

Levi-Strauss, Claude, *Tristes Tropiques*, Paris, Plon, 1955.

Maurin-Garcia, Michèle, *Le Henné, plante du paradis*, Casablanca, Eddif, 1993.

Saba, n°1, Bruxelles, Amyris, 1994.

Seydou Keita, introduction de Youssouf Tata Cissé, Paris, "Photopoche", Centre national de la photographie, 1995.

Thornton, Lynne, *La Femme dans la peinture orientaliste*, Paris, ACR Éditions, 1993.

Cosmetics and Magazines

Archives des magazines *Marie Claire*, *Elle* et *Votre Beauté*.

Perfumes

Barillé, Elisabeth, *Coty*, Paris, Éditions Assouline, 1995.

Charles-Roux, Edmonde, *Le Temps Chanel*, Paris, Chêne-Grasset, 1979.

Corbin, Alain, *Le Miasme et la Jonquille*, Paris, Aubier-Montaigne, 1982.

Delbourg-Delphis, Marylène, *Le Sillage des élégantes*, Paris, Lattès, 1983.

Edwards, Michael, *Parfums de légende*, Paris, HM éditions, 1998.

Etherington-Smith, Meredith, *Patou*, Paris, Denoël, 1984.

Fellous, Colette, *Guerlain*, Paris, Denoël, 1987.

Grayson, Susanne B., "The Myth of Fine Fragrance", in *American Cosmetics and Perfumery*, juin 1972.

Huysmans, Joris-Karl, *À rebours*, Paris, Pocket, 1999.

Roudnitska, Edmond, *Le Parfum*, Paris, "Que sais-je ?", PUF, 1980.

Roudnitska, Edmond, *L'Intimité du parfum*, Paris, Olivier Perrin, 1974.

Sachs, Maurice, *La Décade des illusions*, Paris, Gallimard, 1932.

Page 392 :
Greek goddess. Lili St Cyr photographed by Bernard of Hollywood.

Photography Credits

6 Coll. part. Serge Kakou. © D.R.
9 © Photo Cindy Sherman/Metro Pictures.
11 © Courtesy Deitch Projects, NY.
12 © Archives Esquire.
13 © Photo Helmut Newton/ Votre Beauté.
15 © 1994 Matthew Barney/Courtesy Barbara Gladstone Gallery.
16 © Photo Philippe Halsmann/ Magnum.
17 © The Andy Warhol Foundation, Inc./Art Ressource, NY.
19 © Photo René Burri/Magnum.
20 © Man Ray Trust/Adagp/ Télimage 1999.
23 © Photo David Seidner.
26 © D.R.
27 © Photo Laziz Hamani/Éditions Assouline.
28 Musée du Louvre, Paris. © Éditions Assouline.
29 © Photo Hermann Wagner/ Archaeological Receipts Fund.
30 © Photo Araldo De Luca.
33 Musée national d'Archéologie, Naples. © D.R.
35 Musée du Louvre, Paris. © RMN.
37 Cathédrale de Naumburg. © AKG Photo Paris.
38 Musée royal des Beaux-Arts, Anvers. © AKG Photo Paris.
40 Kunsthistorisches Museum, Vienne. © AKG Photo Paris.
41 Gemäldegalerie, Berlin. © AKG Photo Paris.
44 Galerie des Offices, Florence. © AKG Photo Paris.
45 Musée Condé, Chantilly. © Giraudon.
47 Städelsches Kunstinstitut, Francfort. © AKG Photo Paris.
49 © AKG Photo Paris.
50 Galerie des Offices, Florence. © AKG Photo Paris.

53 National Gallery of Art, Washington. © Giraudon.
55 Musée du Prado, Madrid. © AKG Photo Paris.
56 Bibliothèque des Arts décoratifs, Paris. © Photo J.-L. Charmet.
57 Kunsthistorisches Museum, Vienne. © AKG Photo Paris.
59 Hatfield House, Angleterre. © AKG Photo Paris.
61 The Wallace Collection, Londres. © The Bridgeman Art Library, Paris.
62 Musée Condé, Chantilly. © AKG Photo Paris.
63 Bibliothèque nationale, Paris. © AKG Photo Paris.
65 Musée du Louvre, Paris. © RMN.
67 Kunsthistorisches Museum, Vienne. © AKG Photo Paris.
68 Le Bon Ton, 1945. © D.R.
69 Metropolitan Museum of Art, New York. © The Bridgeman Art Library, Paris.
70 Kunsthalle, Hamburg. © AKG Photo Paris.
71 © Gilman Paper Company Collection, New York.
73 Tate Gallery, Londres. © AKG Photo Paris.
75 Musée du Louvre, Paris. © Photo Gérard Blot/RMN.
77 © Bibliothèque nationale de France, Paris.
81 © Arch. phot. Paris/CNMH.
82 Photo George Charles Beresford. © By courtesy of the National Portrait Gallery, Londres.
83 © D.R.
84 © D.R.
85 © D.R.
86 Coll. part. © D.R.
87 Photo Reutlinger. Coll. part. © D.R.
88 Bibliothèque des Arts décoratifs, Paris. © Photo J.-L. Charmet.
89 © Archives Schwarzkopf.

90 Musée Carnavalet, Paris. © Cliché Joffre/Photothèque des Musées de la Ville de Paris.
91 © Photo J.-L. Charmet/Bibliothèque des Arts décoratifs, Paris.
92-93 1, 2, 3 : © Archives Elizabeth Arden ; 4, 5 : © Archives Helena Rubinstein ; 6 : © Photo Laziz Hamani/Éditions Assouline.
95 Coll. Robert Cushman. © Mary Pickford Foundation.
96 © D.R.
97 © Rue des Archives.
98 © Archives Nivéa.
99 Galleria d'Arte Moderna, Venise. © Austrian Archives, Vienne.
100 © Photo Keiichi Tahara/Éditions Assouline.
101 Photo Malcolm Arbuthnot. © D.R.
102 © Archives L'Oréal.
103 Coll. part. © D.R.
104-105 1, 5 : © D.R. ; 2, 7, 8 : © Archives Coty ; 3 : © Archives Guerlain ; 4 : © Archives Bourjois ; 6, 9, 10 : © Archives Roger & Gallet.
107 © Association des amis de J.-H. Lartigue.
108 © Rue des Archives.
109 © Rue des Archives.
110 Montage Studio Manassé. © D.R.
111 © Man Ray Trust/Adagp/ Télimage 1999.
112 © D.R.
113 © Collection Viollet.
114 © Archives Guerlain.
115 Coll. G.P.A. © Hulton Getty.
116 © D.R.
117 © Archives L'Oréal.
118-119 Coll. part. © D.R.
120-121 1 : © AKG Photo Paris ; 2 : © D.R. ; 3 : © Boyer-Viollet ; 4 : © Photo J.-L. Charmet ; 5 : © Collection Viollet.
123 © Coordination, Paris/D.R.

124 © Rue des Archives.
125 Coll. part. © D.R.
126 © Rue des Archives.
127 © Rue des Archives.
128 © Archives L'Oréal.
129 © Collection Viollet.
130 © D.R.
131 © Association des Amis de J.-H. Lartigue.
132-133 © Danziger Gallery.
134-135 © Archives Max Factor.
137 © Kobal/PPCM.
138 © Archives Votre Beauté.
139 © Collection Viollet.
140 © Photo Christian Bouvier.
141 © Archives L'Oréal.
142 © Rue des Archives.
143 © Kharbine Tapabor.
144 © Archives Rochas.
145 Coll. part. © D.R.
146 © Rue des Archives.
147 © Kobal/PPCM.
148 © Archives of Milton Greene.
149 © Photo Herbert List/Magnum.
150-151 1, 3 : © Kharbine Tapabor ; 2 : © Rue des Archives ; 4 : Coll. part. © Photo J.-L. Charmet ; 5 : © D.R.
153 © Photo Arik Népo/D.R.
154 © Archives of Milton Greene.
155 © Illustration René Gruau/Sylvie Nissen.
156 © Archives of Milton Greene.
157 © Photo Philippe Halsmann/ Magnum.
158 © Archives Wella.
159 © Photo Mark Shaw/Photo Researchers.
160 © Photo Jock Carroll/PPCM.
161 Photo Sam Lévin. © Ministère de la Culture, France.
162-163 1, 2, 3 : © Coll. part. Alexandre ; 4 : © Photo Peter Knapp ; 5 : © Photo Mearson/Archives Carita ; 6 : © Archives Carita.

165 © Rue des Archives/Everett.
166 © Archives Mary Quant.
167 © Photo Peter Knapp.
168 © Archives L'Oréal.
169 © Archives of Milton Greene.
170 © D.R.
171 © William Klein.
172 © Hulton Getty.
173 © 1978 Bob Willdughby/MPTV/ Prakasha Inc.
174 © Photo Berry Berenson.
175 © Photo Franco Rubartelli/ Condé Nast Publications Inc.
176-177 © Photos Serge Lutens.
179 © Photo Bruce McBroom/ MPTV/Prakasha Inc.
180 © United Artists/ Kobal/PPCM.
181 © Photo Victor Skrebneski.
182 © Esquire/D.R.
183 © Columbia/Kobal/PPCM.
184 © Archives L'Oréal.
185 © Archives Votre Beauté.
186 © Photo Ron Galella/Sygma.
187 © Photo Gene Spatz/ 1979 Images.
188 © D.R.
189 © Photo Liaison Agency/Gamma.
190-191 1 : © Miramax/Kobal/ PPCM ; 2 : © Condé Nast Publications Inc. ; 3 : © Archives of Milton Greene ; 4, 5 : © Rue des Archives.
193 © Photo Norman Parkinson/ Hamilton Photographers.
194 © D.R.
195 © Photo M. Childers/Sygma.
196-197 © Photos Roxanne Lowit.
198 © Photo Andy Schwartz/ Orion Pictures Corp.
199 © Photo Svenska Dagbladet/ Keystone.
200 © Photo François Dymant. Avec l'aimable autorisation de Virgin France.
201 © Photo Gilles Bensimon/Elle.

202-203 1 : © Photo Tyen/Archives Dior ; 2 : © D.R. ; 3 : © Archives Thibault Vabre ; 4 : © Photo François Lamy ; 5 : © Archives Givenchy.
205 © Photo Mario Sorrenti/ Archives Calvin Klein.
206 © Photo Mario Testino.
207 © Photo Pamela Hanson.
208-209 © Photo Peter Lindbergh.
211 © Photo Bill Davila/PPCM.
213 © Photo Kevyn Aucoin.
214 © Photo Gilles Bensimon.
215 © Photo Bruno Juminer.
217 © Photo Éric Traoré/Vogue France
218-219 © Photos Wolfgang Ludes/ Madison.
220 © Eidos.
221 Coiffure Aldo Coppola, maquillage Fred Farrugia, pour le livre Infinium. © Photo Javier Vallhonrat/Michele Filomeno.
222-223 1 : © Photo Albert Watson ; 2 : © Photo Nick Knight/ Archives Lancôme ; 3 : © Photo Nick Knight/Archives Lancôme ; 4 : © Photo Patrick Swirc/MPA ; 5 : © Photo Ellen von Unwerth/ Archives Lancôme ; 6 : © Photo Wolfgang Ludes ; 7 : © Photo Dah Len.
227 © Photo Lehnert et Landrock/ Musée de l'Élysée, Lausanne.
229 © Photo Albert Watson.
230 © Photo Fabio Paleari, 1993.
233 © Photo Toni Catany.
234 © Photo Peter Knapp.
237 Coll. part. © D.R.
238 © Photo Lynn Harey/ Rue des Archives/Everett.
239 Coll. part. © D.R.
240 © Photo Dominique Darbois.
241 © Archives Barbier-Mueller, Genève.

Beauty

Acknowledgment

From the publisher
This book could not have been produced without the invaluable advice and understanding of its many contributors. Sadly, the sheer number of people who have collaborated on the project prohibits them from all being listed here. Apologies to those whose names are not included—they are nevertheless sincerely thanked for their help and we are and shall remain extremely grateful to them.
The publishers would like to thank the following houses:Alexandre, Elizabeth Arden, Baccarat, Bourjois, Cacharel, Carita, Caron, Chanel, Comme des Garçons, Coty, Christian Dior, Max Factor, Jean Paul Gaultier, Givenchy, Annick Goutal, Grès, Guerlain, Kenzo, Calvin Klein, Karl Lagerfeld, Lancôme, Lanvin, Guy Laroche, Estée Lauder, L'Oréal, Lux, Issey Miyake, Molinard, Thierry Mugler, Nivéa, Patou, Mary Quant, Paco Rabanne, Revlon, Nina Ricci, Rochas, Roger & Gallet, Helena Rubinstein, Yves Saint Laurent, Schiaparelli, Schwarzkopf, Shiseido et Wella.**And many thanks to all the artistic directors, makeup artists, and photographers who helped us:**Kevyn Aucoin, Gilles Bensimon, Berry Berenson, Toni Catany, Dominique Darbois, Patrick Demarchelier, François Dymant, Olivier Echaudemaison, Fred Farrugia, Fabrizio Ferri, Vincent Godeau, Torkil Gudnason, Armin Haab, Laziz Hamani, Pamela Hanson, Bruno Juminer, William Klein, Peter Knapp, Nick Knight, David Lachapelle, François Lamy, Dah Len, Peter Lindbergh, Araldo de Luca, Wolfgang Ludes, Serge Lutens, Roxanne Lowit, Dilip Mehta, Heidi Moravetz, Nicolas Muray, François Nars, Helmut Newton, Fabio Paleari, Norman Parkinson, Mattew Rolston, Paolo Roversi, Franco Rubartelli, Sante D'Orazio, Victor Skrebneski, Mario Sorrenti, Gene Spatz, Patrick Swirc, Keiichi Tahara, Terry, Mario Testino, Topolino, Éric Traoré, Tyen, Ellen von Unwerth, Thibault Vabre, Javier Vallhonrat, Albert Watson et Claus Wickrath.**We are also grateful to all those who provided encouragement and support for the project, particularly:**Nadja Auermann, Matthew Barney, Marisa Berenson, Björk, Naomi Campbell, Dominique Casta, Laetitia Casta, Catherine Deneuve, Miki Denhof, Devon, Farida, Farrah Fawcett, Jane Fonda, Marie Gillain, Bettina Graziani, Amy Greene, René Gruau, Jerry Hall, Shalom Harlow, Kim Iglinski, Iman, Grace Jones, Milla Jovovich, Kenneth et Victoria Meekins, Patrice Lerat-Nagel, Gong Li, Heather Locklear, Madonna, Rosemary McGrotha, Elle McPherson, Mariko Mori, Kate Moss, Karen Park Goude, Paloma Picasso, Cristiana Reali, Isabella Rossellini, Inès Sastre, Claudia Schiffer, Stephanie Seymour, Cindy Sherman, Jean Shrimpton, Stella Tennant, Christy Turlington, Twiggy, Veruschka, Estella Warren, Alek Wek, Leslie Winner et Inna Zobova.**Finally, our thanks to the many agencies, collectors, galleries, magazines, and museums who have made this publication possible:**Stéphane Allart (Michele Filomeno), *Allure,* Elaina Archer (The Mary Pickford Foundation), la bibliothèque des Arts décoratifs, Gabriel Bauret, Renate Benecke (AKG Photo), Alain Bernard (La Pac), Susan Bernard (Bernard of Hollywood), Anne-Catherine Biderman et Frédéric Doat (Mission du patrimoine photographique), Marie-Christine Biebuyck (Magnum), la Bifi, Jacques Borgé, The Bridgeman Art Library, Pierre-Yves Butzbach (Télimage), la Caisse nationale des monuments historiques, Sophie Cantiniau (Lighthouse Artists Management), Cat, Nicole Chamson (Adagp), Jean-Loup Charmet, Nakiah Cherry, City, Condé Nast Publications Inc., Pierre Cosar, Fiona Cowan (Hamilton Photographers Limited), Sue Daly (Sotheby's), la Danziger Gallery, Corinne Decelle, Deitch Projects, Laure Deren (*Marie Claire*), Eidos, Elite, *Elle,* le musée de l'Élysée de Lausanne, *Esquire,* Amy Fisher, les éditions FMR, Ford, Thierry Freiberg (Sygma), Florence Frutoso, Gamma, la Gilbert Paper Company Collection, Giraudon, la Barbara Gladstone Gallery, *Glamour,* Peter L. Gould (Images Pictures Inc.), *Harper's Bazaar,* Hélène (Marilyn Agency), Michael Houlette (Association des amis de Jacques-Henri Lartigue), Hulton Getty/Fotogram- Stone Images, Pierre Husson (PPCM), Huw (Art Partner), IMG, Anne de Jouvenel, Soffie Kage (Archives of Milton Greene), Serge Kakou, Keystone, Mark Kriendler Nelson, Derrick Lacey (Creative Exchange), Françoise de Lapparent, *Madame Figaro,* Candice Marks (Art Partner), *Marie Claire,* Laurence Mattet (Musée Barbier-Mueller), Metro Pictures, Sandrine Michard, la photothèque des Musées de la Ville de Paris, Franck Nasso (Leyla Basakinci), la National Portrait Gallery de Londres, Sylvie Nissen, Karina Pollock, Prestige et collections, Deanna Raso (*Vogue* américain), Diana Reeve (The Andy Warhol Foundation), Hassan Rizk, la photothèque de la RMN, Roger-Viollet, Marina Rossi (*Vogue* Italie), Rue des Archives, Marie-Paule Sapijanskas (*Votre Beauté*), Shen She (CFPA), Stacy (Le Book New York), Michael Stier (*Vogue* américain), Kharbine Tapabor, *Top Model,* André Tubeuf, *Vanity Fair,* monsieur Vigoureux (Bibliothèque nationale de France), Virgin, Viva, *Vogue, Votre Beauté,* Linda Wells (*Allure*) et Marisa Zanatta (Industria Produzioni).

From the authors:
Catherine Jazdzewski would like to thank Olivier Echaudemaison and Peter Knapp.
Françoise Mohrt would like to thank Martine Paillard, Masha Magaloff, Terry by Terry, Béatrice Braun, Dominique Moncourtois, and Michel Mohrt.
Fabienne Russo would like to thank Annie Barbera (Bibliothèque du Musée Galliera, Paris, Josyane Sartre, curator, and Lysiane Allinieu, librarian (Bibliothèque des Arts Décoratifs, Paris).
Dorothy Schefer Faux would like to thank Heather Keller.
Francine Vormese would like to thank Françoise Dautresme, Esther Kamatari, Shi Kaï de Baecque and Song, as well as Abderrazzak Benchâabane and Apollinaire Yengayenge.